wildlife

photographs by
MITSUAKI IWAGO

wildlife

CHRONICLE BOOKS
SAN FRANCISCO

First published in the United States in 1998 by Chronicle Books.
First published in Japan in 1998 by Yama-Kei Publishers Co., Ltd.
Text and photographs copyright © 1998 by Mitsuaki Iwago.
All rights reserved. No part of this book may be reproduced in
any form without written permission from the publisher.

Printed in China
ISBN 0-8118-2203-6 [pb]
ISBN 0-8118-1858-6 [hc]

Library of Congress Cataloging-in-Publication Data available.

Cover and text design: Sarah Bolles
Translation: Isao Tezuka

Distributed in Canada by Raincoast Books
8680 Cambie Street, Vancouver, B.C. V6P 6M9

10 9 8 7 6 5 4 3 2

Chronicle Books
85 Second Street
San Francisco, California 94105

www.chroniclebooks.com

contents

preface

FLYING EAST OVER THE PACIFIC OCEAN, THROUGH THE SMALL WINDOW I CAN SEE THE SKY IN THREE COLORS: BLUE, RED, AND WHITE. THE READING LIGHTS THAT WERE ON A LITTLE WHILE AGO ARE OFF NOW, AND INSTEAD THERE ARE SEVERAL SEATS WHERE THE SHADES ARE LIFTED TO MAKE A MODEST LOOKOUT SPACE. OBVIOUSLY I AM NOT THE ONLY PERSON IN THIS PLANE WHO IS CURIOUS ABOUT HOW THE EARTH LOOKS AT DAYBREAK.

I wonder why people travel. Do they travel because they wish to go to a world totally different from their everyday lives? Or, do they want to know a different culture and history? Perhaps they just want to enjoy nature and scenery, to feel something new. They may be moved. They may experience surprise, joy, sorrow, and sometimes even anger.

When I was a young boy, I visited a temple in the midst of a mandarin orange field deep in the mountains on the Seto Inland Sea of Shikoku, Japan. I went with my father, a wildlife photographer, to help him capture on film the flying squirrels that leapt from tree to tree at night. I stood on a stepladder in the dark, holding a strobe light, waiting to flash it on the abdomen of a squirrel as it took flight. I stood with my eyes wide open, looking out at the starlit night. At least I thought my eyes were open.

I woke to a crash, followed by the angry voice of my father. I had fallen asleep and dropped the strobe. Embarrassed, I blamed it on the Seto Inland Sea, which had shone so blue and clear in the moonlight.

The next day I went down to the rugged beach, climbed a rock, and gazed out at the sea. What beautiful, blue water! I had never known such a sea existed. How deep was it? I threw a small stone and watched it drop through the clear water toward the bottom. A school of small fish chased it. Suddenly a big fish appeared. As the small fish scurried to escape, many of them jumped into the air. Then the ripples they created subsided and the peaceful surface of the sea returned to normal, as if nothing had happened. I could not help giving a shout of excitement.

I did not spend my boyhood collecting insects or becoming fascinated by television programs about animals, as many of my friends did. I didn't spend hours pouring over illustrated guides to plants. I was born and raised in Tokyo, where I grew up watching *The Lucy Show* and listening to the Beatles. Inspired by the LIFE magazines and photography books on the shelves of our living room, I dreamed of becoming a fashion photographer. That seemed like a glamorous profession.

In the meantime, I continued to travel halfheartedly as my father's assistant. After the flying squirrels in Shikoku, we shot pictures of foxes in Kyushu, bats in Iwate, and Japanese monkeys in Nagano. Together we saw many beautiful creatures, but I was more fascinated by the green of the forest, caught floating in the headlights of the car. I admit I enjoyed the sight of a Japanese nighthawk flying in the headlights' circle. And once, while taking pictures of a fox burrow in the middle of summer, a shiver of excitement made the sweat on my back run cold. But these things stayed with me as sensations rather than memories. I had not yet discovered the joy of observing animals in the wild.

Then I made my first journey abroad. In November 1970, when I was a sophomore in college, I traveled to the Galápagos Islands, which lie in the Pacific Ocean, right on the equator, about 600 miles (1,000 kilometers) off the coast of Ecuador. At that time these rugged volcanic islands, whose unusual wildlife led Charles Darwin to conceive the theory of evolution, were restricted to 1,000 tourists a year. I had been told they were islands of mystery—a harsh environment that was home to iguanas who looked like descendants of dinosaurs, giant tortoises on whose backs Darwin is said to have ridden for fun, and equatorial penguins.

My impression was quite different. I found that the environment of these solitary islands, far from being harsh or mysterious, was quite natural to the animals that lived there. The iguanas, the tortoises, the penguins, and even the clownish blue-footed boobies fit right in. They even seemed to enjoy themselves. The land provided comfortable places to lay eggs and raise chicks. The Humboldt Current—now known as the Peru Current—supplied abundant food. As the sun set over the ocean, I watched a flock of blue-footed boobies repeatedly dive headlong into the sea and then, like falcons, take off into the sky.

On my way home, I stopped in Los Angeles. It had long been the city of my dreams, but I found that it had lost its impact in the sea spray of the Galápagos.

Traveling inspired me to observe the world and, eventually, to make a career of that observation, but I also learned a great deal from the people I met. One such meeting occurred while I was visiting the Galápagos Islands on a small, miserable yacht. One day, while we were anchored in the cove of an island that resembled the surface of the moon, a British ship with a watch barrel topping the mast like a pirate ship approached us. On board was an American businessman named Malcolm Forbes. He invited us to dinner.

The interior of his ship was gorgeous. There were sofas of bright red leather and walnut bookshelves containing neatly organized copies of *National Geographic*. We were served tomato soup with the meal. It may have been canned, but it was sweet and delicious. Mr. Forbes was dressed in a neatly ironed white shirt.

"Are you going to be a nature photographer?" he asked me.

When I said I was, he said, "I envy you very much."

These words from the mouth of such a wealthy man carried great weight with me. I was living on a time-worn yacht, wearing a discolored and dirty T-shirt, and eating spaghetti cooked in sea water every day, yet Mr. Forbes' eyes showed that he was not joking.

When we're surrounded by nature, social status loses its meaning. In a forest in India, then-Prime Minister Rajiv Ghandi told me about the wild animals that lived there. Sir Peter Scott conversed with me as an equal about how vital it is for whales to thrive. Jacques Yves Cousteau taught me the importance of human consideration for nature and respect for animals in their wild state.

On tiny Rain Island near the northern end of the Great Barrier Reef, a green turtle expert explained to me the mystery of the green turtles that come by the thousands at night to lay their eggs. Under a star-filled sky, as we lay on the sandy beach taking a break from our research and picture taking, he told me in a simple and serious manner how these turtles travel from ocean to ocean. Only after forty or fifty years do they return to this island, which is no more than a mile-and-a-half (two kilometers) wide, to lay eggs where they were born. He said that his life was too short to learn everything about them. He hoped his sons and grandsons would continue his observations.

Nature and wild animals are the treasures of our earth. Protecting them seems like a simple matter, but it is difficult because we humans know too

little about them. What animals in the wild have acquired from their environment in the long history of the earth can never be measured by man's standard. It comprises the complex rhythm of life. By observing wild animals tenderly and continuously, we can better understand their behavior—and their needs.

As an animal photographer I try to be keen and bold in capturing nature. But I keep in mind that in our desire to see and understand animals it's important not to change their way of living. I took pictures of penguins because I wanted to see how they live in the Antarctic, laying eggs, hatching them, and raising chicks. I remember their rookeries were red with their droppings. I photographed kangaroos because I wanted to understand how this marsupial has evolved so peculiarly on the island continent of Australia. It was a difficult task for me, as a mammal. I was fascinated by whales because they are so large, but when I photographed them I realized that the ocean where they live is much larger. It gave me the desire to explore more seas.

On all these occasions, I trusted my feelings. Man's five senses have drastically degenerated, but nature has the power to bring them back to us. When I press the shutter of my camera, I rely completely on these senses to seize images of wild animals that are constantly in motion. It reminds me of that moving experience on the Seto Inland Sea when I was a young boy. It is this heightened awareness of being alive in nature that makes me continue to work as a wildlife photographer.

Sometimes as I'm shooting I feel my body grow heavy from too much concentration. At these times I relax my shoulders. I look around. The wind is blowing. There are hills and mountains, and the sky is beautiful. I feel as if I could capture the entire earth through my lens.

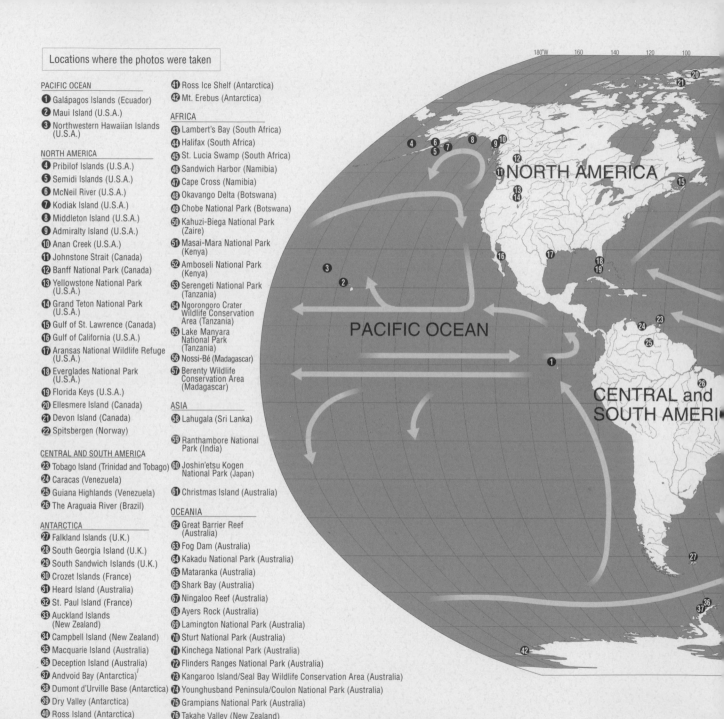

Locations where the photos were taken

PACIFIC OCEAN
1. Galápagos Islands (Ecuador)
2. Maui Island (U.S.A.)
3. Northwestern Hawaiian Islands (U.S.A.)

NORTH AMERICA
4. Pribilof Islands (U.S.A.)
5. Semidi Islands (U.S.A.)
6. McNeil River (U.S.A.)
7. Kodiak Island (U.S.A.)
8. Middleton Island (U.S.A.)
9. Admiralty Island (U.S.A.)
10. Anan Creek (U.S.A.)
11. Johnstone Strait (Canada)
12. Banff National Park (Canada)
13. Yellowstone National Park (U.S.A.)
14. Grand Teton National Park (U.S.A.)
15. Gulf of St. Lawrence (Canada)
16. Gulf of California (U.S.A.)
17. Aransas National Wildlife Refuge (U.S.A.)
18. Everglades National Park (U.S.A.)
19. Florida Keys (U.S.A.)
20. Ellesmere Island (Canada)
21. Devon Island (Canada)
22. Spitsbergen (Norway)

CENTRAL AND SOUTH AMERICA
23. Tobago Island (Trinidad and Tobago)
24. Caracas (Venezuela)
25. Guiana Highlands (Venezuela)
26. The Araguaia River (Brazil)

ANTARCTICA
27. Falkland Islands (U.K.)
28. South Georgia Island (U.K.)
29. South Sandwich Islands (U.K.)
30. Crozet Islands (France)
31. Heard Island (Australia)
32. St. Paul Island (France)
33. Auckland Islands (New Zealand)
34. Campbell Island (New Zealand)
35. Macquarie Island (Australia)
36. Deception Island (Australia)
37. Andvoid Bay (Antarctica)
38. Dumont d'Urville Base (Antarctica)
39. Dry Valley (Antarctica)
40. Ross Island (Antarctica)
41. Ross Ice Shelf (Antarctica)
42. Mt. Erebus (Antarctica)

AFRICA
43. Lambert's Bay (South Africa)
44. Halifax (South Africa)
45. St. Lucia Swamp (South Africa)
46. Sandwich Harbor (Namibia)
47. Cape Cross (Namibia)
48. Okavango Delta (Botswana)
49. Chobe National Park (Botswana)
50. Kahuzi-Biega National Park (Zaire)
51. Masai-Mara National Park (Kenya)
52. Amboseli National Park (Kenya)
53. Serengeti National Park (Tanzania)
54. Ngorongoro Crater Wildlife Conservation Area (Tanzania)
55. Lake Manyara National Park (Tanzania)
56. Nossi-Bé (Madagascar)
57. Berenty Wildlife Conservation Area (Madagascar)

ASIA
58. Lahugala (Sri Lanka)
59. Ranthambore National Park (India)
60. Joshin'etsu Kogen National Park (Japan)
61. Christmas Island (Australia)

OCEANIA
62. Great Barrier Reef (Australia)
63. Fog Dam (Australia)
64. Kakadu National Park (Australia)
65. Mataranka (Australia)
66. Shark Bay (Australia)
67. Ningaloo Reef (Australia)
68. Ayers Rock (Australia)
69. Lamington National Park (Australia)
70. Sturt National Park (Australia)
71. Kinchega National Park (Australia)
72. Flinders Ranges National Park (Australia)
73. Kangaroo Island/Seal Bay Wildlife Conservation Area (Australia)
74. Younghusband Peninsula/Coulon National Park (Australia)
75. Grampians National Park (Australia)
76. Takahe Valley (New Zealand)

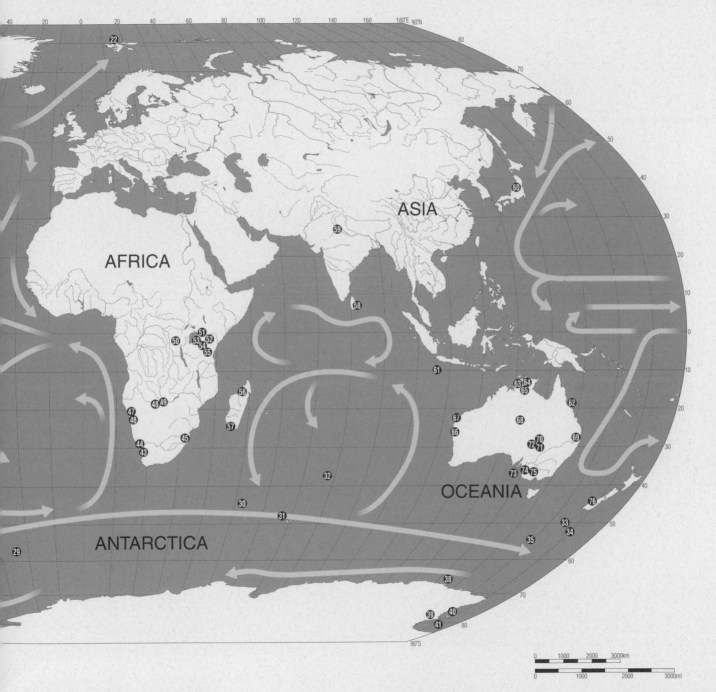

ASIA

AFRICA

OCEANIA

ANTARCTICA

⑬

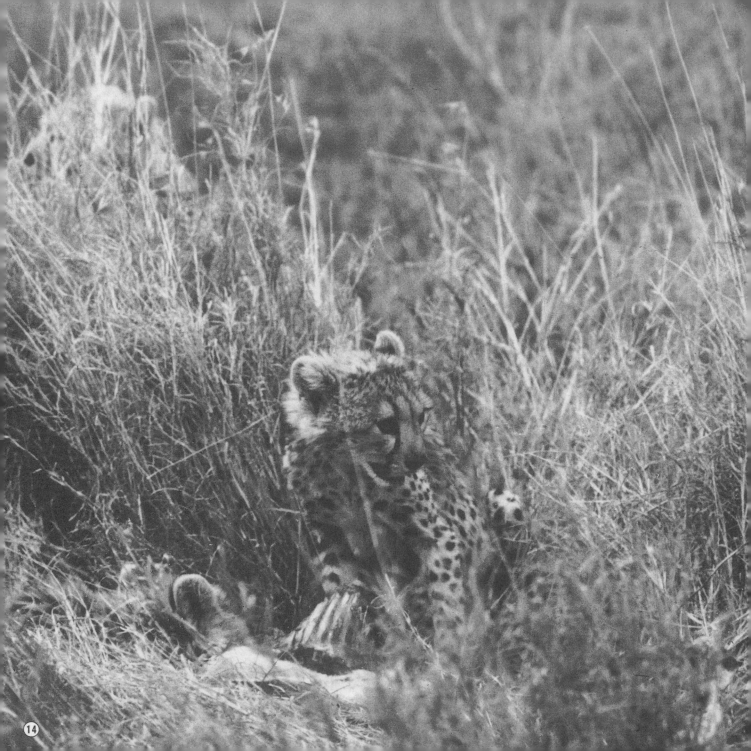

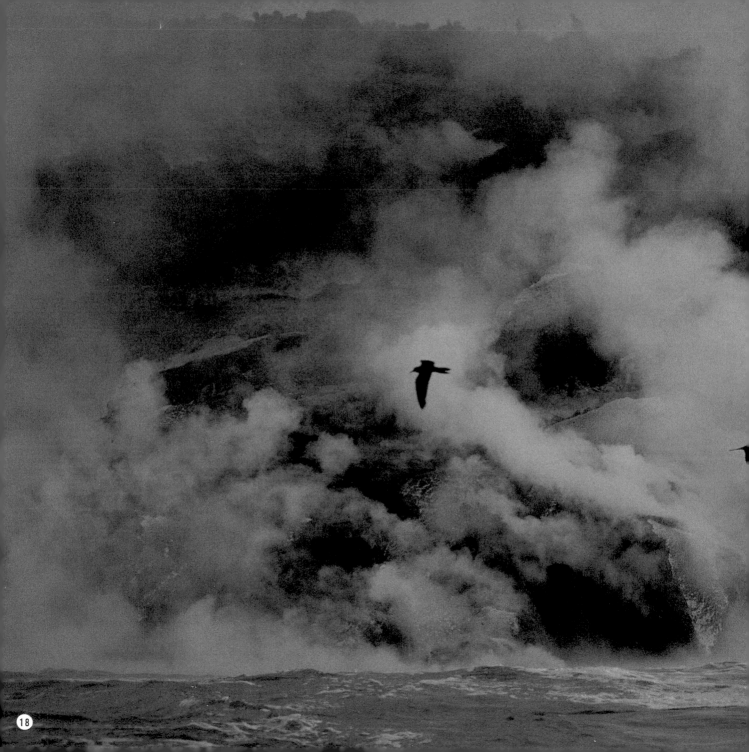

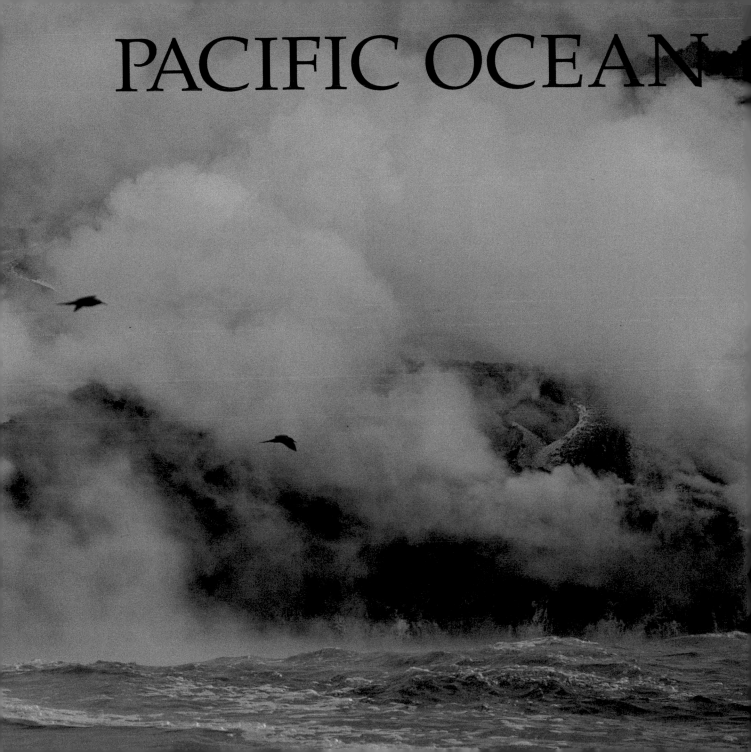

THE VAST EXPANSE OF THE
PACIFIC OCEAN SHELTERS
several diverse habitats, isolated
and unique, where the forces
of evolution are evident every
day. In the Galápagos Islands and
in the small islands northwest of
Hawaii we find unusual, dynamic
clusters of animals, birds and
marine life. Warm ocean currents
warm these islands, providing
breeding grounds and food for
migratory colonies that travel
thousands of miles on their
timeless journeys.

preceding pages: Volcanoes continue
to be active on the Galápagos
Islands. Lava pours into the ocean,
causing a violent steam explosion
that kills many fish. Soon, seabirds
circle to begin an easy feast.

Marine iguanas are indigenous
to the Galápagos. Good
swimmers, they need outside
warmth when their body
temperature is low. They bask
on the sun-heated lava rocks
after swimming in cold
seawater in search of seaweed.

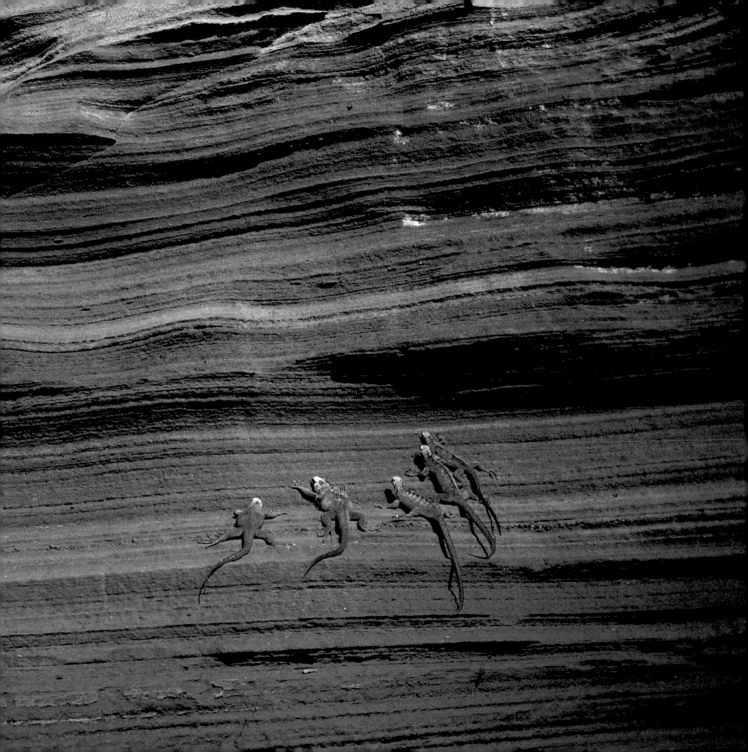

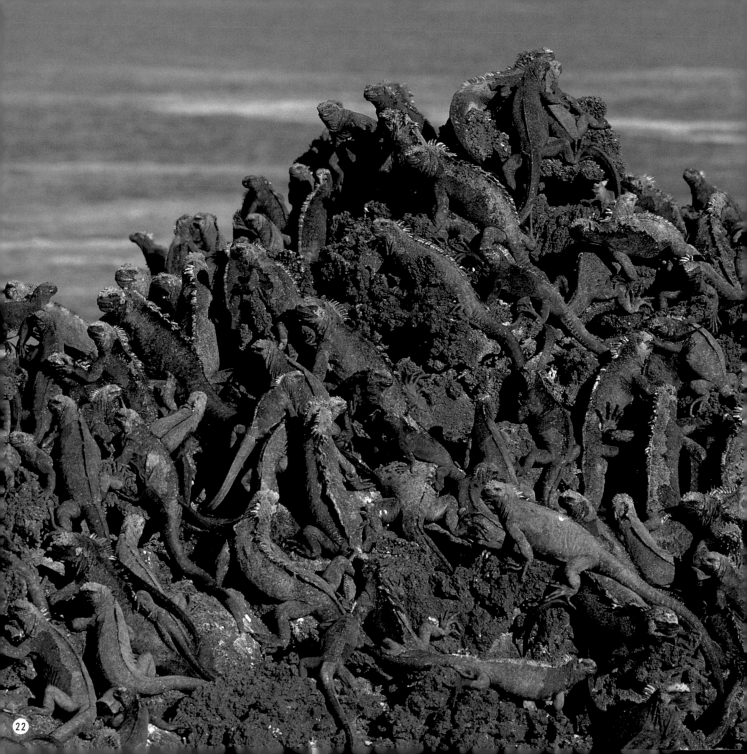

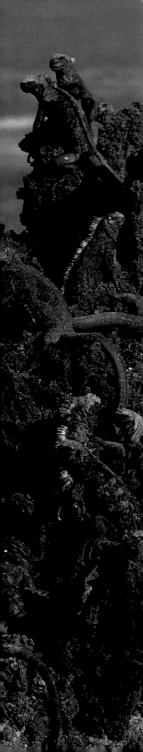

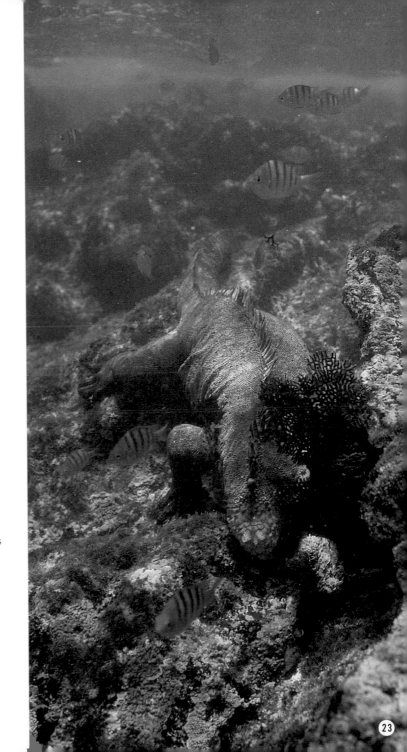

left: The routine for marine iguanas changes according to the time and the tide. In the evening calm, heavy scraping sounds echo as they slide across the coastal rocks.

Clutching the rock with long claws and fighting the tide, this marine iguana samples seaweed.

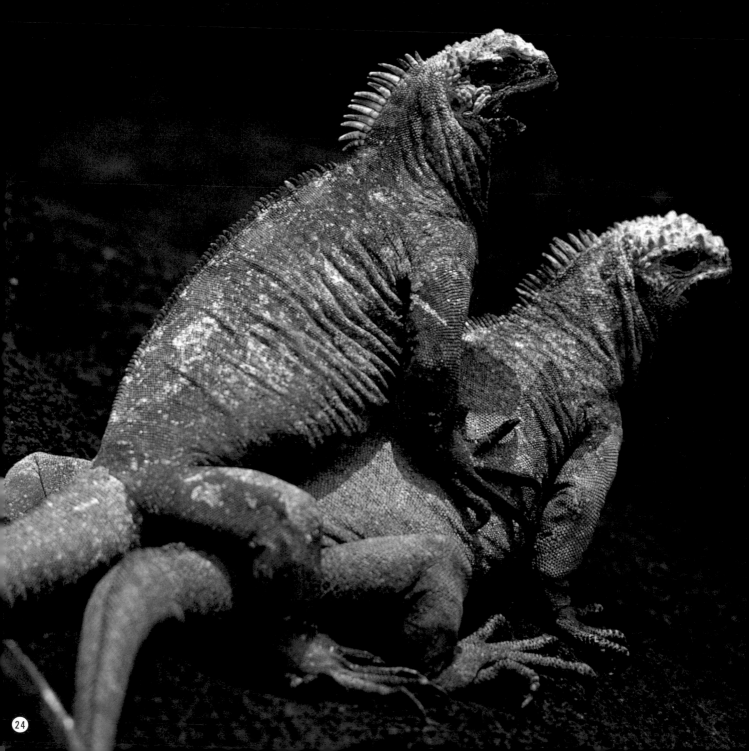

Marine iguanas
mate once a year. The
female will lay her
two eggs in a hole in
the sand.

When they eat seaweed,
marine iguanas take in a lot
of salt, which they blow
out through their nostrils
with a slight puffing sound.

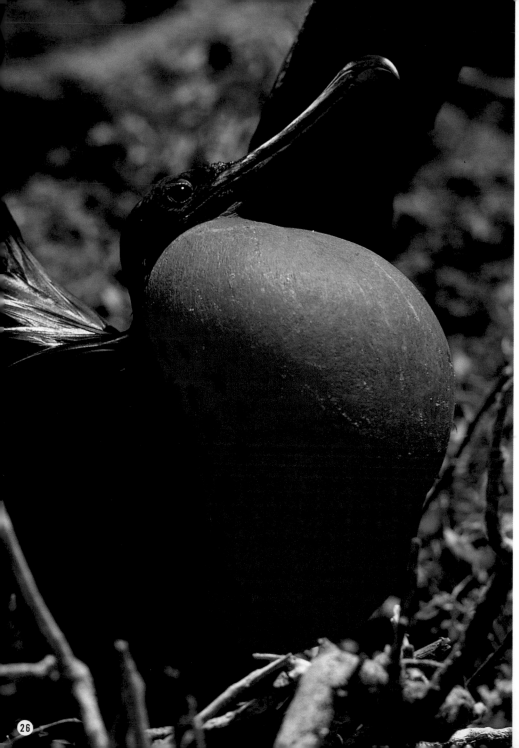

right: Easy prey to predators—including human hunters—the Galápagos flightless cormorant feeds on octopus and small fish. Here, they court in a fiery dance.

The pouch of a Great frigatebird expands like a balloon during courtship, becoming a resonating chamber for a variety of yodeling sounds.

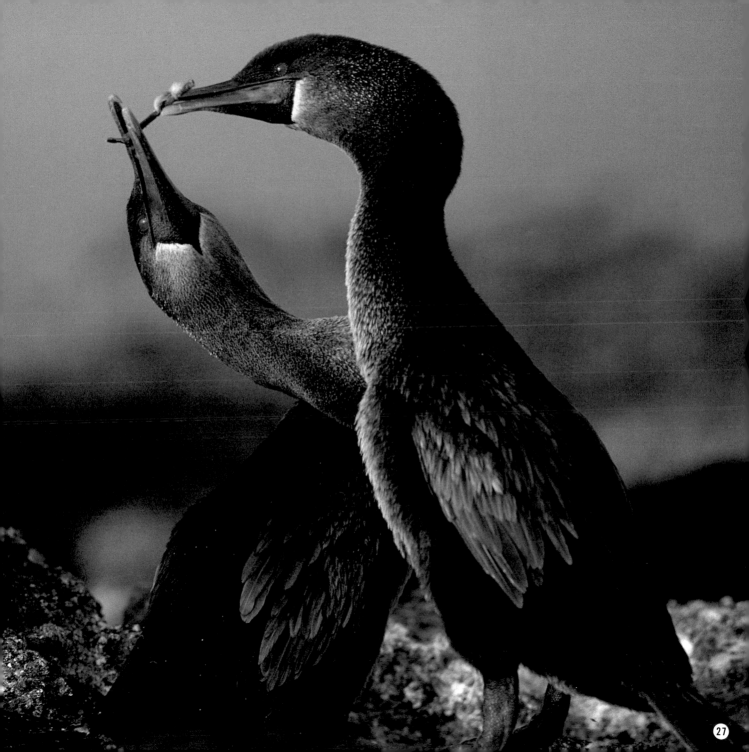

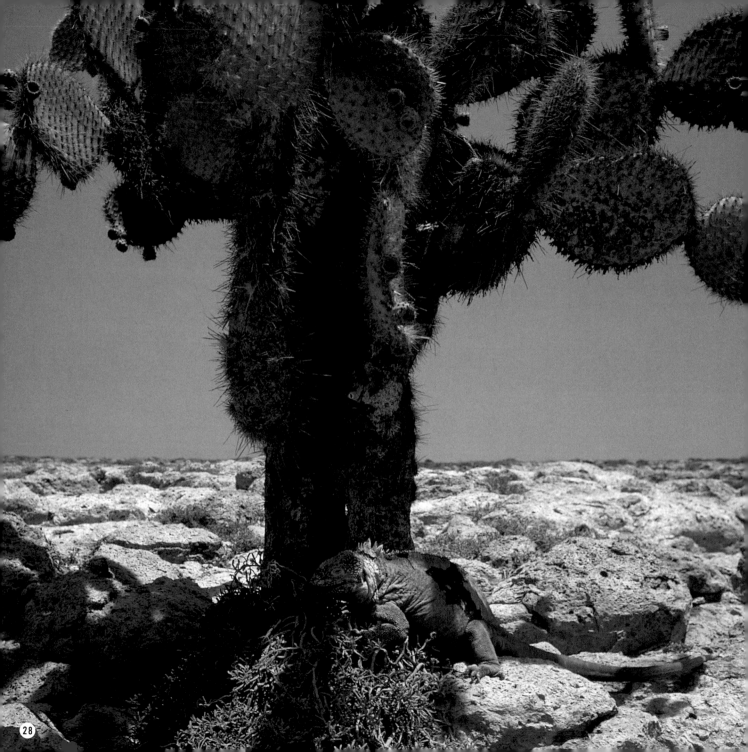

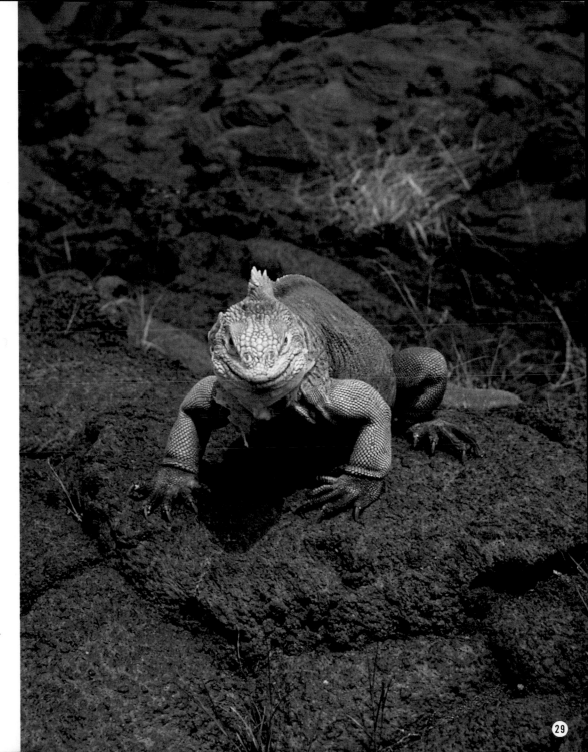

left: Quiet and retiring, land iguanas subsist on cactus flowers and fruits. On Fernandina Island, where eruptions left acres of steaming hot lava, this land iguana managed to find a cactus fruit and a patch of shade.

Birds of prey and encroaching goat pastures have reduced the number of land iguanas. The yellow of their body varies subtly according to the islands on which they live.

29

left: A baby marine
iguana investigates its
parent's back.

Destruction of the already
sparse vegetation on the
rocky islands has left the
land iguana vulnerable
to attack.

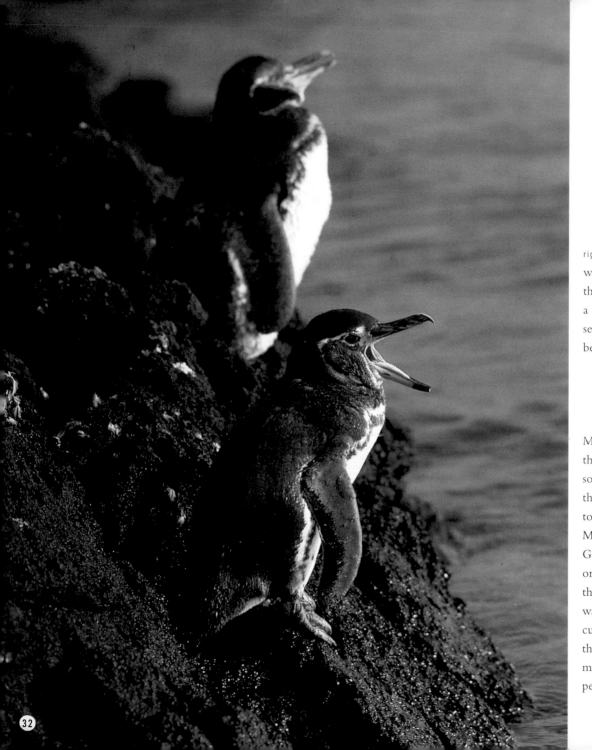

right: With featherless wings well adapted to swimming, the Galápagos penguin is a small bird that has been severely reduced in numbers by hunting.

Most penguins live in the cold climate at the southern most region of the earth. Closely related to South America's Magellan penguin, the Galápagos penguin is the only species of penguin that lives in equatorial waters. The cold Peru current circulates around the Galápagos Islands, making it possible for these penguins to live there.

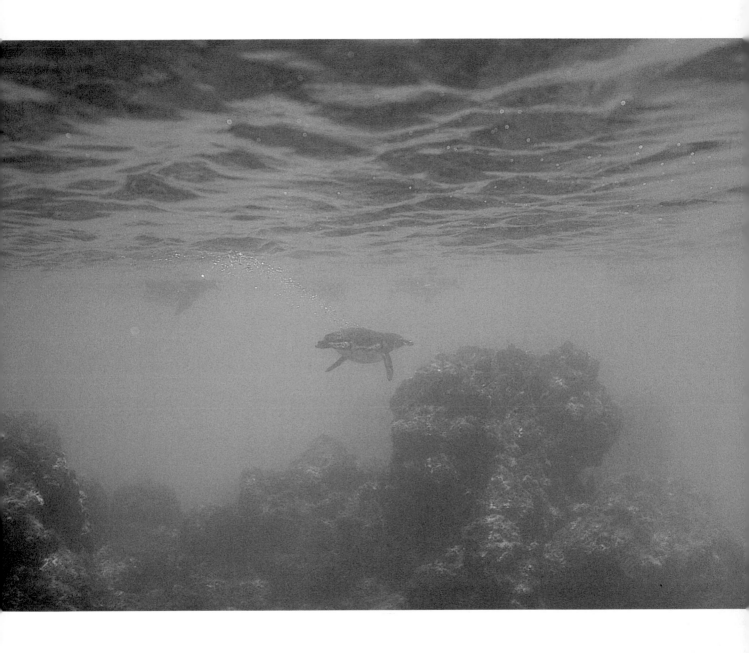

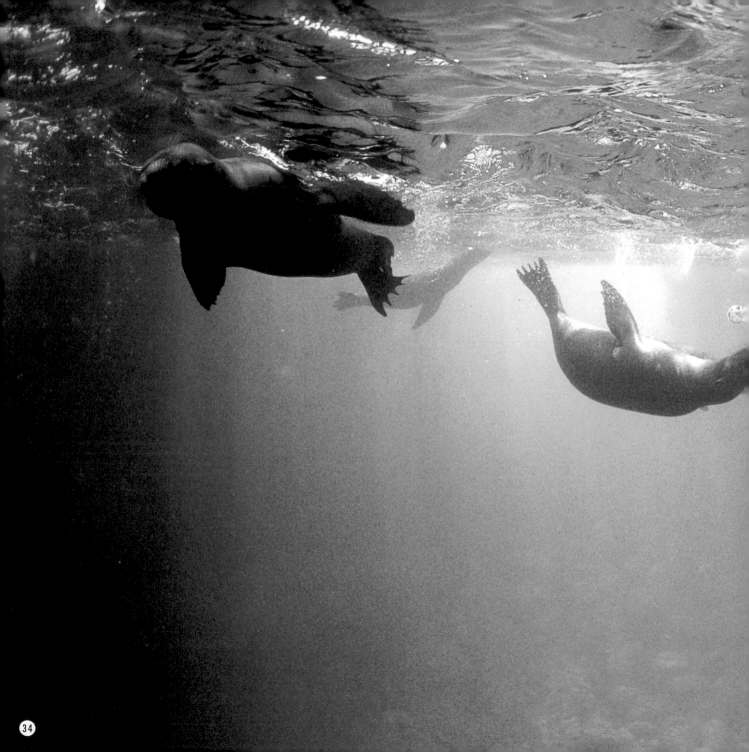

preceding pages:
Superbly adapted to
water, Galápagos sea lions
often appear to be playing
even when hunting in
earnest. Sea lions and fur
seals are the only large
mammals native to the
Galápagos.

right: Elliot's storm petrels
fly with their legs skim-
ming the surface as if they
were walking on water.
They catch small fish near
the water's surface.

The only seals that live in
the tropical sea, Galápagos
fur seals propel themselves
with powerful forelegs.
During the day, they retreat
to caves formed by lava to
avoid the heat.

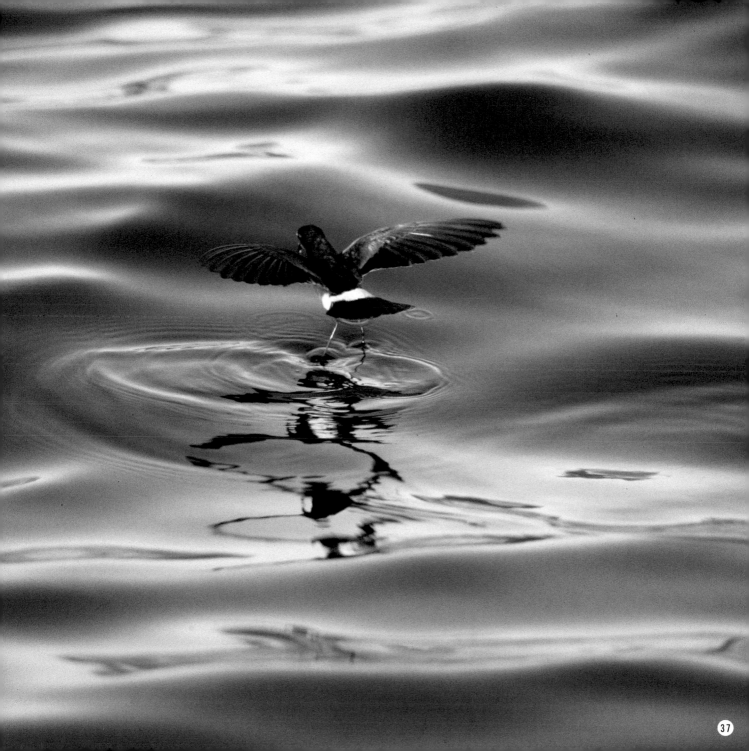

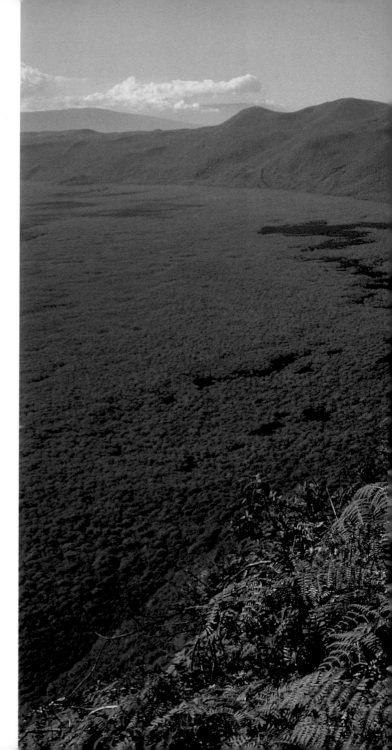

"Galápago" means tortoise
in Spanish. At home in this
arid climate, the Galápagos
giant tortoise has learned
to travel from the ocean to
the high volcanic plains,
where it swims and feeds
in small lakes.

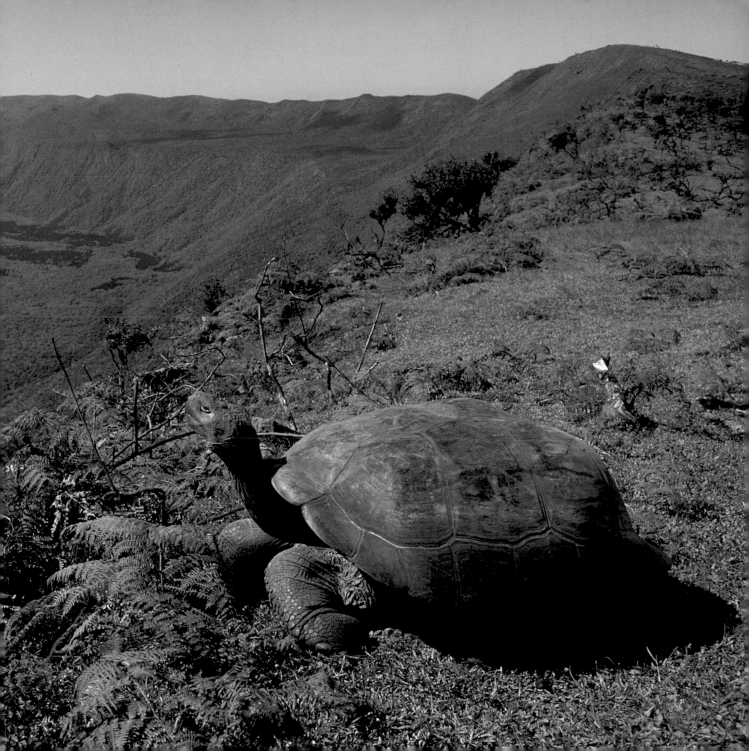

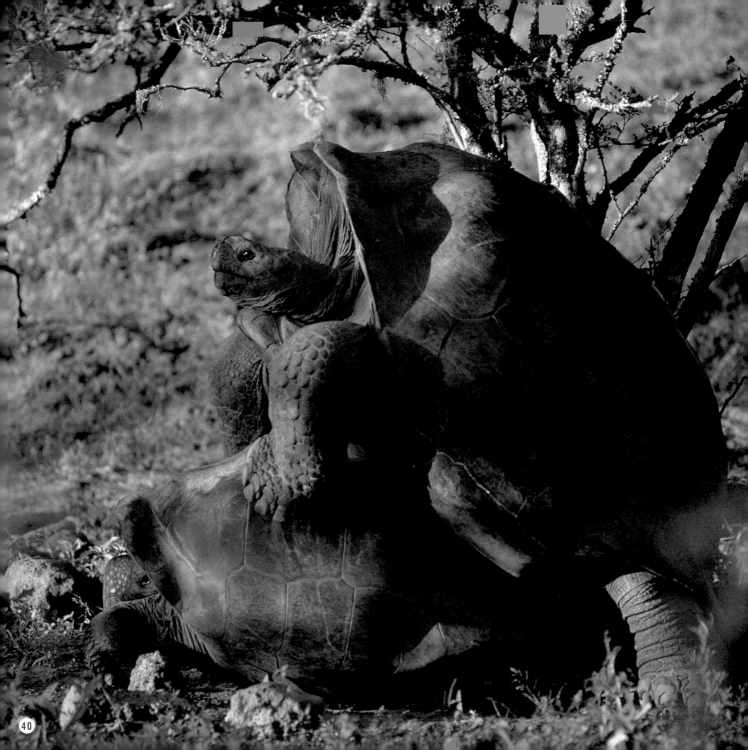

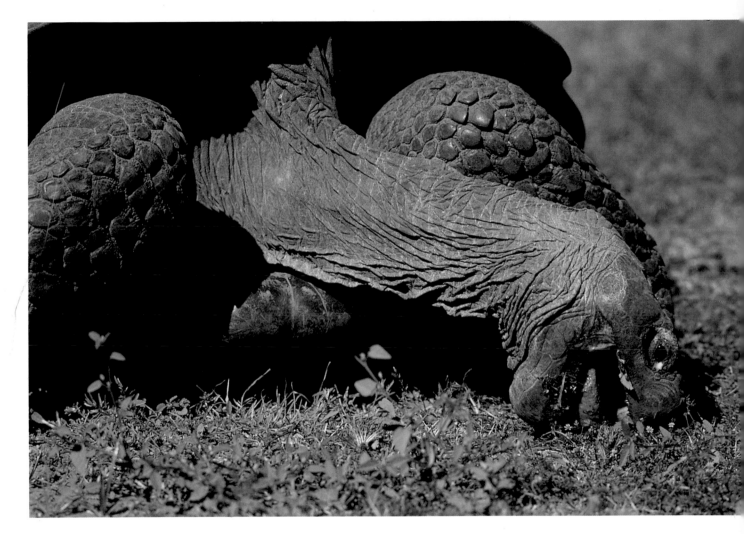

left: Several subspecies of the Galápagos tortoise are extinct. The breeding season is from March to May. Female tortoises lay eggs in volcanic calderas or holes dug close to the shore.

Flat on the ground, a giant tortoise is eating grass as if he were mowing it. A giant tortoise may be three to four feet long and weigh up to 450 pounds.

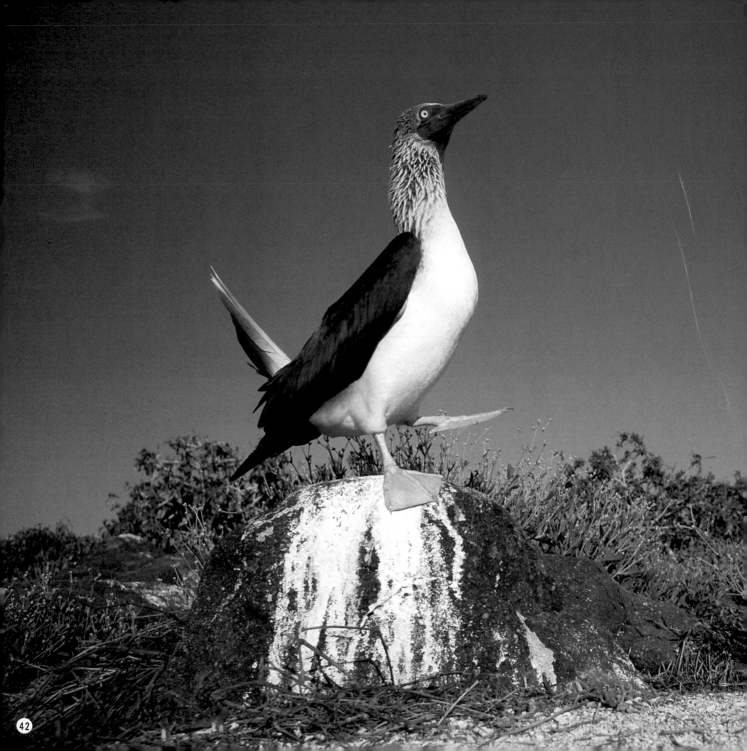

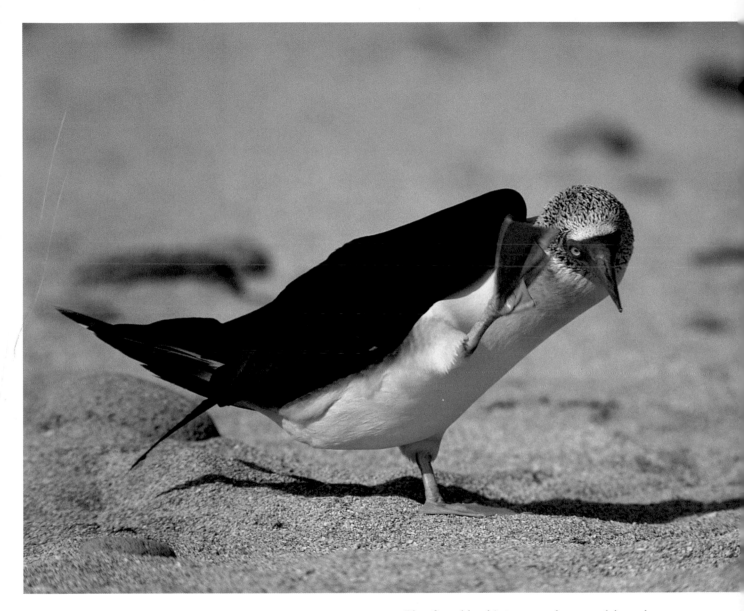

left: There are no females around, but this blue-footed booby doesn't care. He stomps his feet and does a solitary display dance.

Blue-footed boobies nest on the ground, but when seeking fish they may range hundreds of miles at sea.

Seals are familiar animals in
the northern seas, but Hawaiian
monk seals live in the coral
reefs of warm Hawaii. They
are a native species of the north-
western Hawaiian Islands, but
their surviving number is fewer
than seven hundred.

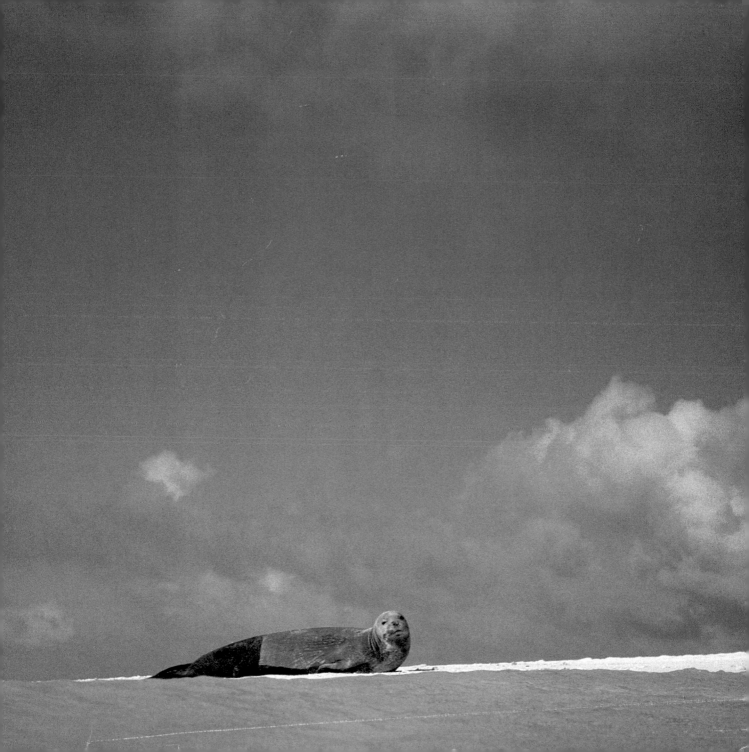

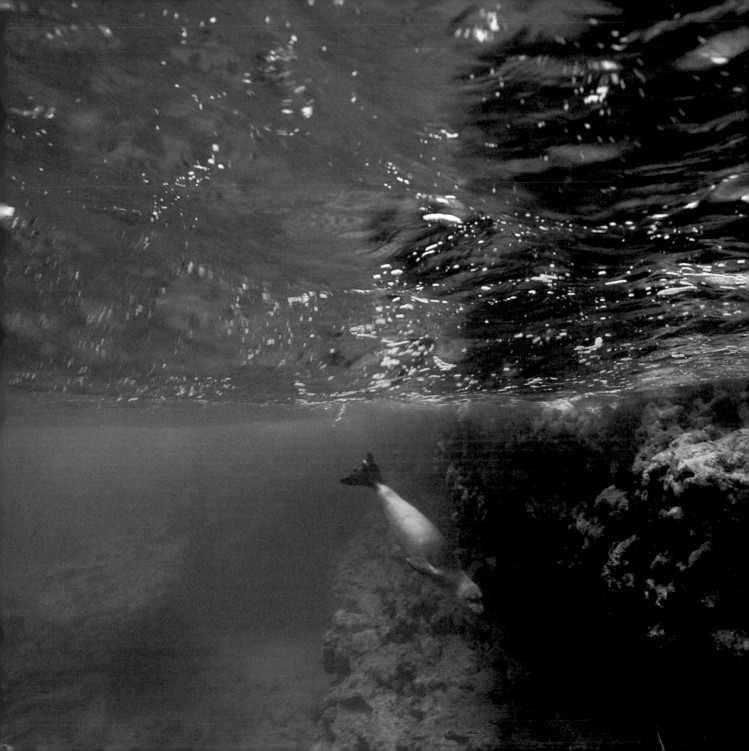

The water of this area is
very clear and surprisingly
cold despite the tropical
temperatures of the islands.

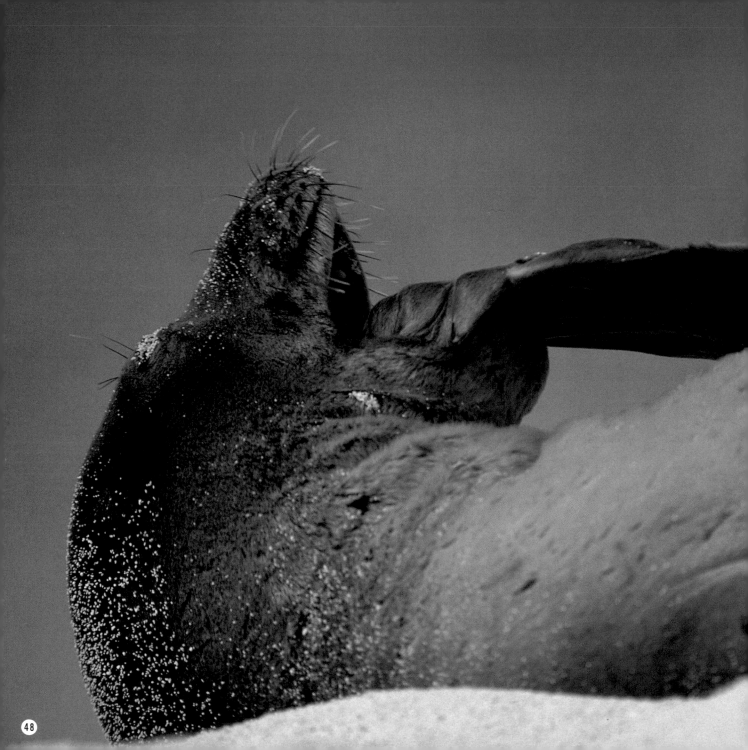

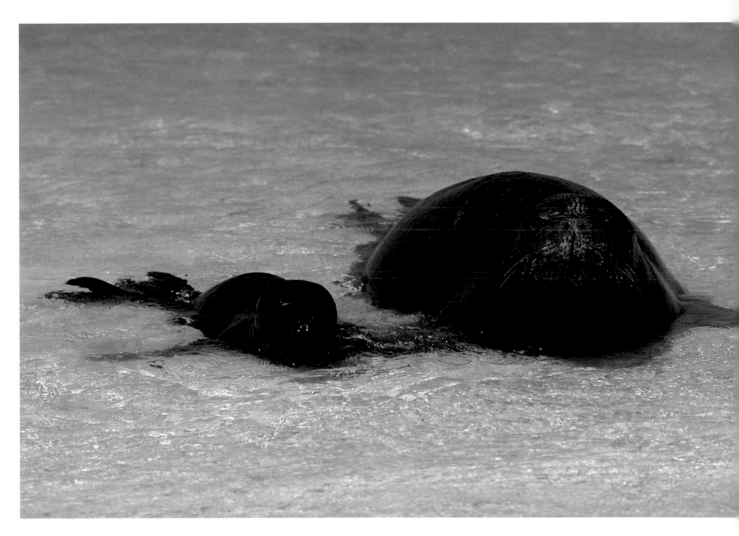

left: The fish hunted by Hawaiian monk seals are counted every year to ensure an adequate food supply for the seals.

This newborn Hawaiian monk seal narrowly escaped being swept away by waves. Their sleek, fishlike shape and easily closed, narrow nasal openings permit these mammals to live in the hostile seas.

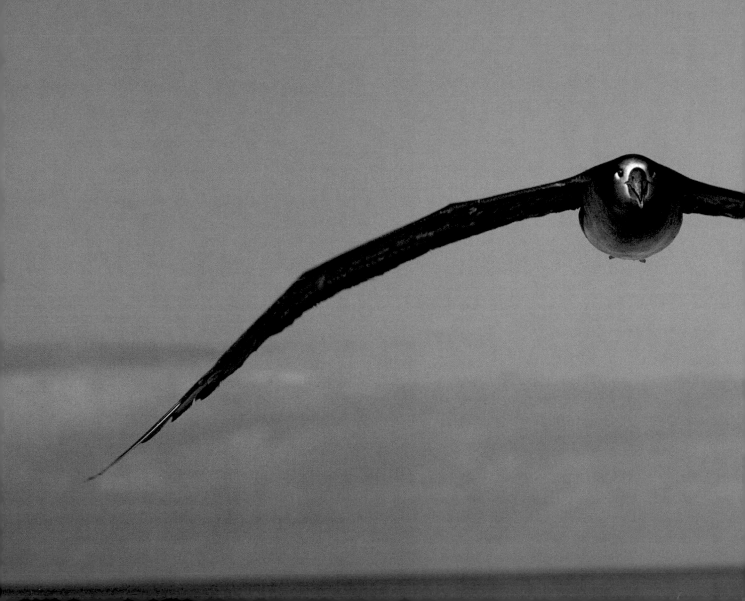

This black-footed albatross has just taken off against the wind. Magnificent flyers, albatross are seldom seen over land except when breeding and occasionally after a storm. Their wingspan is more than two yards long.

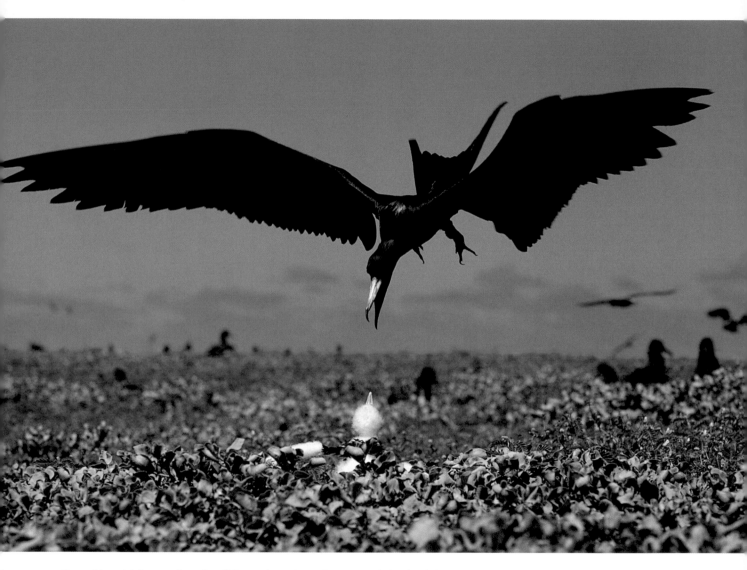

Great frigatebirds are adapted to life on-the-wing. They eat and drink while in the air. Compared to its large wings, its body is small and light, enabling the bird to perform aerial acrobatics in play and in pursuit of food.

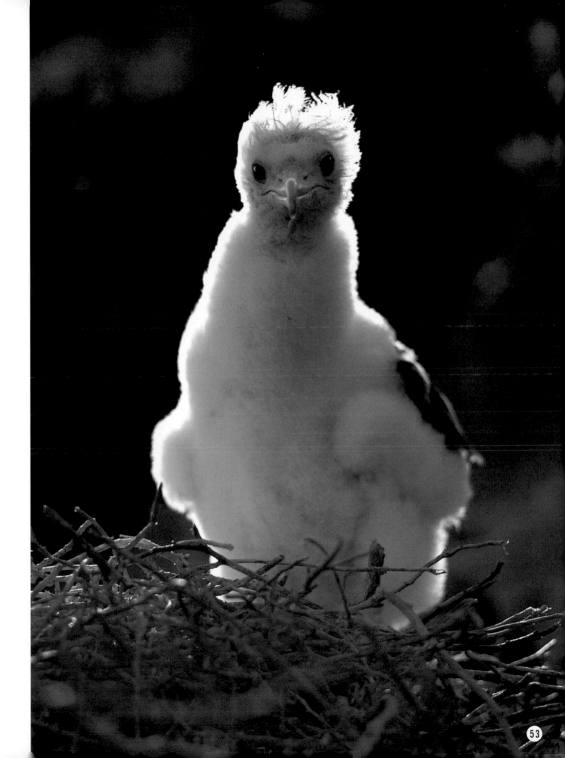

A great frigatebird chick
is snow-white, but turns
black when fully grown.

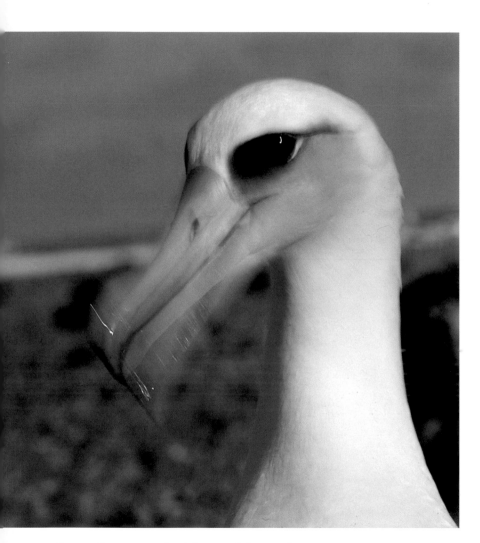

Laysan albatross courting. They stand face-to-face,
touching beaks and repeatedly raising them to
the sky, thus displaying their distinctive markings.

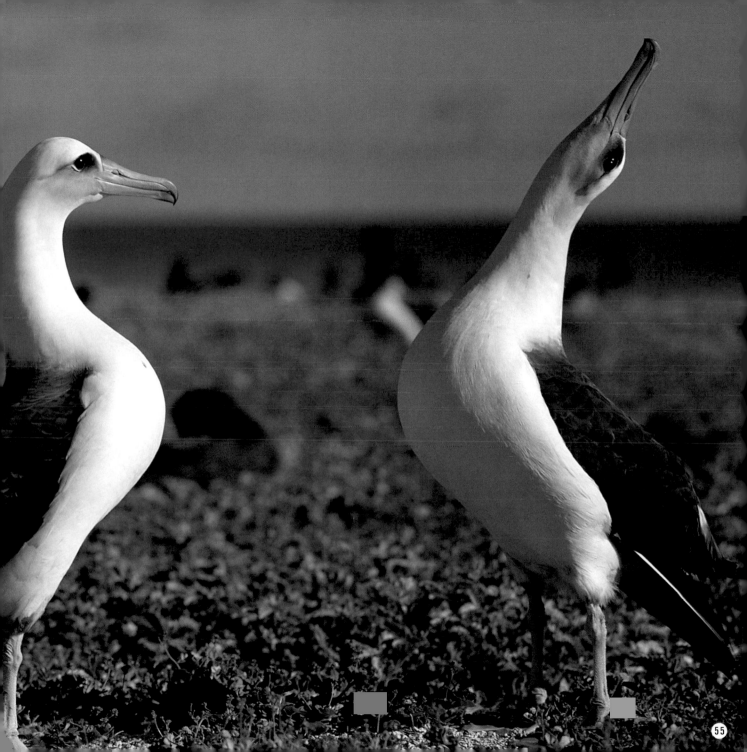

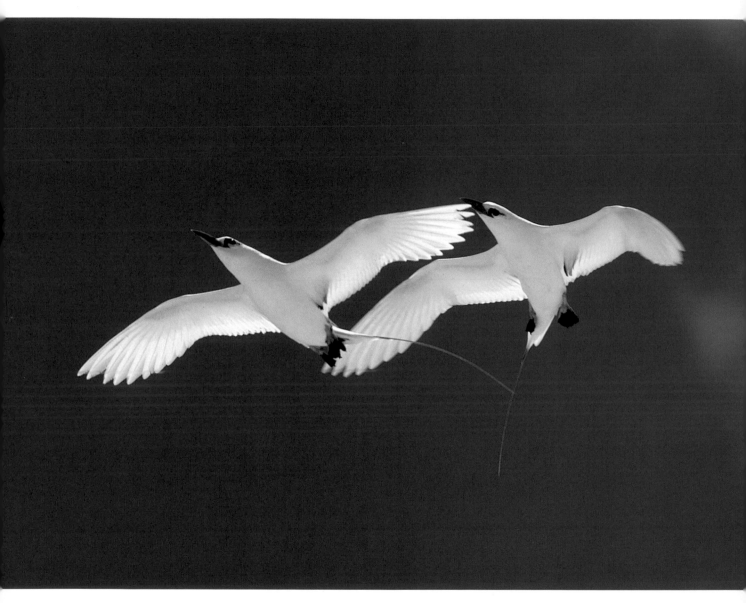

Red-tailed tropicbirds in courtship flight may hover, one
above the other, with the upper bird's long tail feather
hanging down to touch its mate.

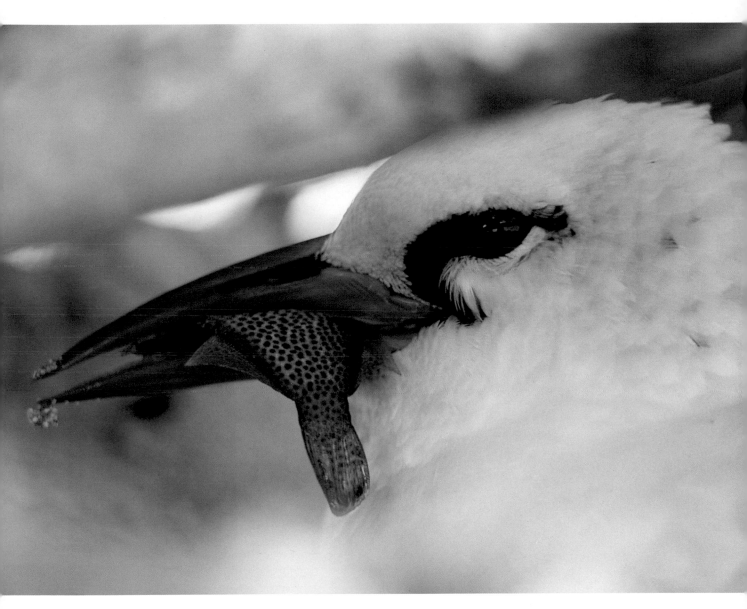

A successful hunter returns to its chicks, which are waiting in a nest built on the edge of a cliff.

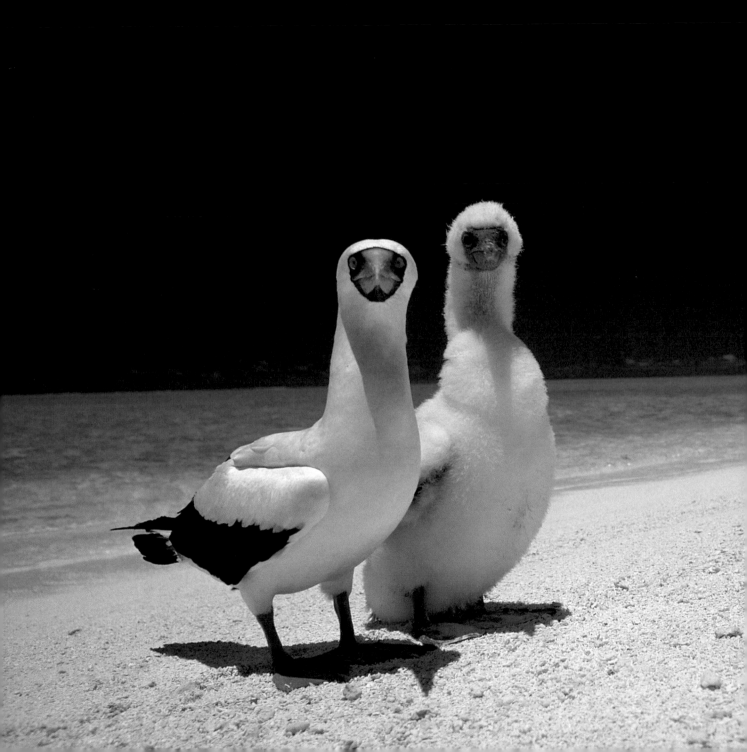

Masked boobies have waterproof plumage, a necessity when they range far from land in search of food.

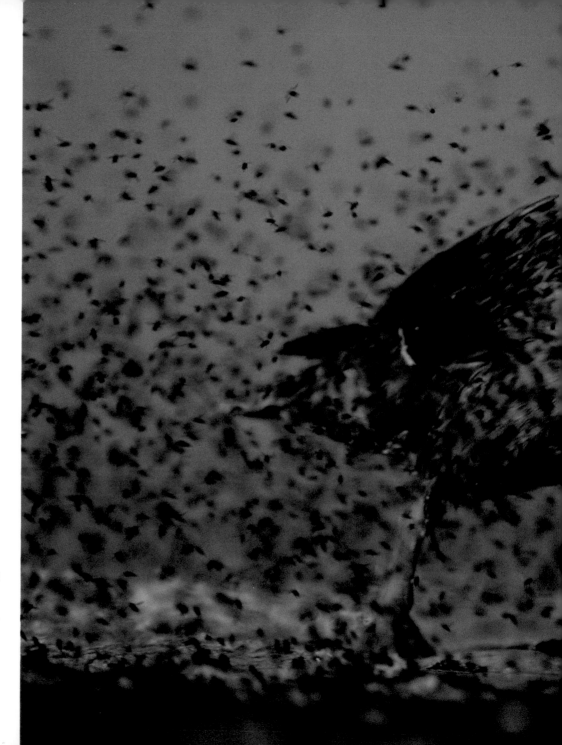

This Laysan duck is running on the shore through a swarm of flies with its beak open. The diet of Laysan ducks is said to have changed since humans brought in rabbits. The rabbits eat the grass these ducks used to eat, forcing them to adapt to new food sources.

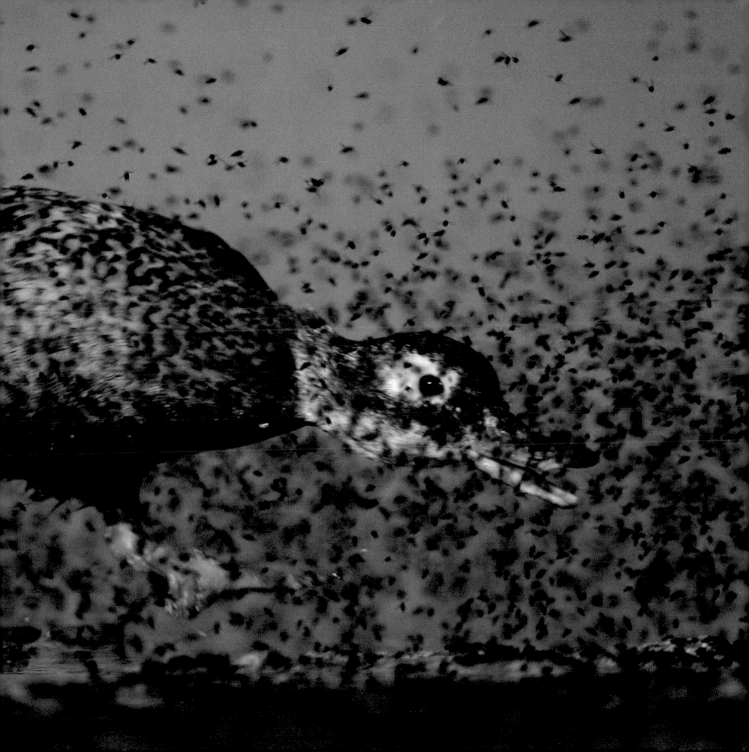

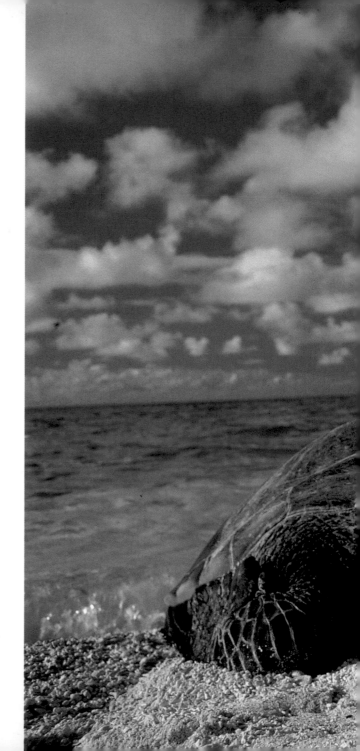

A black-footed albatross
chick waits for its molting
feathers to change. During
molting, it receives no food
from its parents. When it
has new plumage, it will be
light enough to fly.

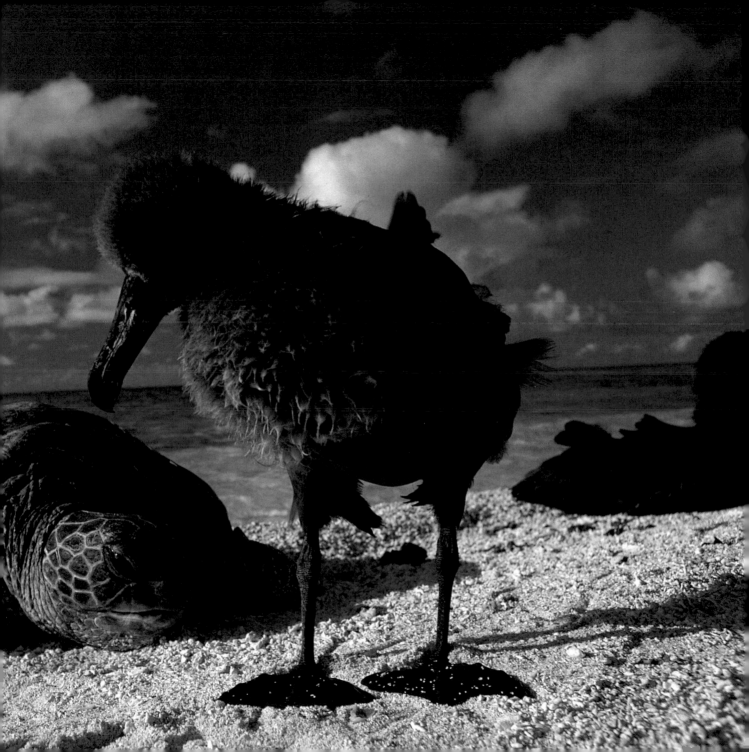

A bull humpback whale sings. Lasting three or four hours, the song is composed of intricate phrases, and it changes according to the areas of the sea and the time of year.

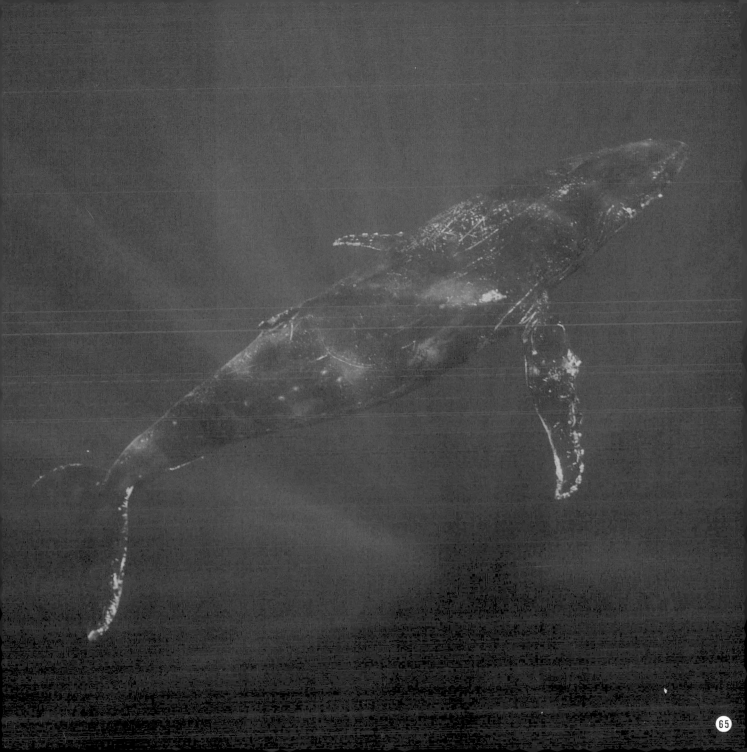

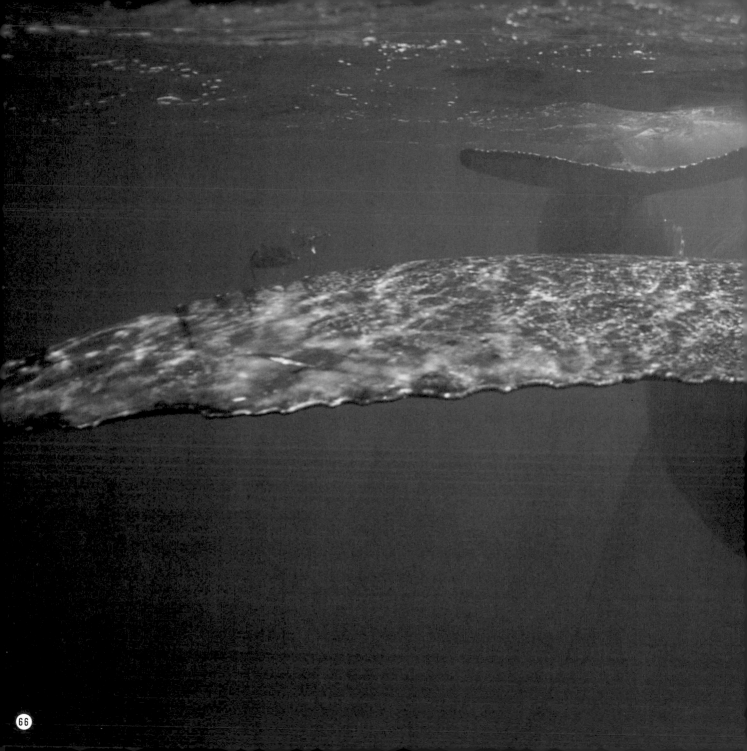

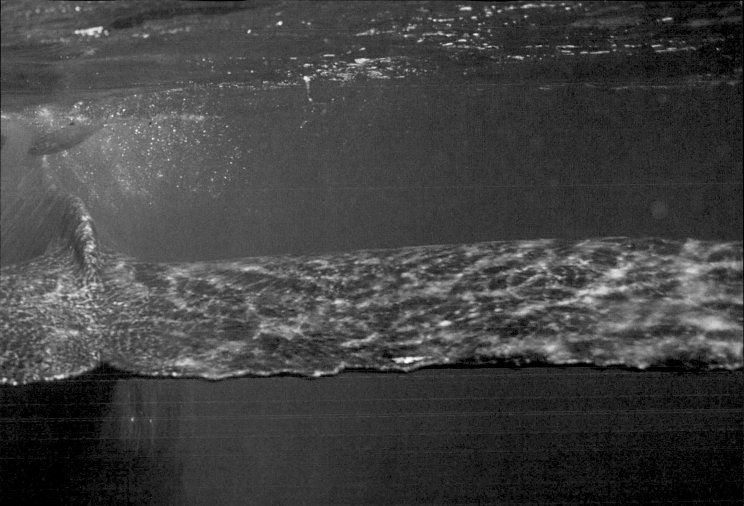

preceding pages:

Humpback whales have babies and raise them in the warm ocean before returning to the colder northern oceans. A young baby's tail looks vulnerable next to its mother's.

A humpback whale calf has to go up to the surface to breathe more often than its mother. Like other sea-dwelling mammals, whales have evolved numerous physical characteristics for survival. They use oxygen very efficiently, have low metabolic rates, slow heart-beats, and are clad in blub-ber, which simultaneously insulates and streamlines.

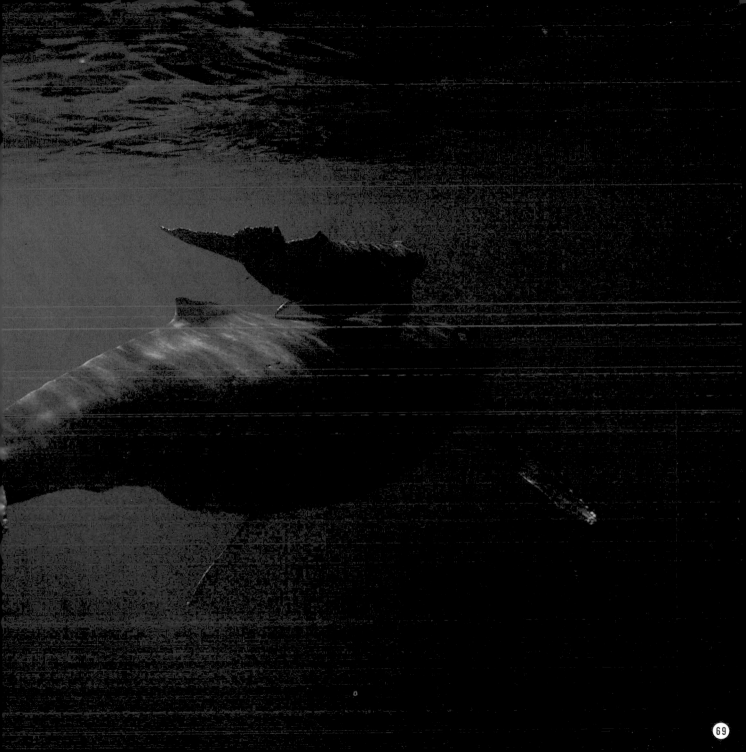

Behind the mother whale
and her calf, an escort's tail
is visible: a bull whale that
accompanies a cow during
the breeding season.

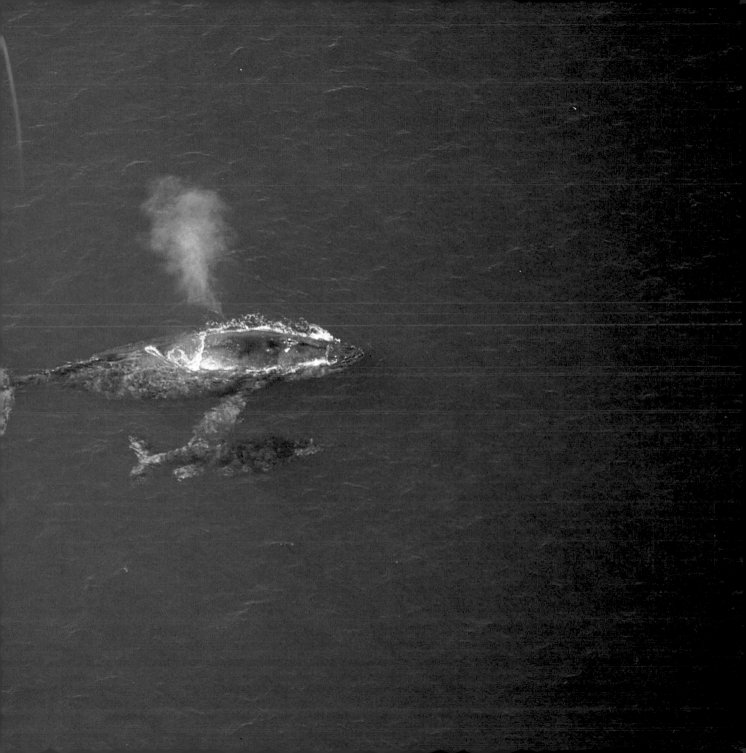

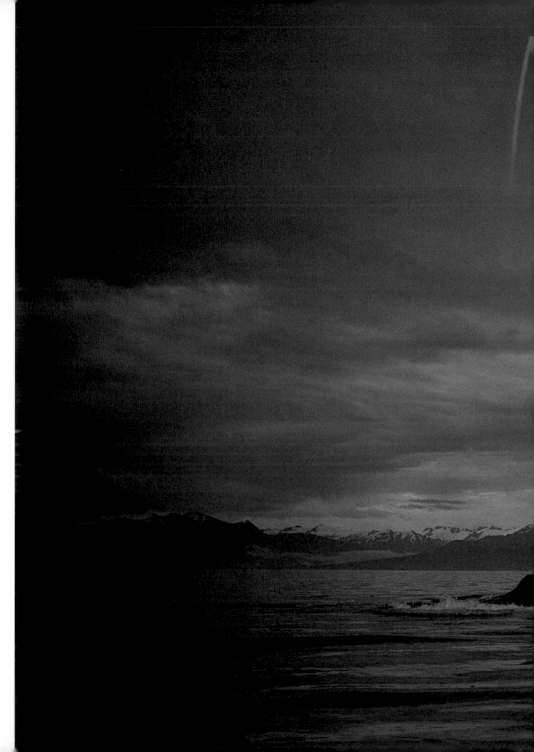

FROM ITS FROZEN ARCTIC, home to polar bears, seals, and whales, to the humid swamps of Florida with its flamingos and alligators, North America offers an astonishing variety of animal life. North Americans have been at the forefront of the conservation movement. As a result, many species once facing extinction now survive, preserving the diversity that is so important in the natural world.

preceding pages: The red twilight, coming late to Alaska in June, shimmers in the watery spouts of these humpback whales.

Humpback whales form a circle to catch fish. Consuming several fish every few minutes, these whales fed for nearly seven hours.

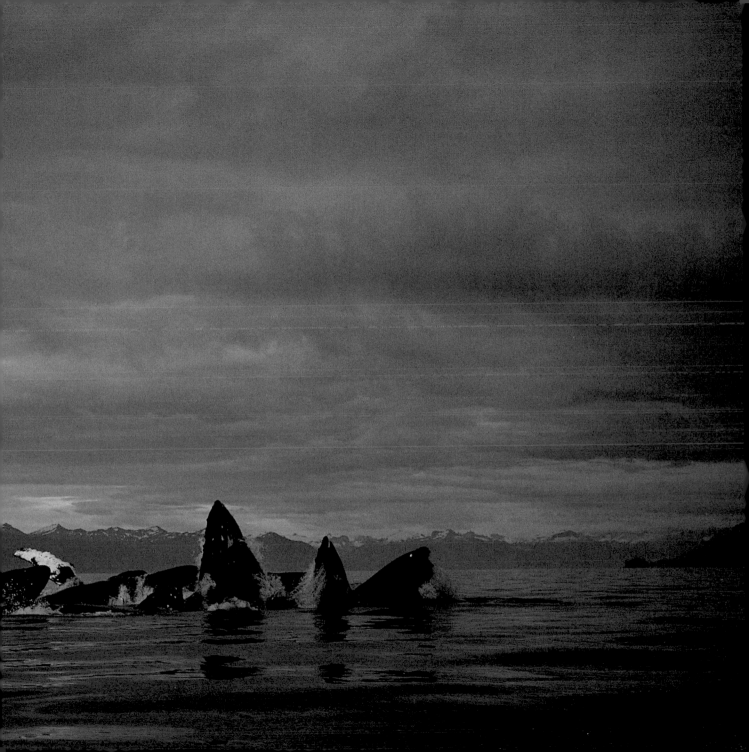

The humpback whale's fishing method is called bubble feeding. Swimming in a circle, they exhale through their blowholes, trapping fish in a mass of bubbles.

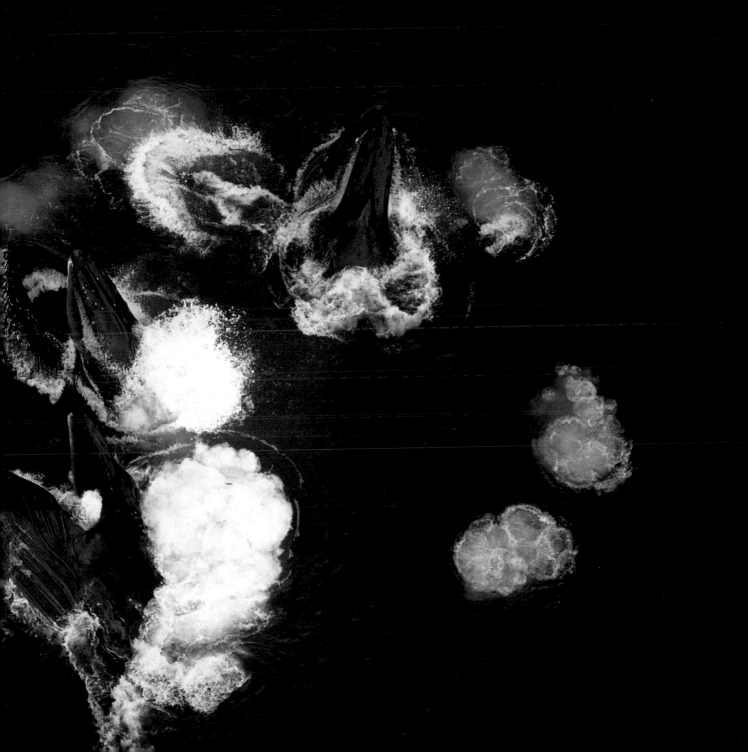

Whalebone whales such as humpbacks have jaws that stretch like an accordion, which allow them to take huge gulps of seawater. The water is filtered by the whalebone, trapping fish and crustaceans. The bumps are vibrissae and are similar to a cat's whiskers.

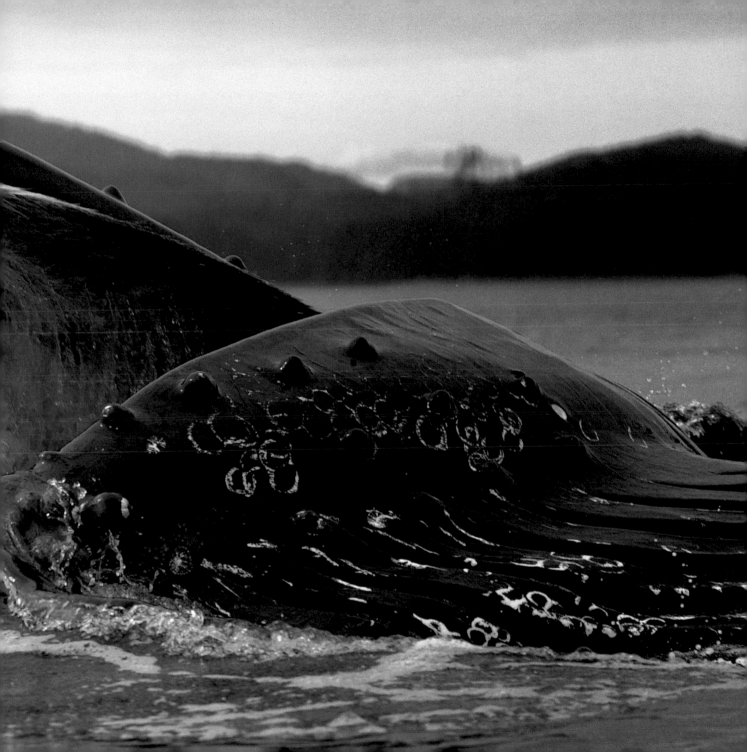

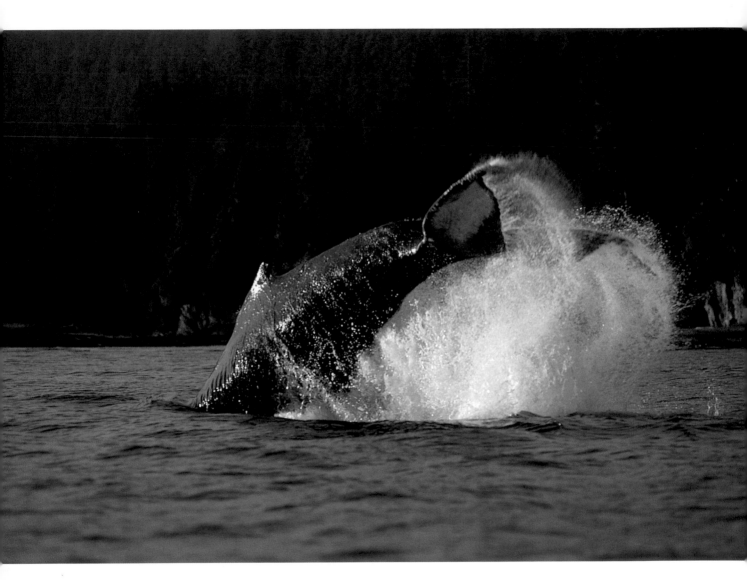

A whale breaches, or jumps out of the water, for no
apparent reason. It may be trying to dislodge parasites
or simply expressing a zest for life.

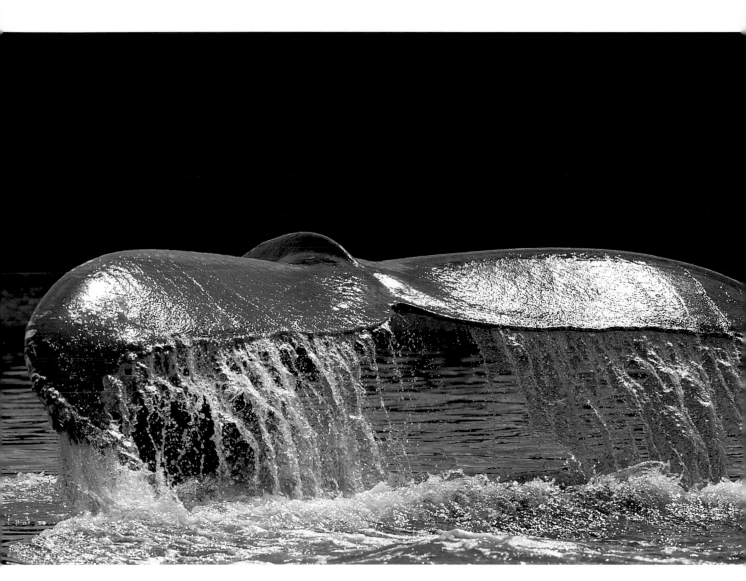

This whale violently beat the water with its tail for about ten minutes. This is called tail slapping and might be used to threaten enemies or to communicate with other whales.

The sounds of tail slapping
carry very far over the water.

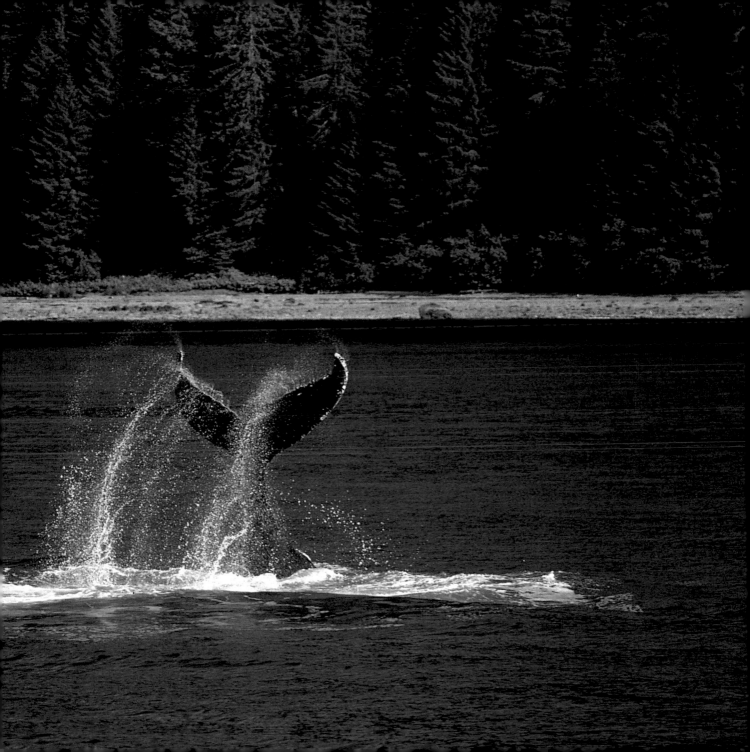

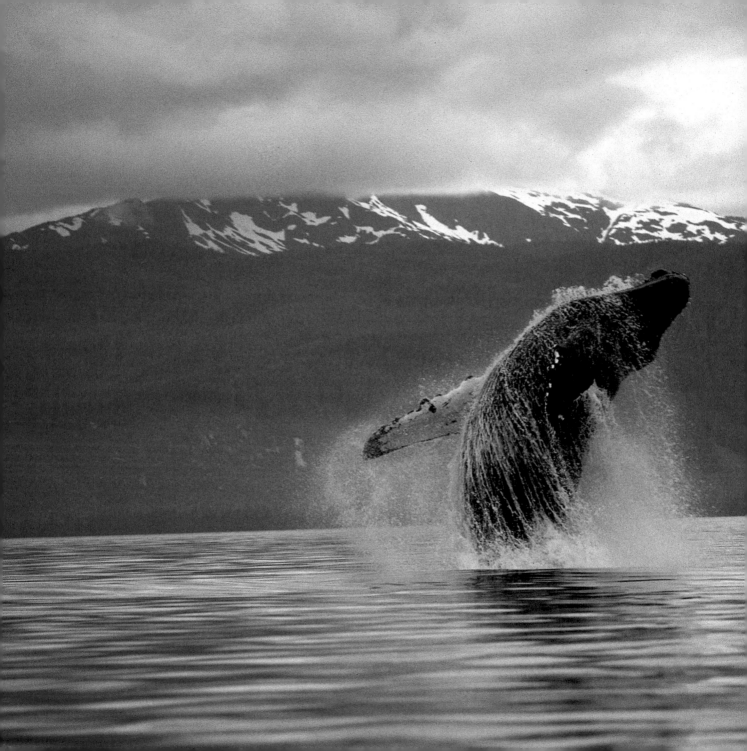

Thirty tons of whale burst
the ocean's calm. These
magnificent leaps are called
breaching.

During the summer,
many orcas (or killer whales)
gather in the Johnston
Strait, between Vancouver
Island and mainland
Canada.

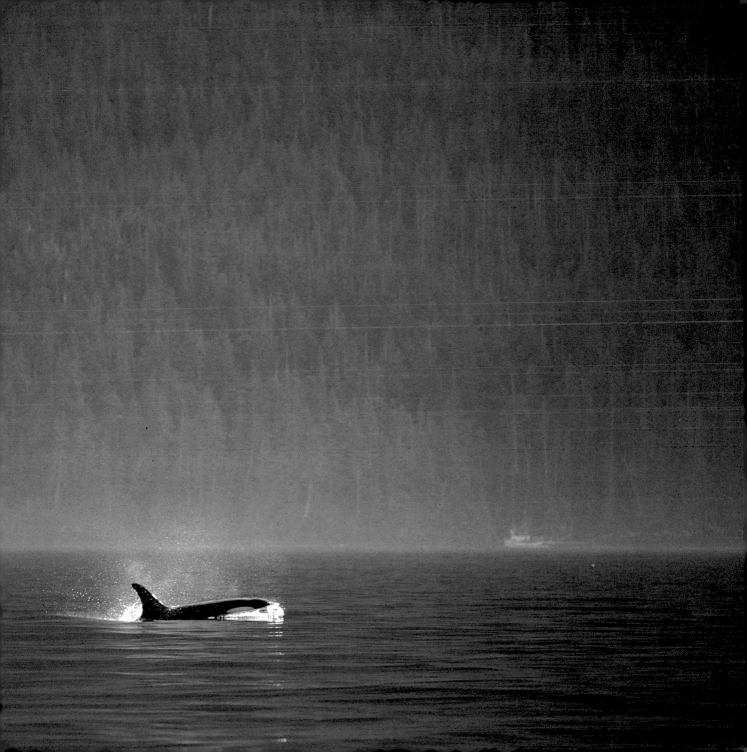

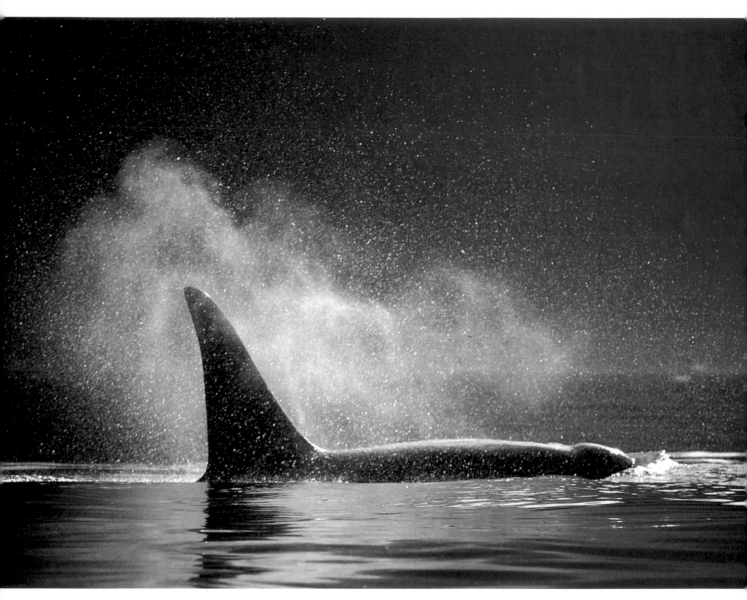

In the clear air, the orca's blowing
sound echoes in the mountains.

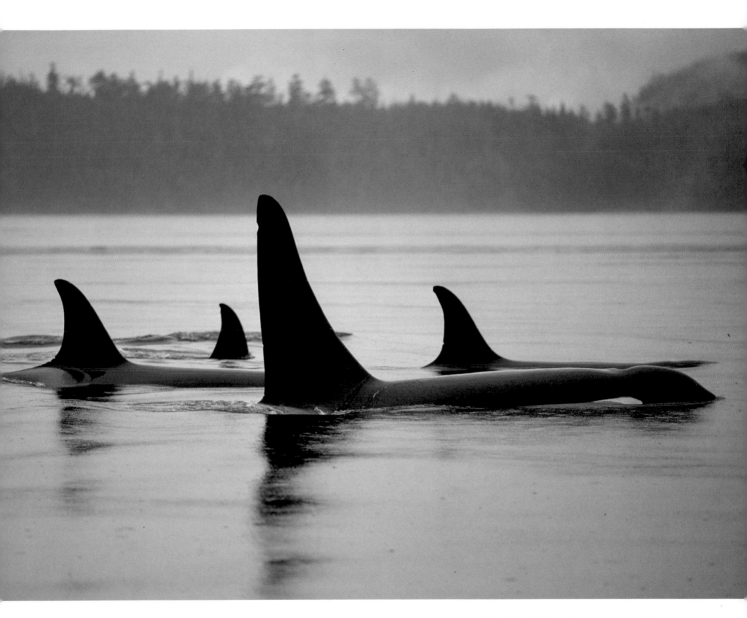

The dorsal fins of orcas are acutely
angled, their shapes delicately different.

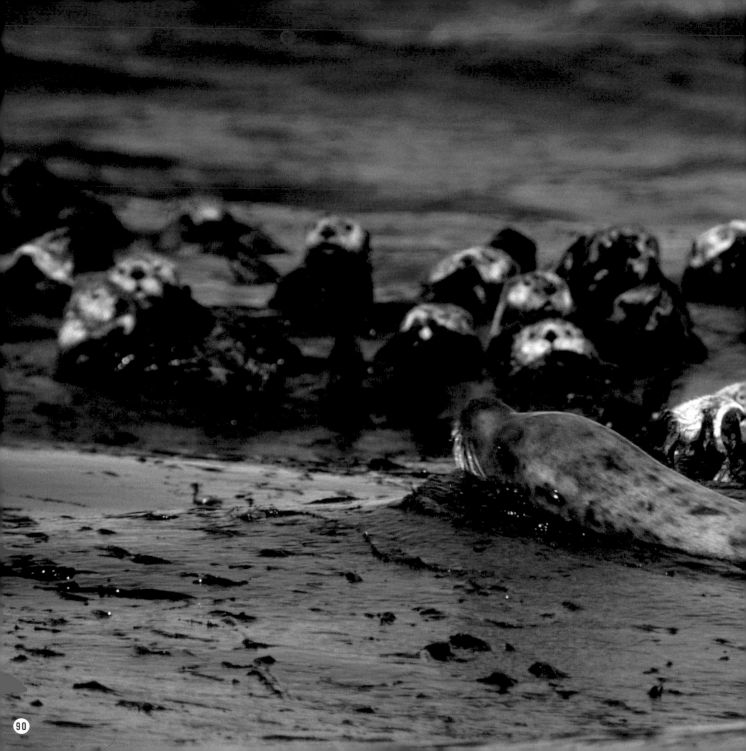

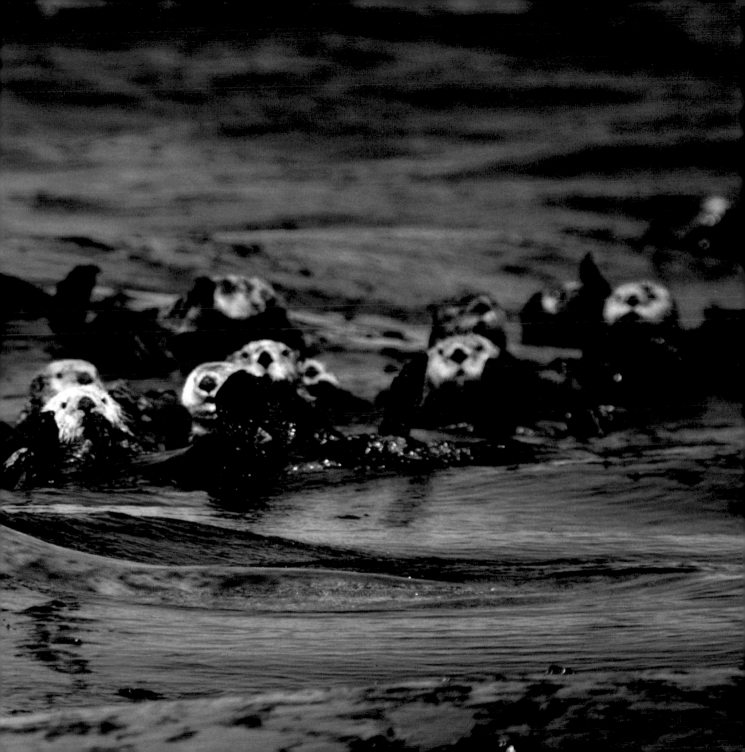

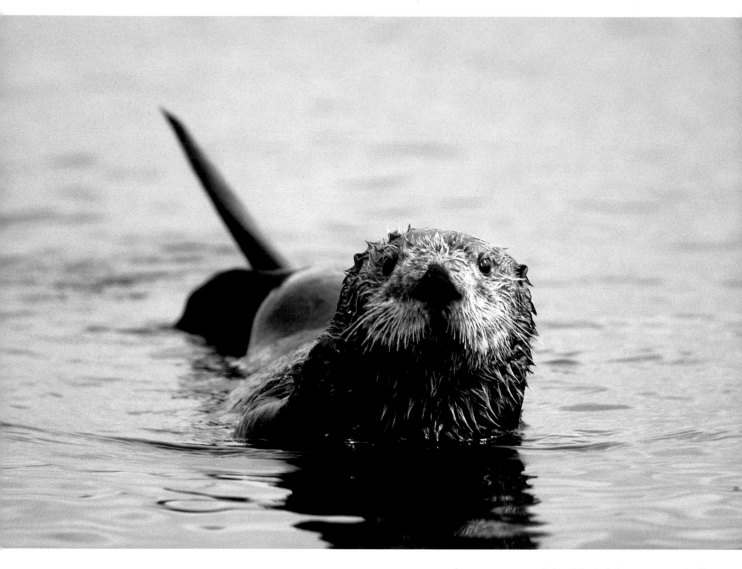

A young sea otter's head is dark but turns gradually white with age.

preceding pages: The gregarious sea otter is never far from water. These sea otters gathered together to form a "raft," but they suddenly became alert when a northern sea lion approached.

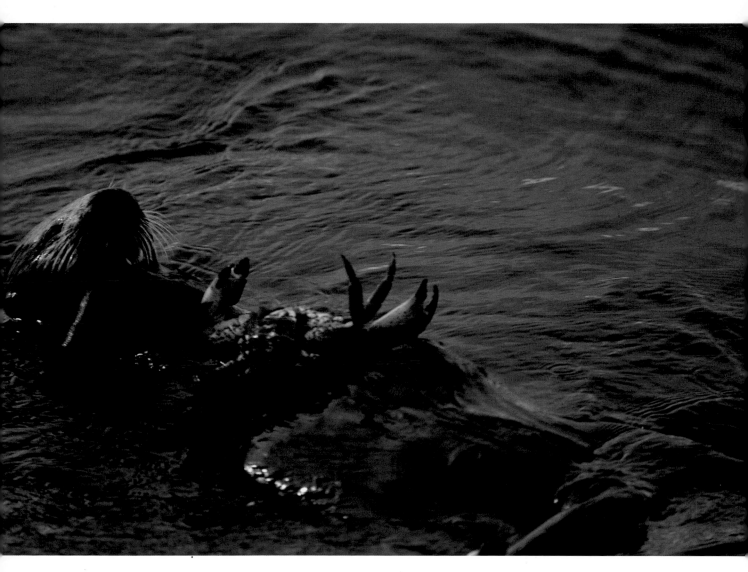

After catching a big crab, this otter plucked off and ate the legs one after another. The whole crab was consumed in an instant. In the water, sea otters must be constantly alert for their natural enemies, sharks and whales.

Sea otters rest on Kodiak
Island, Alaska. When dry,
their dense fur stands up,
making their bodies look
twice as big.

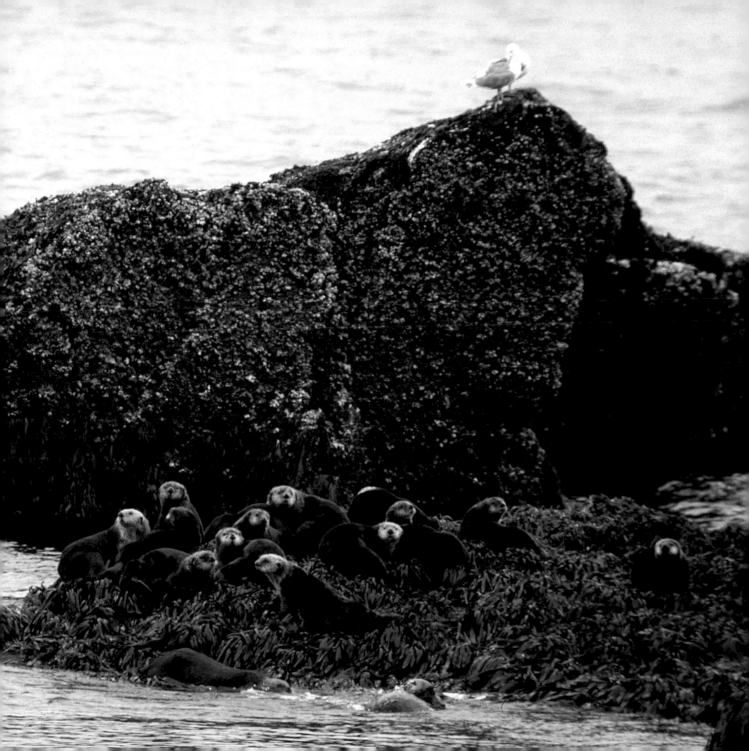

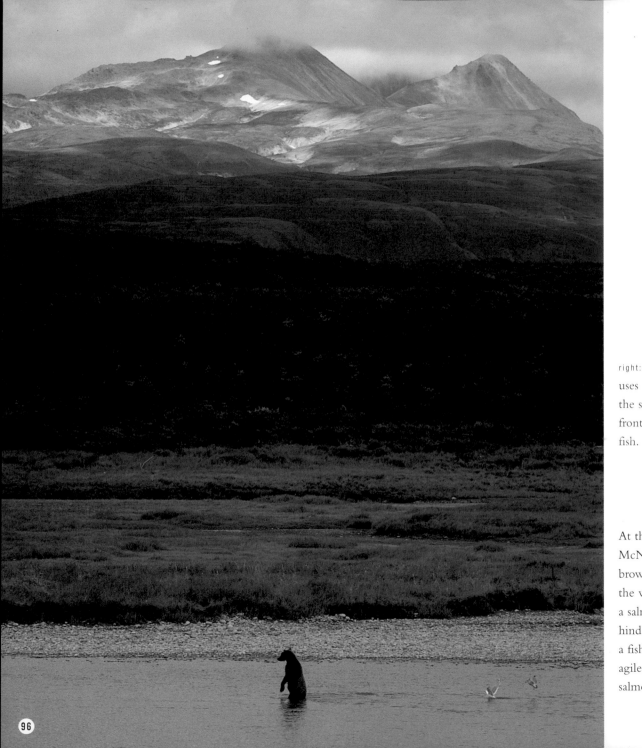

right: A bear skillfully uses its mouth and the sharp claws on its front paws to catch fish.

At the mouth of the McNeil River, a brown bear stands in the water waiting for a salmon to touch its hind legs. Once it feels a fish, the bear is very agile in catching the salmon.

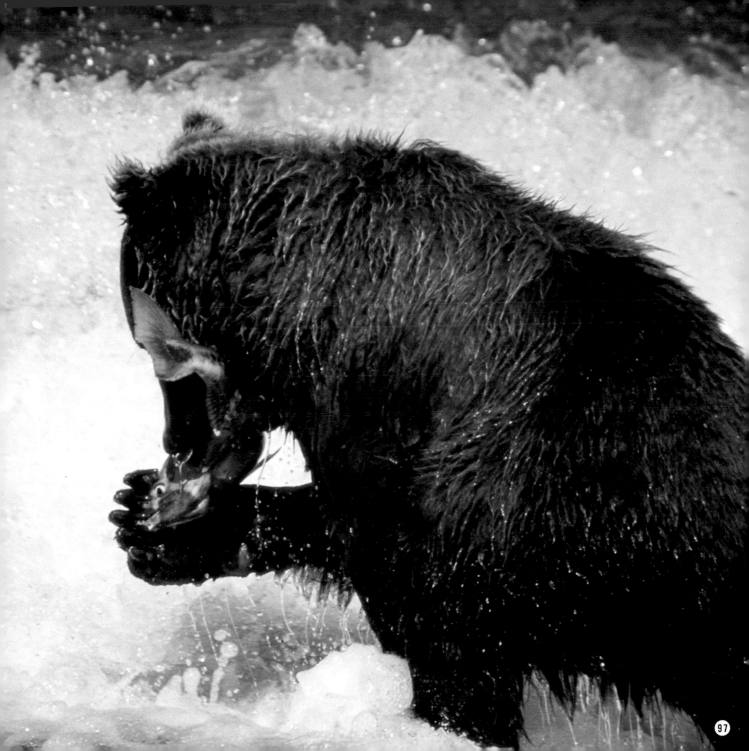

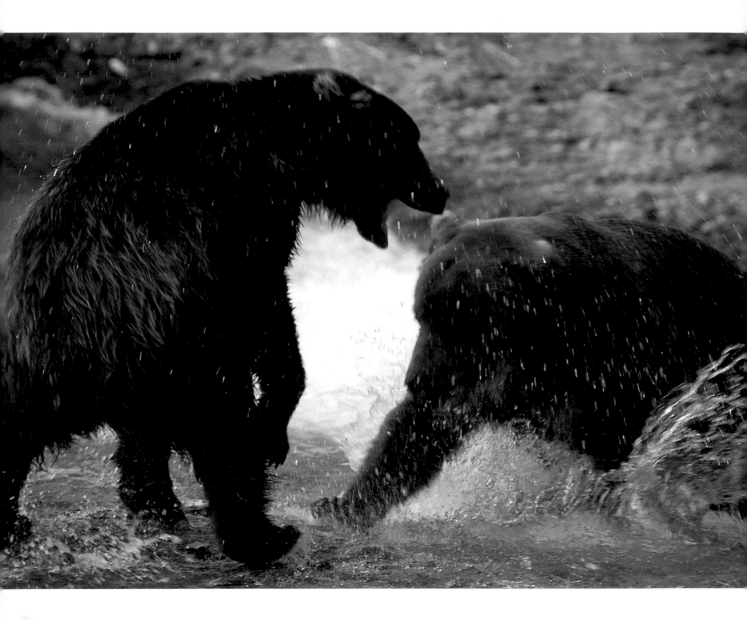

Even if play becomes a fight, they will stop quickly.
It won't do any good to miss a salmon.

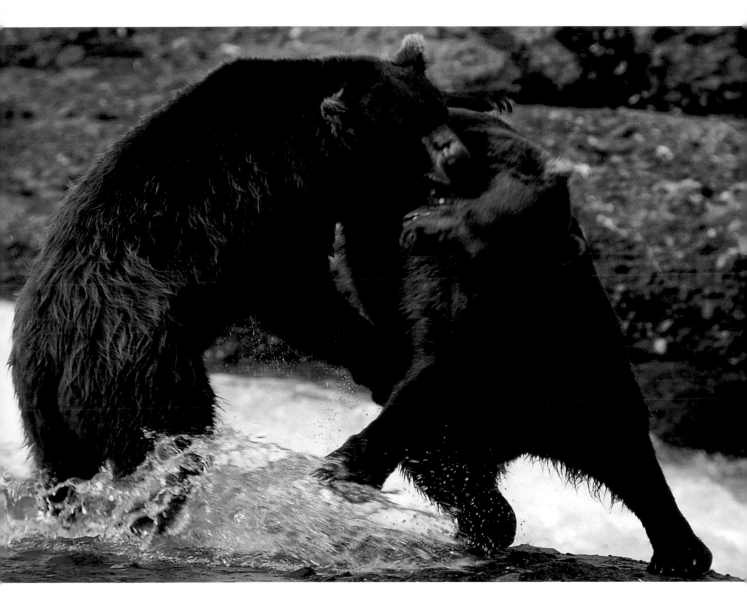

Although they consume berries and grass most of the year, bears grow fat during the midsummer salmon spawning runs. When there is an abundant catch, bears eat the delicious abdomen and throw the rest away. Seagulls feast on the leftover fish.

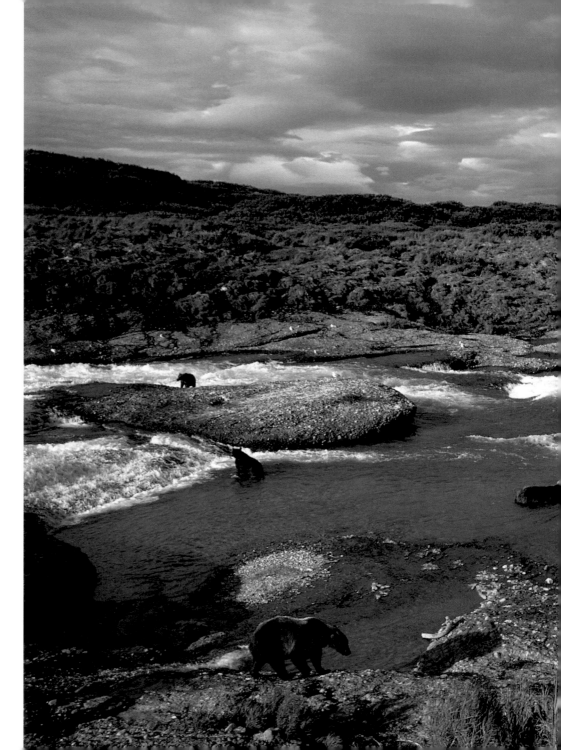

As summer ends, so does
the salmon run. Brown
bears try to catch one last
migrating fish.

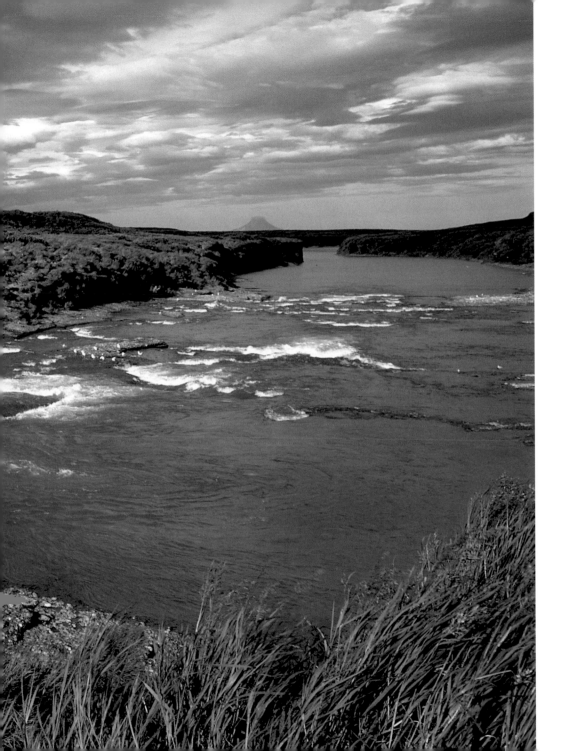

In March, in anticipation of giving birth, female ribbon seals crowd in the Gulf of Saint Lawrence. Within a week to ten days, they give birth to their pups.

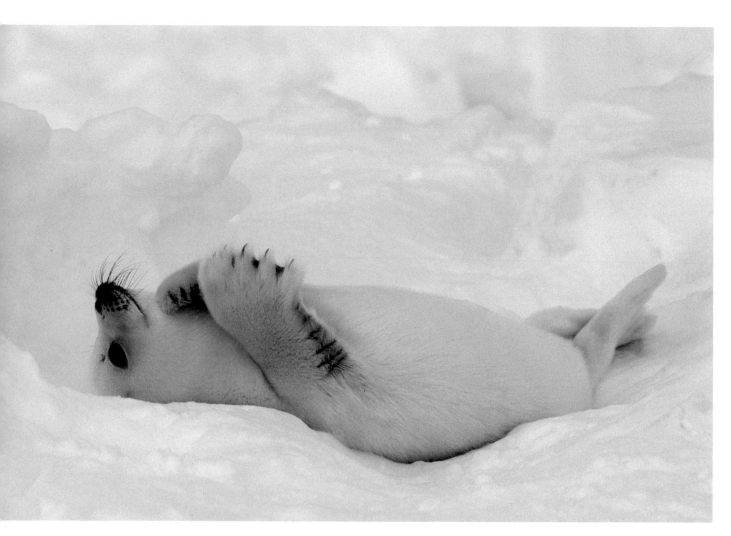

Newborns are cream colored at birth, but soon begin
to turn white. This five-day-old pup is already begin-
ning to turn white.

right: While a mother seal is fishing, her pup stays
still waiting for her. Its white fur and blanket of snow
protect it from predators.

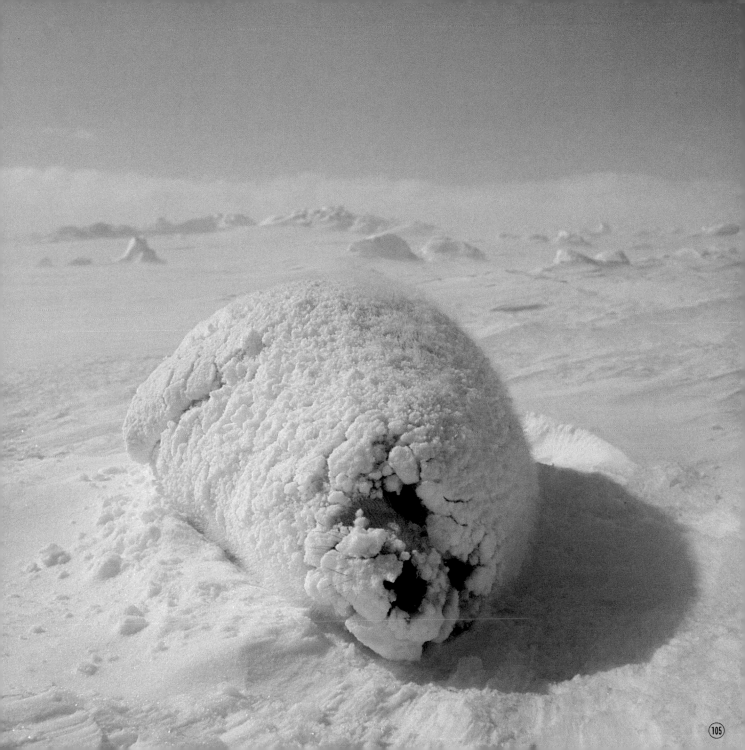

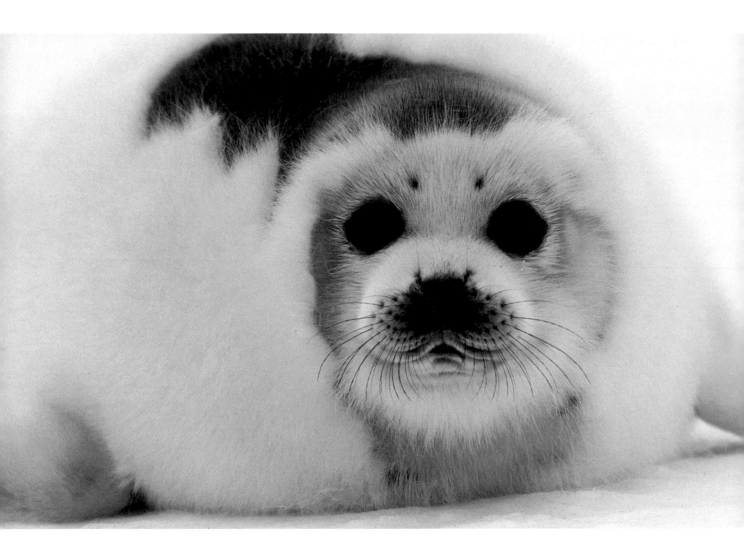

Molting has left this pup with patches. By the time
the molting process is complete, the ice will be
cracked, and the seal must then venture into the sea.

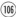

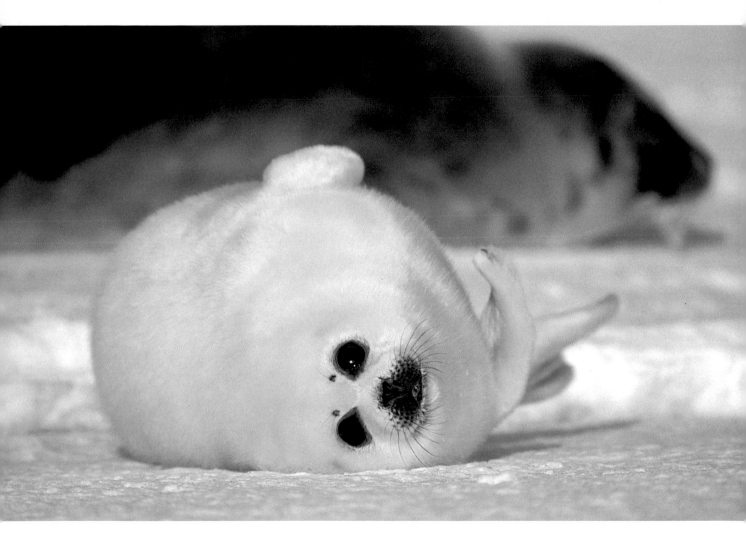

Having fed for about two weeks on its mother's rich milk, this pup is plump with fat for nourishment until it can take care of itself.

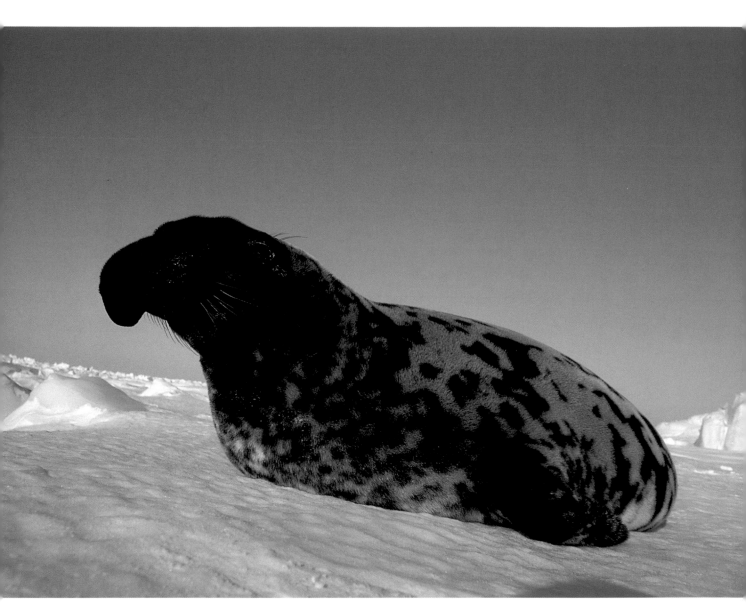

With its protective coat and inner layer of fat, the hooded seal is at home in the Arctic. In fact, its interior temperature is warm, like all mammals, whereas its skin may be the same temperature as the snow.

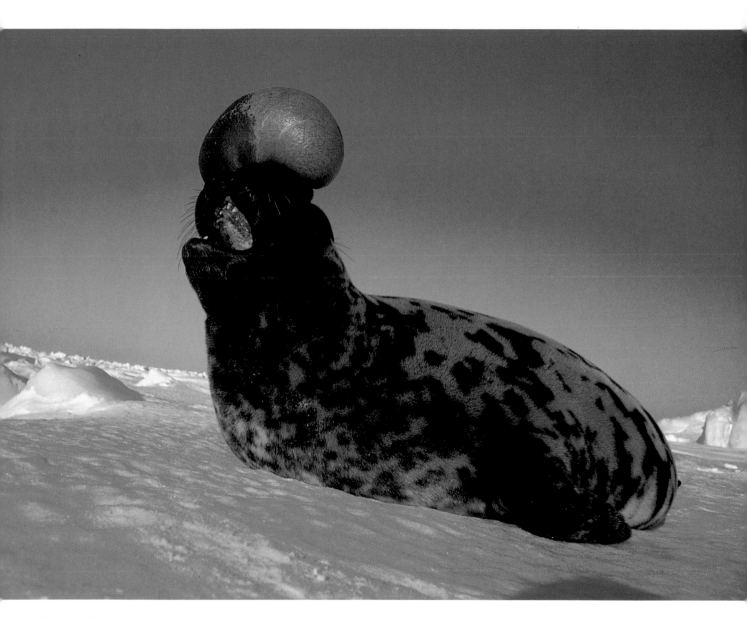

To court his chosen mate, the male hooded seal
inflates a special mucus membrane in his nose.

following pages: Sensing danger, a herd of muskox race across the
snowfield of Ellesmere Island. Their long coats enable them to
survive in the harsh environment of the polar region.

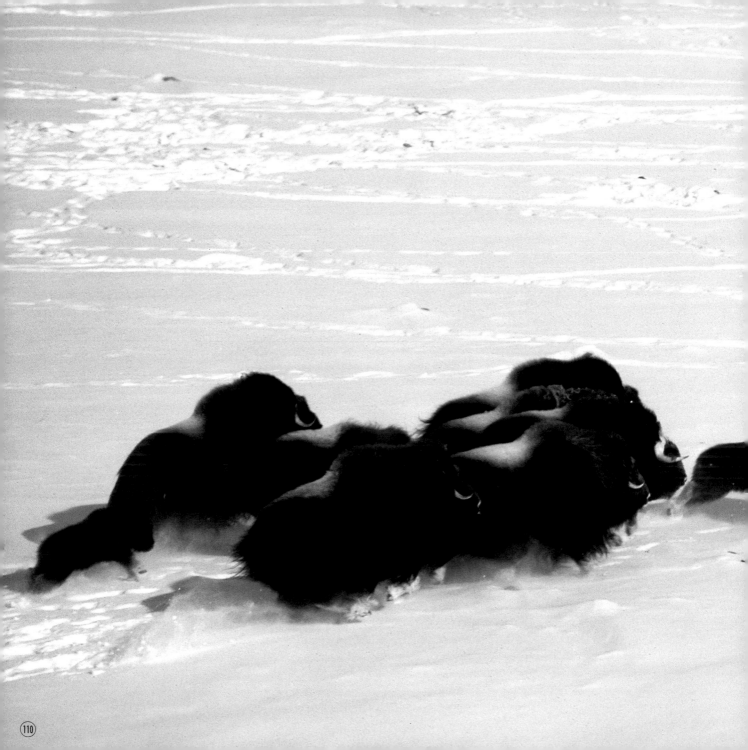

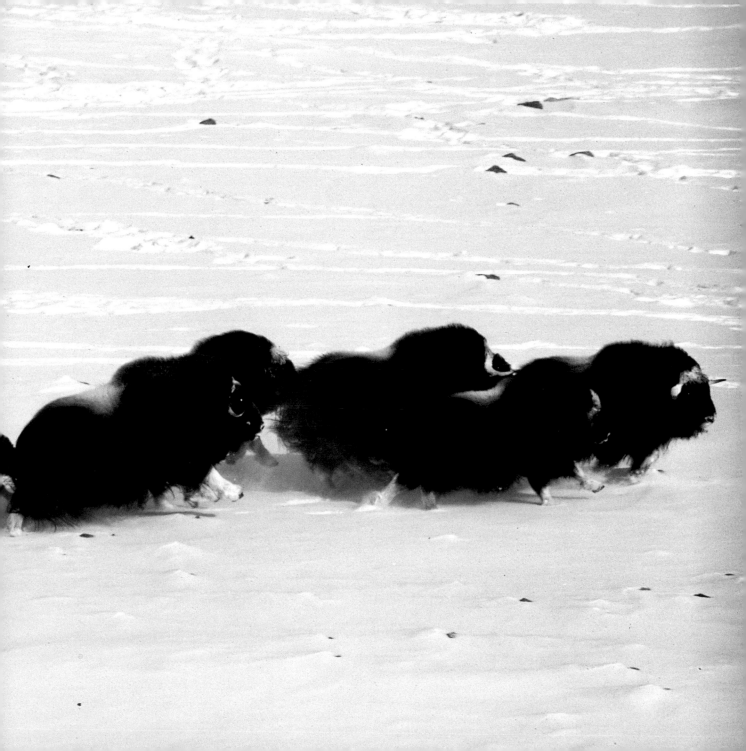

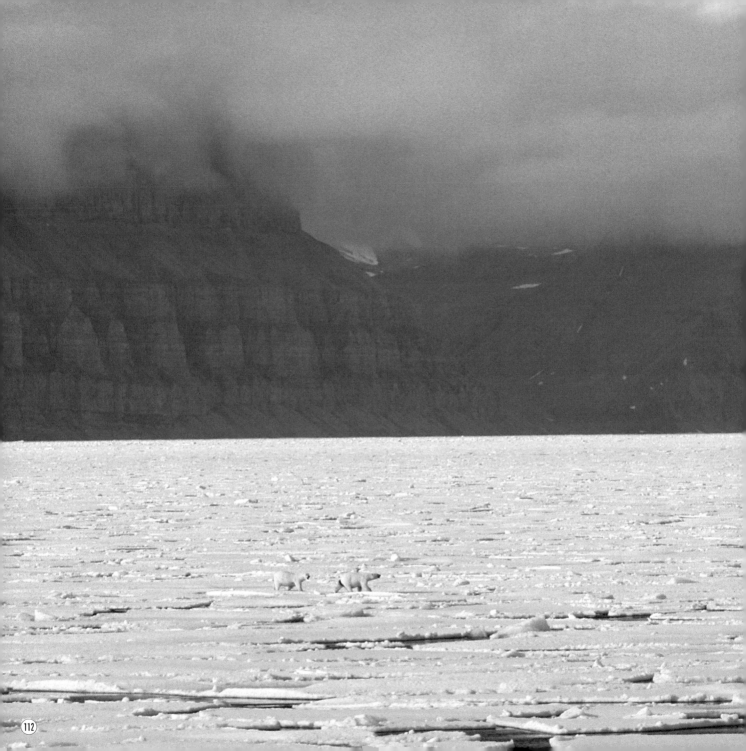

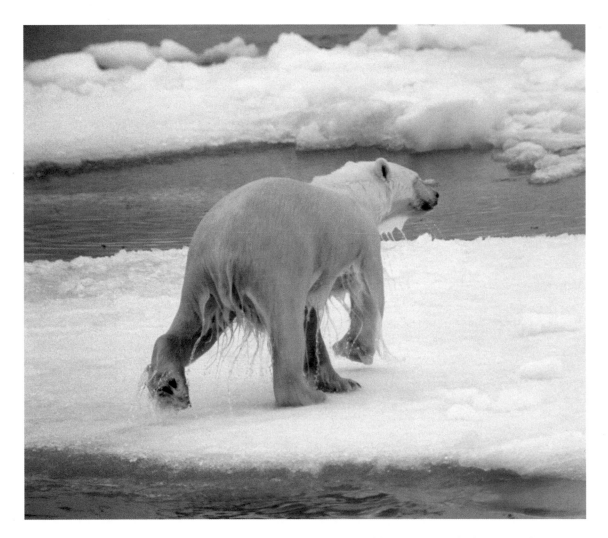

left: One late summer day, by Devon Island, Canada, two polar bears walk on ice that is cracking. Because they inhabit a region with almost no vegetation, polar bears have the most specialized eating habits of all bears: they consume mostly flesh, usually seals.

Powerful swimmers, polar bears may float hundreds of miles on pack ice. Their coat is almost waterproof, permitting long periods of immersion in icy water. Even the soles of their feet have fur for insulation.

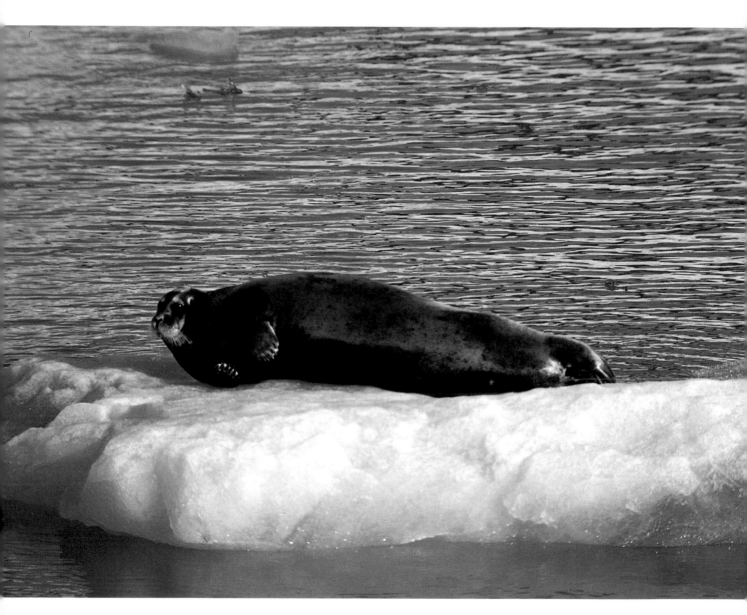

A bearded seal basks on an ice floe near Spitsbergen Island. Normally inhabitants of the Arctic Ocean, these seals occasionally swim to the waters around northern Spain.

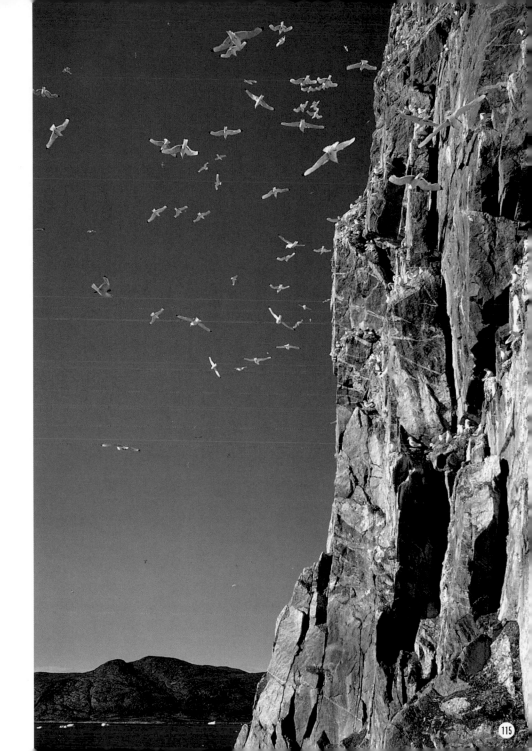

The nests of kittiwakes on the cliffs of Spitsbergen Island are built on ledges so narrow that the nesting material often droops over the edge of the rock.

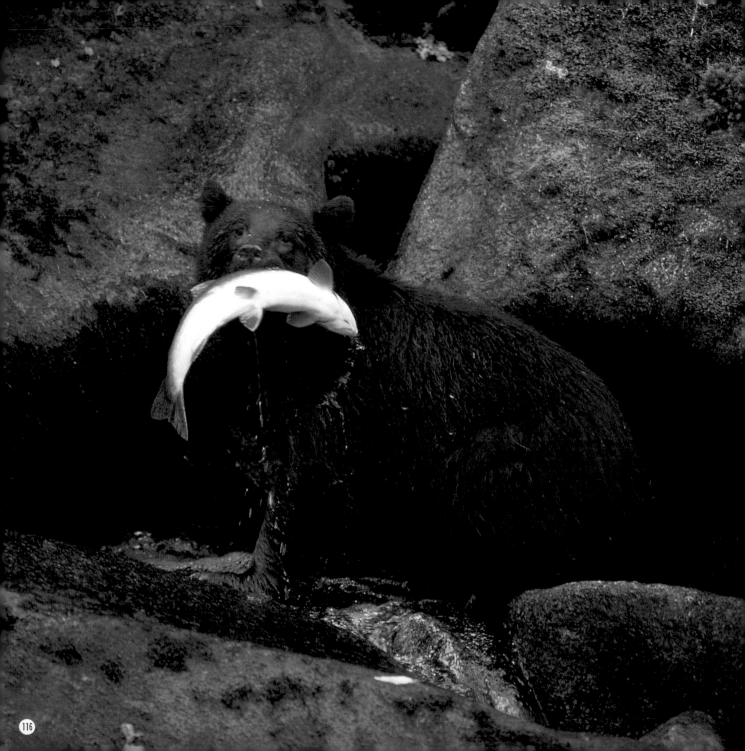

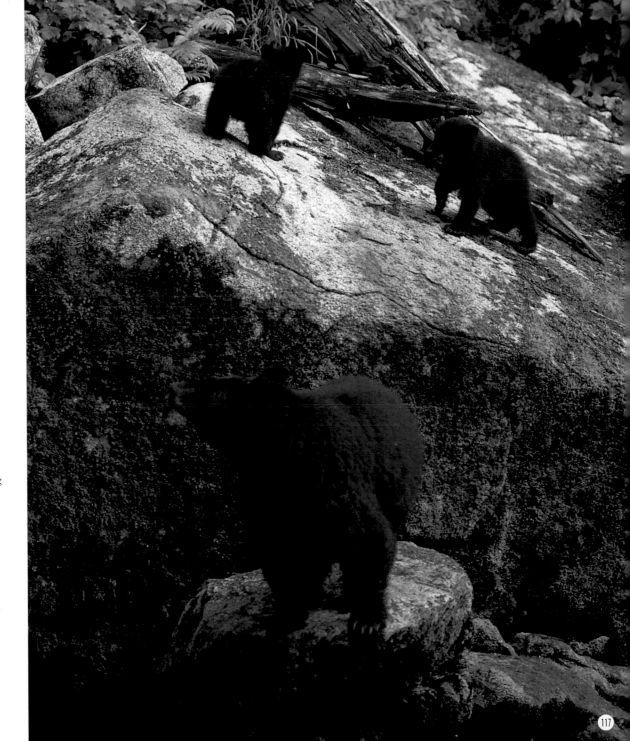

left. At Anan Creek, Alaska, this American black bear caught a salmon without going into the water.

This mother bear is very protective of her two cubs, sending them scurrying to safety at the first hint of danger.

117

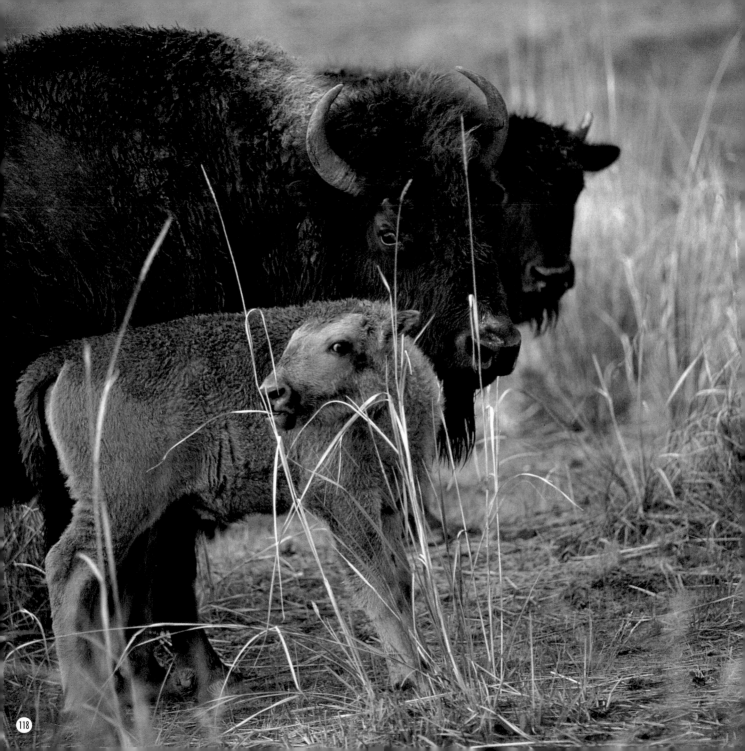

left: American bison once numbered 50 million. In the nineteenth century, hunters reduced this number to fewer than five hundred. Today, several thousand again roam the central plains of North America.

Once on the verge of extinction, bison are now protected in Yellowstone National Park and on preserves in Montana.

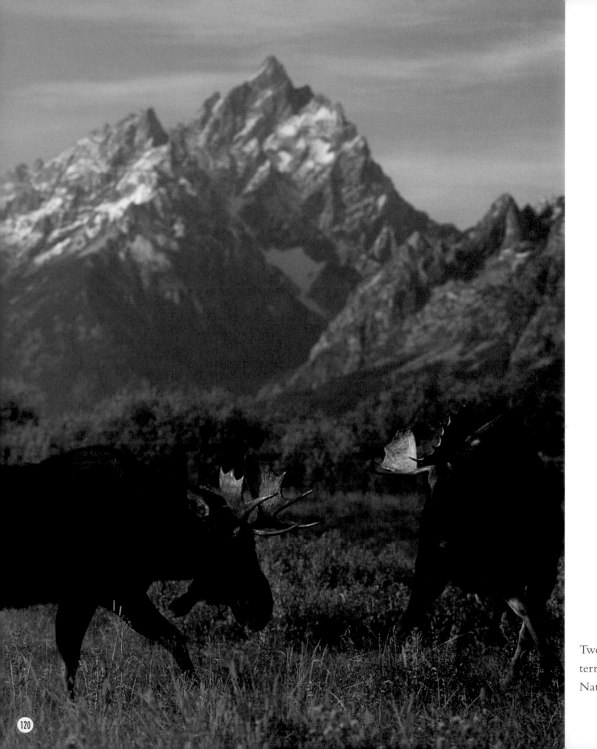

Two moose bulls fight for territory near Grand Teton National Park, Wyoming.

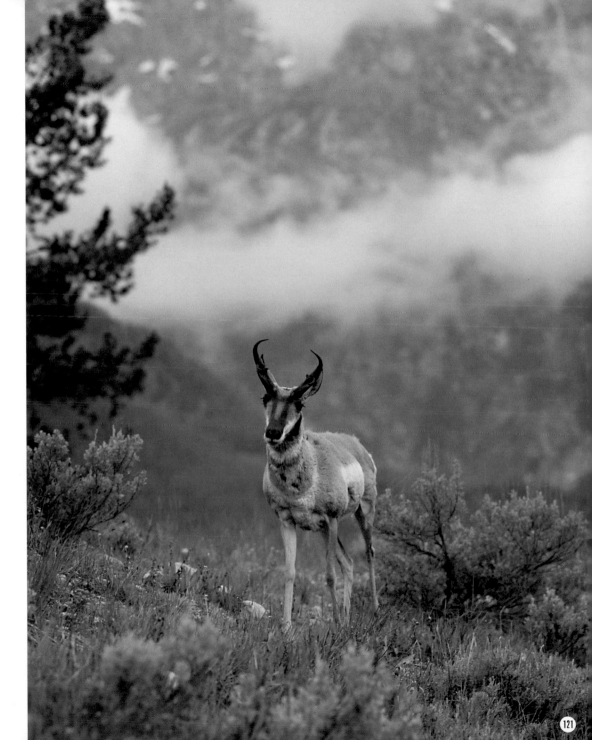

Pronghorns shed the hard sheath of hair covering their antlers and get new ones every year. Early in the twentieth century, pronghorns were nearly extinct, but in recent years their numbers have increased. They are among the fastest animals in the world.

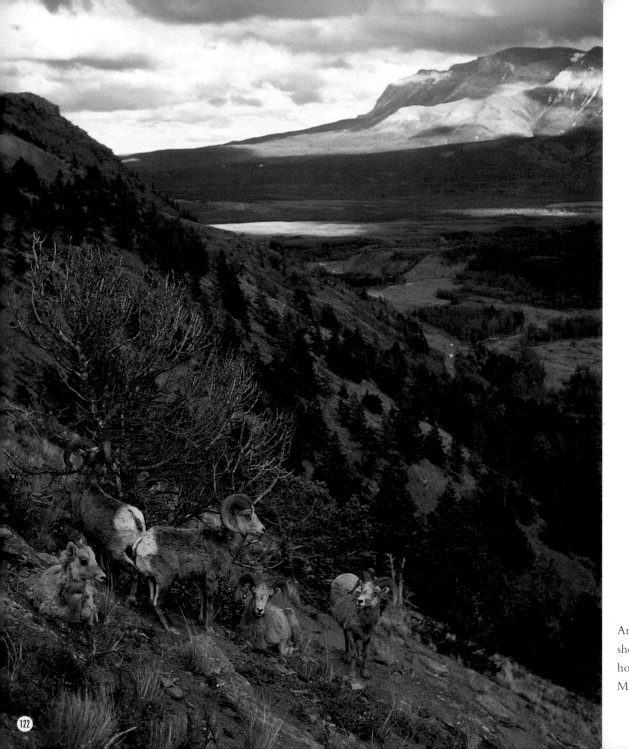

American bighorn
sheep make their
home in the Rocky
Mountains.

following page: Combat between rams during the breeding season is a violent clash of heavy horns and muscular bodies. Once in a while, their horns crack under the crashing blows.

With cleft hooves padded in the center for traction, these bighorn sheep easily climb a steep cliff in Banff National Park.

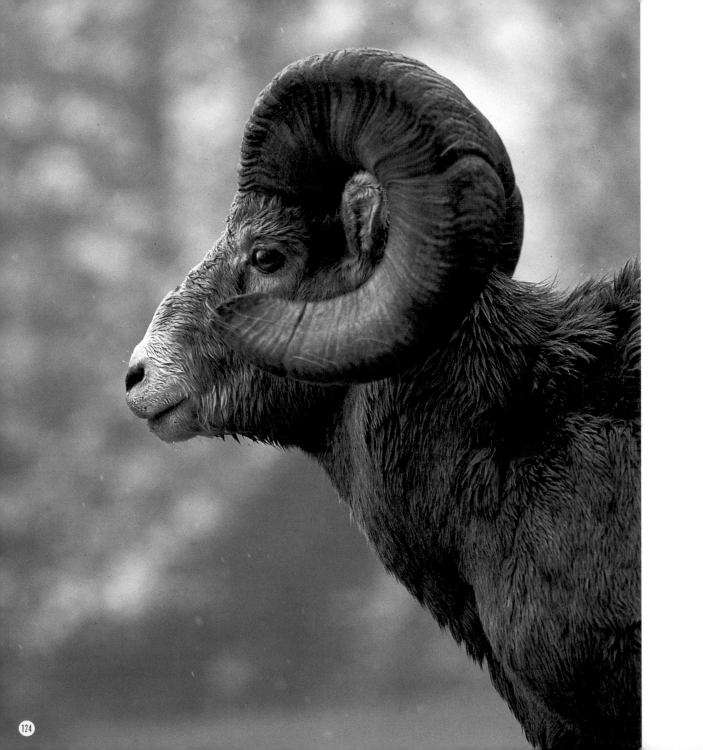

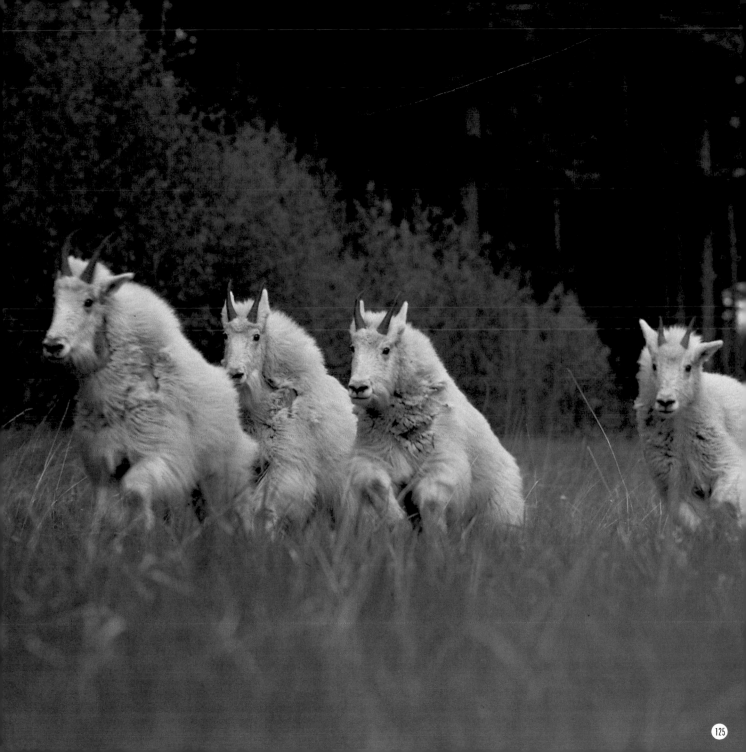

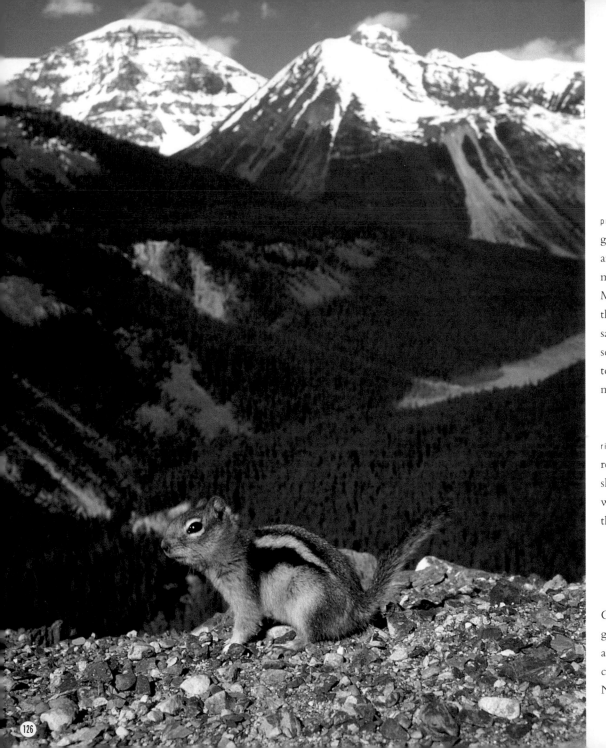

preceding page: Mountain
goats live in forested
areas only during the
most severe winters.
Most of the year, they
thrive above tree line,
safe from predators and
secure in their ability
to traverse all but the
most vertical rock.

right: The American
red squirrel gives a
shrill birdlike squeal
when it sees some-
thing unfamiliar.

Golden-mantled
ground squirrels
are common in the
conifer forests of
North America.

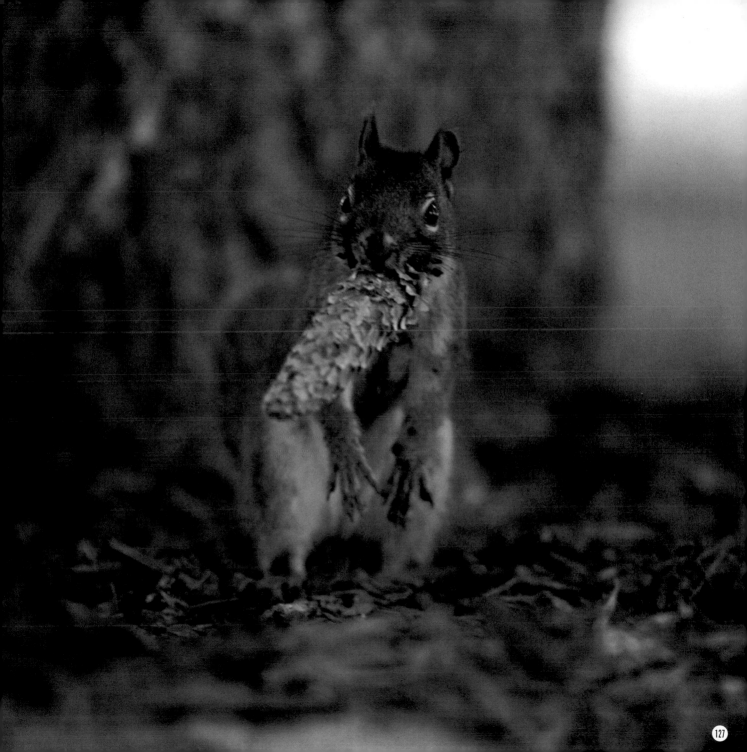

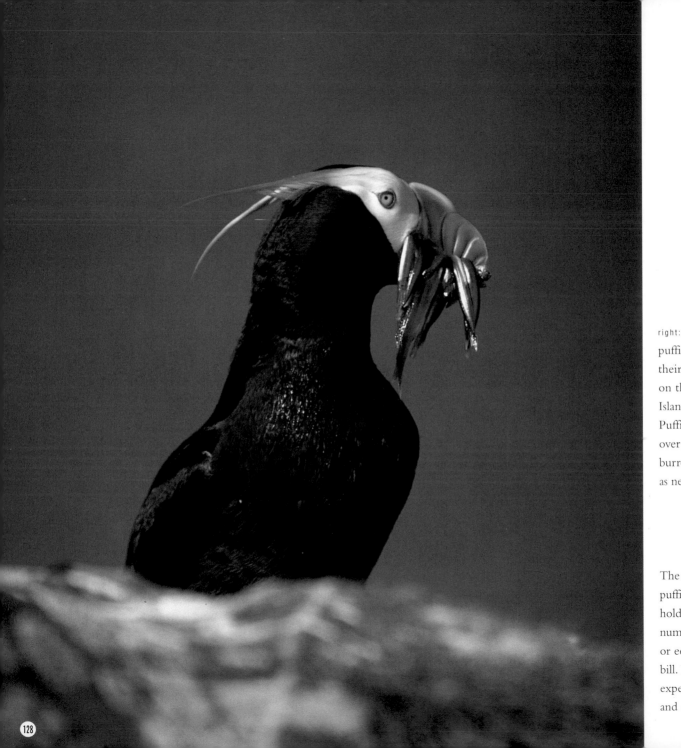

right: Horned
puffins share
their nesting site
on the Pribilof
Islands, Alaska.
Puffins may take
over rabbit
burrows to use
as nests.

The tufted
puffin is able to
hold a large
number of fish
or eels in its
bill. Puffins are
expert divers
and swimmers.

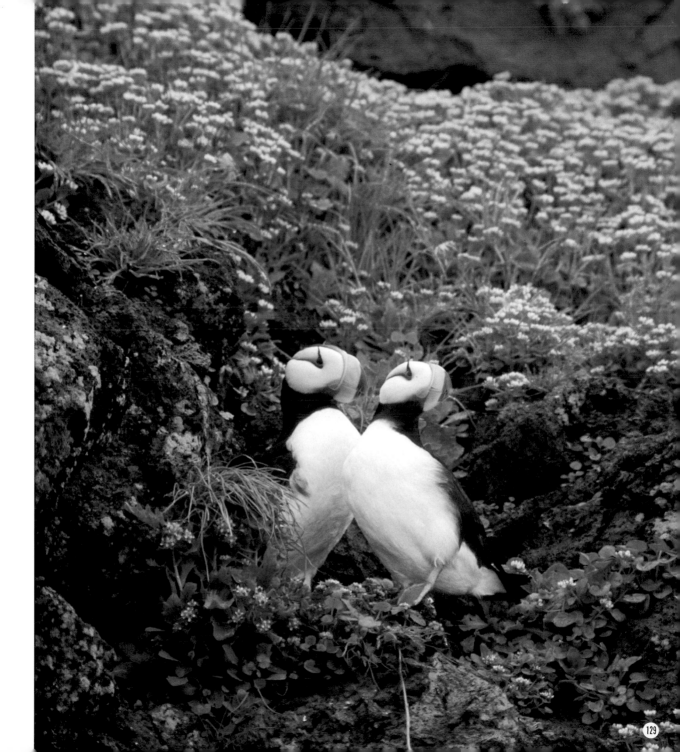

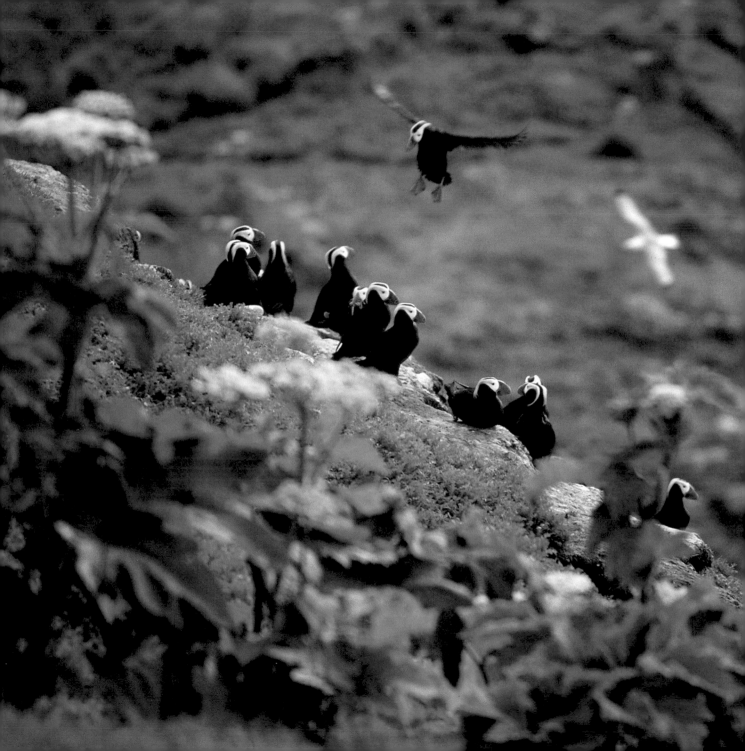

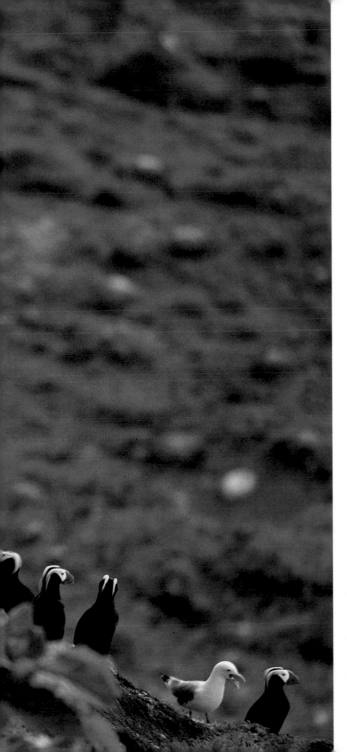

Tufted puffins' hatcheries
on Middleton Island,
Alaska. Very gregarious,
these puffins prefer to live
in colonies that contain
thousands of birds.

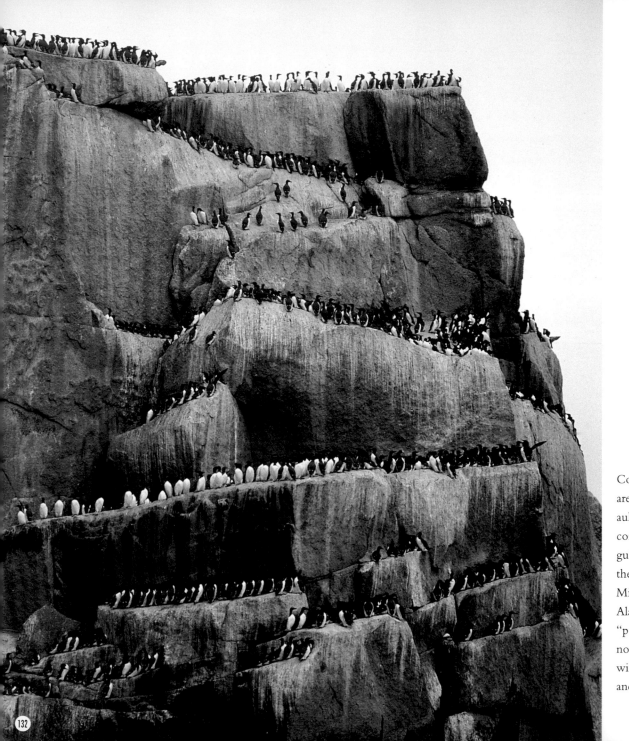

Common guillemots
are members of the
auk family, which also
contains puffins. These
guillemots made
their hatcheries on
Middleton Island,
Alaska. They are called
"penguins of the
north" and use their
wings for both flying
and swimming.

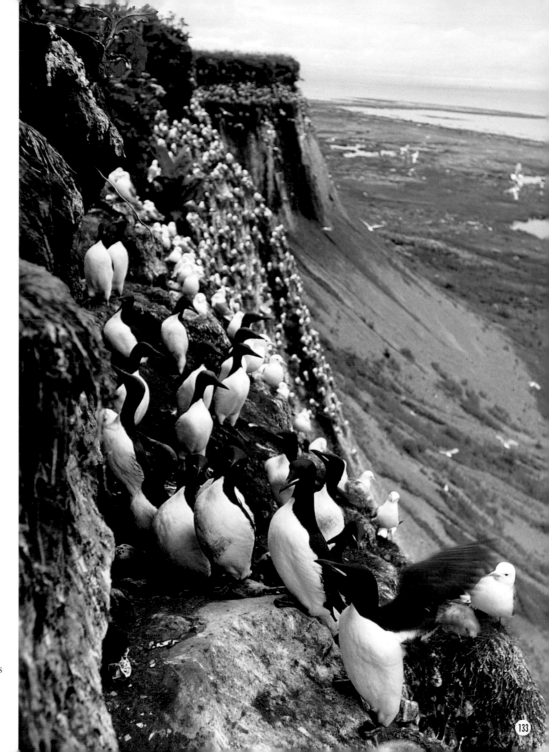

Brunnich's guillemots do
not build nests, but lay eggs
directly on the ground.

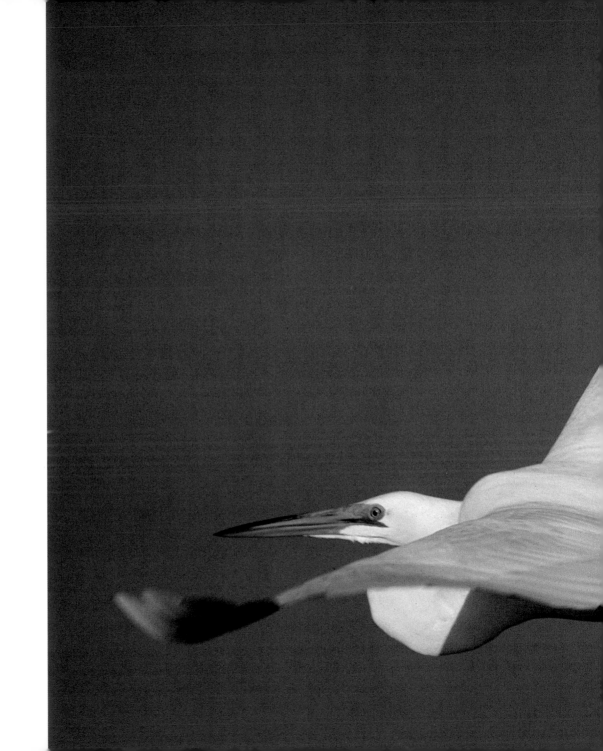

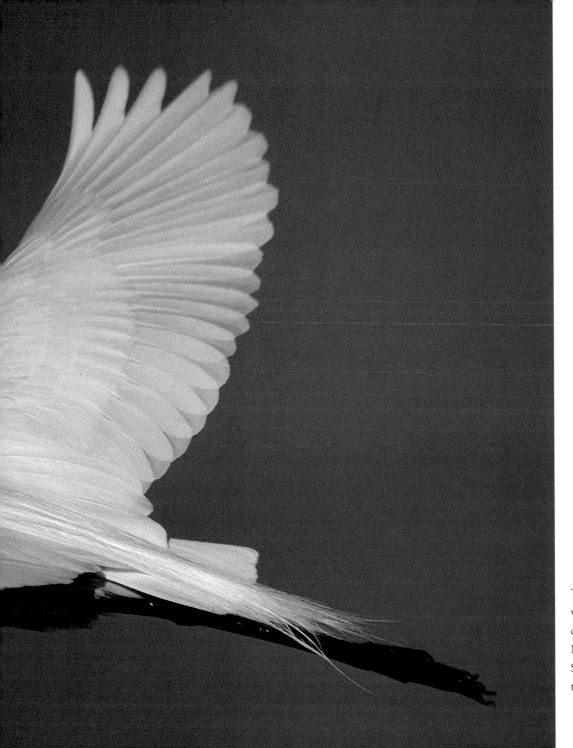

This egret's wings are very clear against the darkening sky over the National Audubon Society's wildlife sanctuary in the Florida Keys.

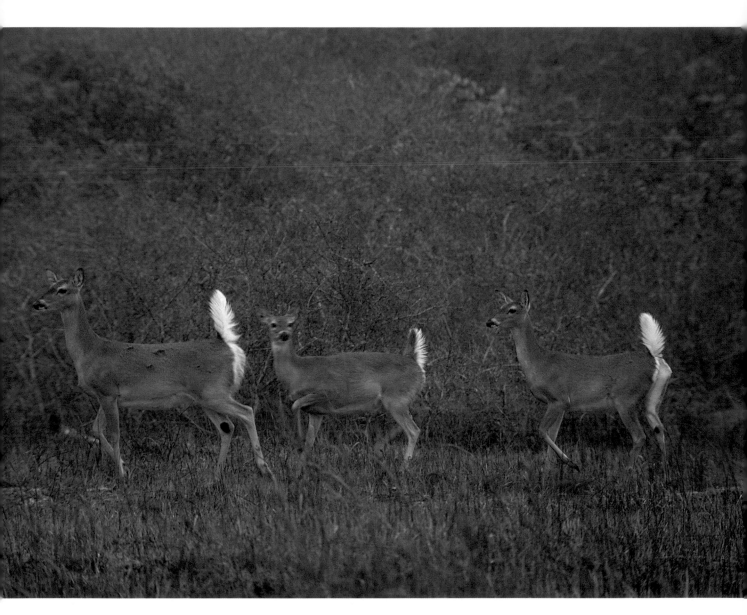

A common sight in the forests and marshlands of North America,
white-tailed deer raise their tails to alert each other to possible danger.

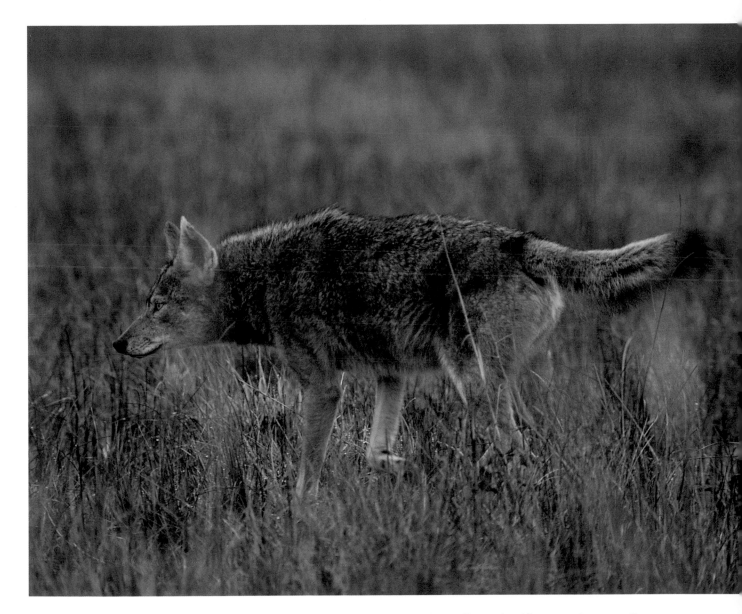

A cunning stalker and swift runner, the coyote lives
primarily upon rabbits and rodents.

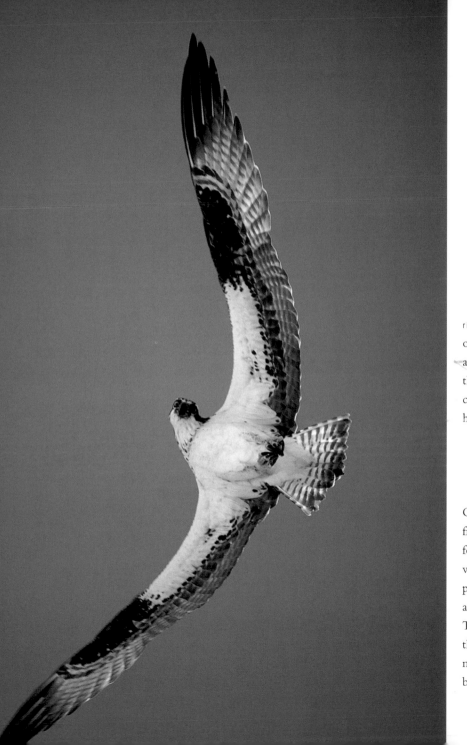

right: In Florida, this osprey's nest is in a tree about sixty feet above the ground. Ospreys carry fish with the prey's head pointing forward.

Ospreys are a large fish-eating bird of prey found throughout the world, except the southern part of South America and the polar regions. They nest in trees or on the ground in cliffs and mate for life, which may be twenty years.

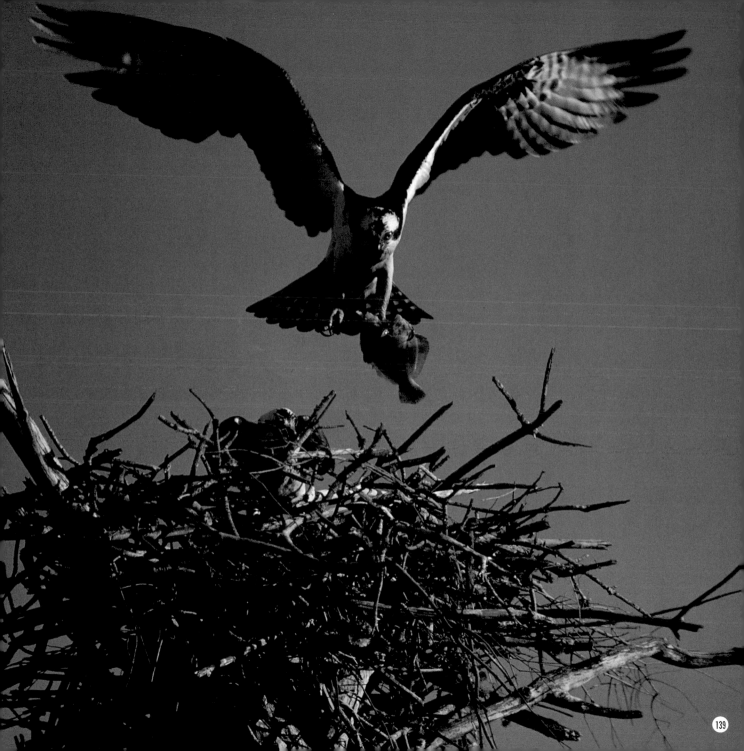

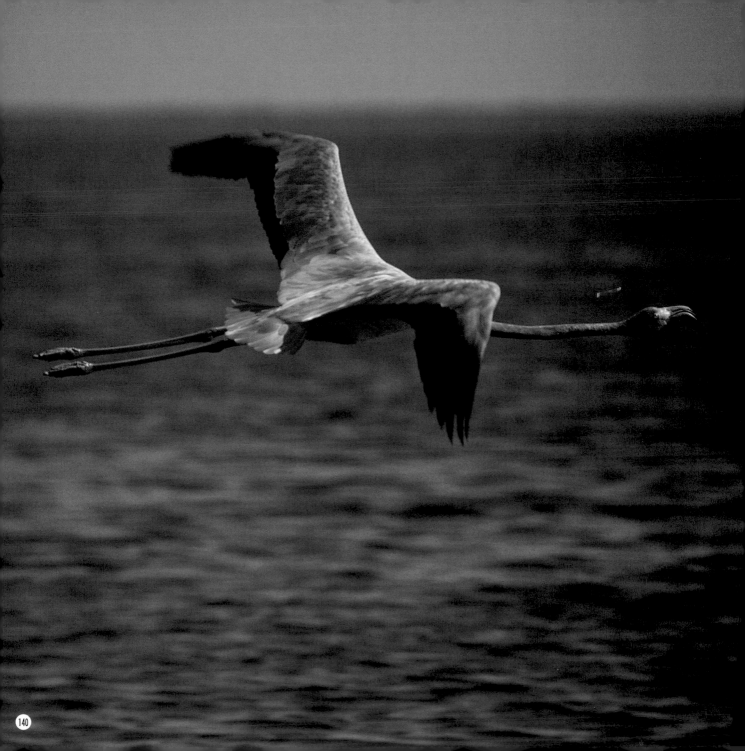

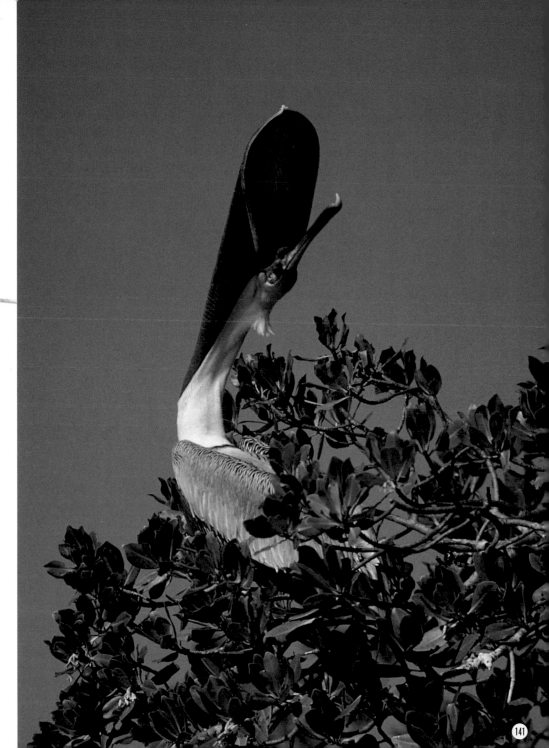

right: This greater flamingo is flying over Everglades National Park, Florida. To feed, flamingos invert their beaks to scoop water, then filter out mud and water to collect algae. Flamingos in Florida breed on Dutch Bonaire Island in the Caribbean Sea.

A brown pelican roosting in a mangrove. Among pelicans, the brown pelican is unique because it usually dives from the air rather than from the water's surface to capture prey.

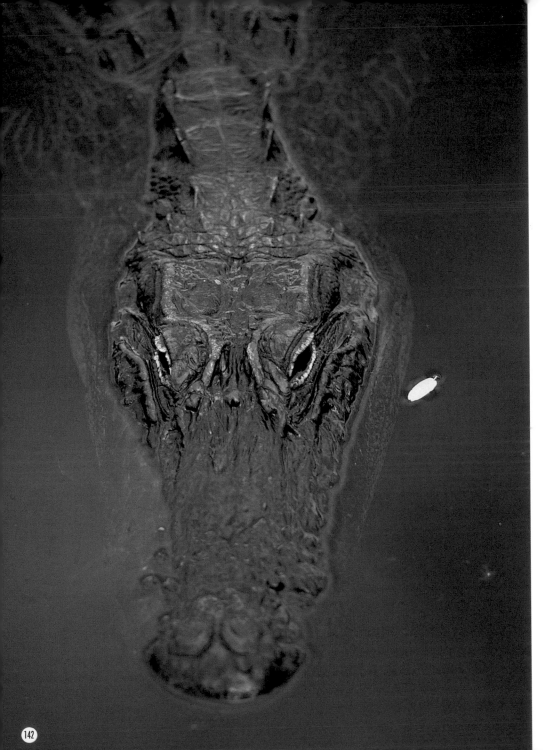

The American alligator
may reach twenty feet
in length.

This Florida softshell is in The Everglades, Florida.

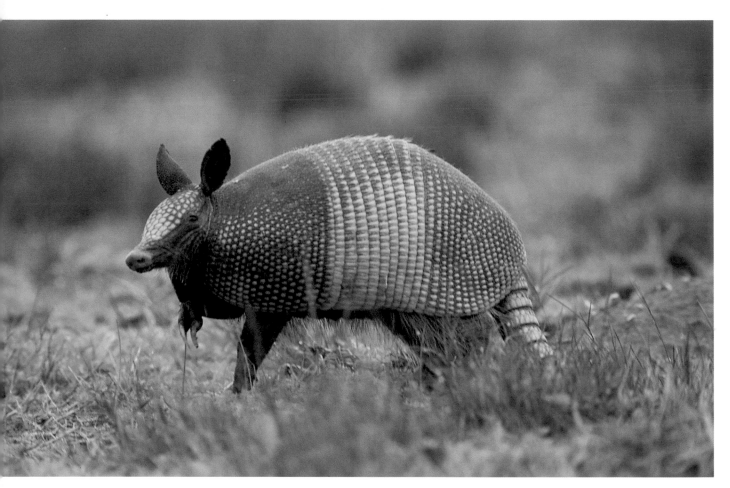

With skin-covered bone armor protecting it, the common long-nosed armadillo uses its snout to catch insects.

right: Raccoons such as this one near the Florida Keys are very adaptable and, in North America, are often seen in cities and towns.

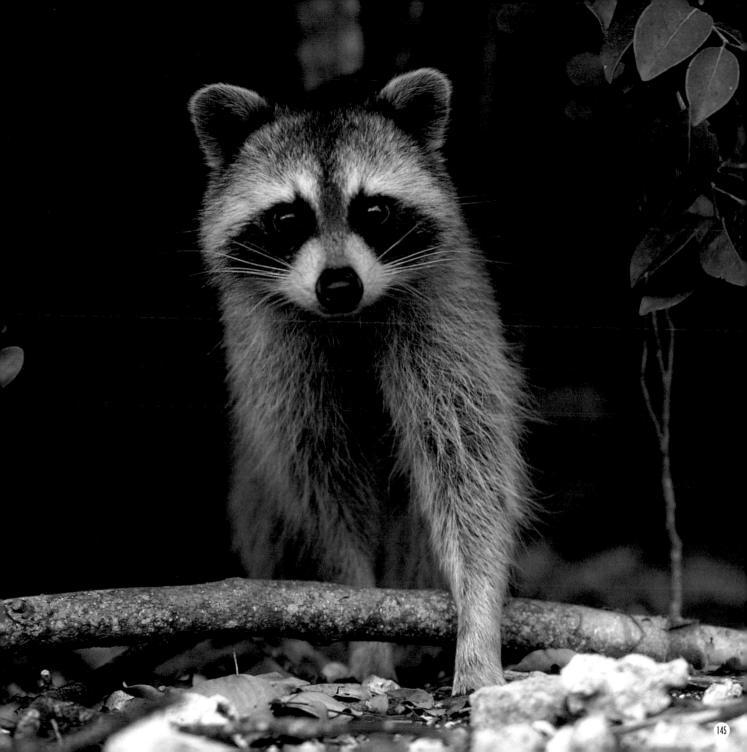

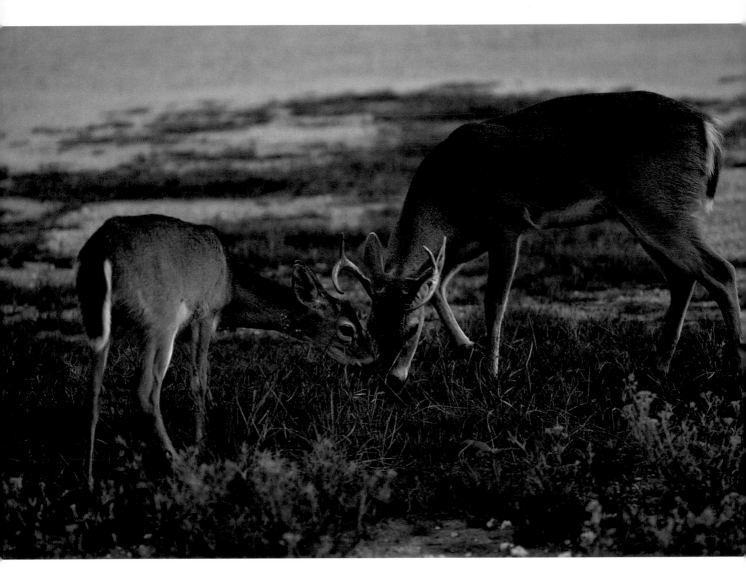

Key deer are a type of white-tailed deer that live only in
the Florida Keys. They are a protected species.

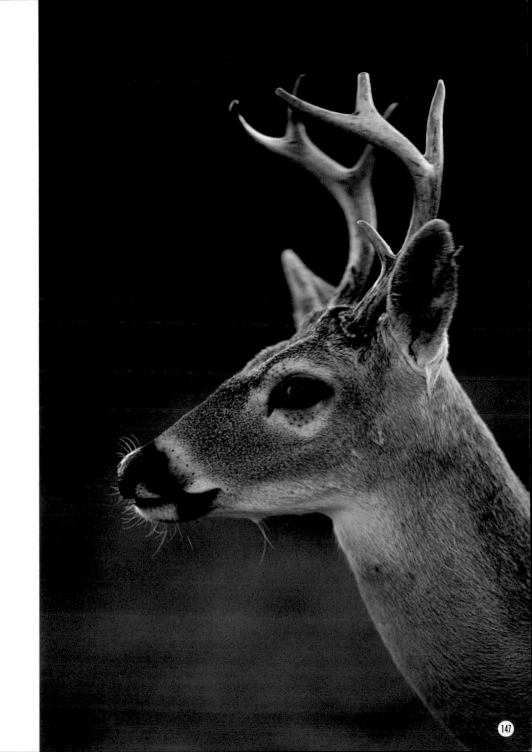

To survive in their wet
environment, Key deer
are good swimmers.

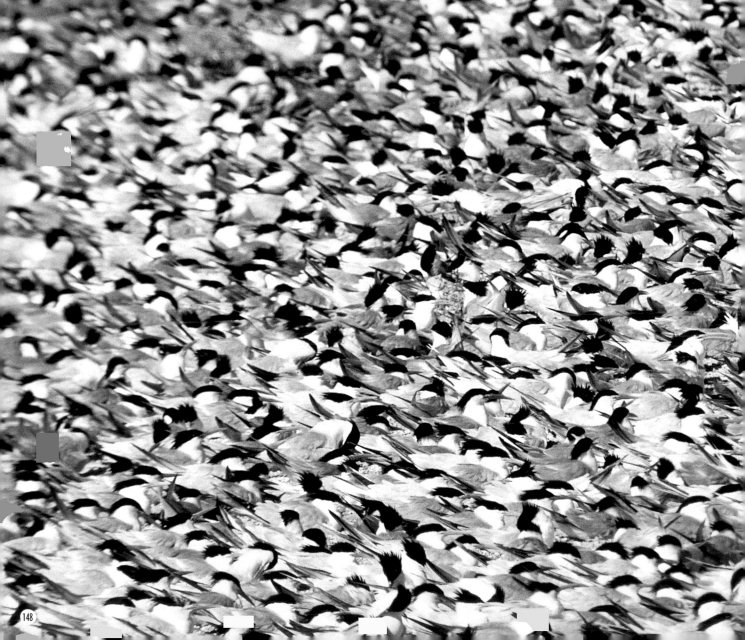

CENTRAL and

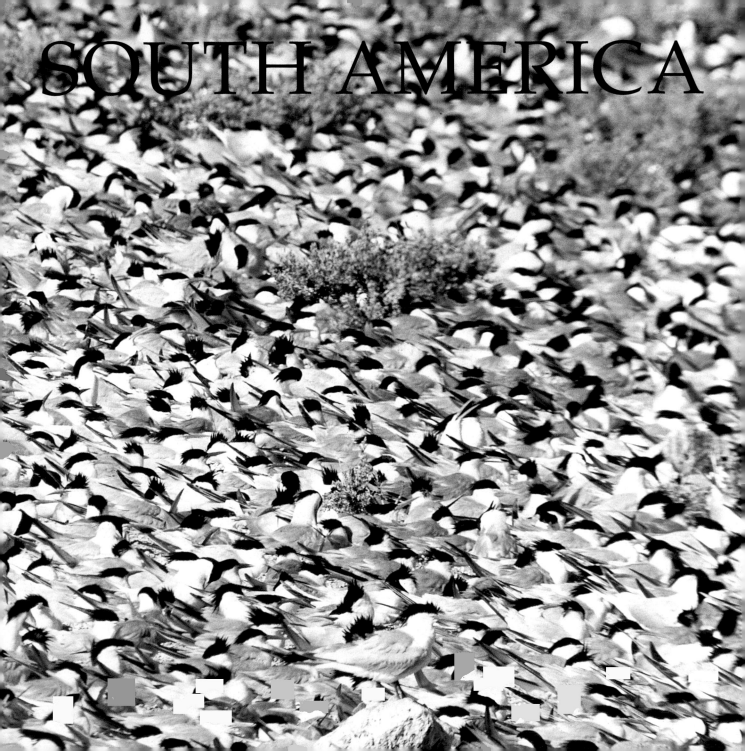

THE GULF OF MEXICO AND the Caribbean Sea support a rich marine wildlife. The area is dotted with islands where colorful birds and reptiles live. South of the equator, despite the waves of development, the thick tropical rain forests resist human intrusion and shelter wildlife native to this area.

preceding pages:
Laza Island in the Gulf of California was covered by elegant terns and crested terns. The entire island was full of their smell and sound.

opposite page: This herring gull is returning to its chick with a stolen tern's egg.

Blue-footed boobies use their beaks and feet to make a hollow in the ground for a nest. Both male and female take turns sitting on the eggs, which are protected by the parents' feet.

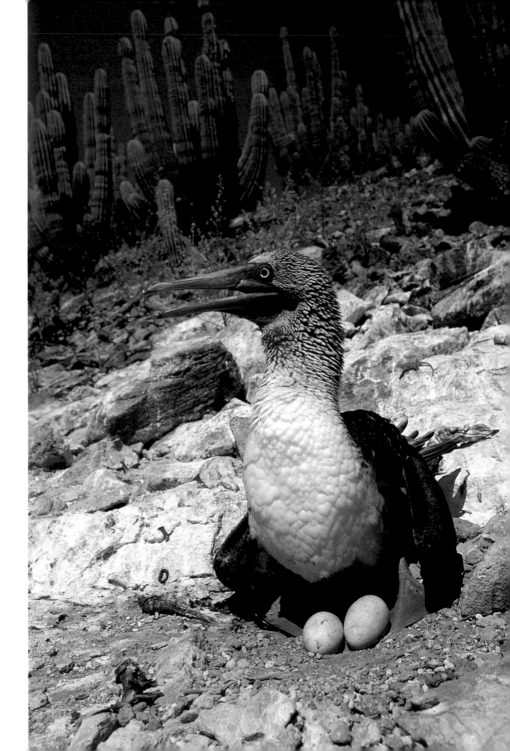

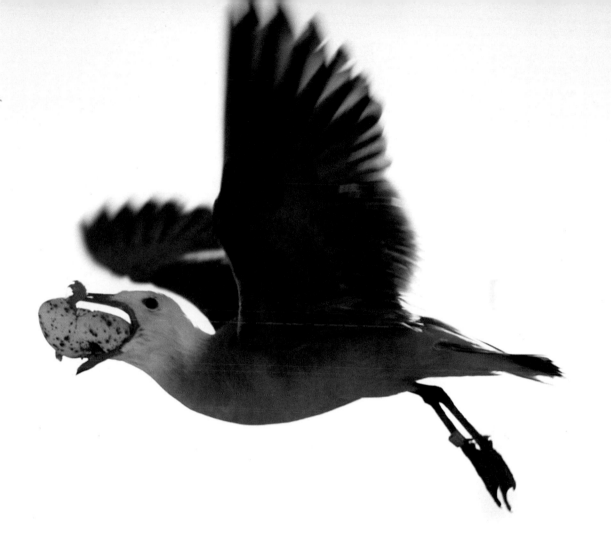

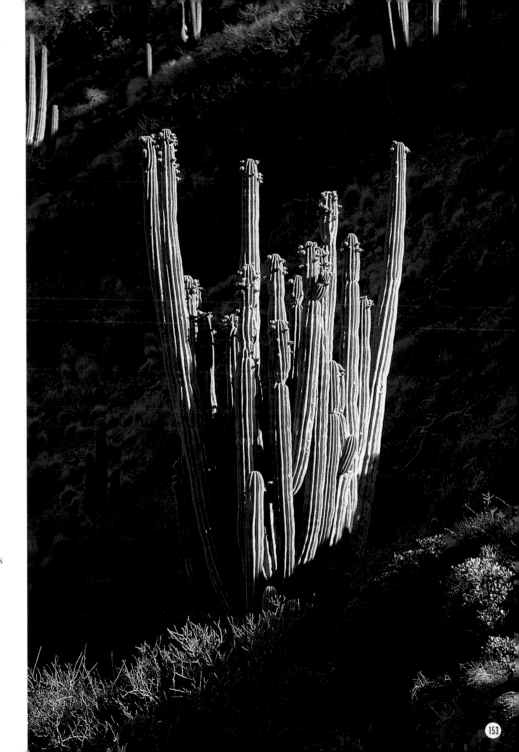

left: Unlike its noisy cousin, the rattleless snake is quiet. It is found on Tortuga Island, where, it seems, there are snakes every fifteen feet.

Gordon cacti bloom on Catarina Island.

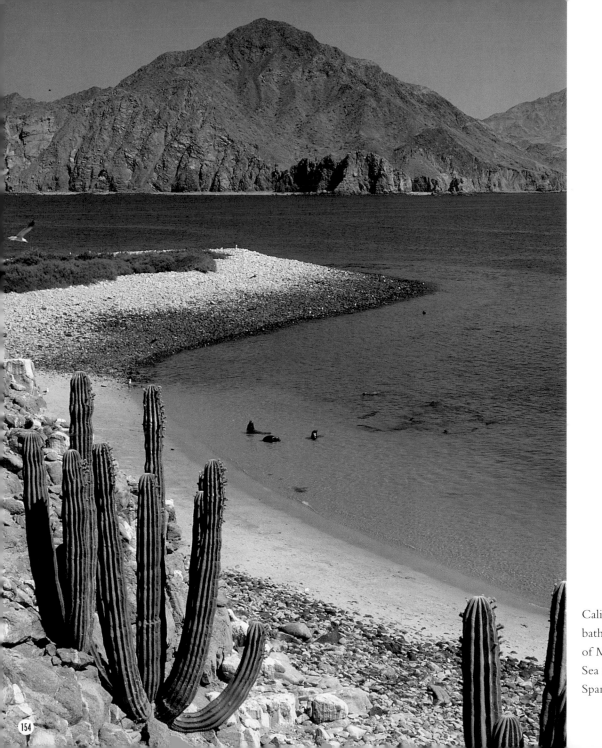

California sea lions enjoy bathing in the tranquil Gulf of Mexico, also called the Sea of Cortez after the Spanish conquistador.

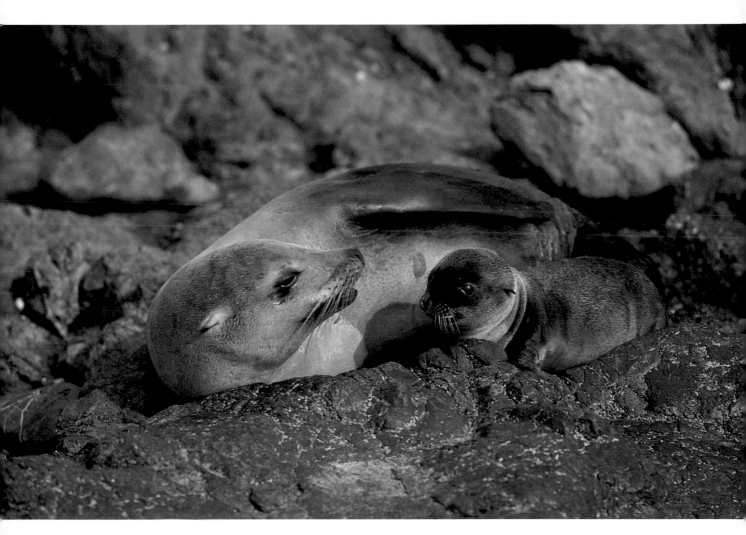

A newborn California sea lion and its mother spent the entire day in the same spot.

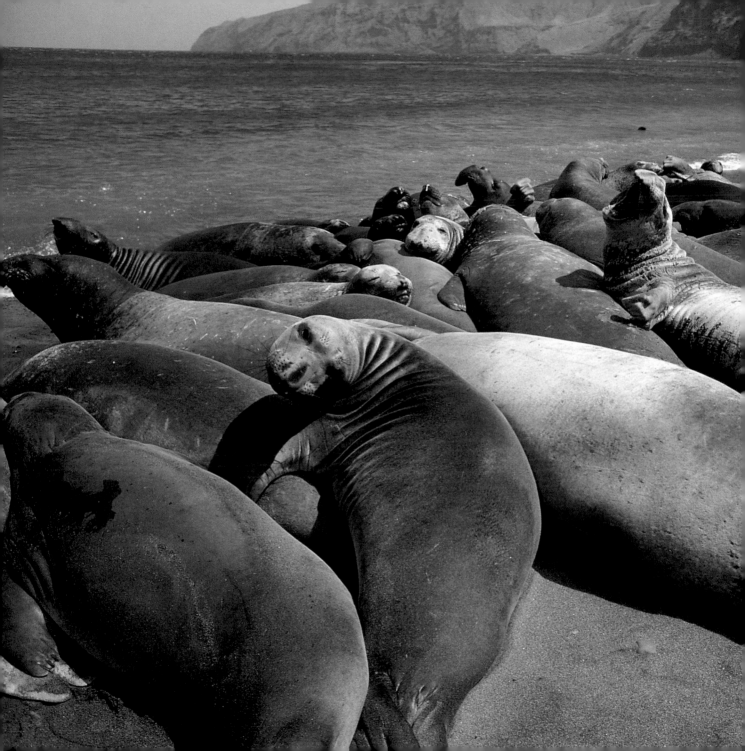

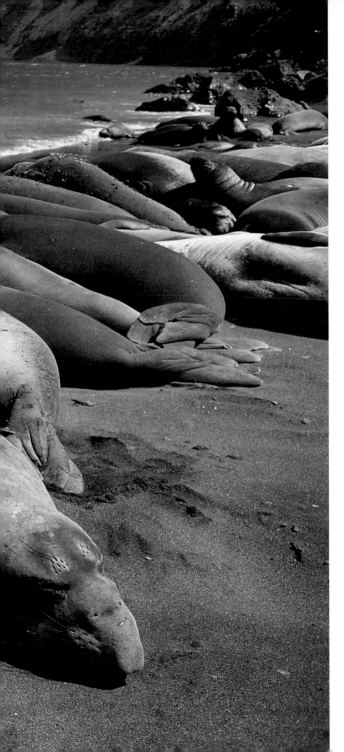

Northern elephant seals usually go on land only twice a year: to breed and—a few weeks later—to molt. Ungainly ashore, they move around by crawling, and very young seals are sometimes crushed to death by adults that often weigh as much as three tons.

Caves in Trinidad and
Tobago offer good
habitats for oilbirds.
Nocturnal birds that
feed on fruit, they fly
in the dark by means
of echolocation, much
like bats.

As the sun goes down, a flock of scarlet ibis returns
to its nesting colony in the darkening mangroves.

right: Scarlet ibis live in the northern coastal area of
South America. Their nesting sites are under strict
protection. From a distance, the mangroves look as
if they are dyed red.

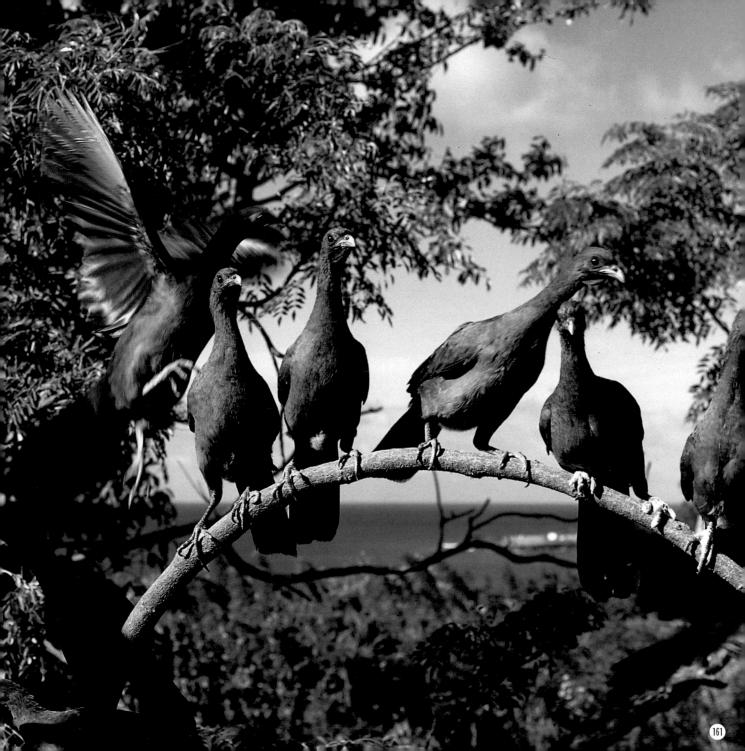

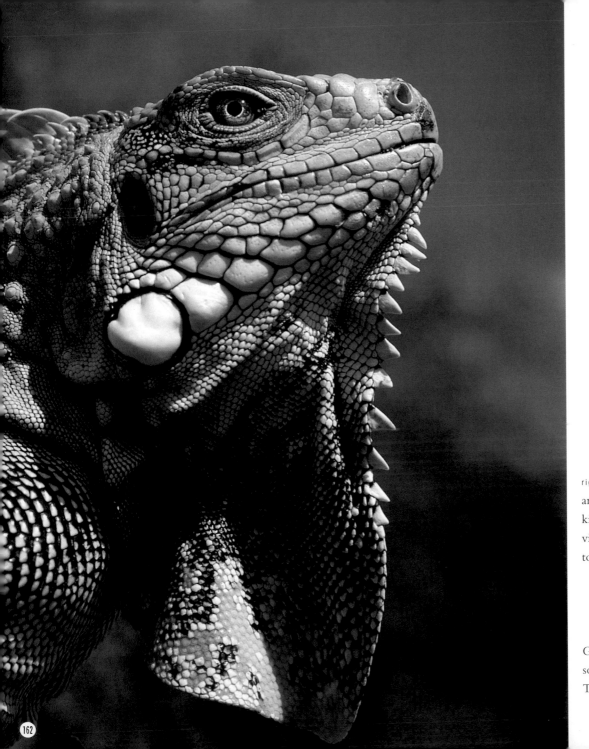

right: The Caribbean islands
are inhabited by many
kinds of reptiles. With their
vivid colors, lizards add life
to the dry environment.

Green iguanas are a food
source for the people of
Trinidad.

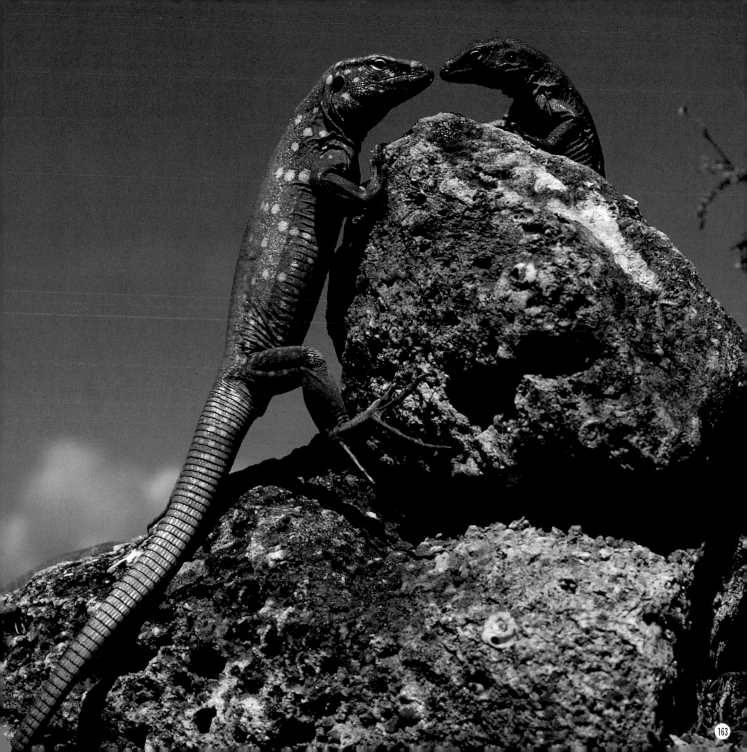

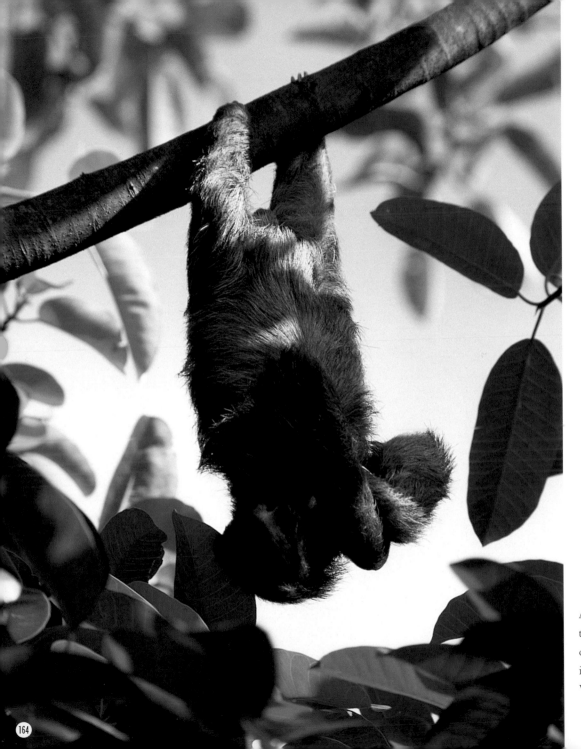

A brown-throated three-toed sloth feeds on the leaves of a tree in the middle of a Venezuelan town.

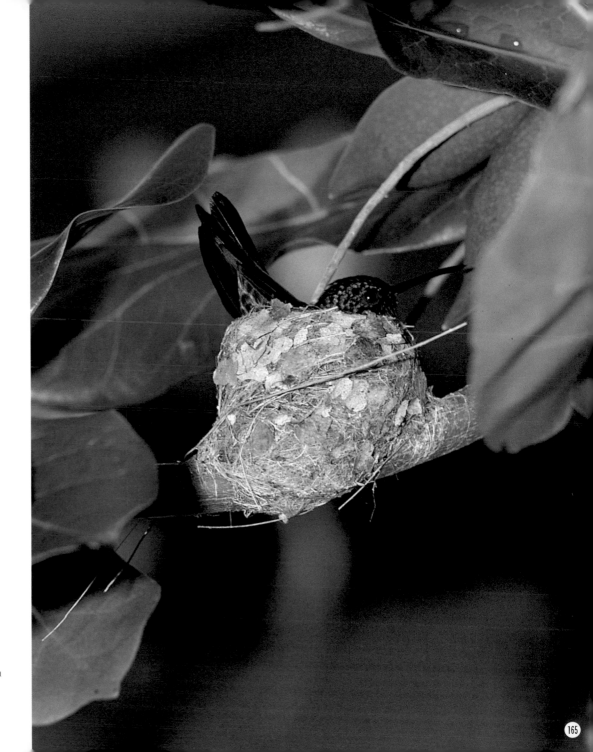

A hummingbird sits on
its eggs in a nest less than
two inches in diameter.

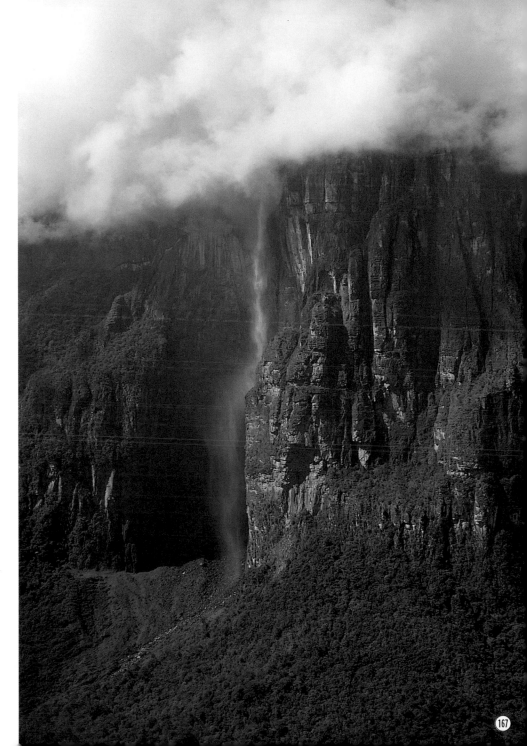

left: On the Araguaia, a tributary of the Amazon, giant anteaters swim slowly across the water.

A cascading waterfall on the Araguaia.

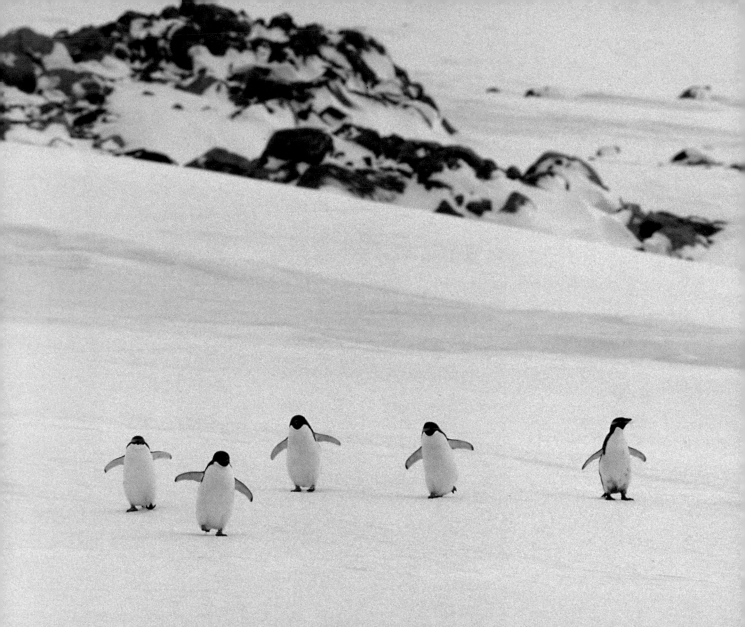

ANTARCTICA

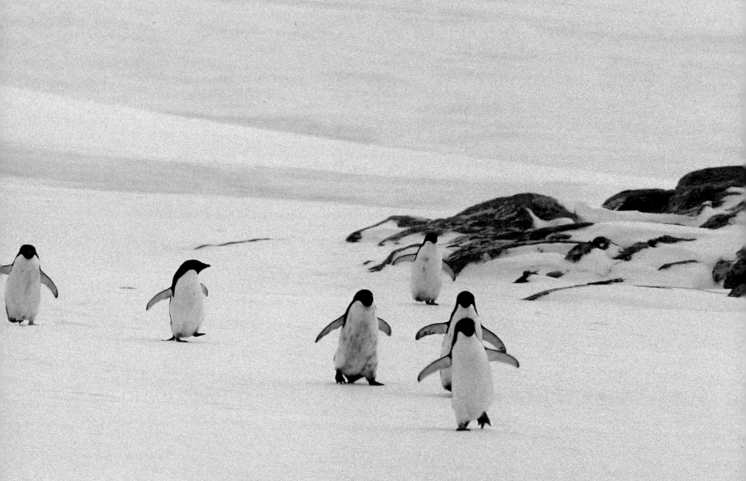

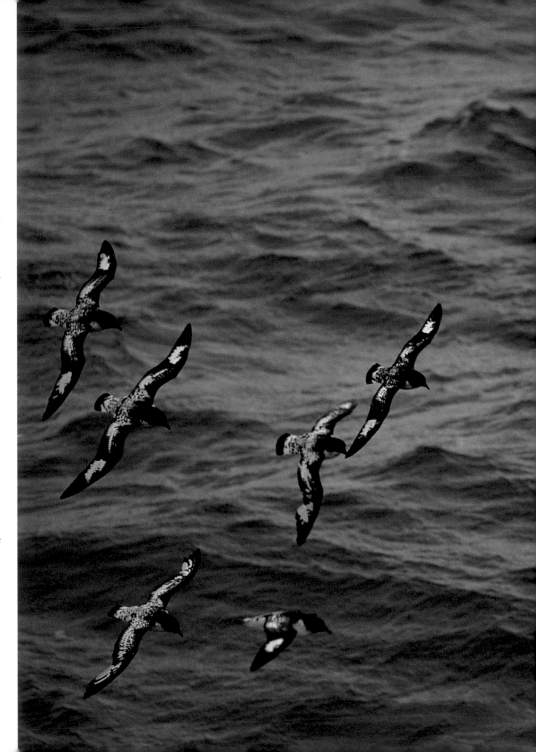

THE ANTARCTIC'S MANY LAY-
ERS OF ICE ENCLOSE MILLIONS
of years of geological change. It
is the coldest and windiest conti-
nent and appears desolate, yet its
surrounding ocean teems with
life and energy. It is an ocean rich
in fish and krill, which sea birds,
penguins, seals, and whales feed
on. Penguins live here by the mil-
lions, but of the 18 kinds of pen-
guins, only four—the Emperor,
the Adélie, the Chinstrap, and the
Gentoo—live on the continent.

preceding pages: Their rookery, or
nesting site, is far away from the
shore. Although they may look
ungainly, these Adélie penguins
actually move quite efficiently on
land, balancing with their short
wings as they walk, run, hop, and
even slide on their chests over the
ice.

Cape pigeons, or Pintado
petrels, flew ahead of the ship
as if they were piloting it as it
approached Deception Island.
They are easily identified by their
distinctive upper-wing markings.

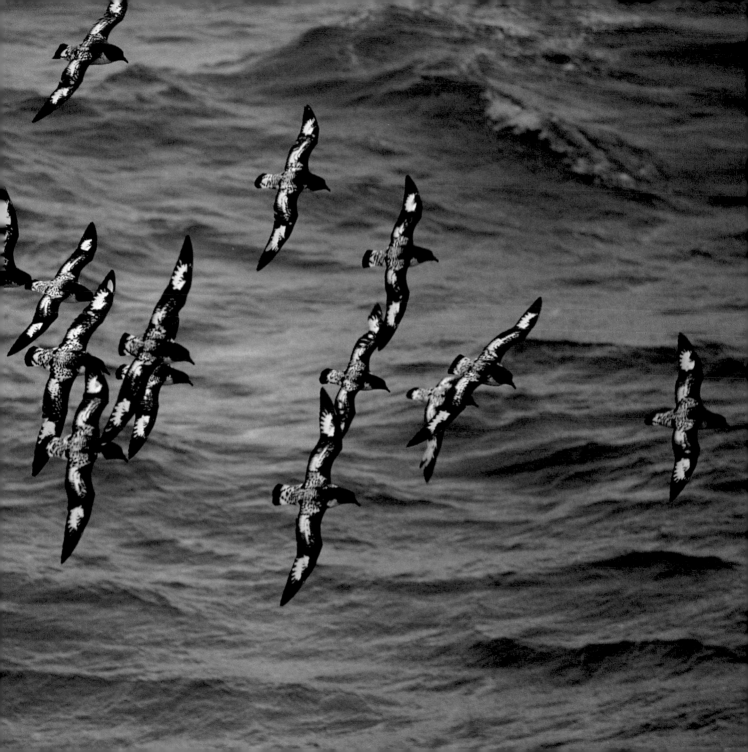

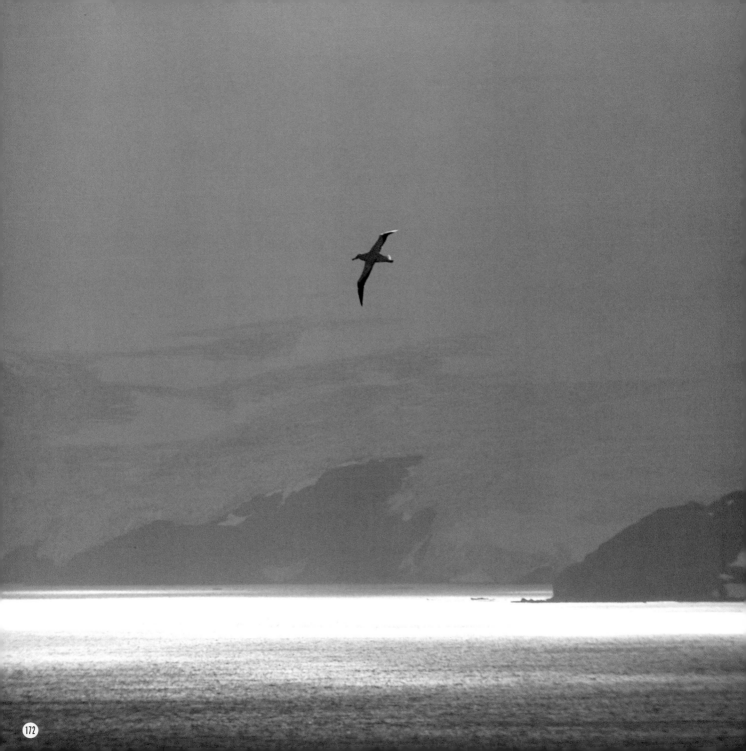

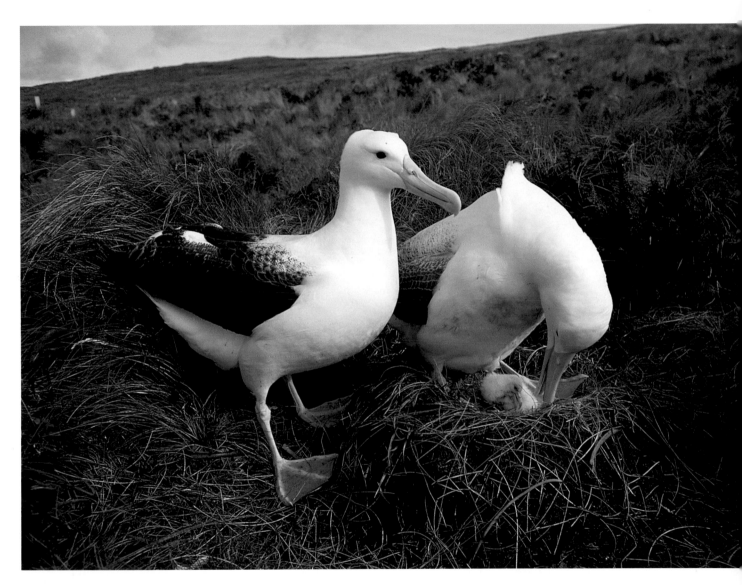

left: The wandering albatross spends most of its life on the vast ocean of the Southern Hemisphere. They skillfully fly through big waves that can reach as high as thirty feet, but in calm weather, without wind, they fly only with great difficulty.

Royal albatross are the largest of this bird order. Campbell Island, New Zealand, is their only breeding site.

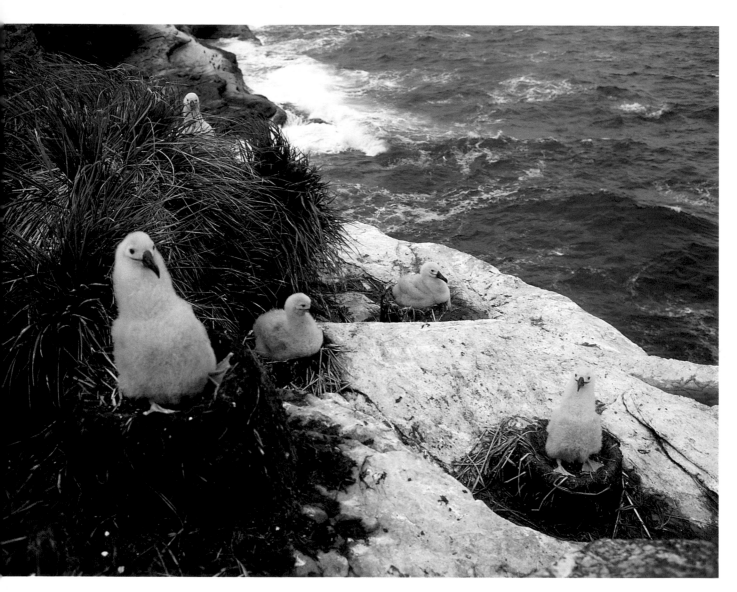

These black-browed albatross chicks are waiting for their mothers to bring back squid and fish for them. In cold nesting sites such as the Falkland Islands, mother birds have to lay eggs early and raise their chicks quickly before the harsh winter comes.

right: In the Falkland Islands, black-browed albatross fly around ships, waiting for fish that flee the vessels.

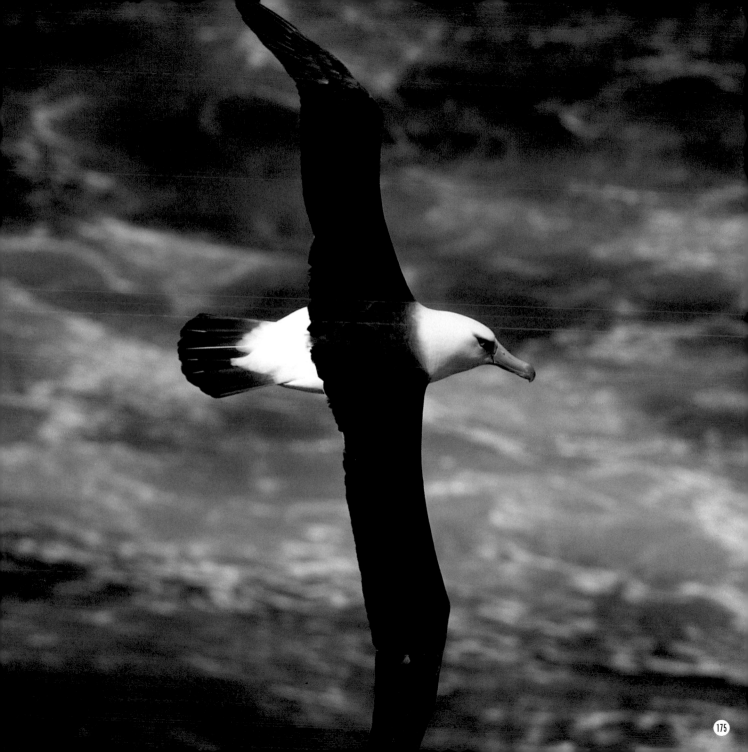

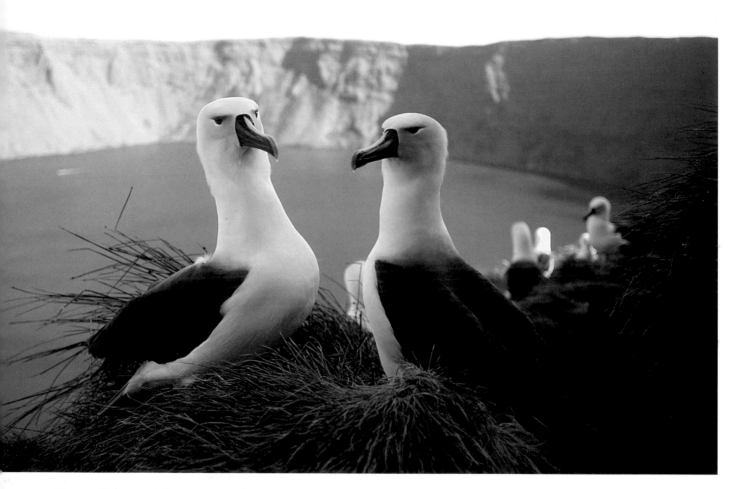

These yellow-nosed albatross are nesting by a crater lake.

right: Giant petrels are also called giant fulmars. *Fulmar* means "stinking gull." By shaking its head, this bird can spray stinking liquid through the nostrils on its beaks.

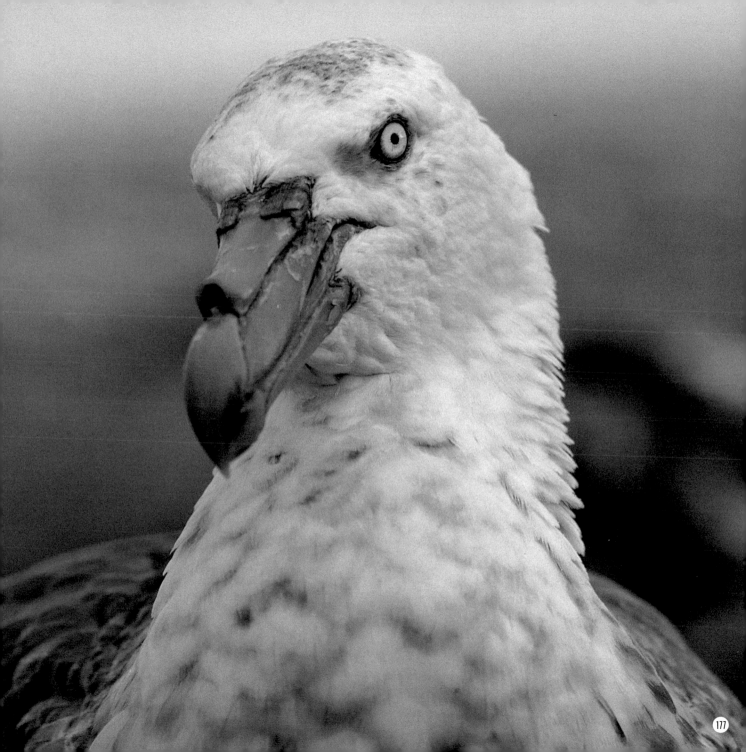

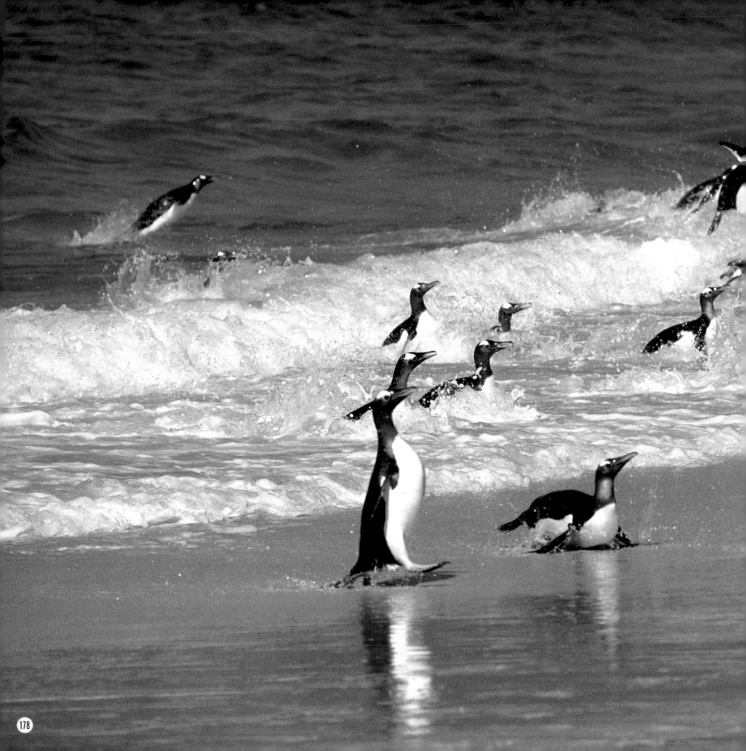

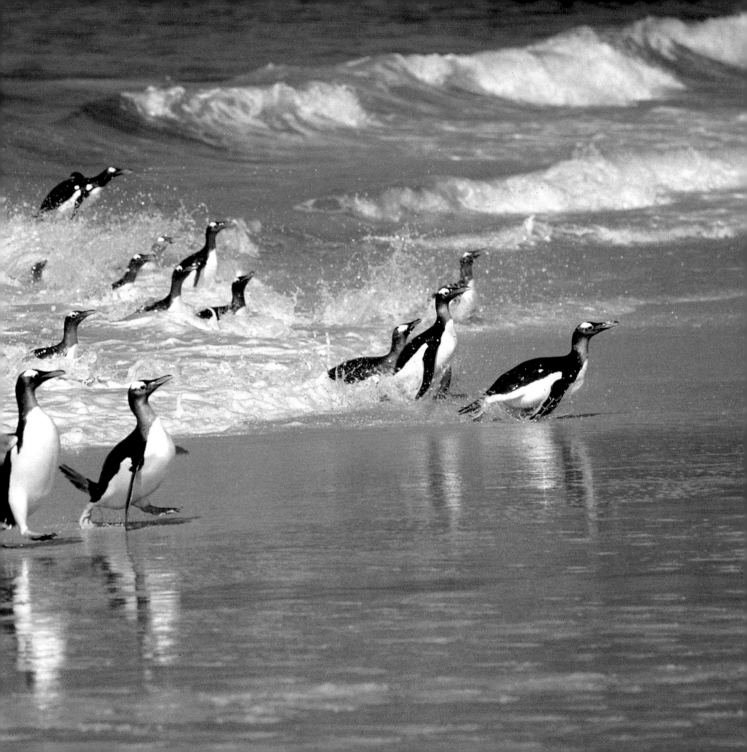

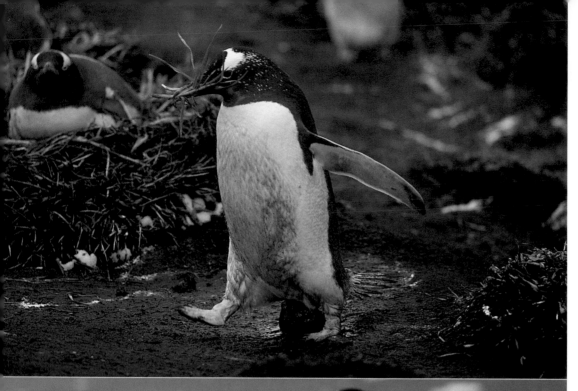

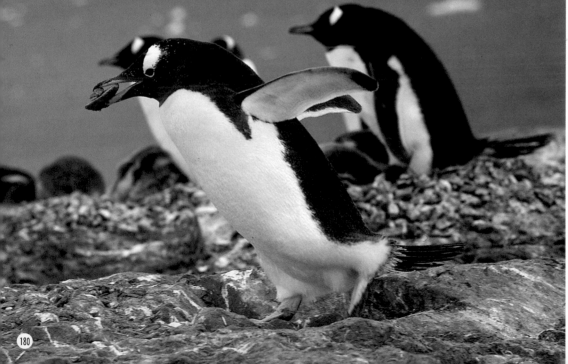

preceding pages:

These gentoo penguins are among the few types of penguins that inhabit Antarctica. No penguins are found in the Northern Hemisphere.

Gentoo penguins use grass and stones to build their nests, but they are flexible enough to change building materials according to the nesting environment.

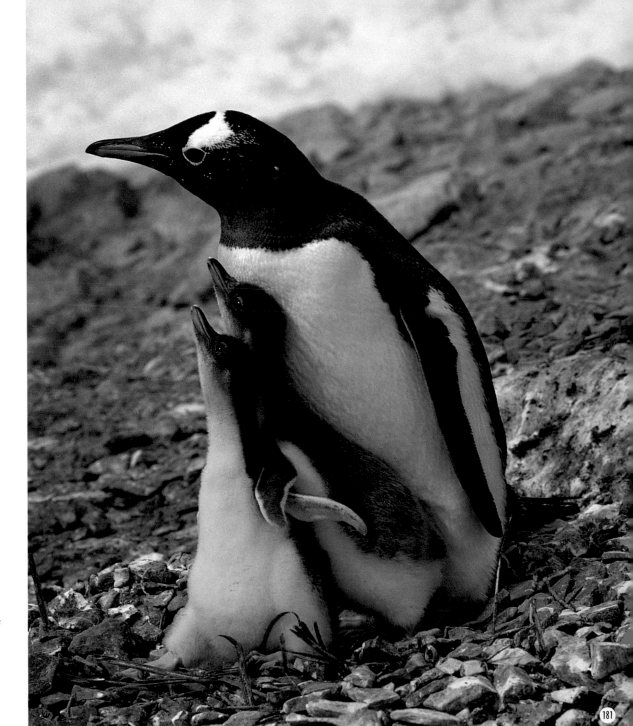

Gentoo penguins build nests and raise babies on the slopes facing the sea. Most penguins breed once a year, and both parents help to raise the chicks.

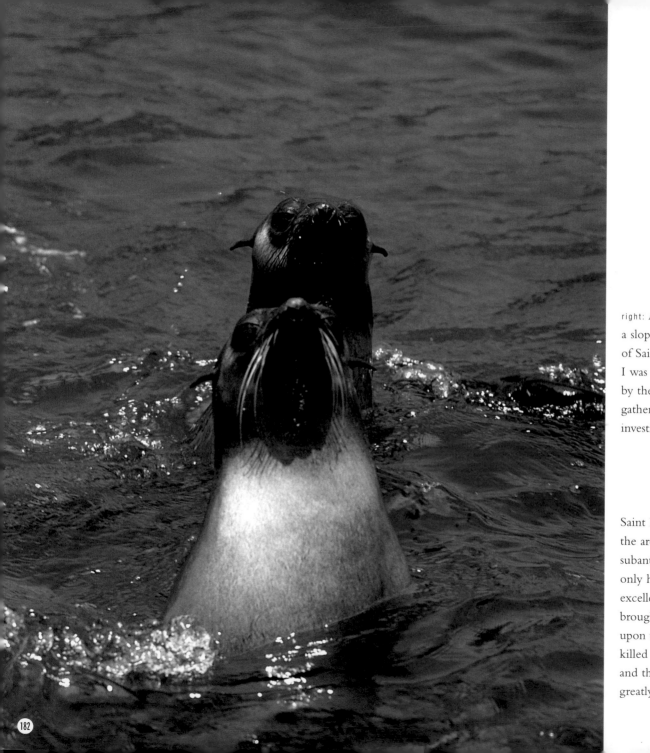

right: After climbing up
a slope from the shore
of Saint Paul Island,
I was soon spotted
by these pups, which
gathered around to
investigate.

Saint Paul Island and
the area around it are
subantarctic fur seals'
only habitat. Their
excellent-quality fur
brought misfortune
upon them. Many were
killed for their pelts,
and their population
greatly declined.

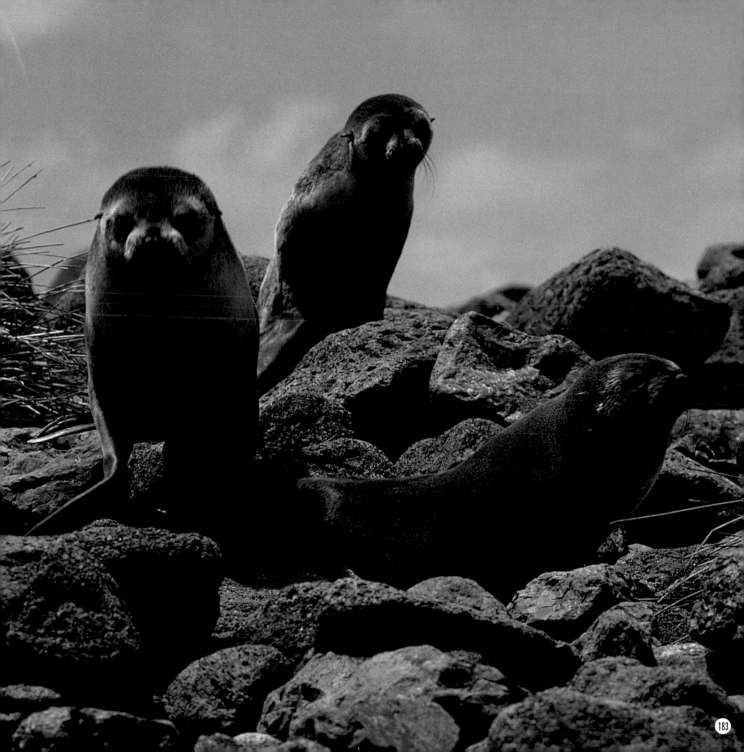

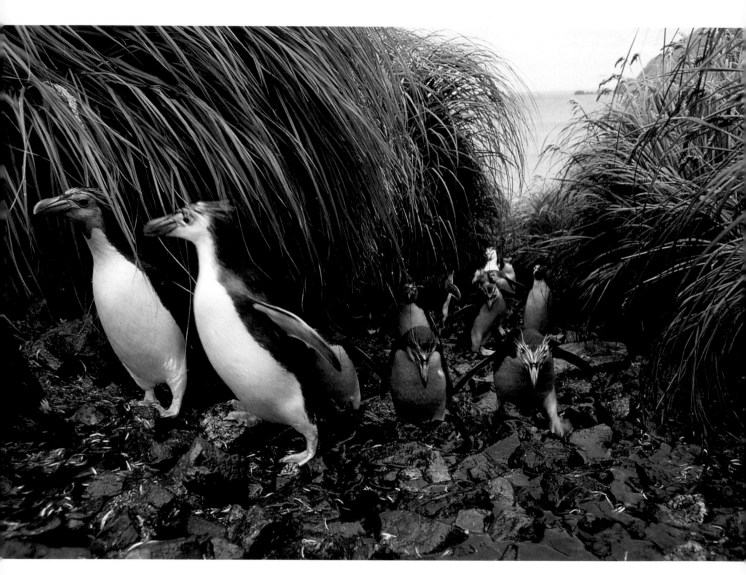

Royal penguins march through tall tussock grass on a path
worn smooth by generation after generation of birds.

following page: Yellow–eyed penguins have become very scarce. They live only in the Auckland Islands, Enderby Island, and other islands that are southeast of New Zealand.

About five hundred thousand royal penguins live in several rookeries on Macauley Island. Although each rookery is packed with birds, these penguins never mistake their own territory.

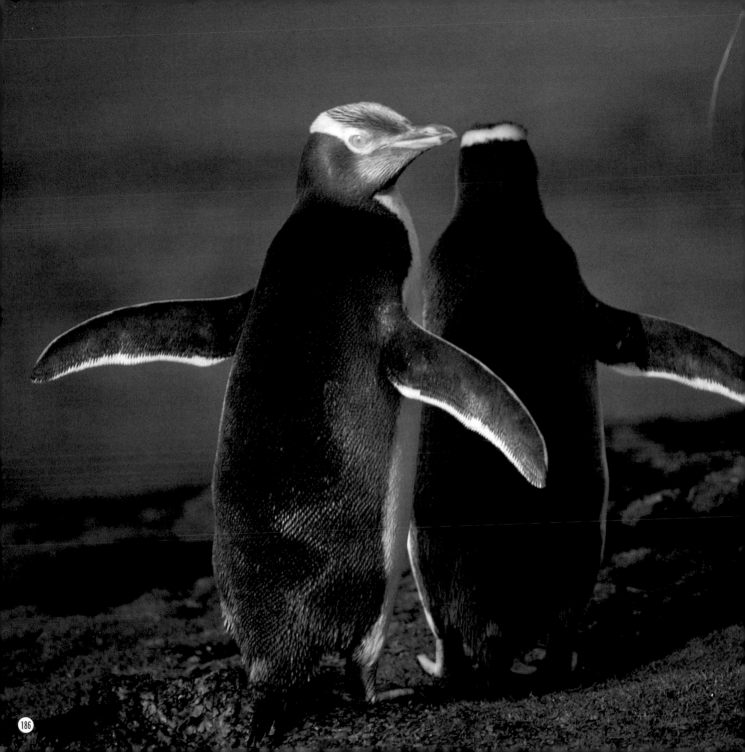

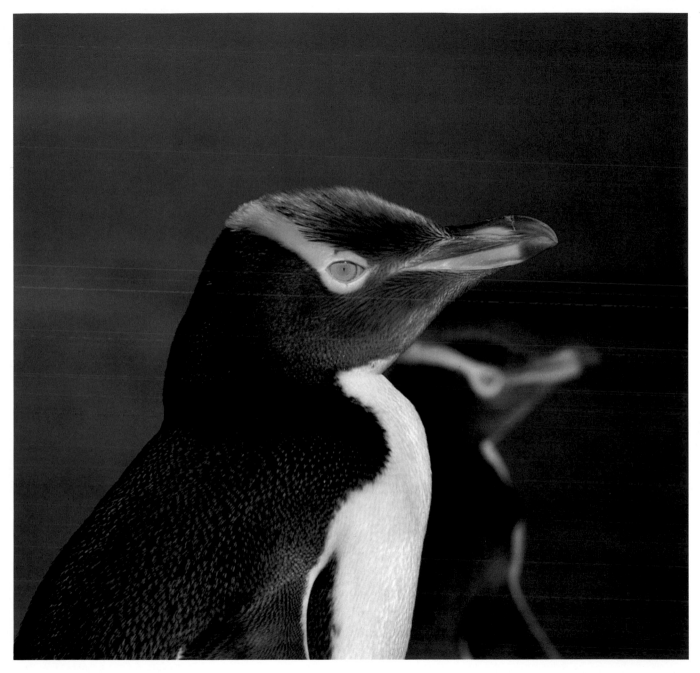

Yellow-eyed penguins build nests on slopes that face the sea and have a cover of bushes and trees.

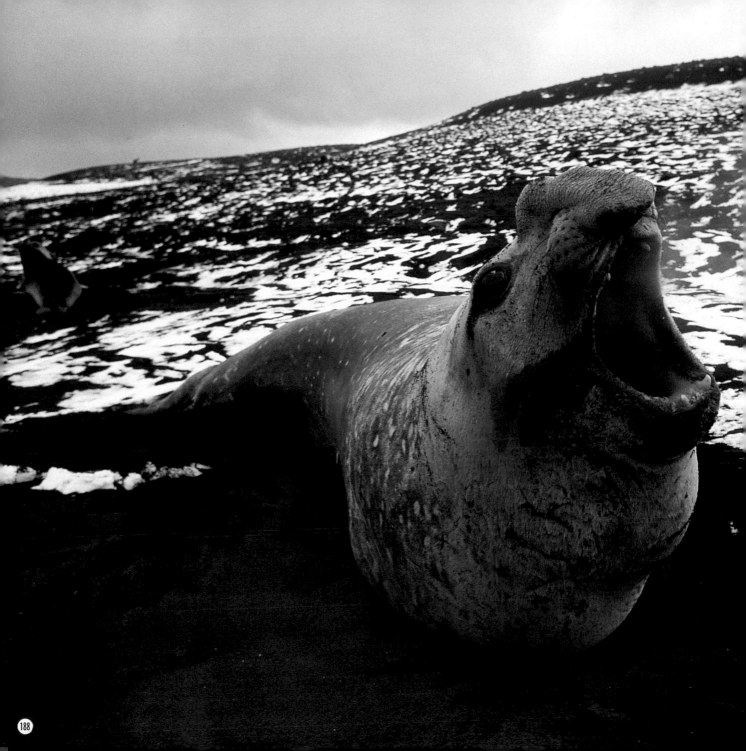

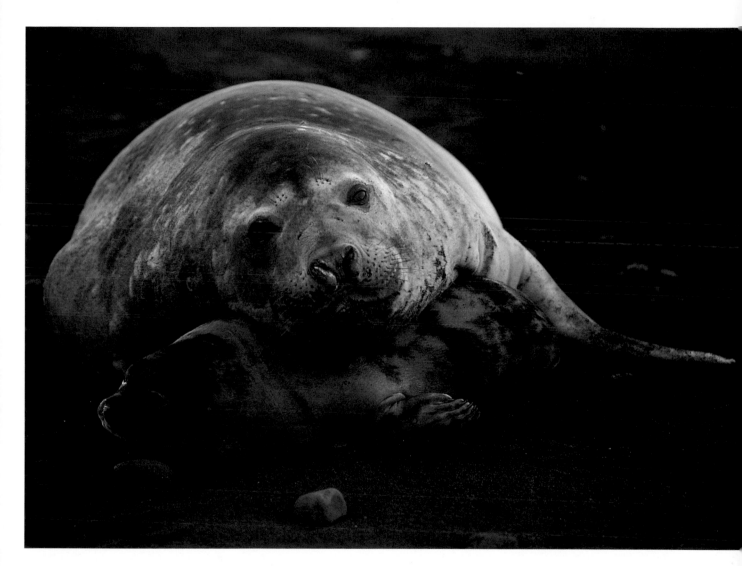

At birth, the southern elephant seal has black fur, which becomes gray as the seal grows.

left: The nose trunk of the southern elephant seal is limp most of the year, but becomes engorged during the mating season.

following page: Snow on Heard Island does not bother these macaroni penguins, which are sitting on their eggs. Their abdomens have less plumage than the rest of their bodies so that their body heat can more easily warm the eggs.

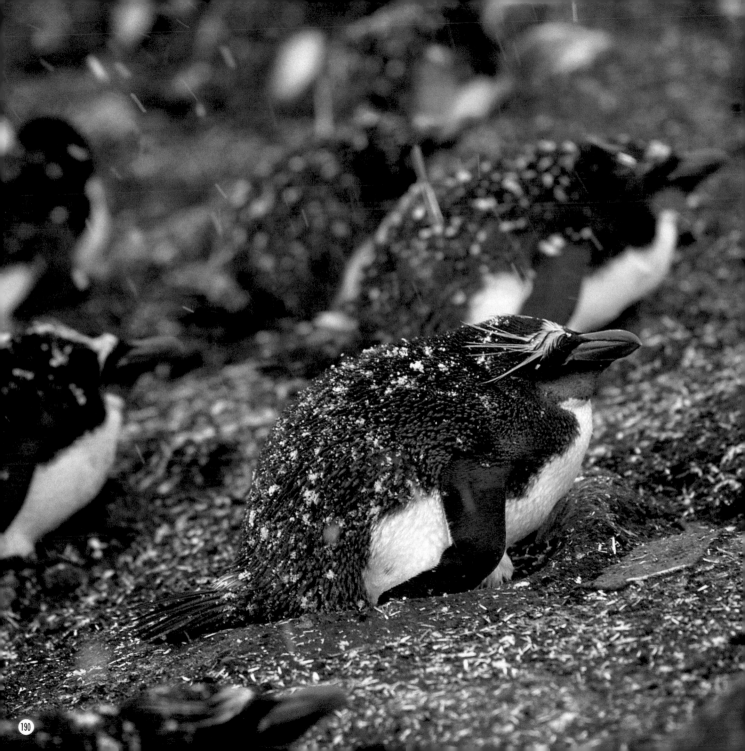

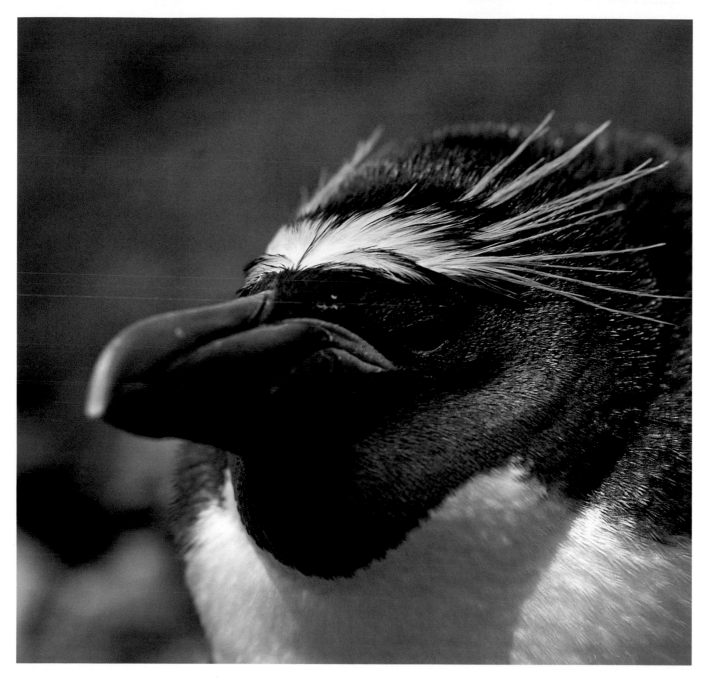

Their plumage gives these stylish macaroni penguins their name.

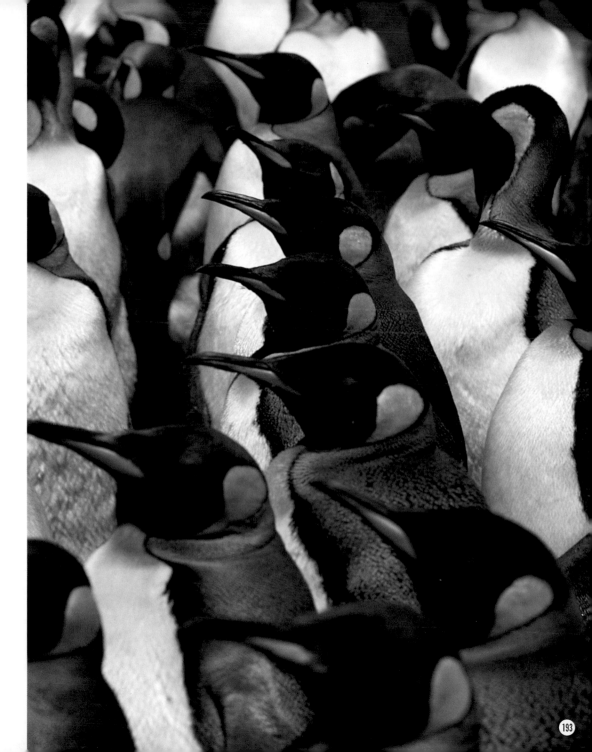

left: A king penguin rookery on Iles aux Cochons of the Crozet Islands. Here and there, the brown down of young penguins contrasts with the plumage of older birds.

King penguins live in the Antarctic and on the subantarctic islands. They grow to be nearly three feet tall, making them second only to emperor penguins in height.

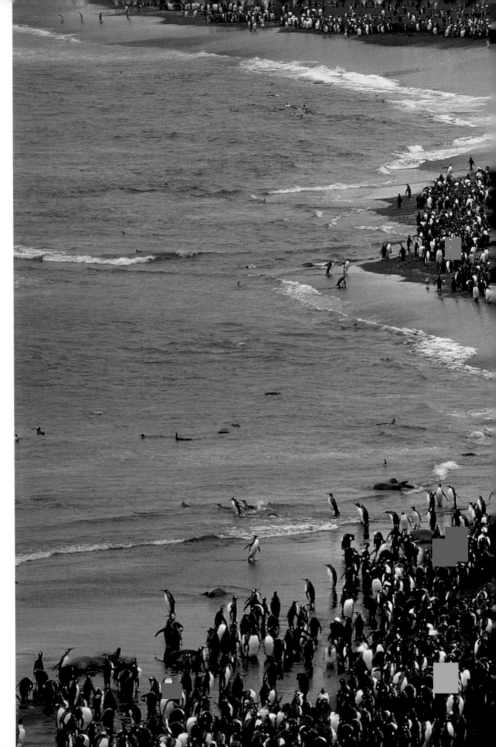

Vast colonies of king
penguins inhabit the shores
of Macauley Island.

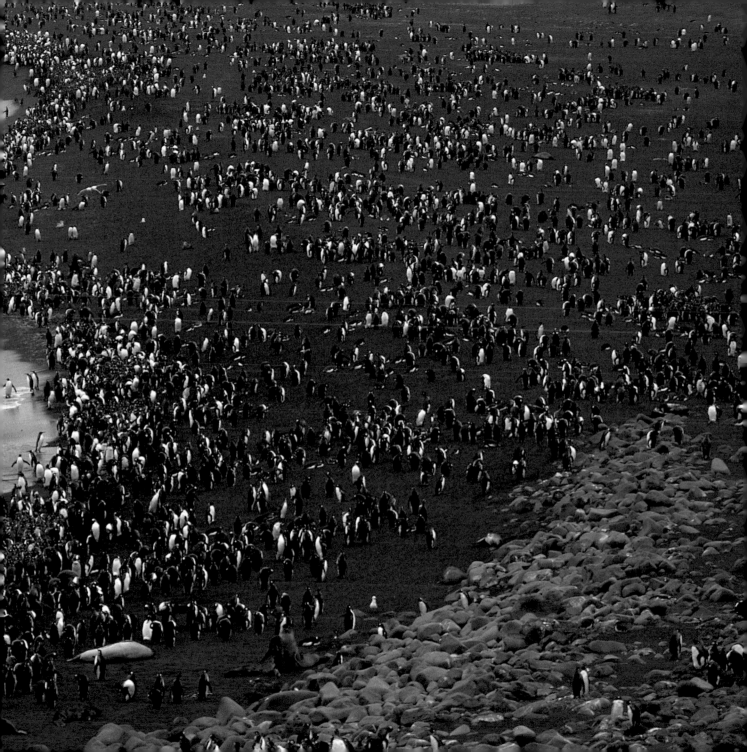

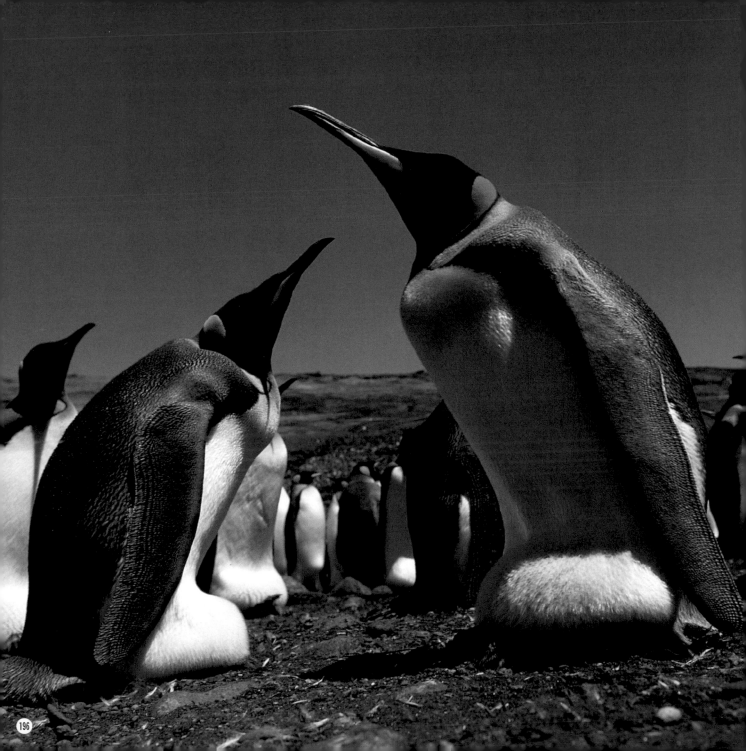

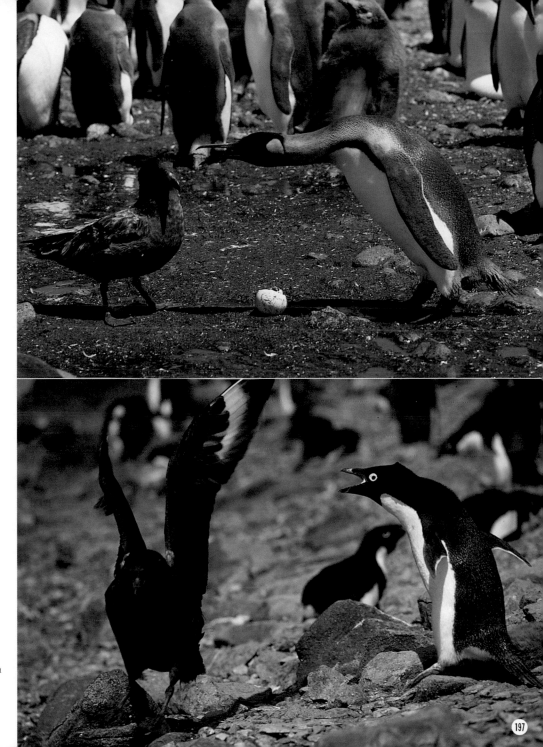

left: A fresh egg is quickly passed from the female to the male to be warmed on his feet. The egg is covered by a part of the skin called the hatching bag.

above: A great skua, known for its ability to rob other birds of their prey, threatens the egg of a king penguin.

below: A similar scene is played out between a Pomarine skua and an Adélie penguin. Baby penguins often fall prey to skuas.

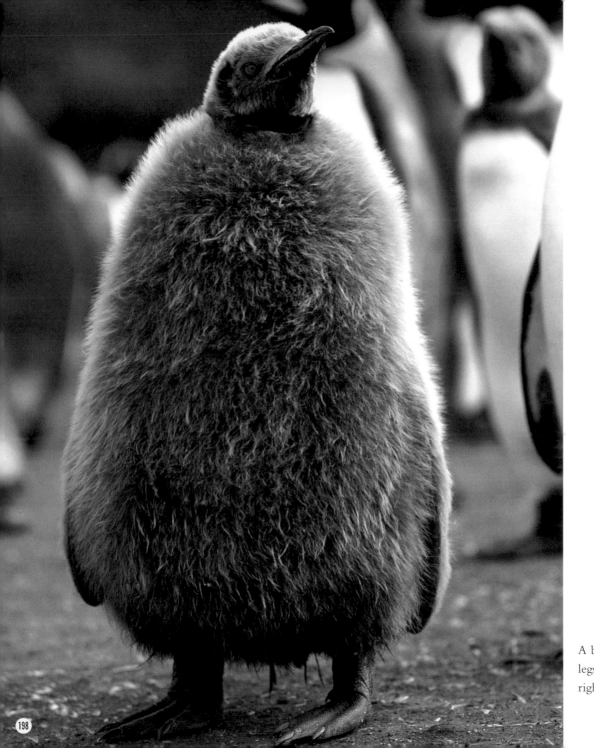

A baby king penguin has legs like a dinosaur's. The right is thicker than the left.

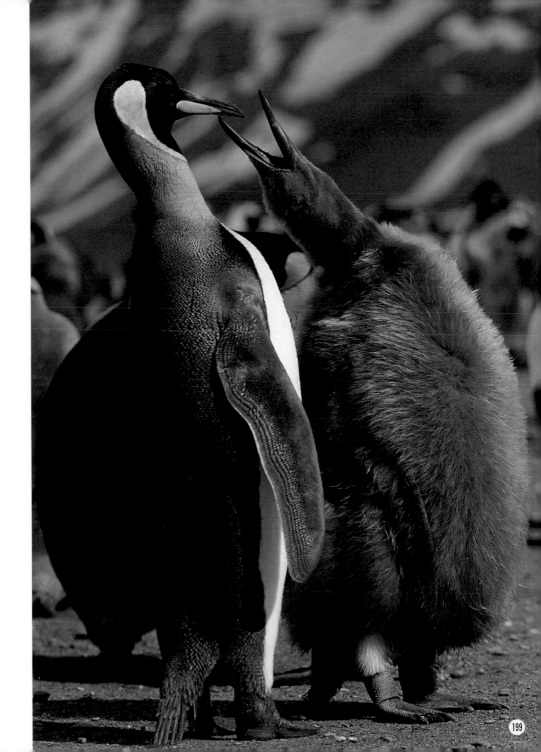

A parent penguin feeds
its baby half-digested krill
and squid.

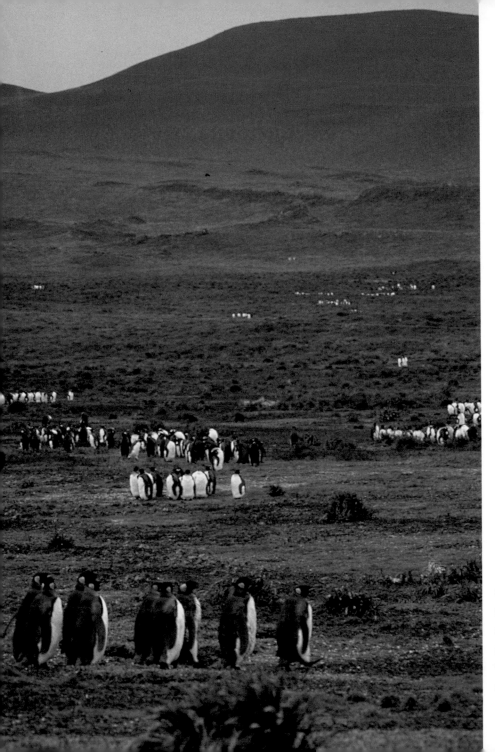

On Macauley Island, inland, where the rocky shore ends, is a gentle sloping grassland dotted with king penguins' rookeries.

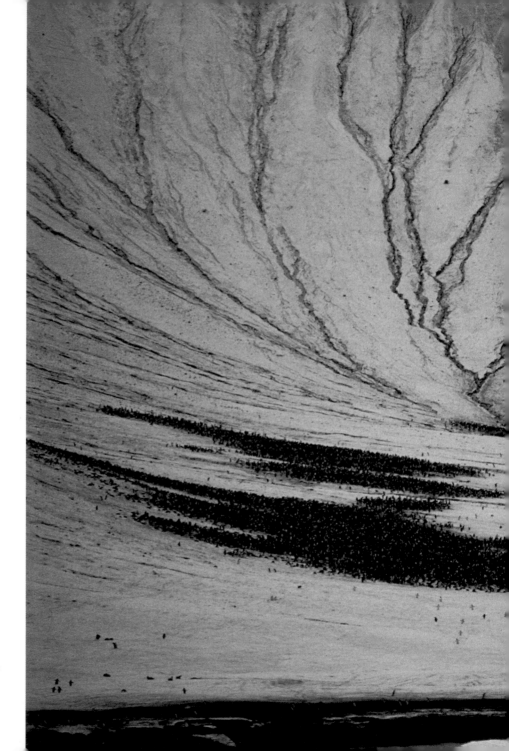

The South Sandwich
Islands are often black
with Adélie and chinstrap
penguins.

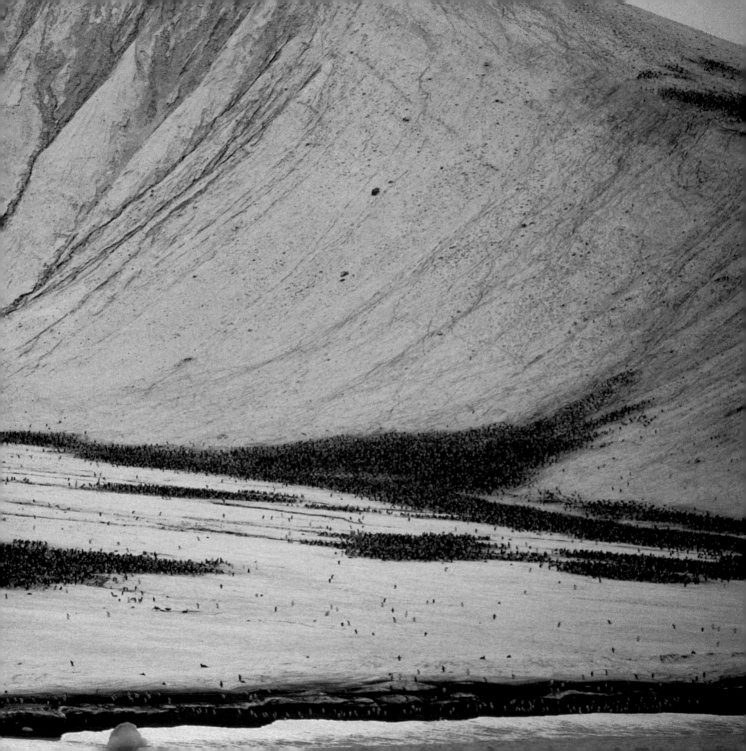

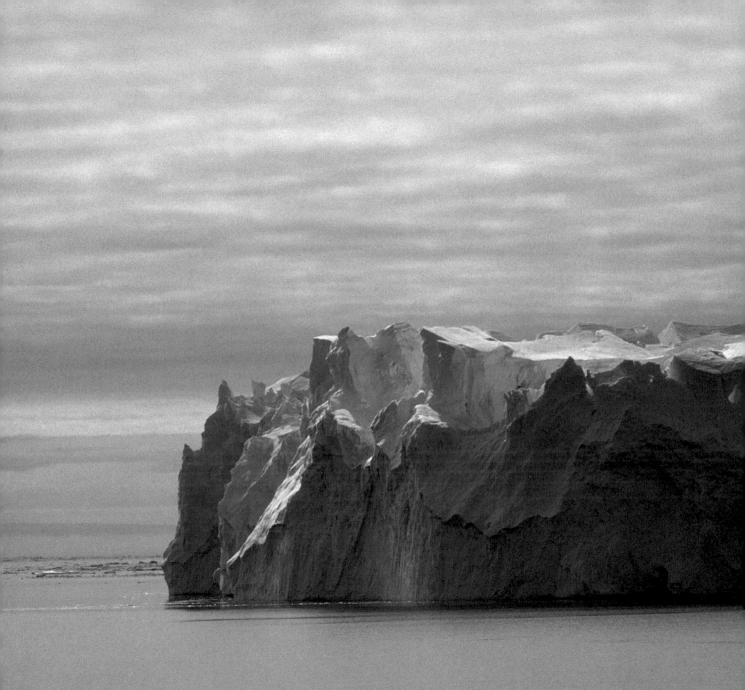

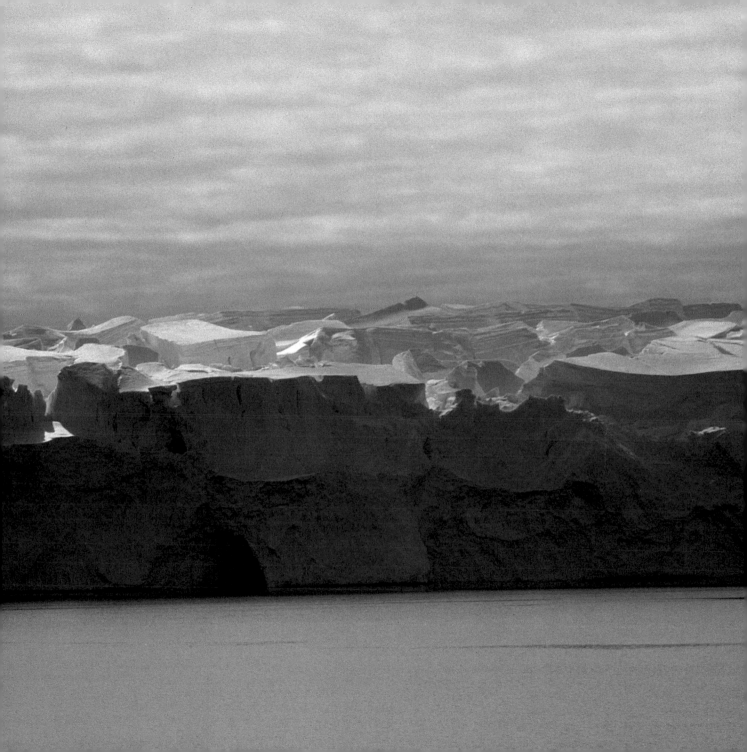

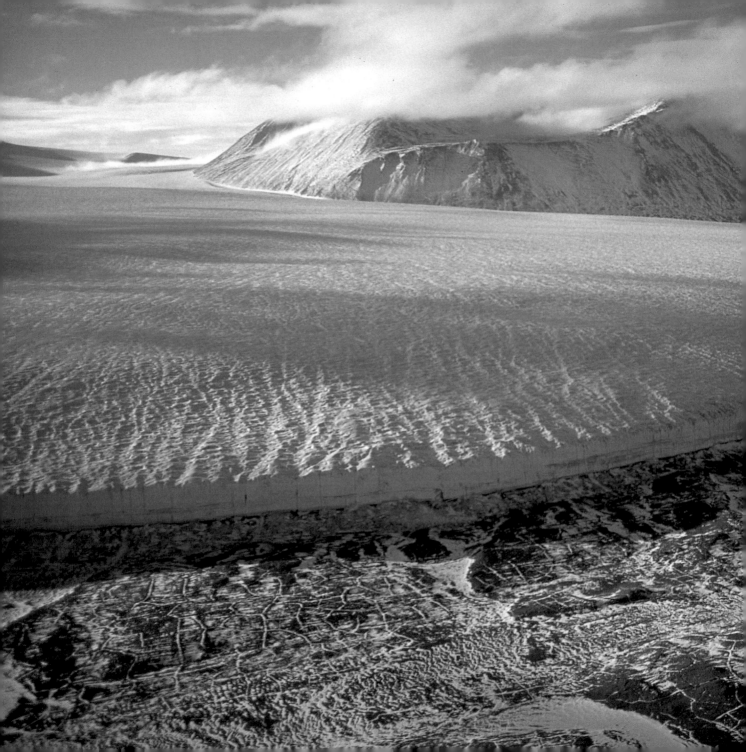

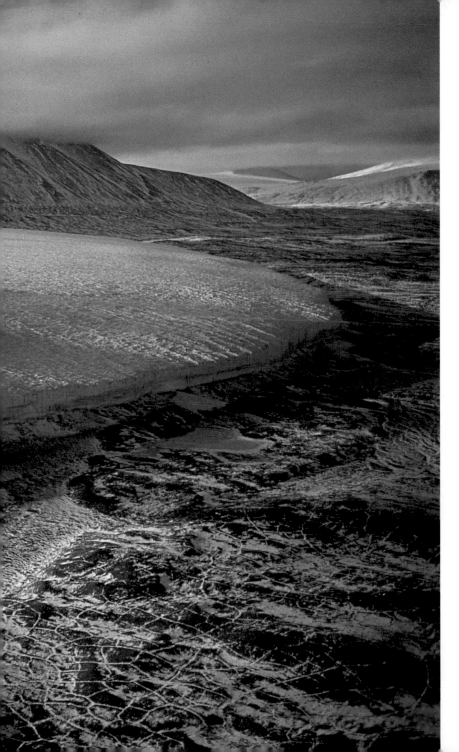

preceding pages: The snows of the Antarctic become an ice sheet, growing into the sea and eventually separating to become a huge iceberg.

The tongue of this Antarctic glacier is about 190 feet long.

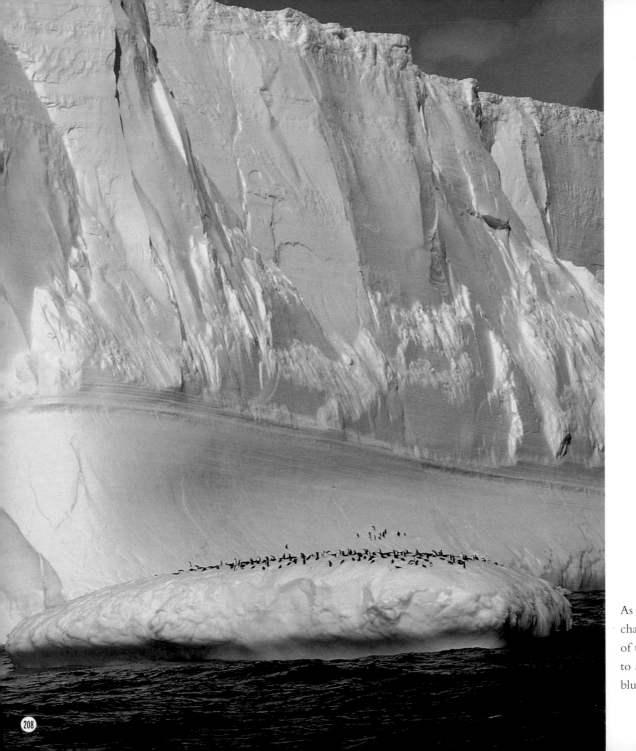

As the weather
changes, the colors
of this iceberg appear
to alter, becoming first
blue, then green.

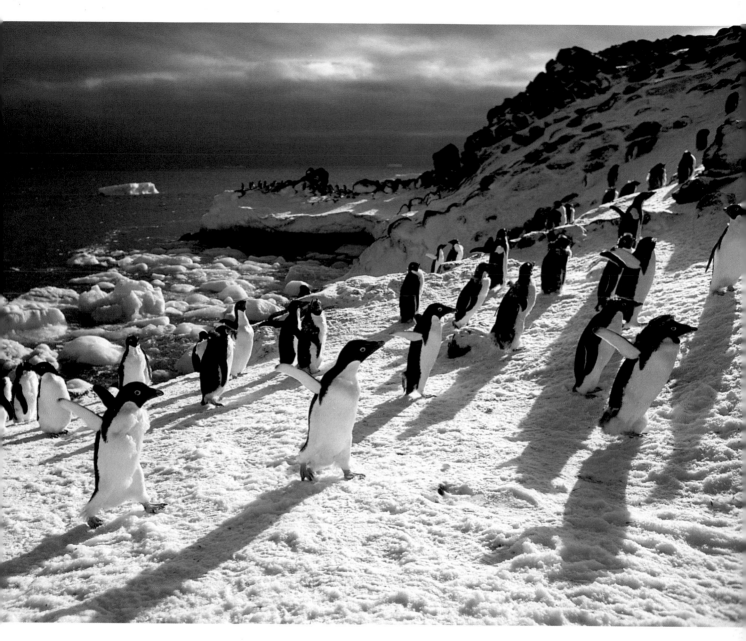

Useless for flight, the wings, or flippers, of Adélie penguins
help them to balance as they walk.

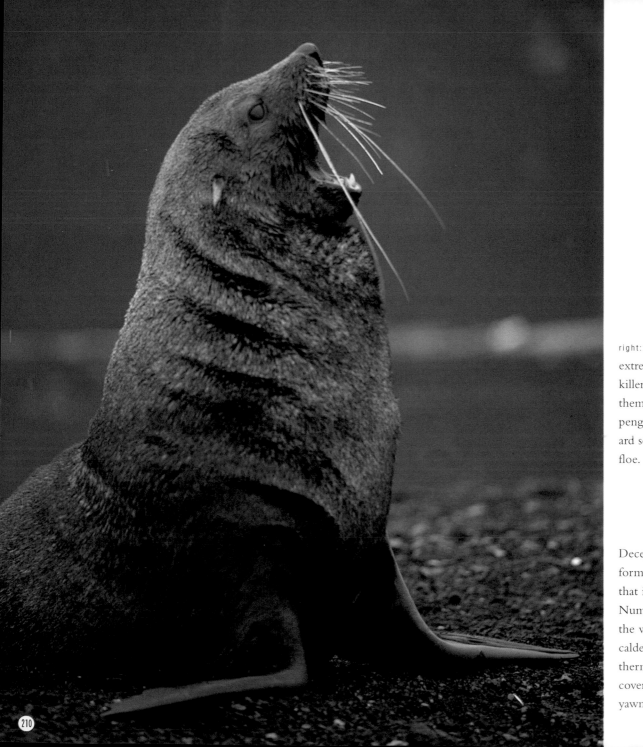

right: Leopard seals are extremely fierce—even killer whales avoid them. They often attack penguins. Here, a leopard seal rests on an ice floe.

Deception Island was formed by a volcano that is still active. Numerous vents heat the water in the caldera. Steam from the thermally heated water covers the whiskers of a yawning seal.

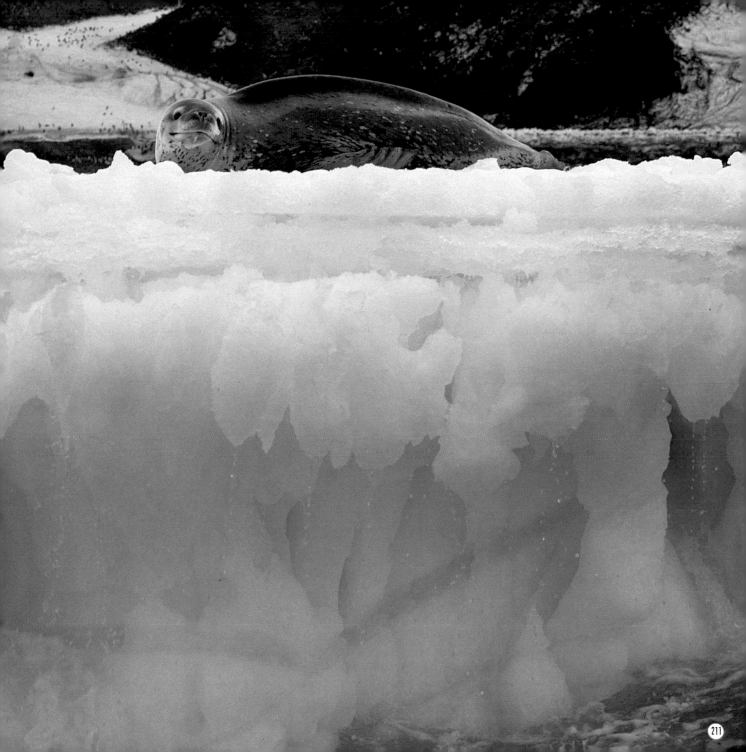

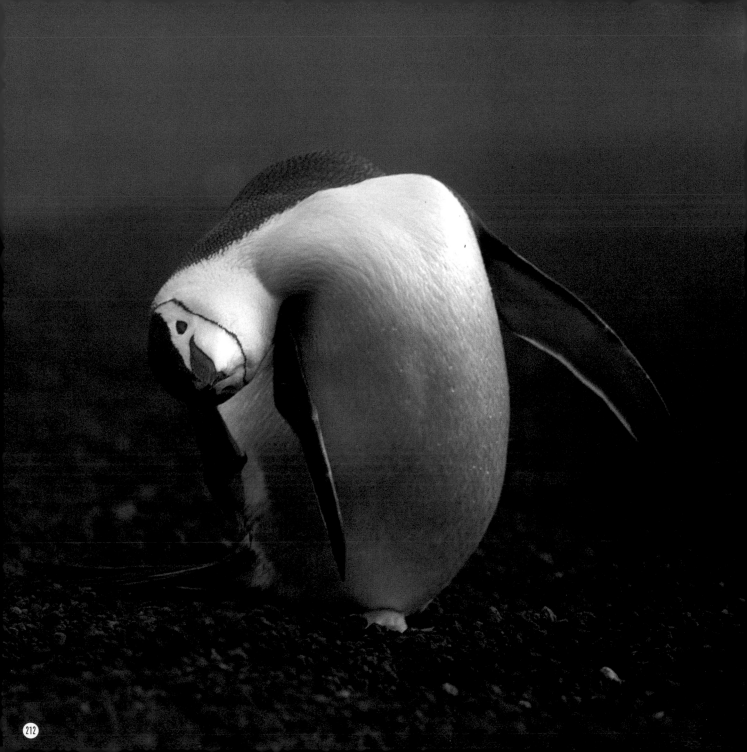

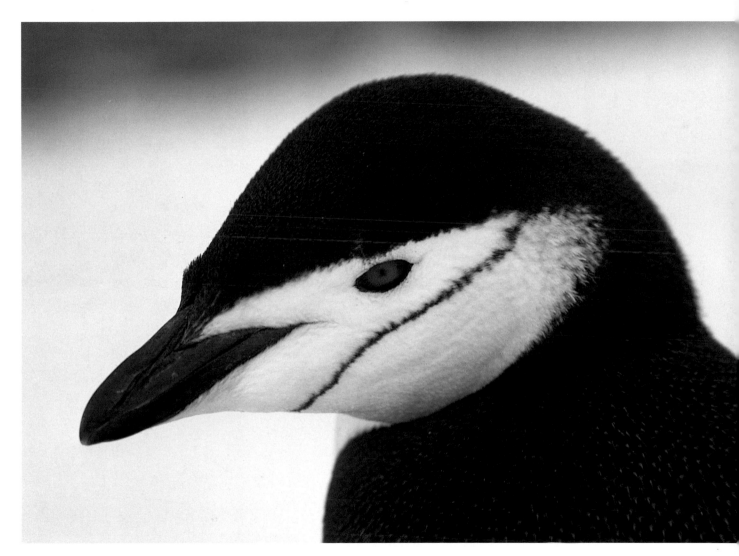

It's easy to see where chinstrap penguins get their name.

left: When spring comes to the Antarctic in mid-October, chinstrap penguins return across the ice floes to their rookeries on the Antarctic Peninsula.

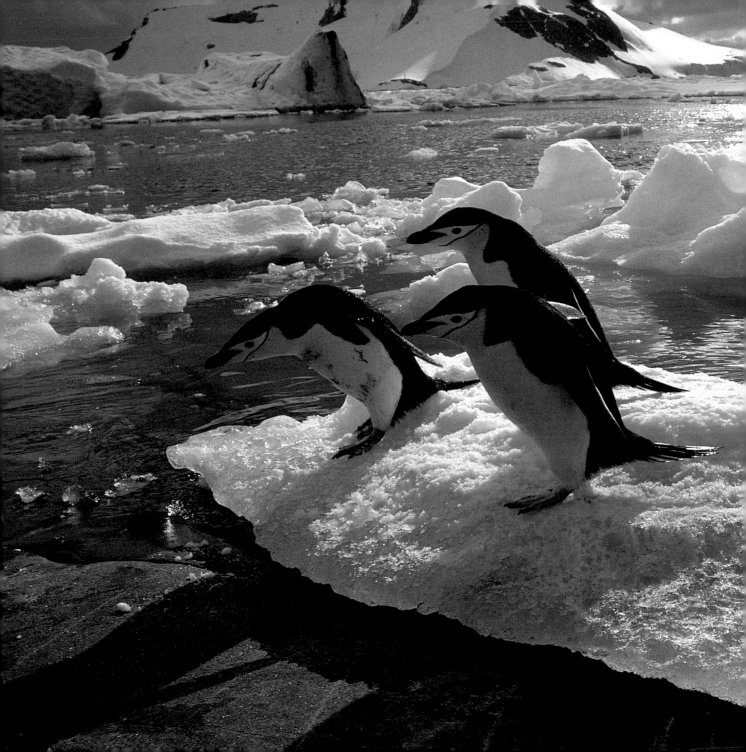

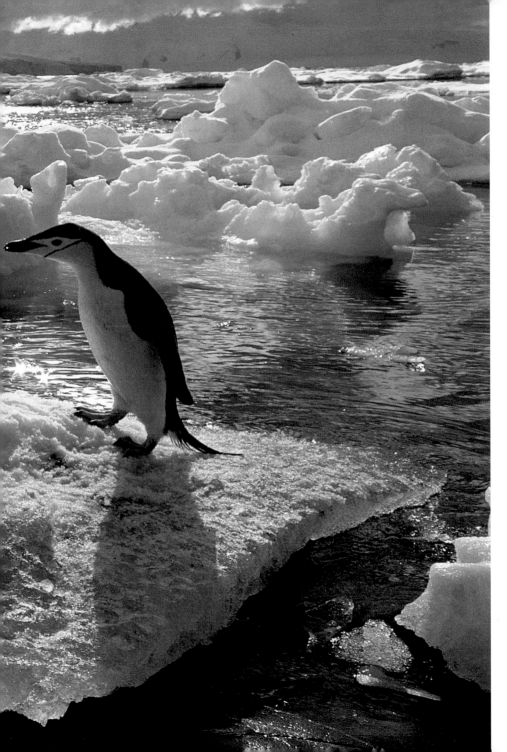

Chinstrap penguins are the fastest swimmers among penguins. These penguins prepare to plunge into the waters of Andvold Bay on the Antarctic Peninsula to hunt small fish and squid.

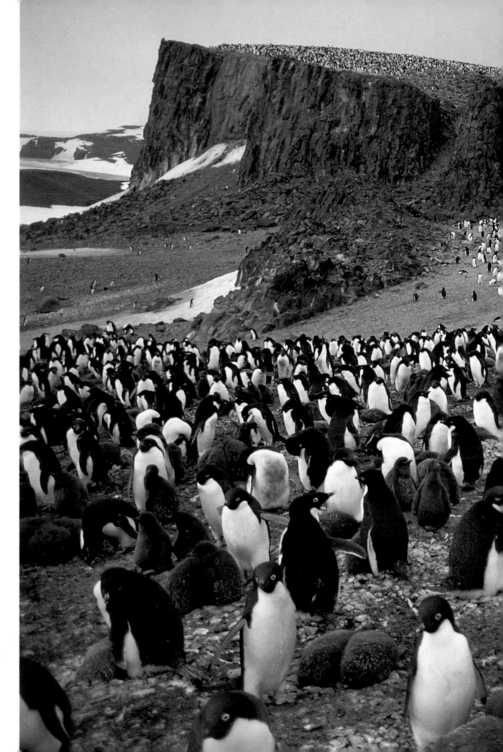

Intensely social, Adélie
penguins may live together
in rookeries of a million
birds.

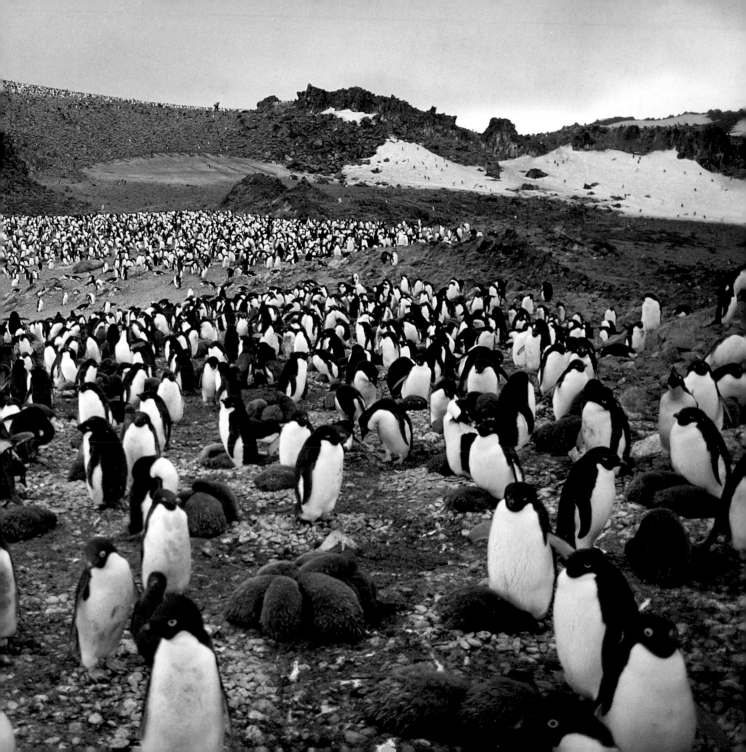

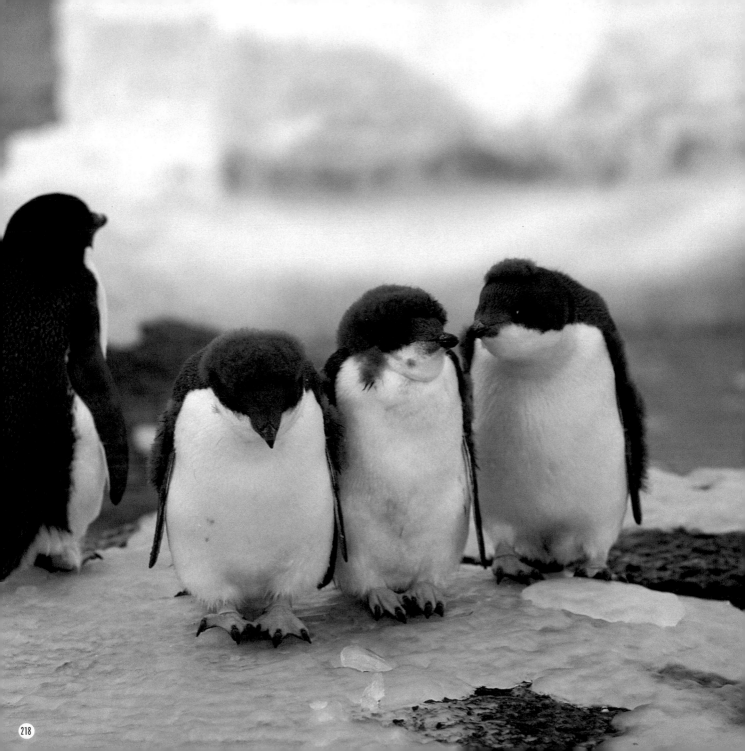

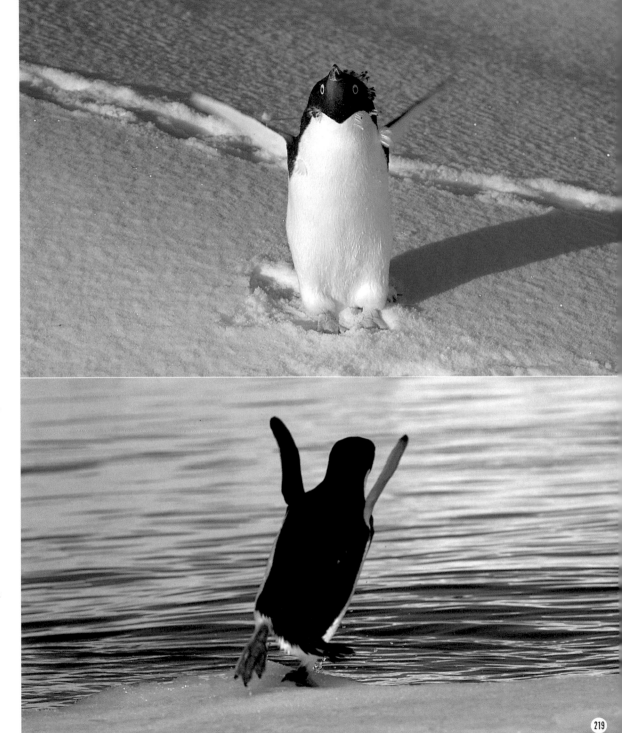

left: After shedding baby down, young penguins grow water-resistant adult plumage, allowing them to enter the sea at last.

Adult penguins also molt or shed their plumage once a year. During molting, which takes a few days, they stay almost motionless. They cannot dive into the water until they have new plumage.

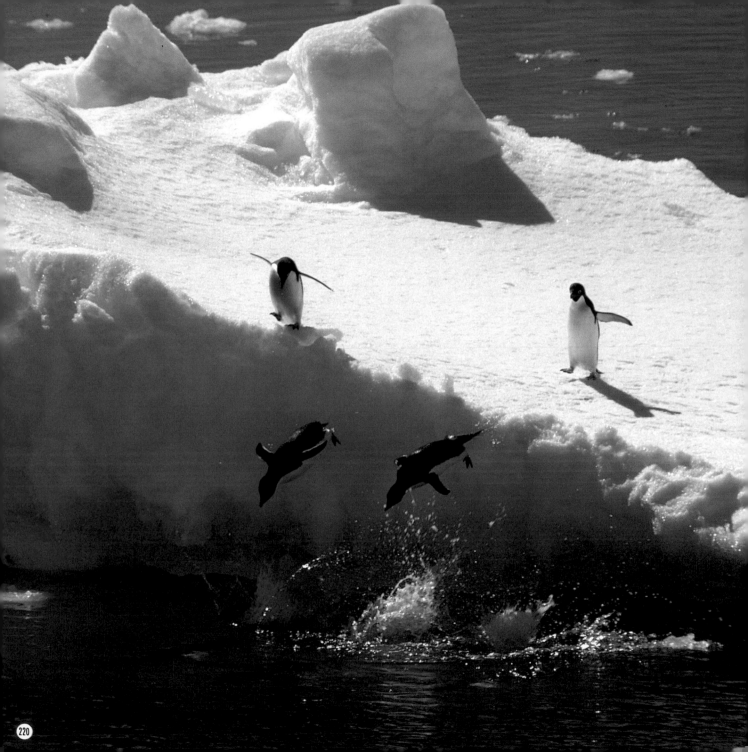

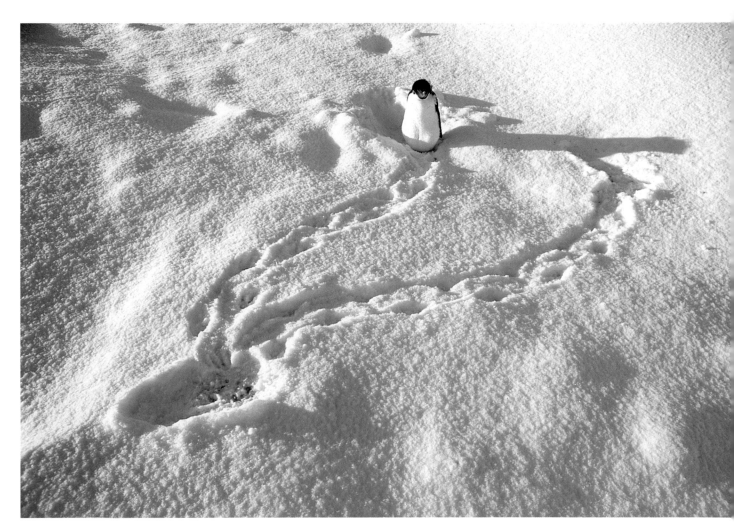

left: Penguins that live in frigid places have three-layer protection against the cold: the short, curved outer feathers overlap like roof tiles to keep water out; each feather is covered by dense down that conserves body heat; and their bodies are lined with blubber.

Although penguins look rather clumsy on land, they are actually quite mobile and adept at negotiating the ice floes.

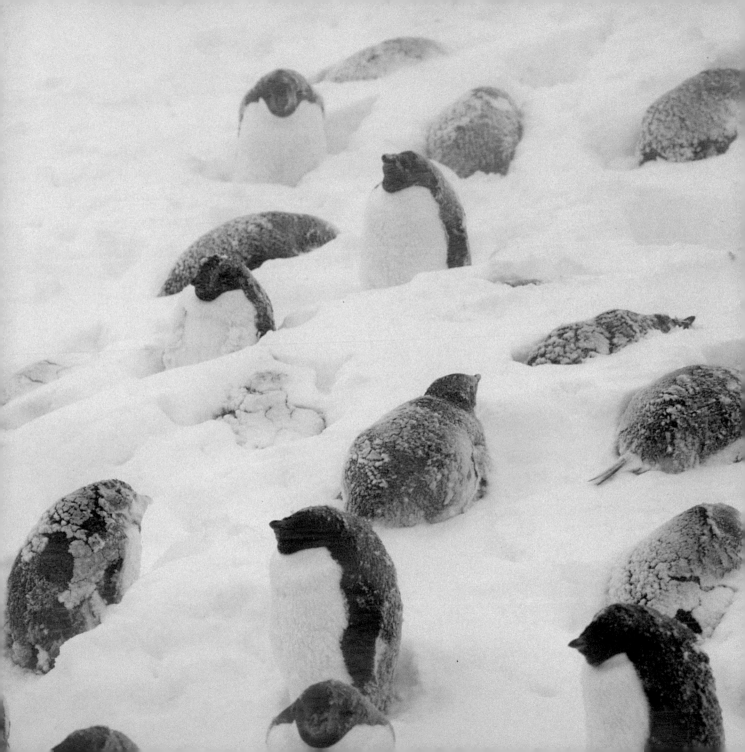

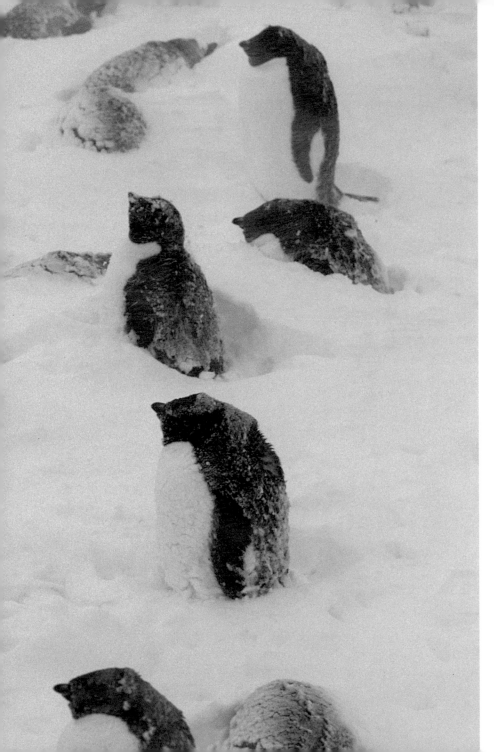

Violent blizzards may last for days. Some penguins, though well insulated, are not strong enough to survive.

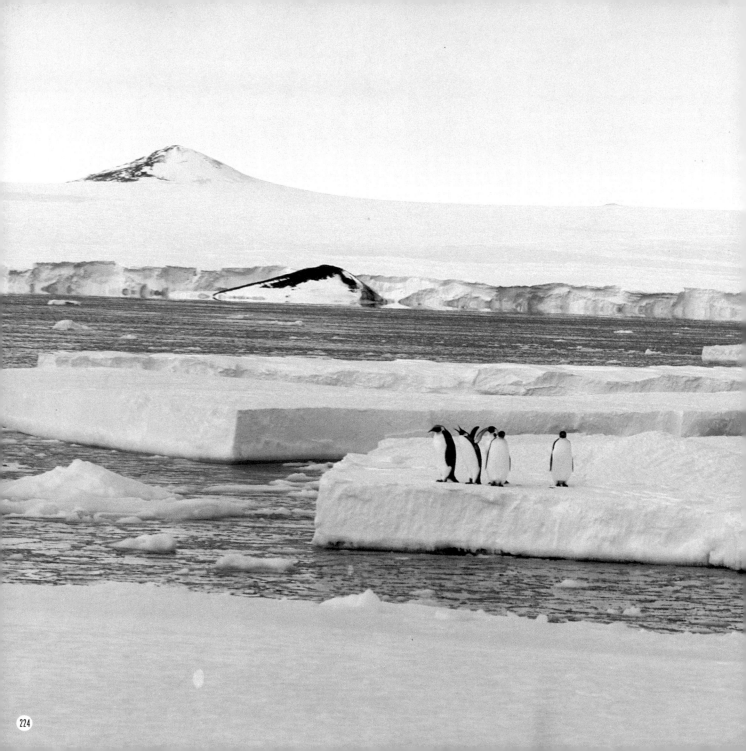

left: Emperor penguins are the only birds that breed during the winter in the Antarctic. At the end of summer, near Mount Erebus, several of them rested.

A male emperor penguin holds a newly laid egg on its feet for two months without eating or drinking. When the egg hatches, the female returns and both parents care for the chick.

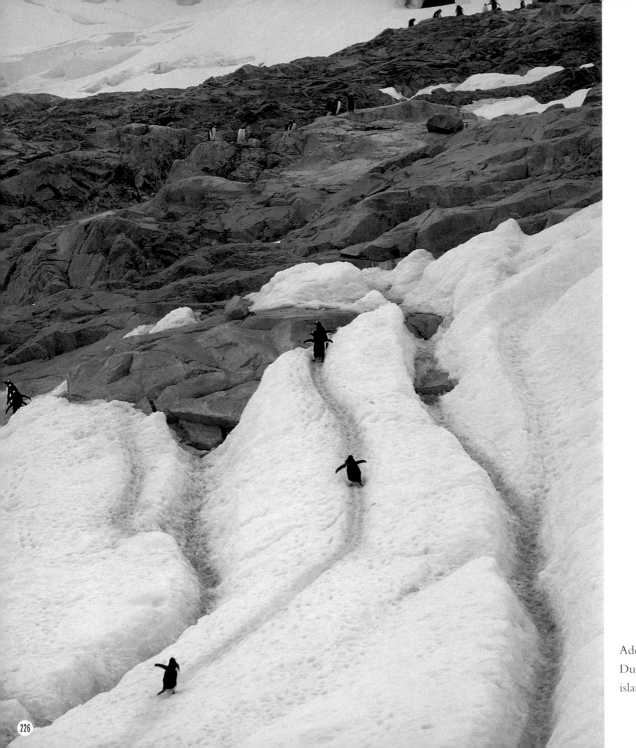

Adélie penguins on
Dumont d'Urville
island.

At midnight, the sun sets. The light makes it look warm, but, in reality, it is very cold.

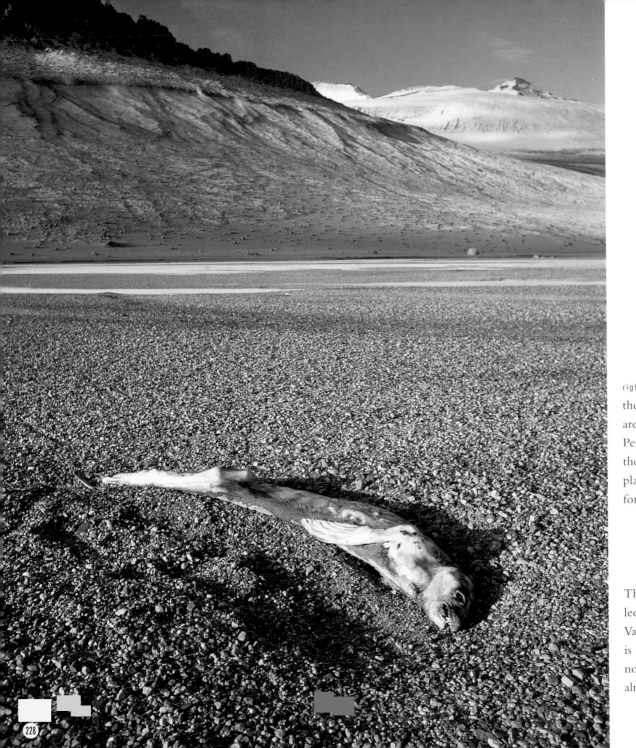

right: Dry Valley is the largest iceless area on the Antarctic Peninsula. It is also the most convenient place in the Antarctic for research.

The carcass of a leopard seal in Dry Valley. Because there is no water, there is no ice. The cold is almost unbearable.

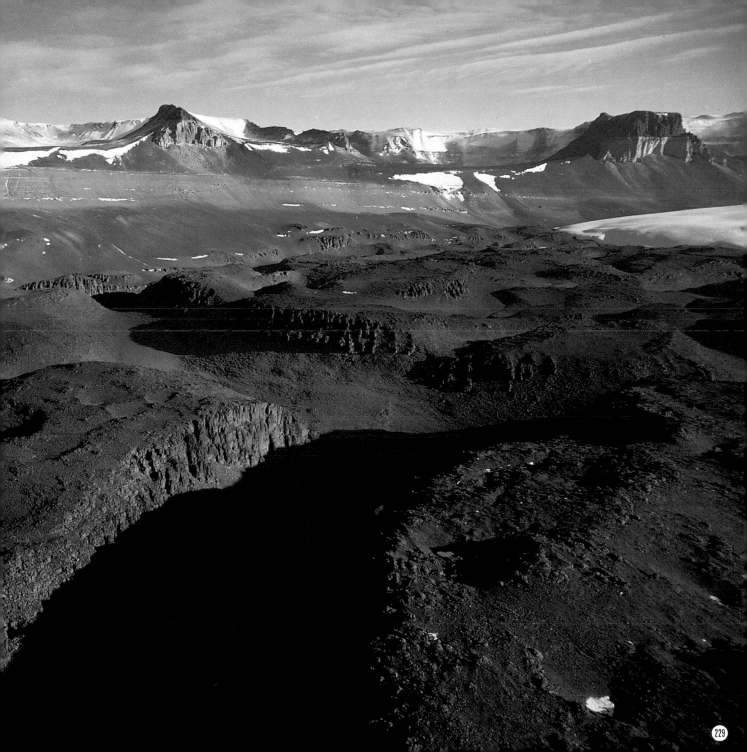

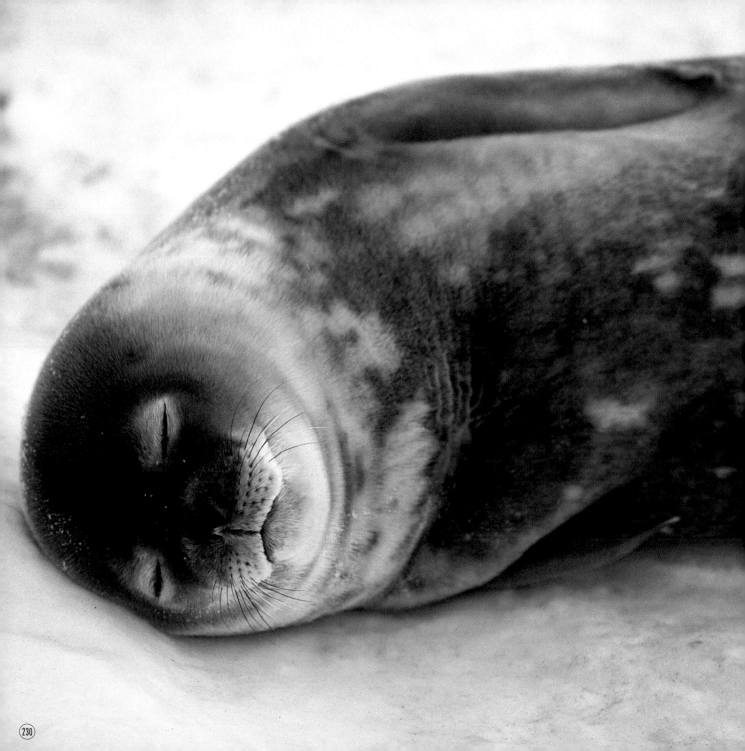

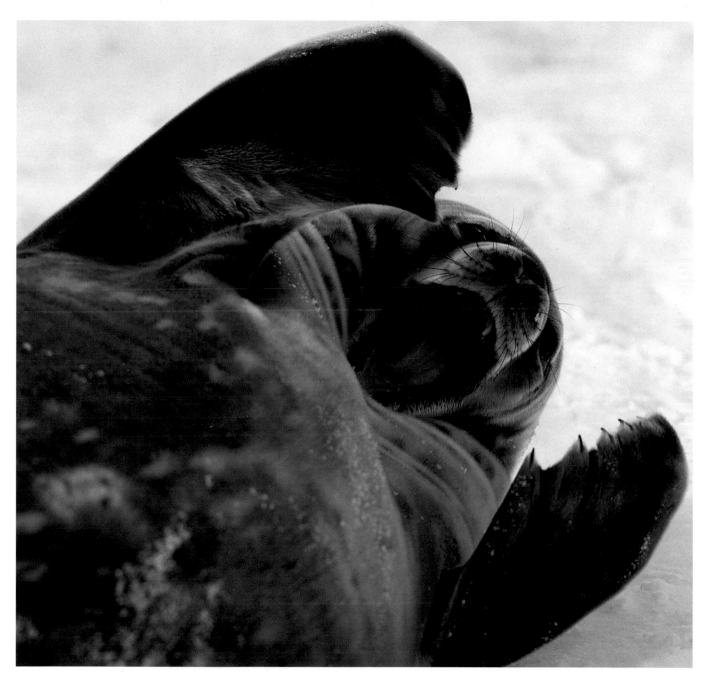

opposite: Weddell seals breed on the permanent ice of the Antarctic Peninsula. This one was on Ross Island.

Weddell seals' teeth are pointy and well suited for making holes in the ice through which the seals enter the sea to catch fish and krill.

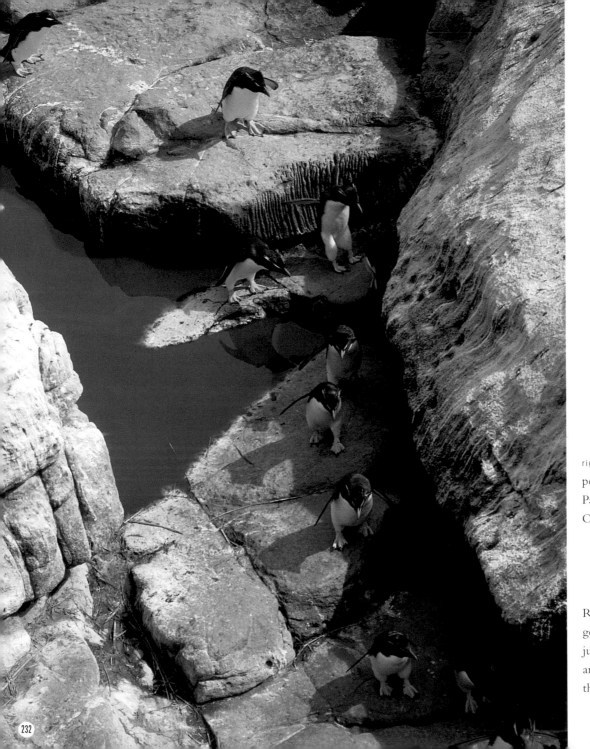

right: These rock-hopper penguins live on Saint Paul Island in the Indian Ocean.

Rock-hopper penguins are good walkers. They have just returned from the sea and are walking back to their rookery.

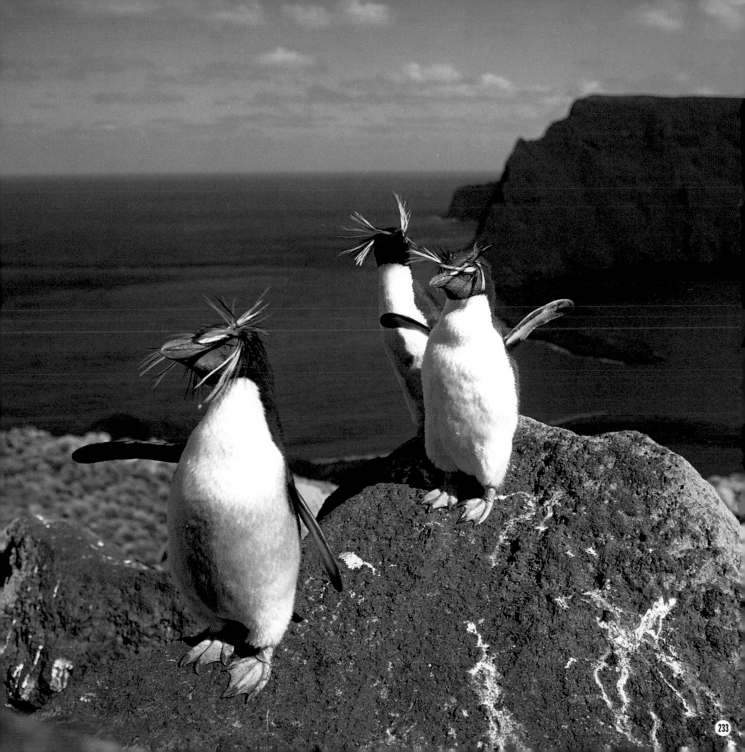

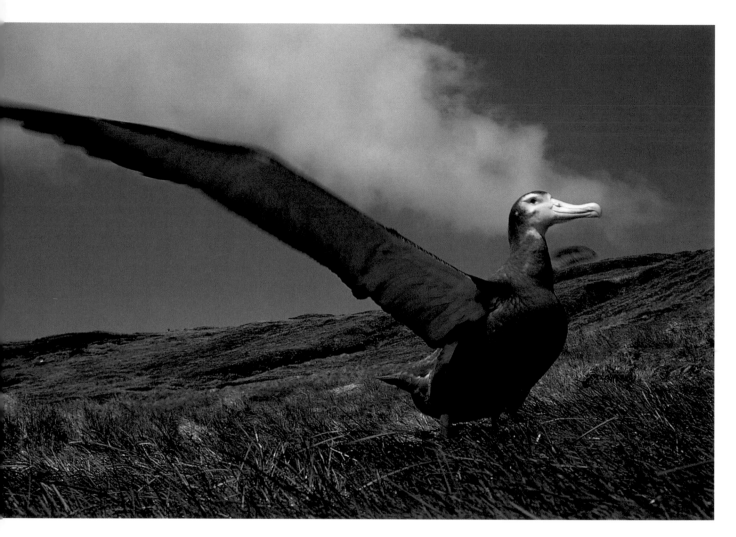

The wandering albatross comes on land only to breed.

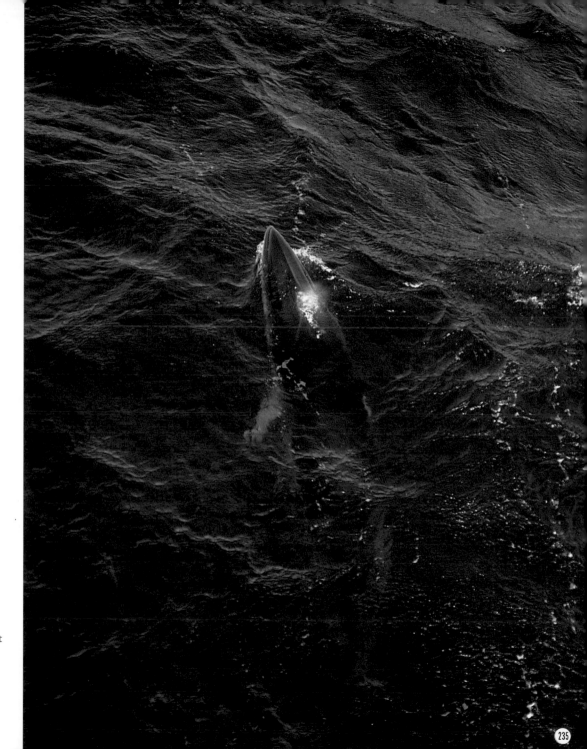

Minke whales, the smallest baleen whales, feed on krill in the waters of the Antarctic.

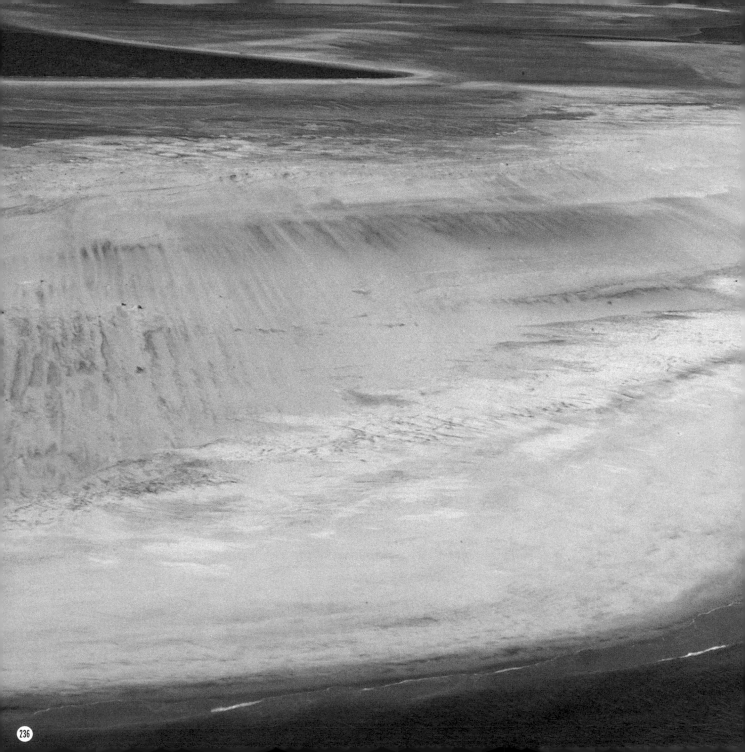

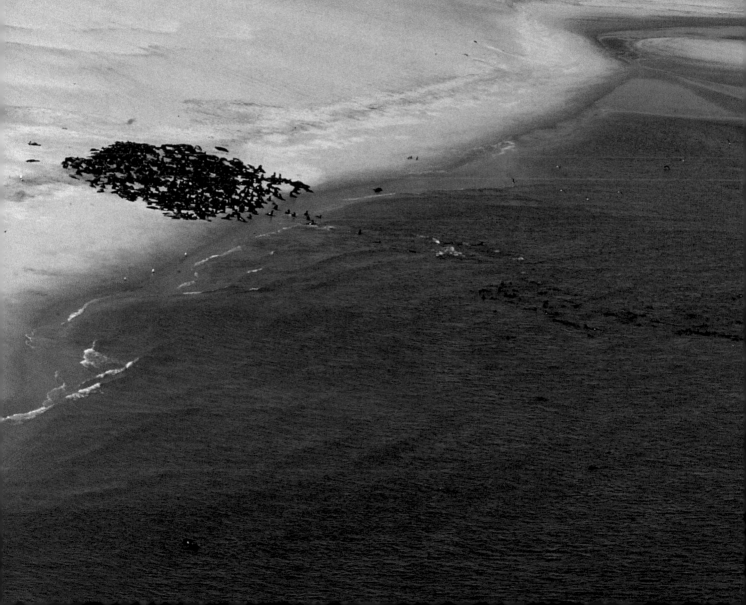

AFRICA

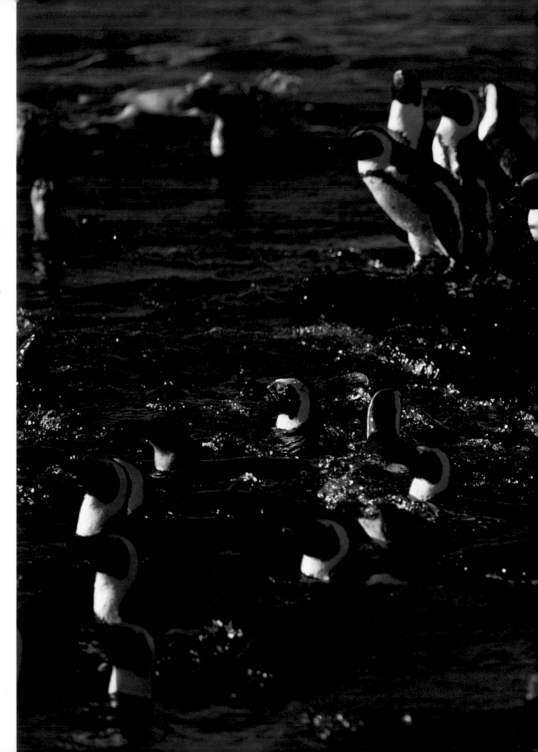

ITS TRACKLESS DESERTS AND tropical heat have protected Africa from extensive development. And while it's true that Africa has serious problems such as desertification, poverty, and exploding populations, the extensive national parks in the eastern and southern countries have become places where large-sized mammals can live in safety. In the savanna that stretches over Tanzania and Kenya, huge herds of wildebeests and zebras migrate for hundreds of miles to feed on the grass that grows during the rainy season. The drama of life unfolds in Africa.

preceding pages: Cape fur seals enjoy the sandy beach of Cape Cross, South Africa. They do not need to migrate, thanks to the rich sea life of this region.

Jackass penguins live in the coastal areas of South Africa. This colony is on an island off Halifax.

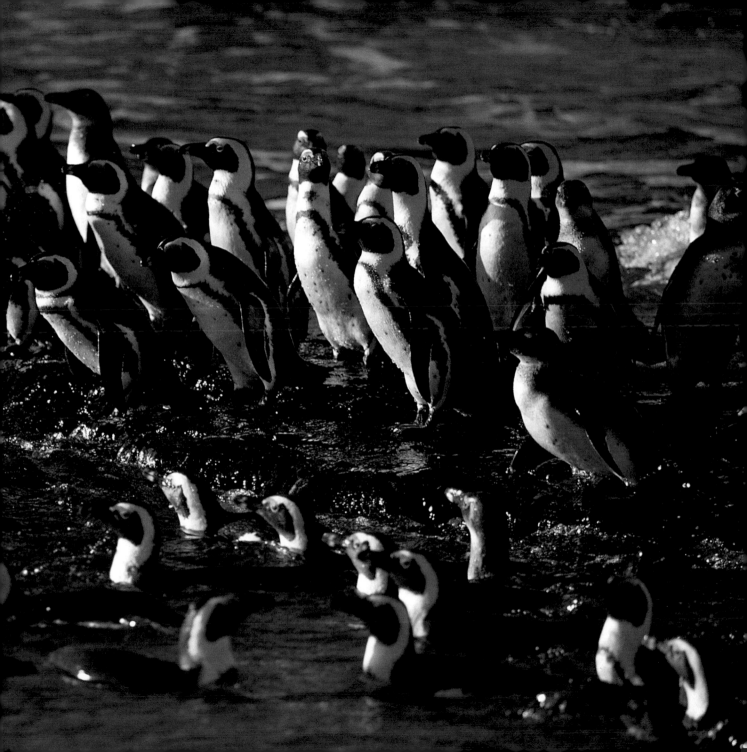

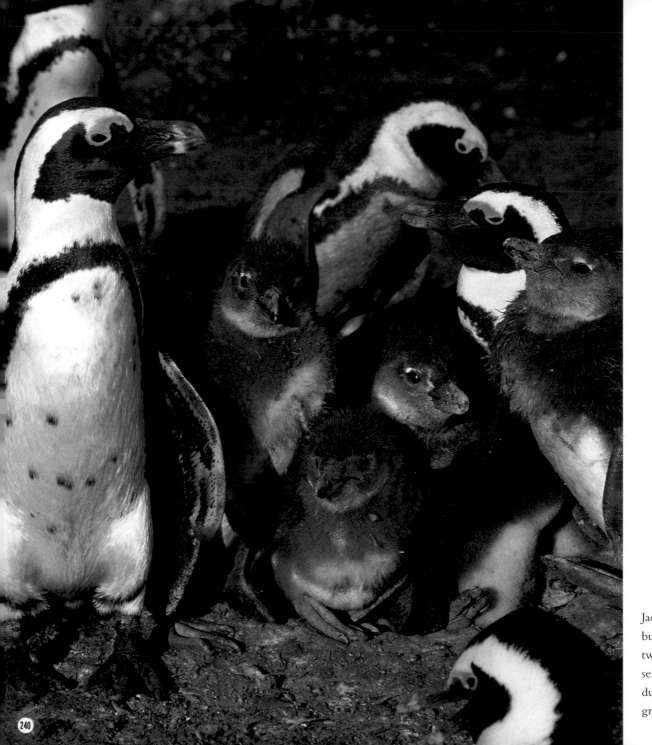

Jackass penguins build nests of twigs, grass, and seaweed in holes dug in rocky ground.

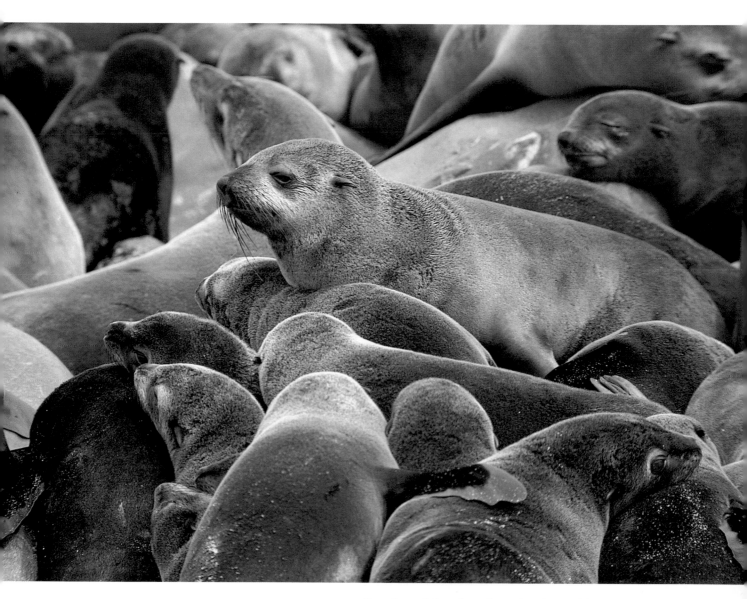

Cape fur seals breed on the rocky places of the Cape. They must stay alert, because sea gulls and jackals will prey on baby seals.

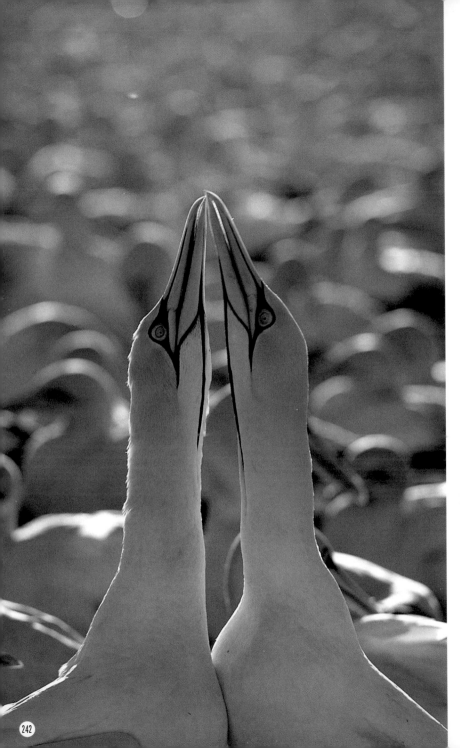

right: Cape gannets breed
on a steep cliff in Lambert's
Bay, South Africa.

Cape gannets display in
highly exaggerated
movements. This pair
repeatedly raise their beaks
as if to confirm their love
for each other.

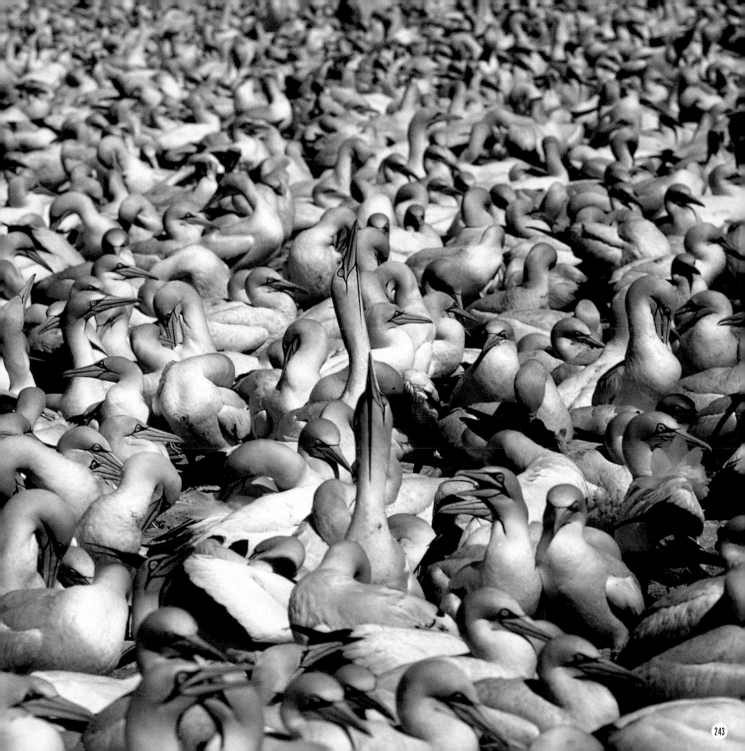

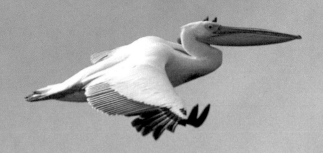
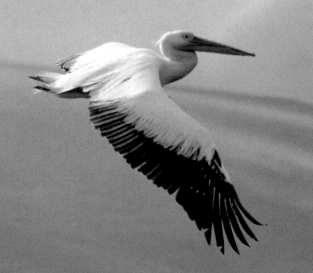

left: A couple of white pelicans in flight over Sandwich Harbor, an oasis in the desert.

In Sandwich Harbor, where the desert meets the shallow sea, fresh water seeps out of the sand. The harbor is favored by flamingos, pelicans, herons, plovers, and many kinds of seabirds.

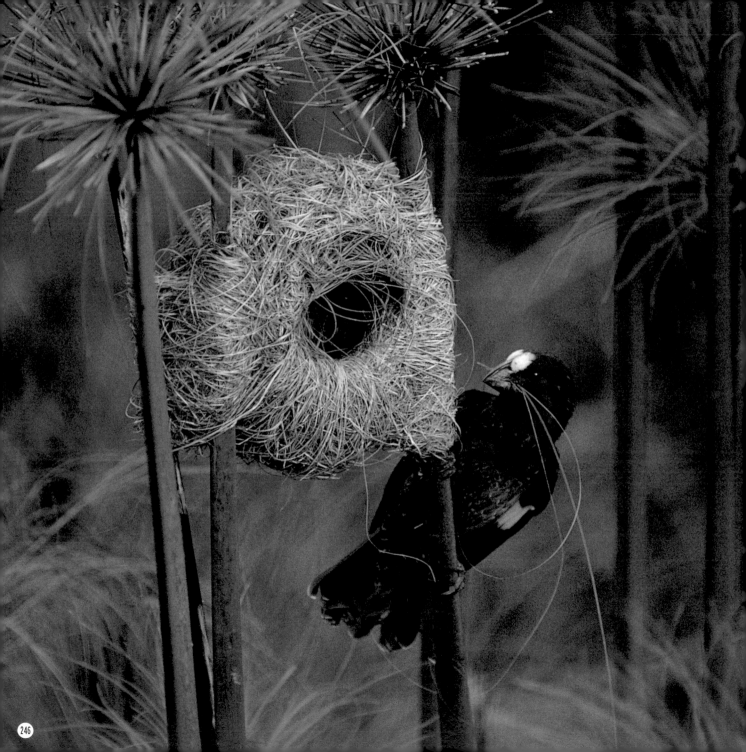

left: A typical domed nest constructed by a male grosbeak weaver on a papyrus stalk in the swamp of Saint Lucia. A female will destroy the nest if she doesn't like its looks, despite the male's several days of hard labor.

Red-headed weavers live in the interior of Botswana and build their circular nests with twigs.

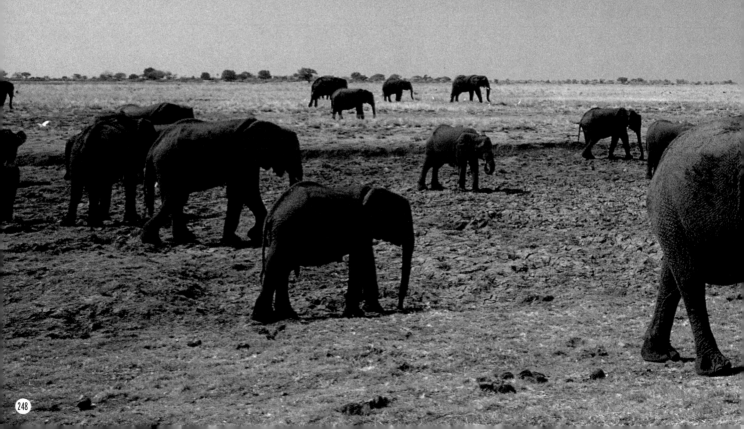

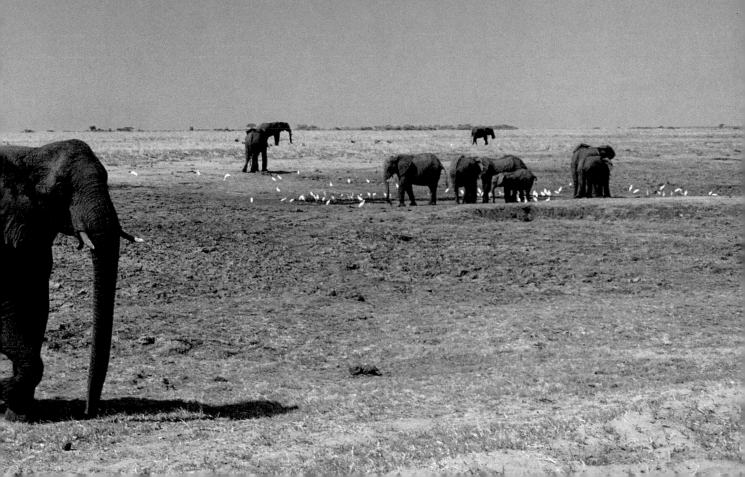

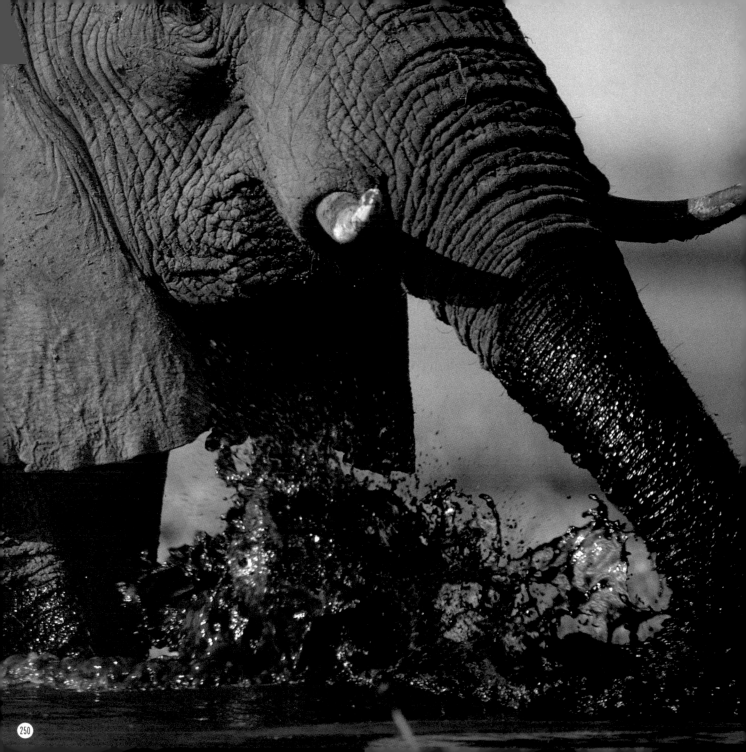

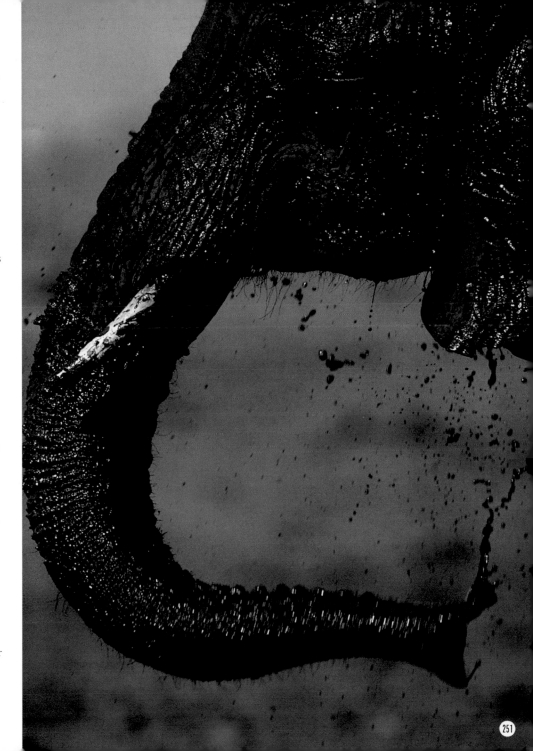

preceding pages: At the end of the dry season, a herd of African elephants comes to the river for water in Sabuchi, Chobe National Park, Botswana. They are now on their way back to the forest. Cattle egrets are in the distance.

left: On the Chobe River, elephants take a mud bath. Because their skin is very sensitive, elephants spend long hours daubing their bodies with mud or spraying dirt over themselves.

The elephant's trunk is used to drink water, gather food, control the young, and even apply the mud.

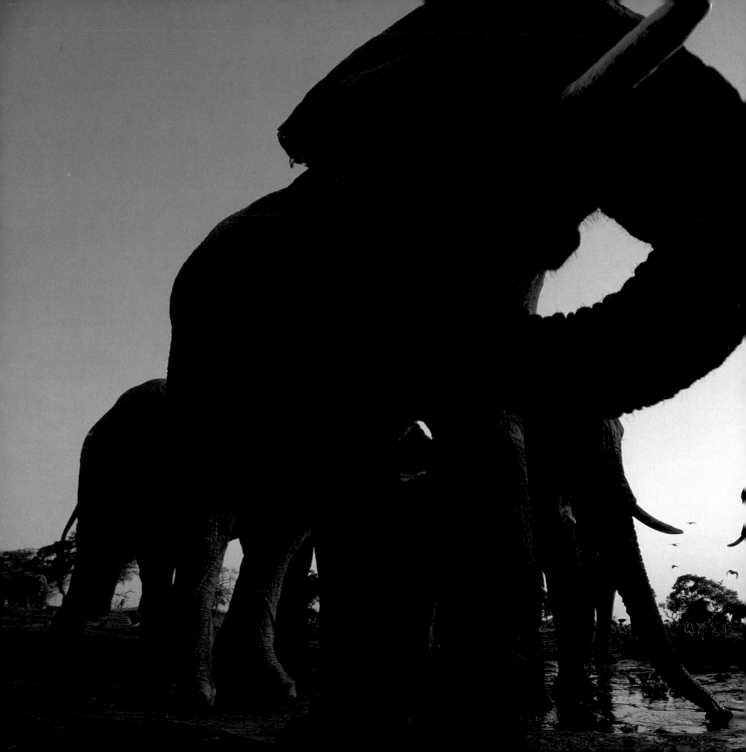

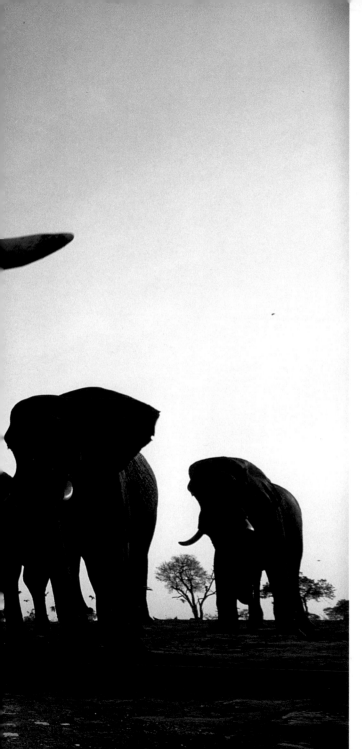

An elephant may drink
thirty to fifty gallons of
water a day. During the
dry season, the search for
water is difficult.

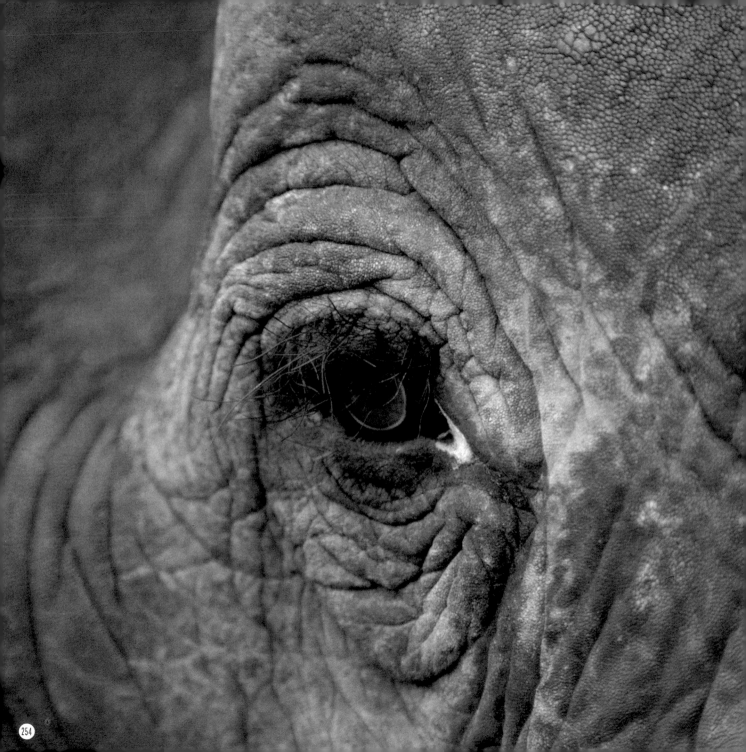

left: Elephants are the biggest land animals. Males may weigh up to 6.6 tons. Their small eyes provide adequate, not excellent, vision.

Following a hard rain, the temperature drops suddenly. Elephants pour warm sand on themselves, probably to keep warm.

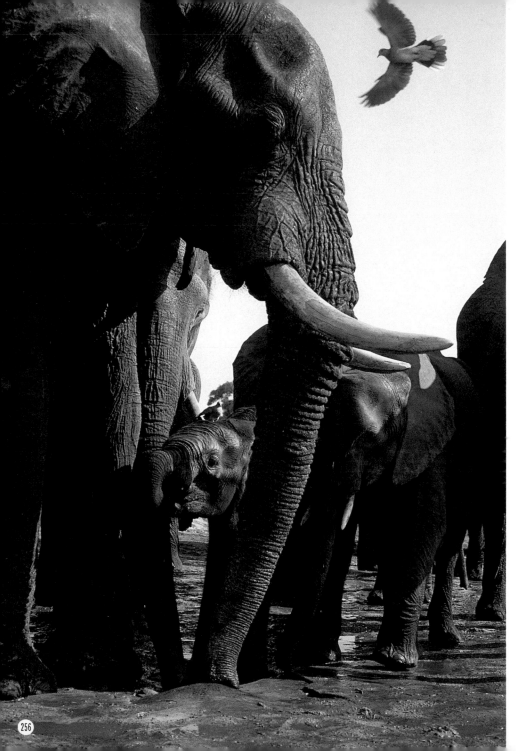

right: A young elephant is excitedly getting his body muddy.

In the midst of adult elephants, a very young elephant is trying to drink water. The young must compete even with their parents for water, but in a drought, a mother will regurgitate water to cool her calf.

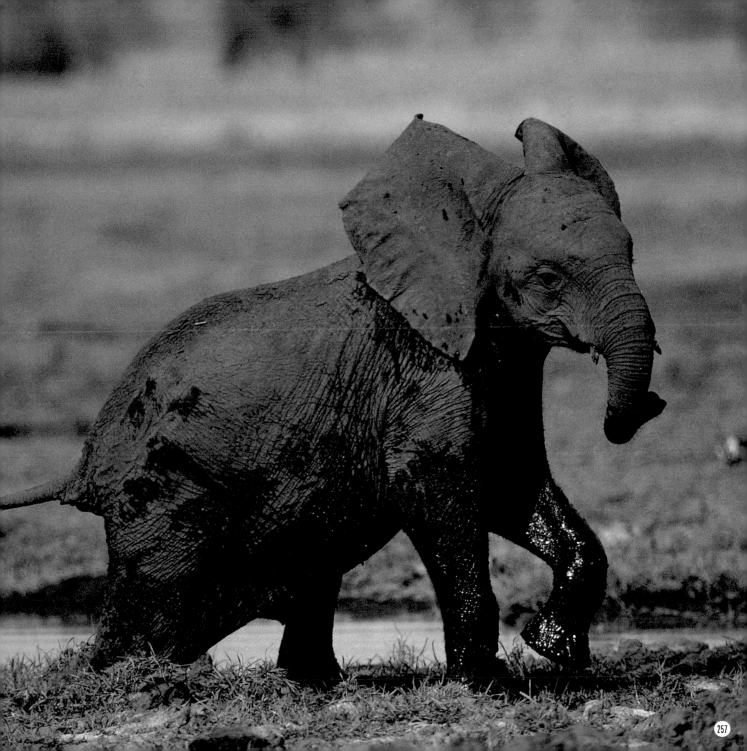

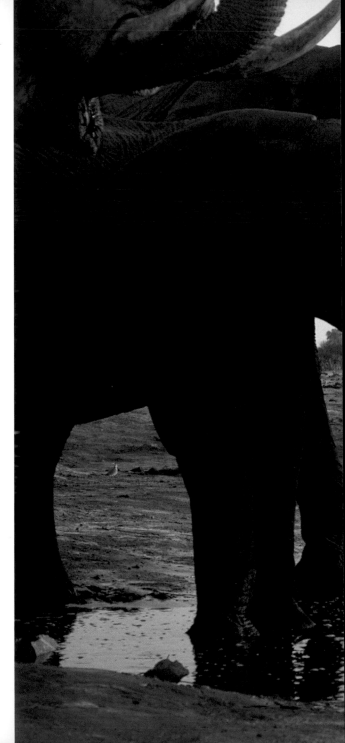

Keeping a wary eye on the elephants, impalas share the water hole with their large neighbors.

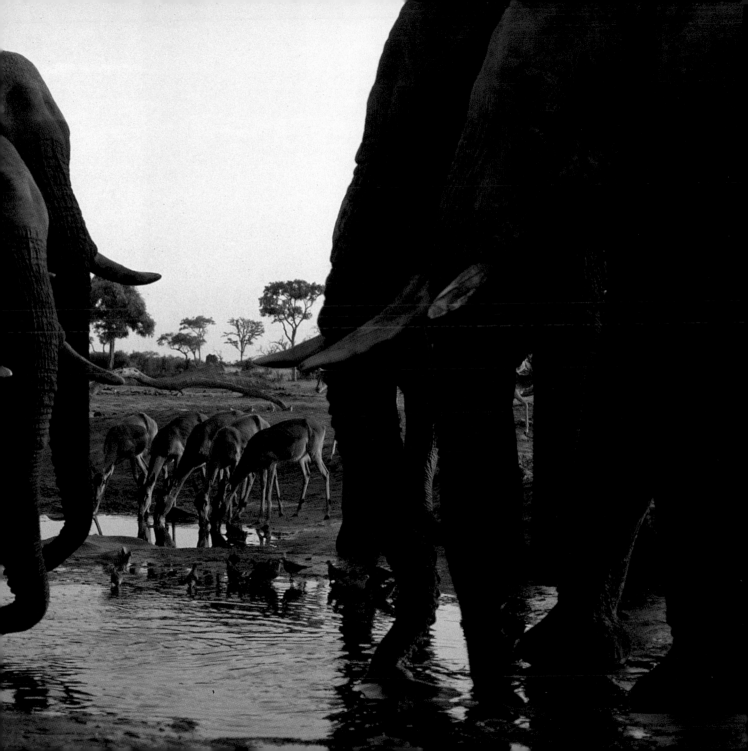

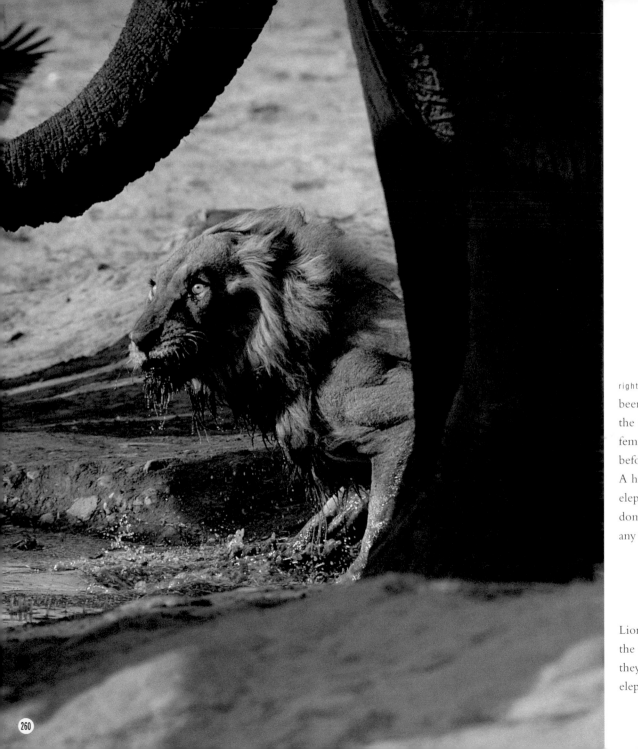

right: This male had
been accompanied to
the water hole by a
female, which retreated
before the elephants.
A herd of thirty
elephants completely
dominates virtually
any water hole.

Lions, too, approach
the water, but even
they must avoid the
elephants' heavy feet.

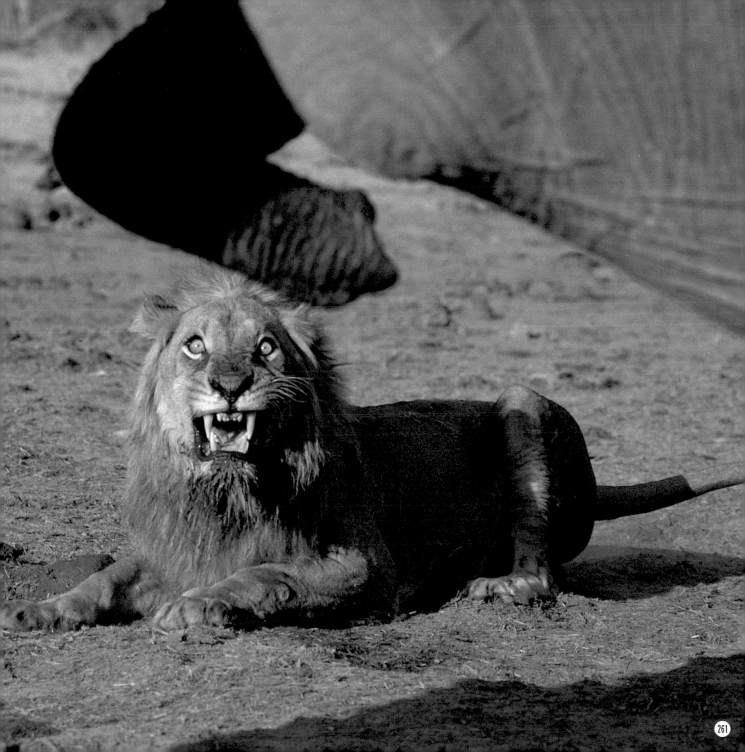

The carcass of an elephant
will serve as food for many
animals over several days.

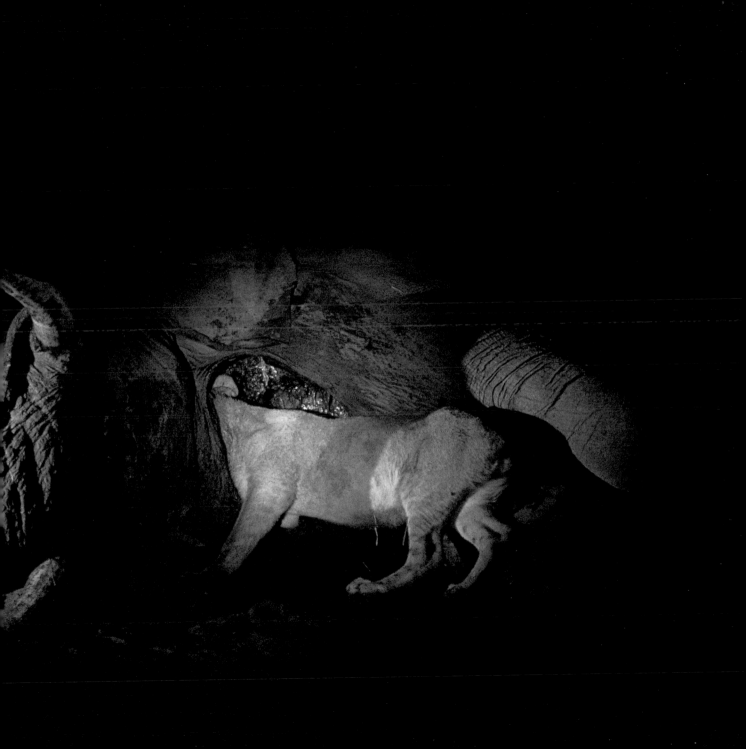

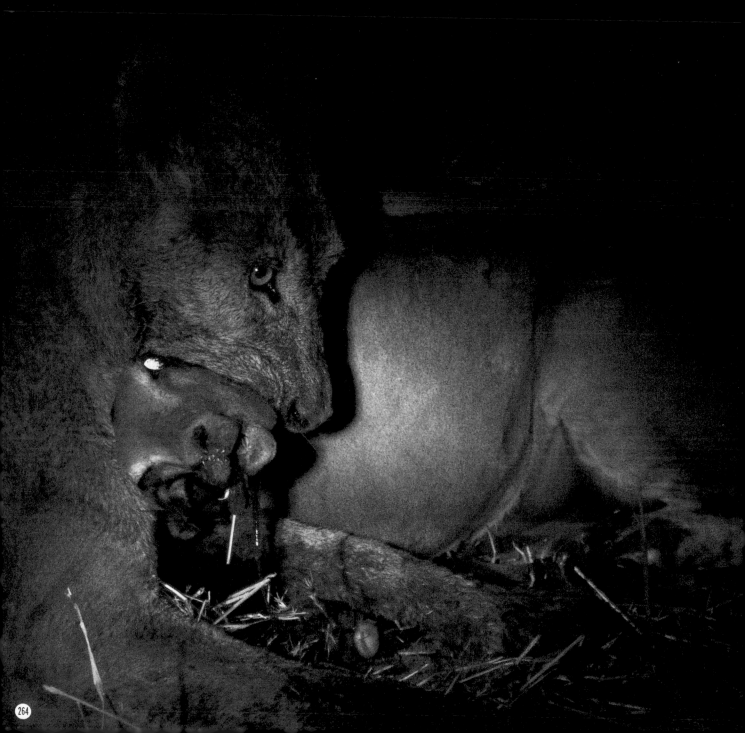

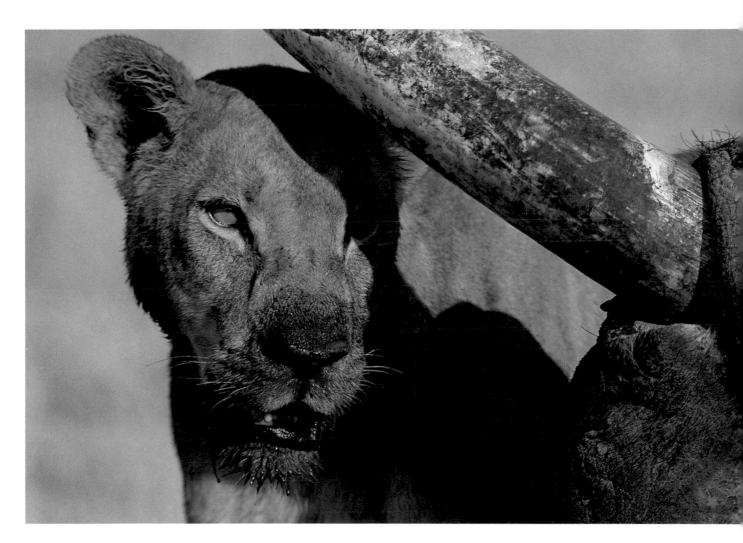

This young lion with the bloodstained mouth was at the elephant carcass.

left: If the heat during the day is intense, lions hunt at night. Members of a pride, hunting together, spread out to form a fan and make prey of a grazing impala in a matter of minutes.

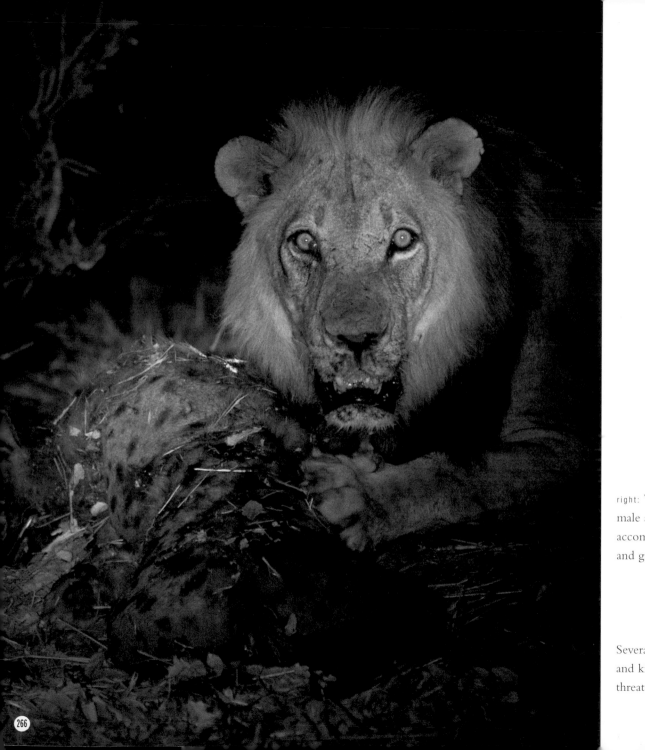

right: The union of a
male and female lion is
accompanied by snarls
and growls.

Several lions attacked
and killed a hyena, a
threat to lion cubs.

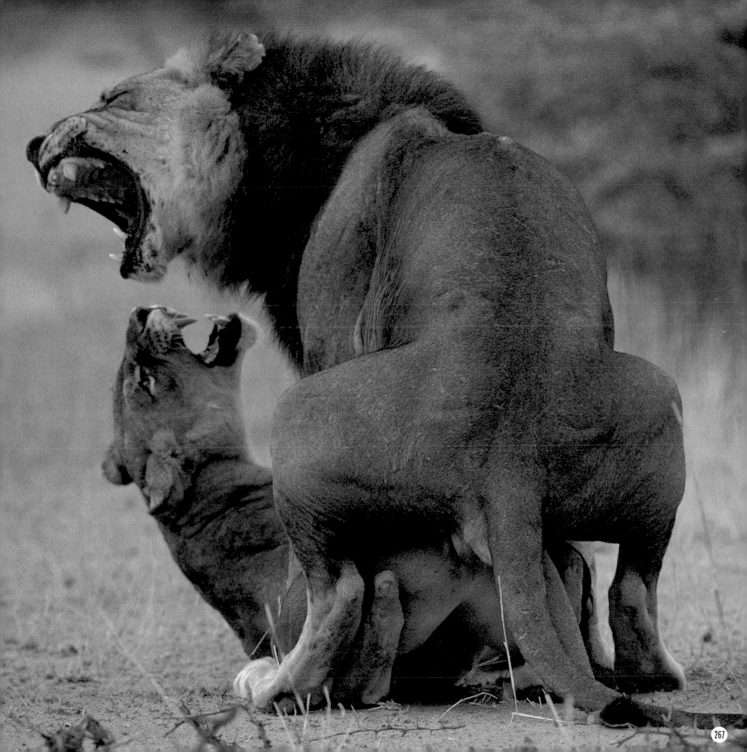

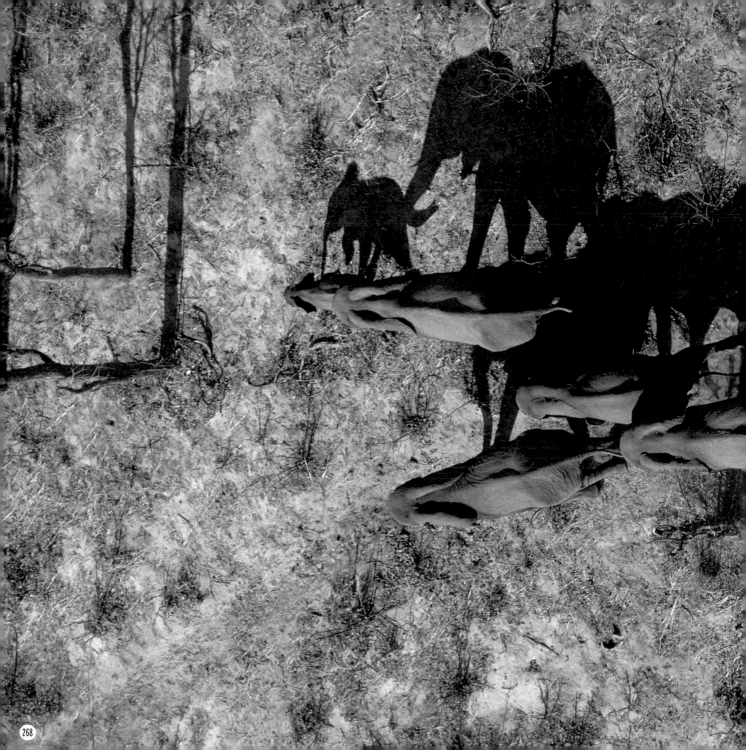

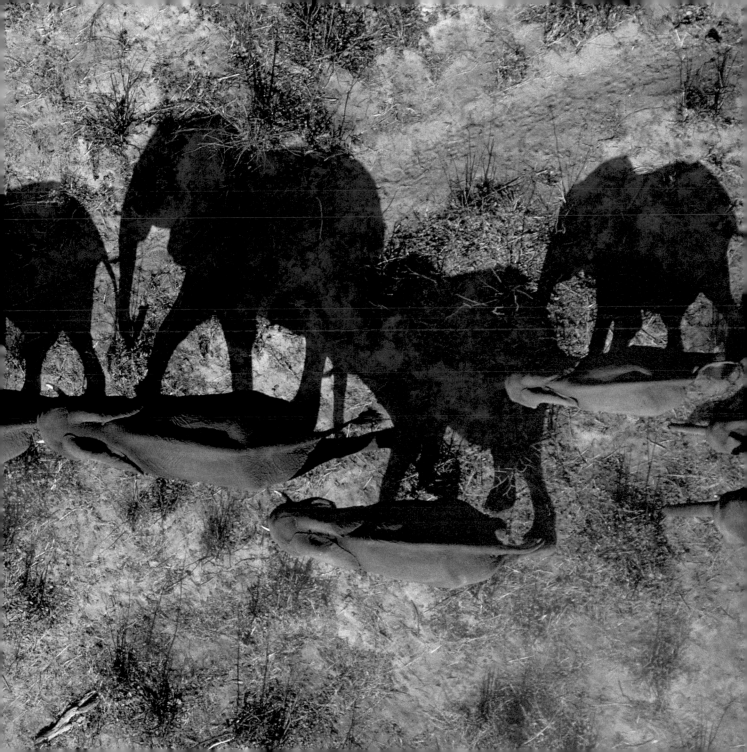

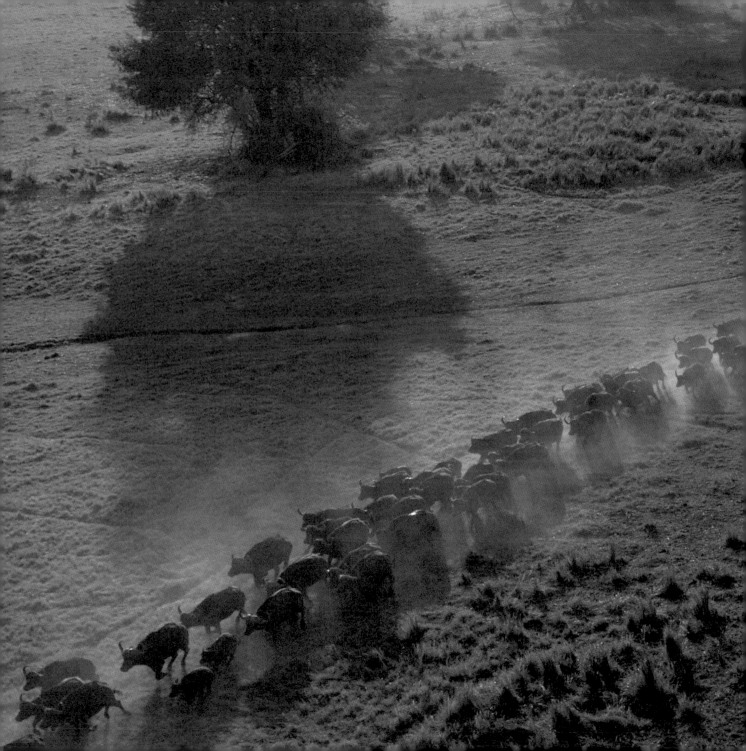

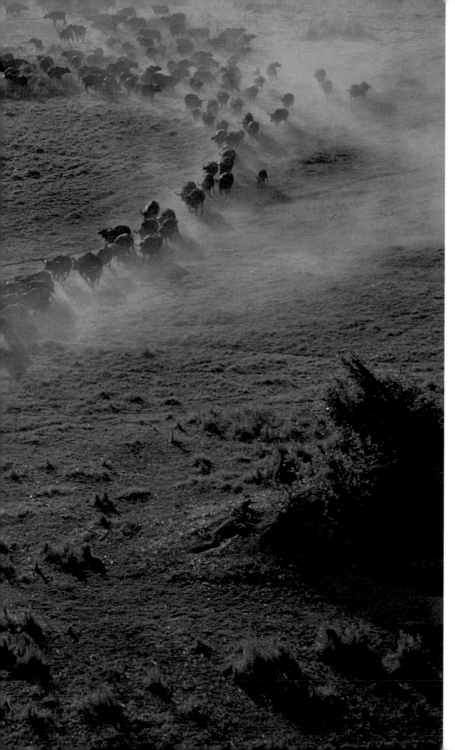

preceding pages: A herd of African elephants marches toward greens and water, leaving white trails of dust behind.

Among the most successful of African mammals, African buffalo commonly live in herds of several hundred animals. In search of water, this group moves across the dry land under the morning sun.

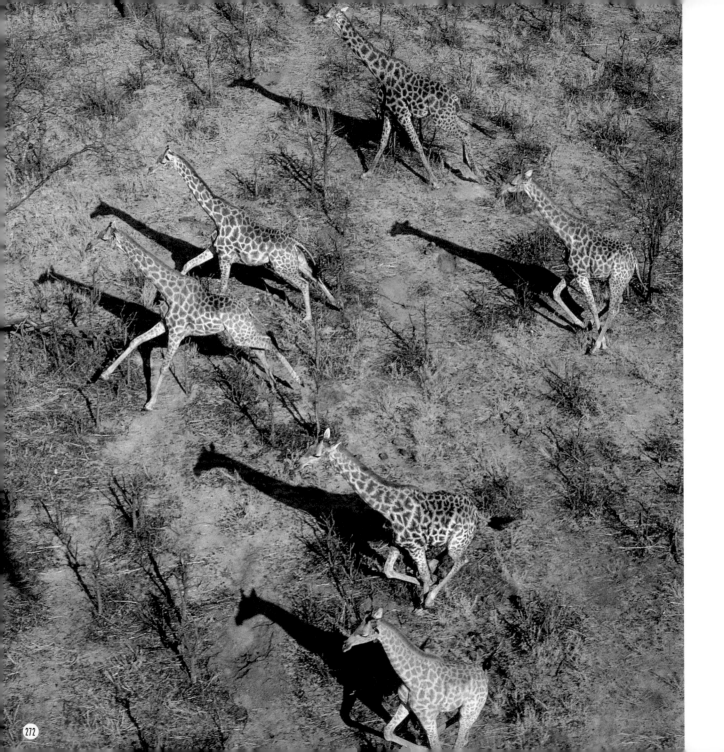

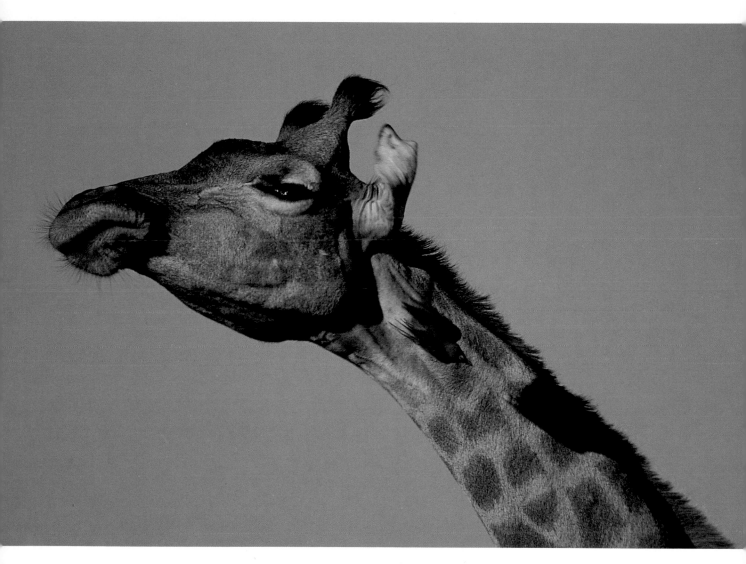

left: Because of their size, giraffes in motion tend to look very slow. From the air, I felt as though I were watching a slow-motion film.

There was a small pool of water after the rain. To drink, a giraffe must stand with its front legs very far apart and stretch its neck or bend its legs without kneeling.

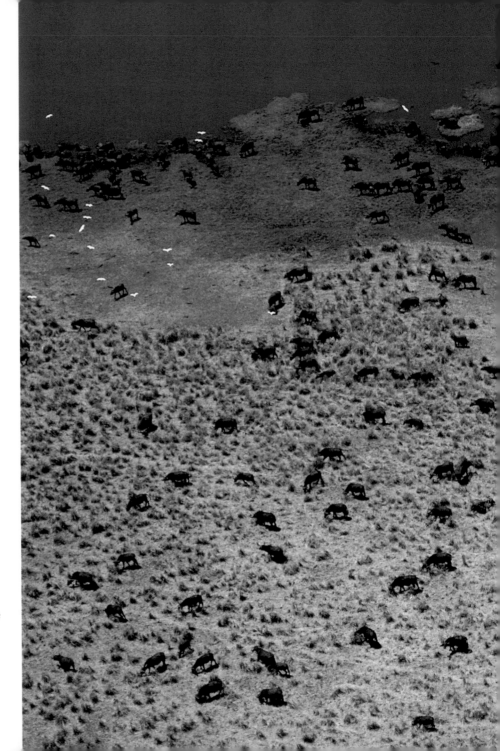

African buffalo are very
gregarious. Living in stable
herds, they confront
impending danger as a
group, facing predators
with their horns.

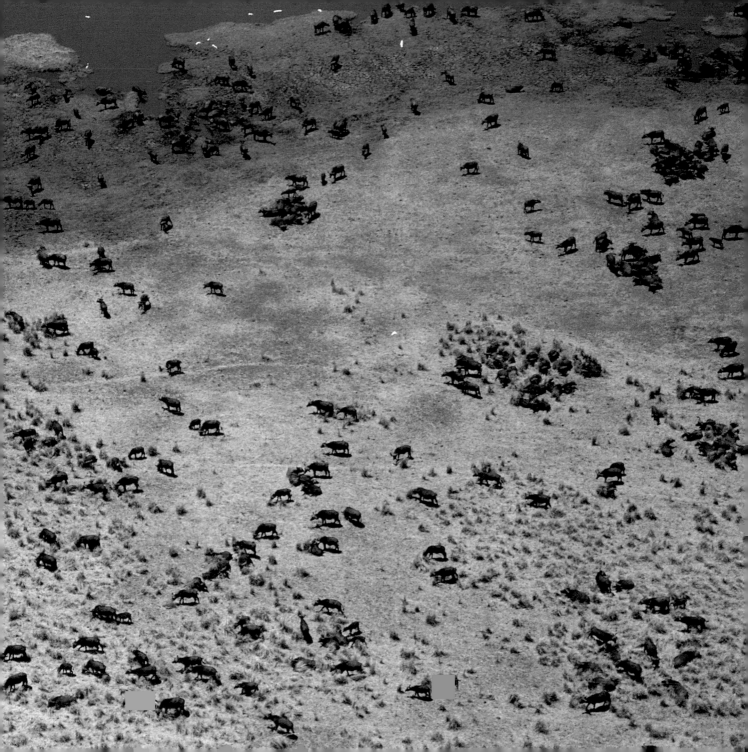

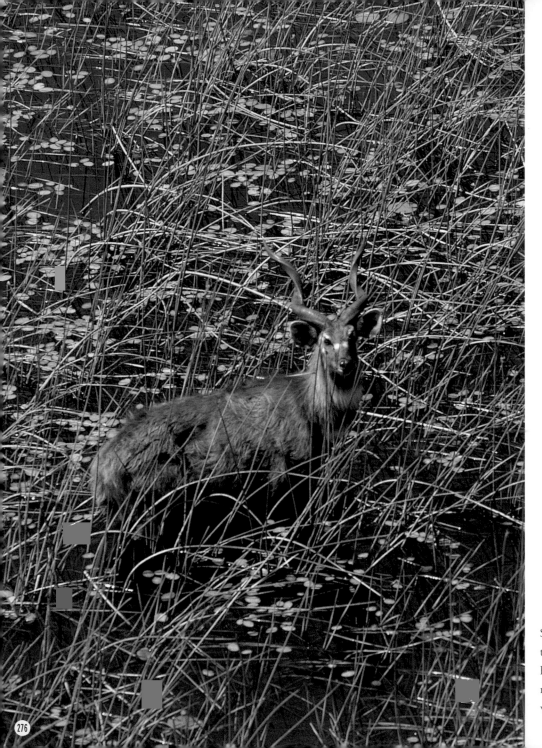

Sitatunga are large antelopes that live in the marsh. Their hooves are widely splayed, making it easy for them to walk in the mud.

Lechwe are aquatic antelope that feed on grasses growing in flooded pastures. They depend on water for food and for refuge from predators.

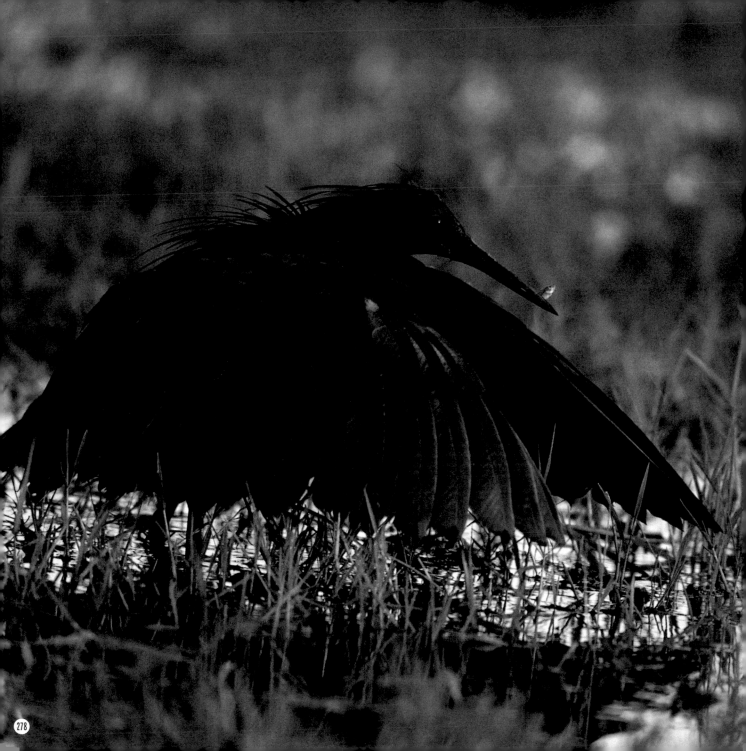

left: A black heron spreads its wings to make a shadow that will help it find and catch fish. Covering a spot of water can draw fish into the shade or reduce the glare of sunlight.

An African fish eagle swoops toward its prey, talons poised to strike. These powerful birds are capable of attacking prey weighing several times more than itself.

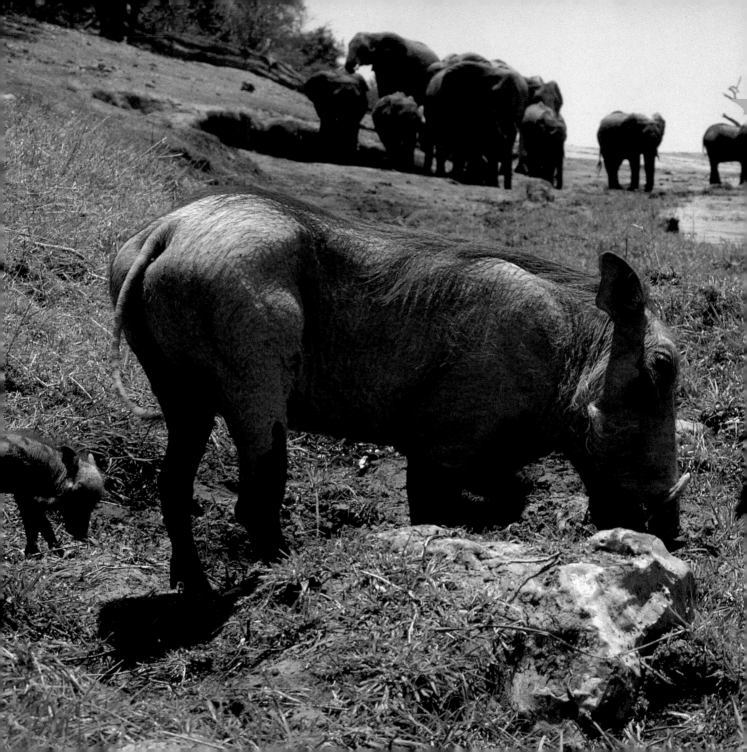

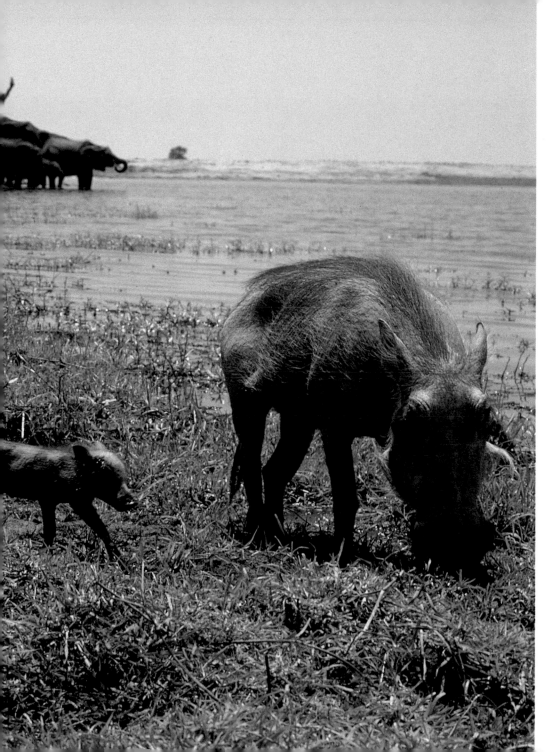

Warthogs search the banks of the Chobe River for food. These animals are active primarily during the day, returning to deep burrows for protection at night.

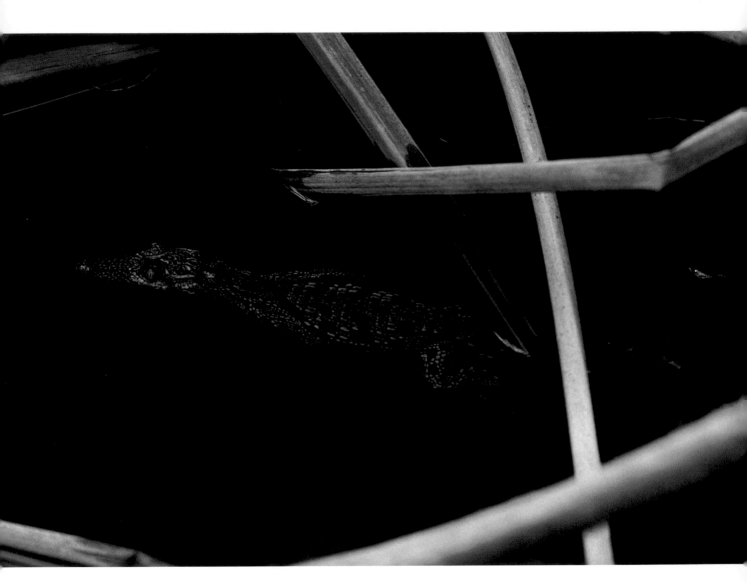

The camouflage pattern on the back of this Nile crocodile
matches the marshy environment. These creatures may grow
to be more than twenty feet long.

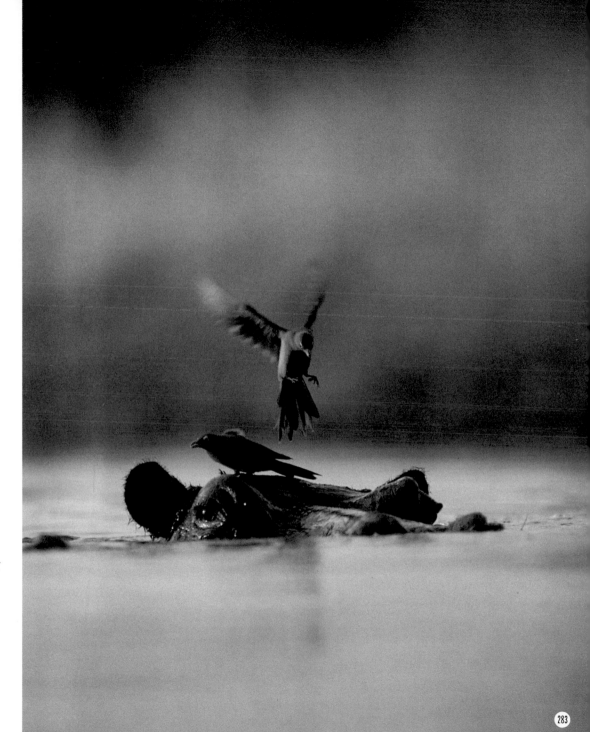

A relative of the starling, red-billed oxpeckers eat parasites from the hides of large herd animals such as rhinoceroses and buffalo. Normally a help to the animal, the birds are not welcome when they peck wounds.

Carmine bee-eaters make nest holes on the banks of the Chobe River. They live and breed in a big flock, and misunderstandings over living space and ensuing territorial fights are common. This bird will often ride on the backs of bustards—large grassland birds—to capture insects flushed by its long legs.

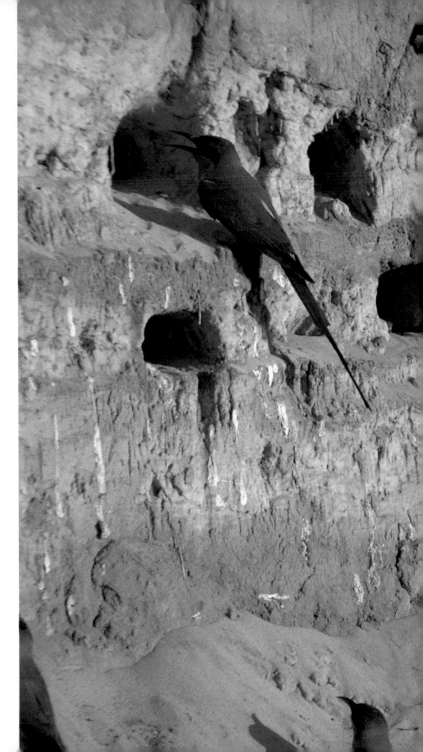

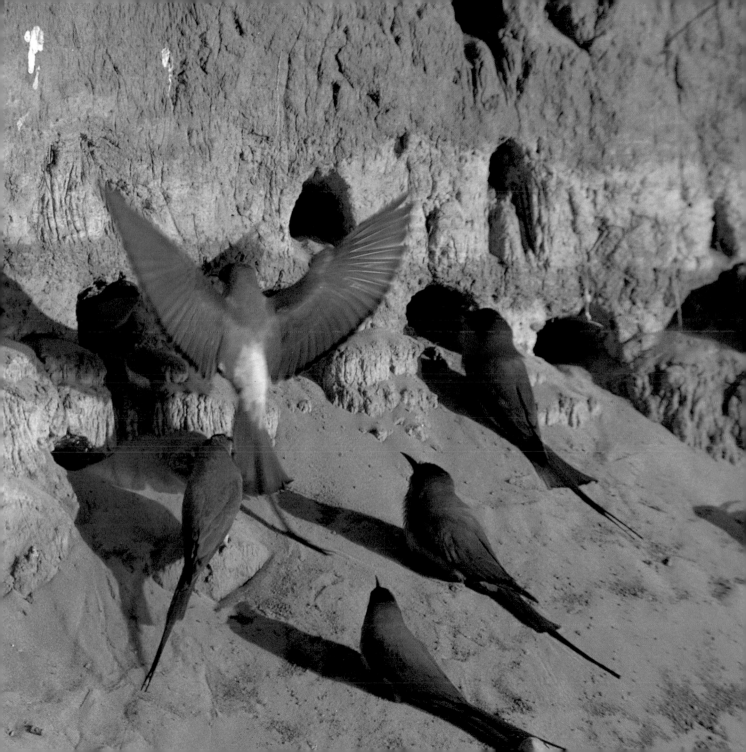

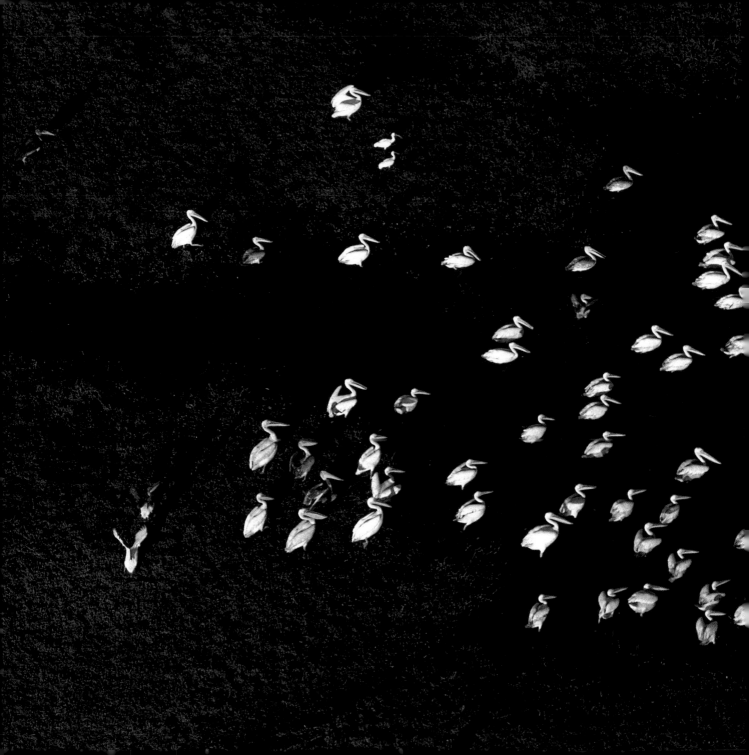

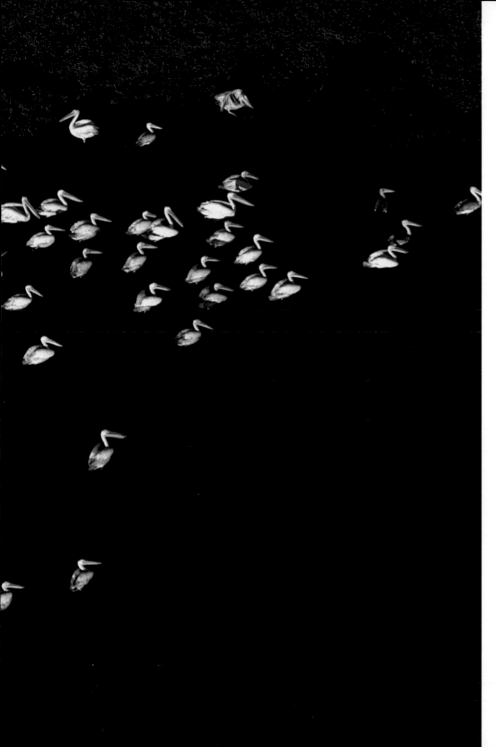

White pelicans nesting on
the Chobe River. Young
birds are darker in color.
On the bank are ibis
and marabou storks.

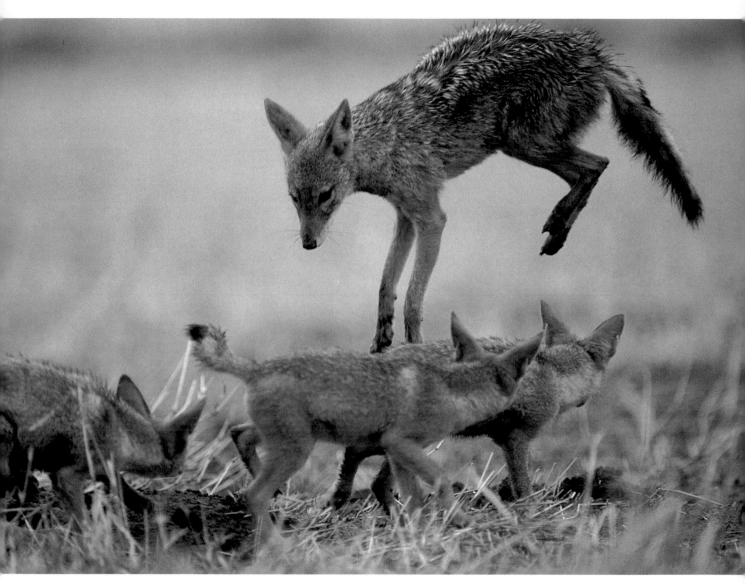

Silver-backed jackals frolic near their den. Even when
they are grown, these jackals like to play.

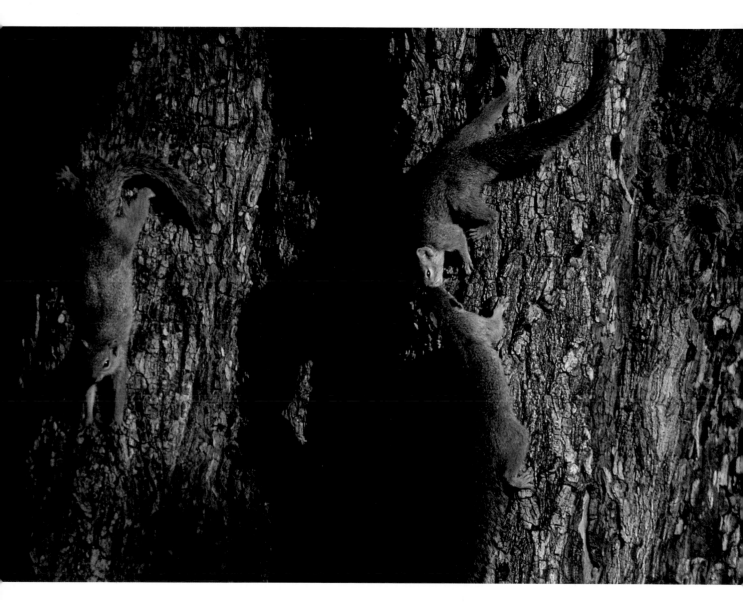

Squirrels at work in their vertical world on a tree trunk.

Dark clouds foretell the coming rainy season. A storm gathers over spotted hyenas in Serengeti National Park.

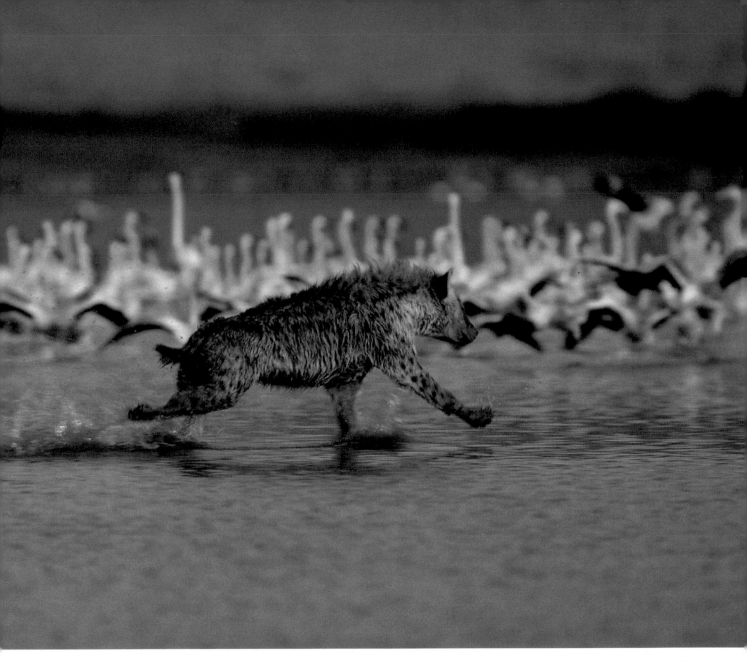

Lake Magadi is a salt lake in the Ngorongoro Crater. At the mouth of the river that flows into this lake, flamingos flock for food and water, while hyenas prowl around hoping to catch an unwary flamingo.

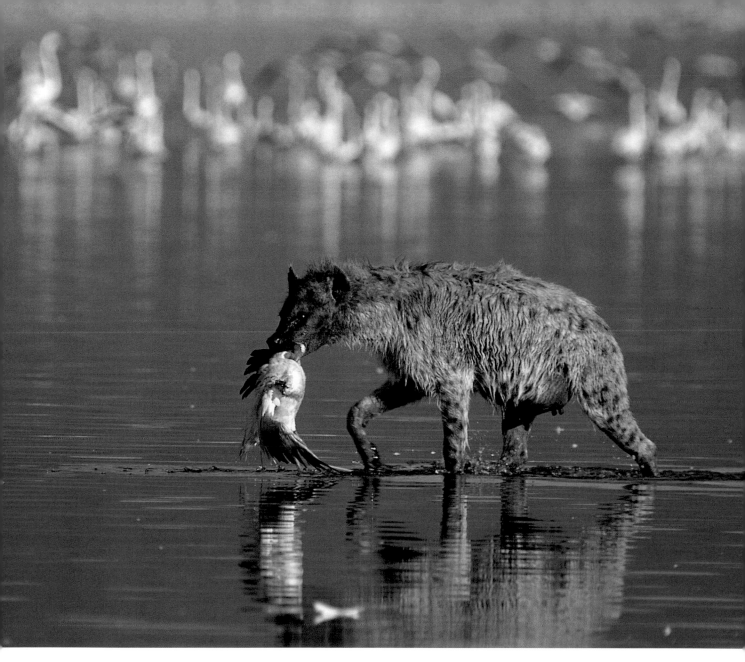

A young, inexperienced male hyena chased futilely after several flamingos until he finally captured a tired and weakened bird.

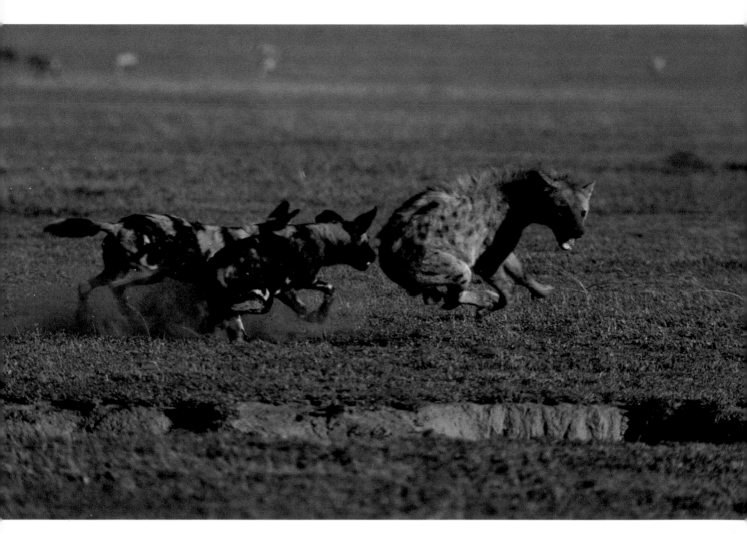

After venturing too close to a pack of Cape hunting
dogs, this spotted hyena was chased by several of them.
Whereas wild dogs cooperate in attack and defense,
hyenas do not normally aid each other, so the smaller
dogs can drive off the larger hyena.

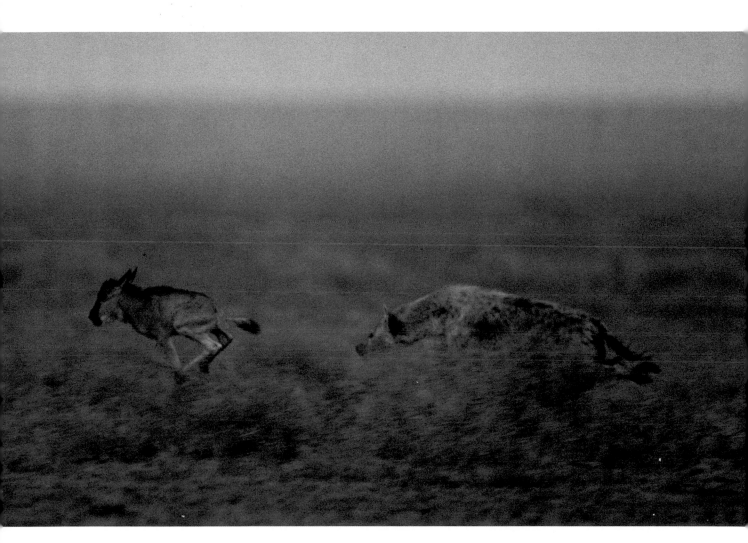

Intent upon a kill, this spotted hyena relentlessly pursues
a blue wildebeest calf. The calf's mother drove the hyena
away, only to have it return and continue the chase until
it captured the exhausted calf.

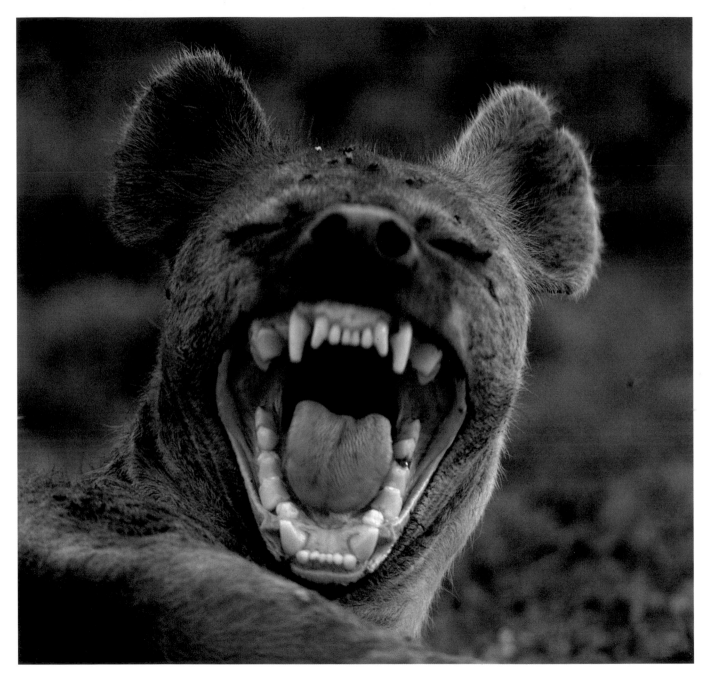

Hyenas are well-equipped predators. Voracious eaters, hyenas do not fight one another for fallen prey. Instead, they speedily consume as much as possible, the victim disappearing under their slashing teeth.

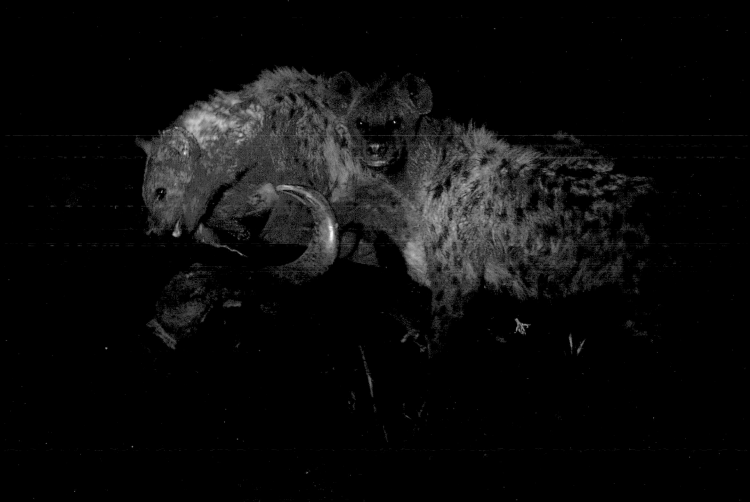

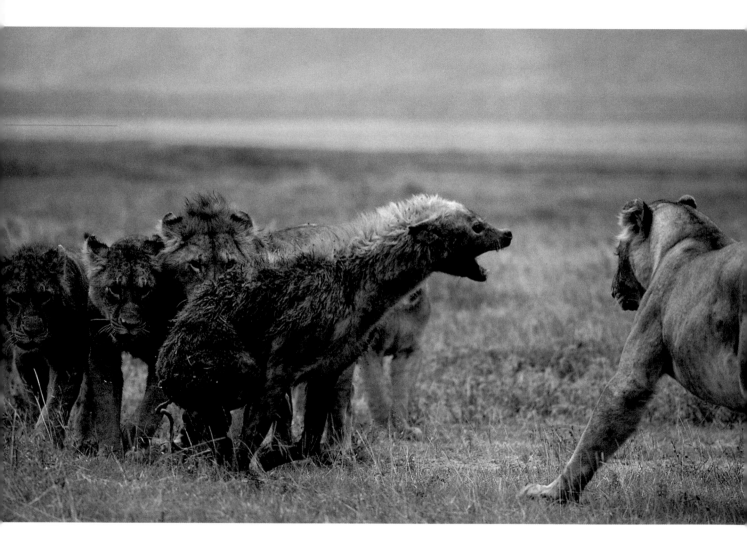

preceding page: The old and infirm are hyenas' favorite targets. This old African buffalo bull fell prey to spotted hyenas. Even lions seldom attack a healthy bull buffalo. While feasting, the hyenas punctuate the air with loud yelps.

Frustrated by a failed hunting attack, this lioness exchanged challenges with a hyena lurking nearby. Early in the battle, the young lions only watch, but when they see the hyena losing his strength, they join in the kill.

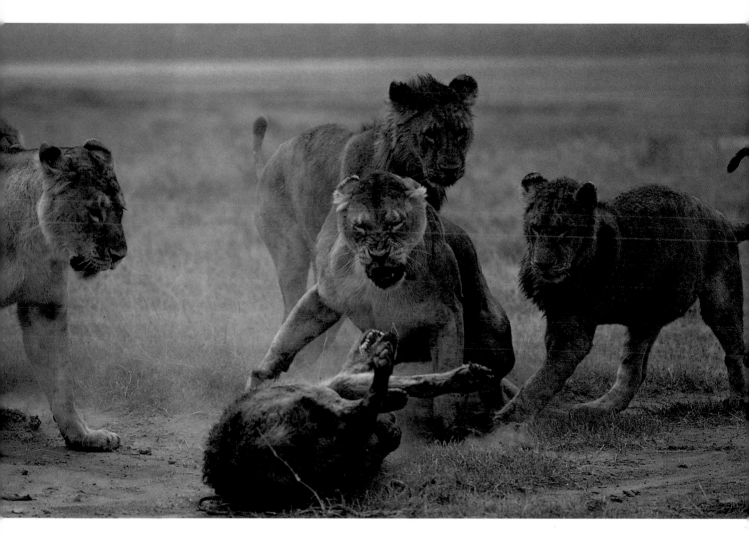

Extraordinarily excited, the lions nevertheless do not eat the hyena.

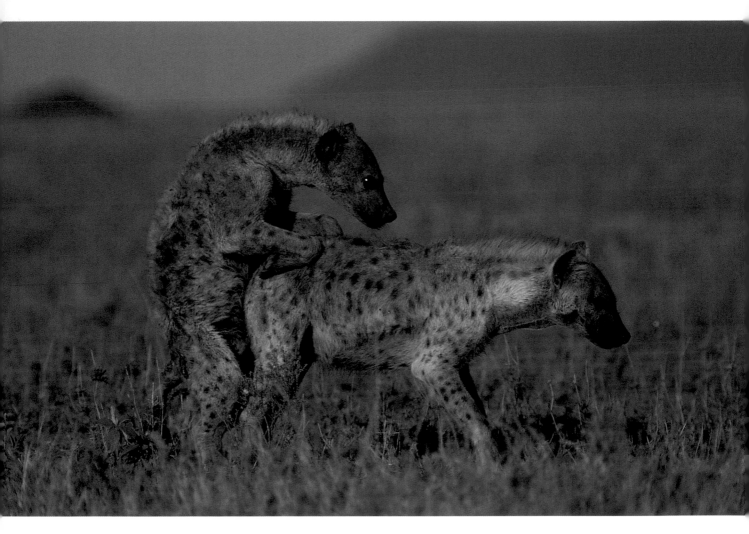

A female hyena is bigger than a male, forcing
him to mate in a standing position.

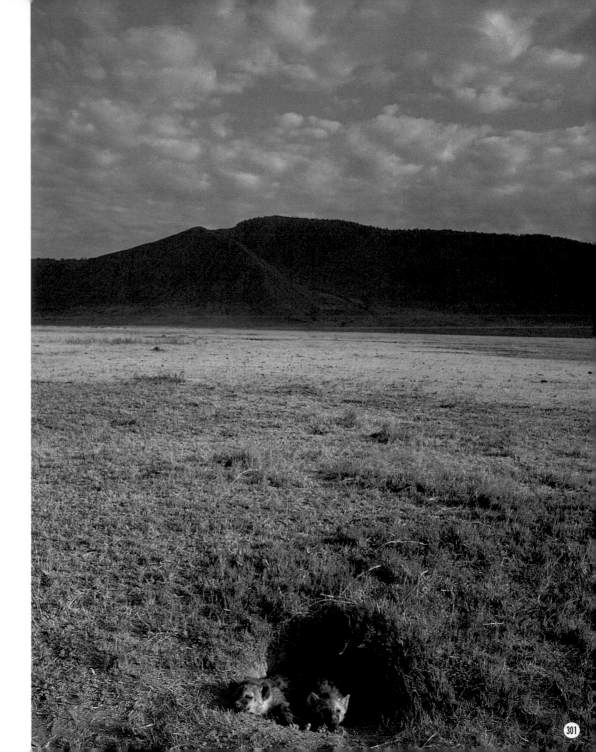

About one month old, these puppies peek curiously and cautiously out of their burrow. Spotted hyenas are black when they are born. Spots will appear on their fur as they grow.

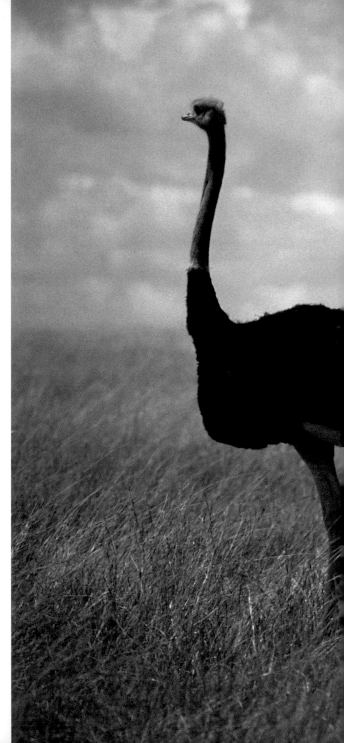

Largest of birds, ostriches
are flightless and depend
upon powerful legs to carry
them at speeds up to forty
miles per hour. Males are
black-feathered. All female
ostriches associated with
one male lay their eggs in
the same nest. After the
eggs have hatched, the
highest ranking female rais-
es the chicks, which can
run as fast as an adult only
one month after birth.

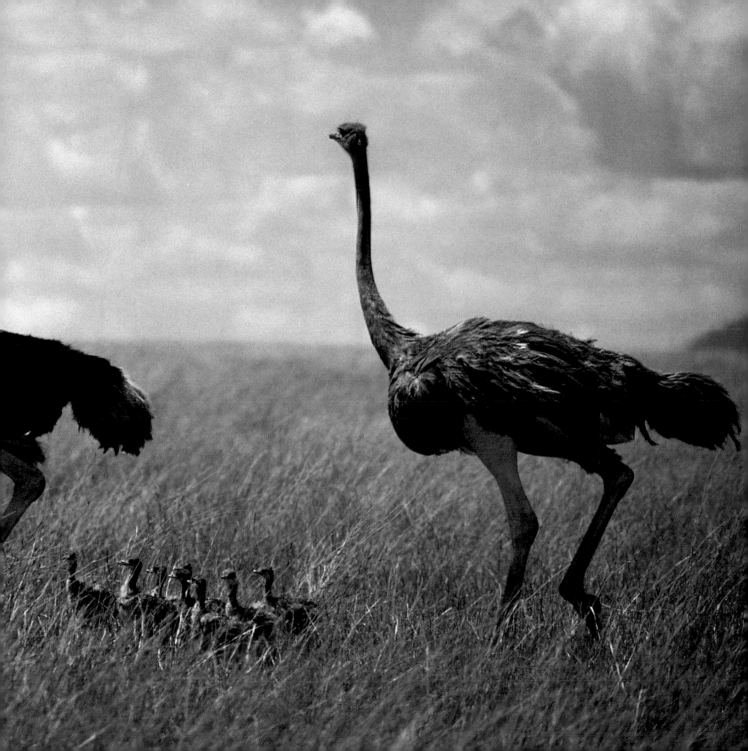

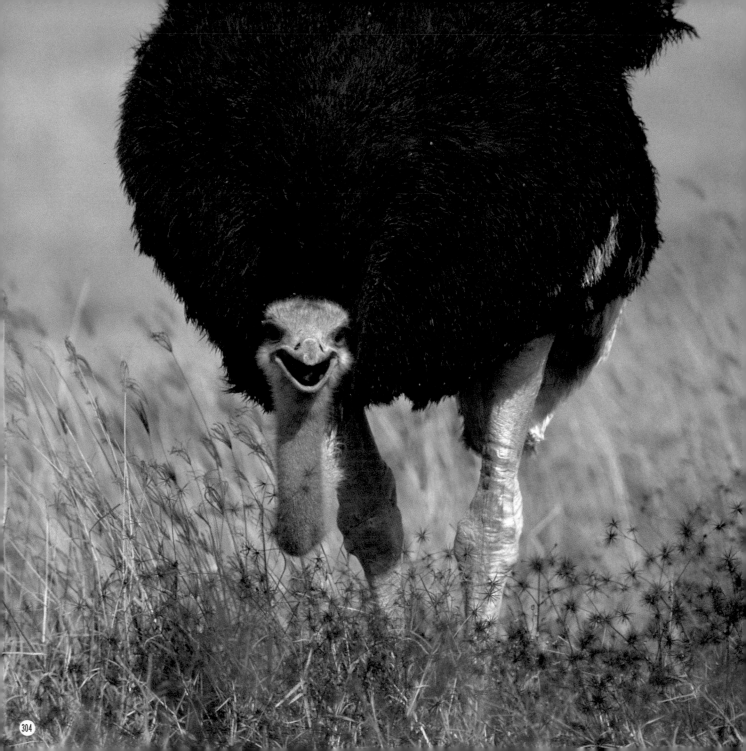

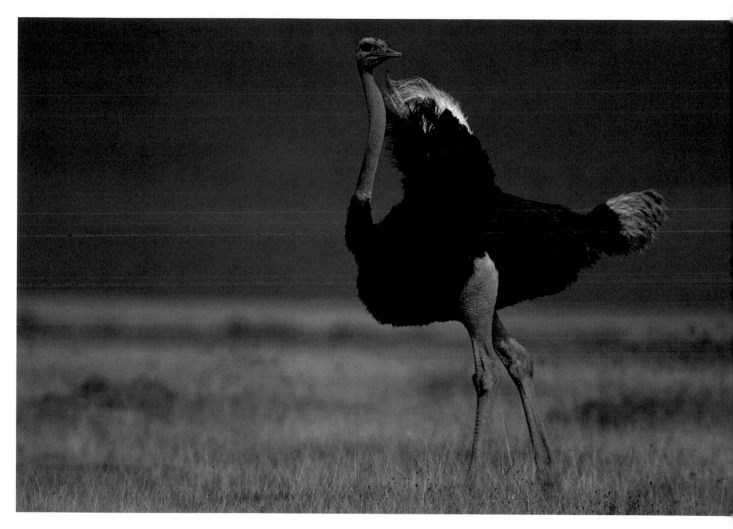

left: Ostriches are found in abundance in East Africa and South Africa. They feed primarily on seeds, but are also fond of small animals and insects.

Ostriches have keen eyes and are difficult to approach. In the rainy season, which is the breeding period, the skin color of the male ostrich becomes brighter.

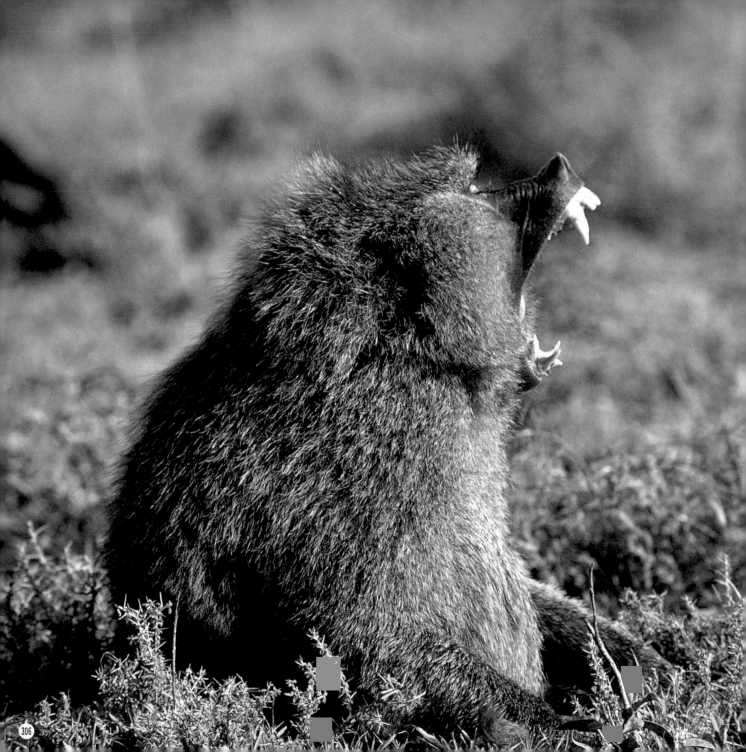

left: An omnivorous and
opportunistic eater, the
anubis baboon devours
nuts, insects, fish, and
everything else it can find.
Sometimes male baboons
attack small antelope.

In the face of danger,
baboons usually prefer to
climb a tree, but they are
ferocious enough to chase
away cheetahs and leopards.

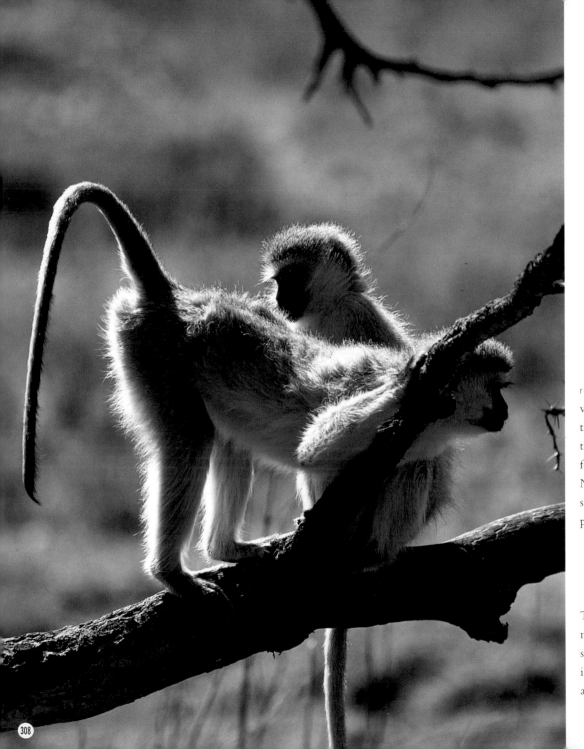

right: With their binocular vision and opposable thumbs, monkeys such as this blue monkey in the forest of Lake Manyara National Park are well suited for a life spent primarily in trees.

The most common monkey of the African savanna, vervet monkeys inhabit forests, savannas and shrubberies.

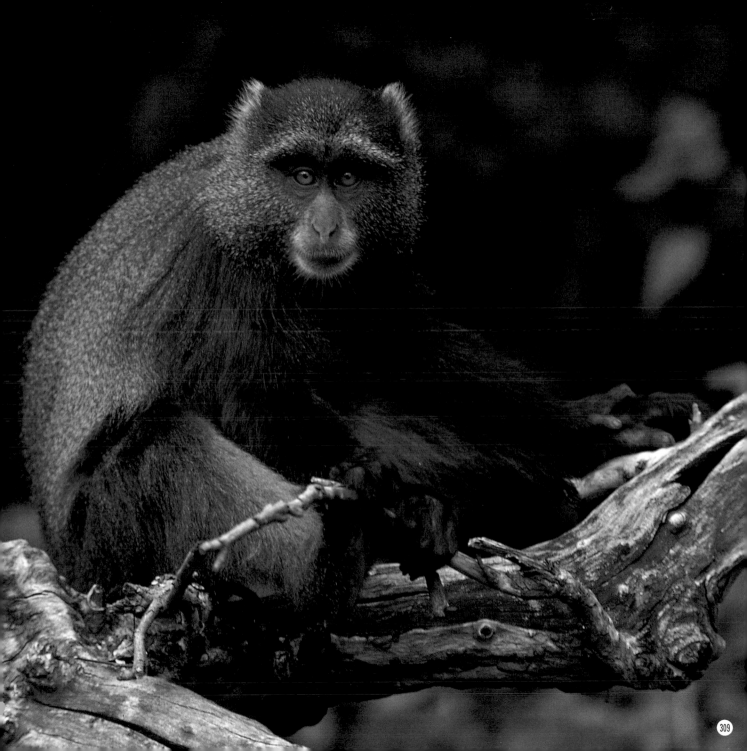

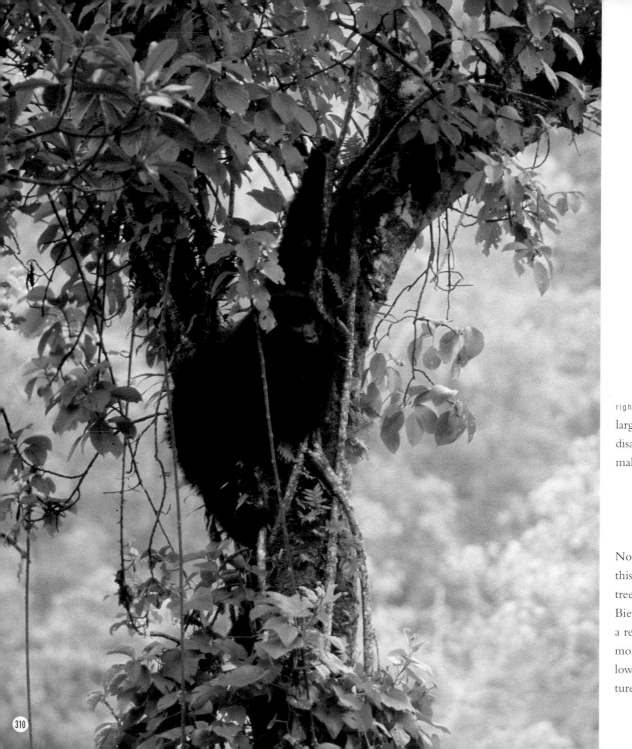

right: Despite their large size, gorillas can disappear without making a sound.

Not quite fully grown, this gorilla lives in the trees of Zaire's Kahuzi-Biega National Park, in a region of damp mountains and often low nighttime temperatures.

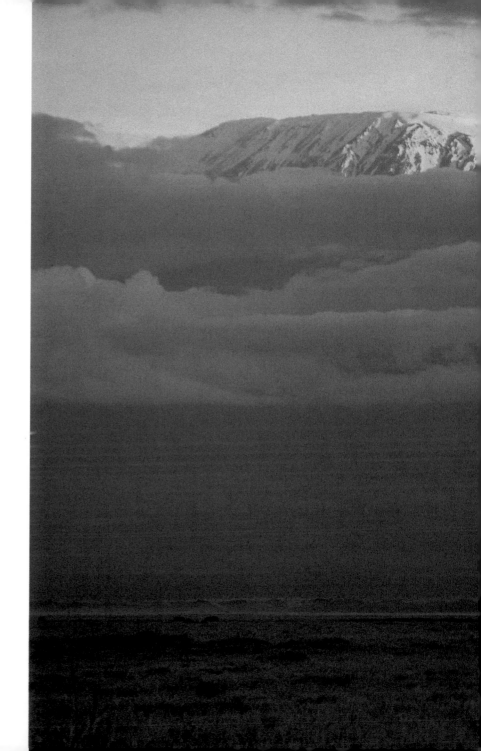

Bathed in the morning
sunlight, Mount
Kilimanjaro dominates
the plains of Amboseli
National Park, Kenya.

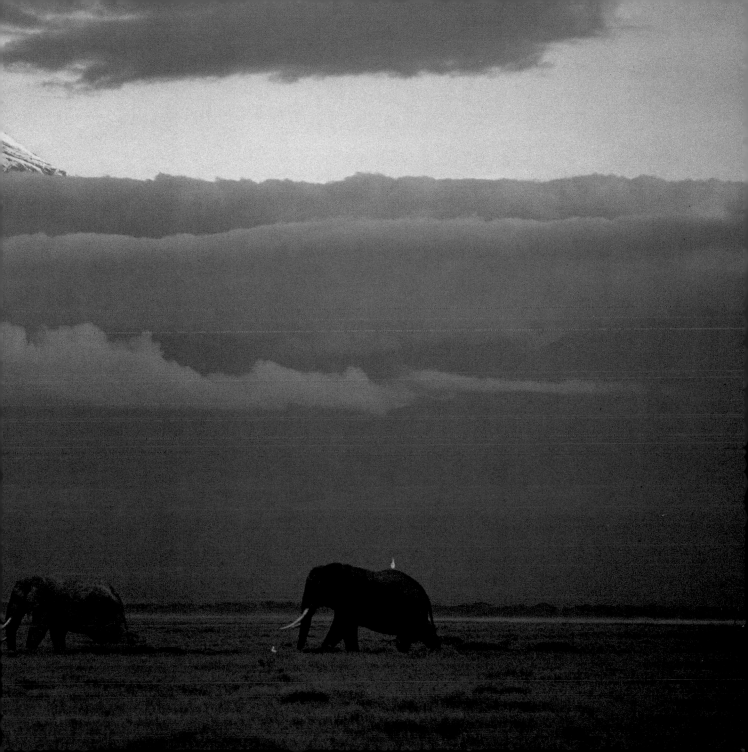

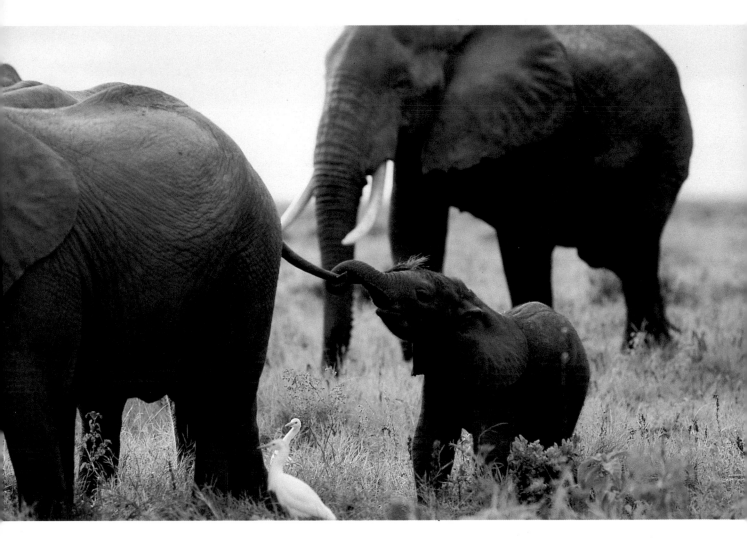

Elephants seem to enjoy touching each other. Here, in Masai-Mara National Park, Kenya, a calf elephant is playing, pulling a cow elephant's tail. Sometimes an adult elephant guides a calf by deliberately gripping the youngster's tail.

preceding pages: The Ngorongoro Crater is so large that it could hold the entire metropolitan area of Tokyo.

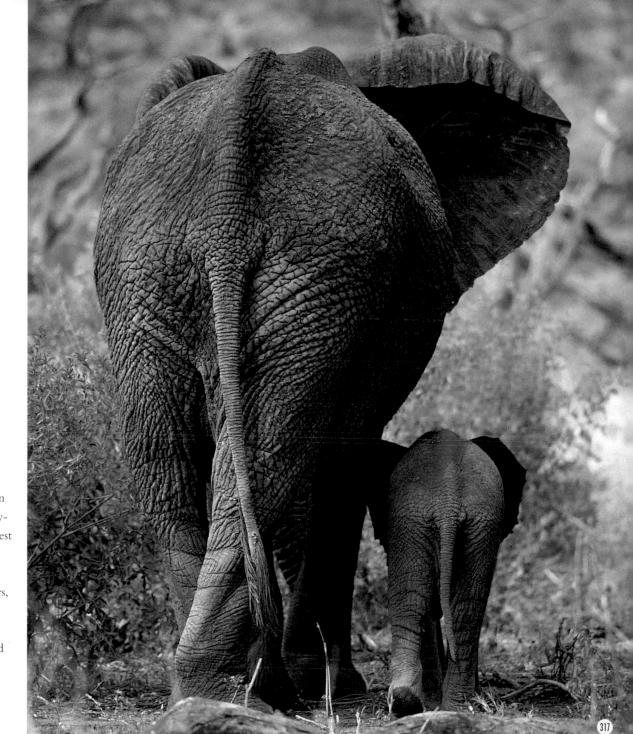

An elephant's gestation period lasts for twenty-two months, the longest of any mammal. Although a calf is weaned after two years, it may nurse for four years. The bond between a mother and her offspring may last several decades.

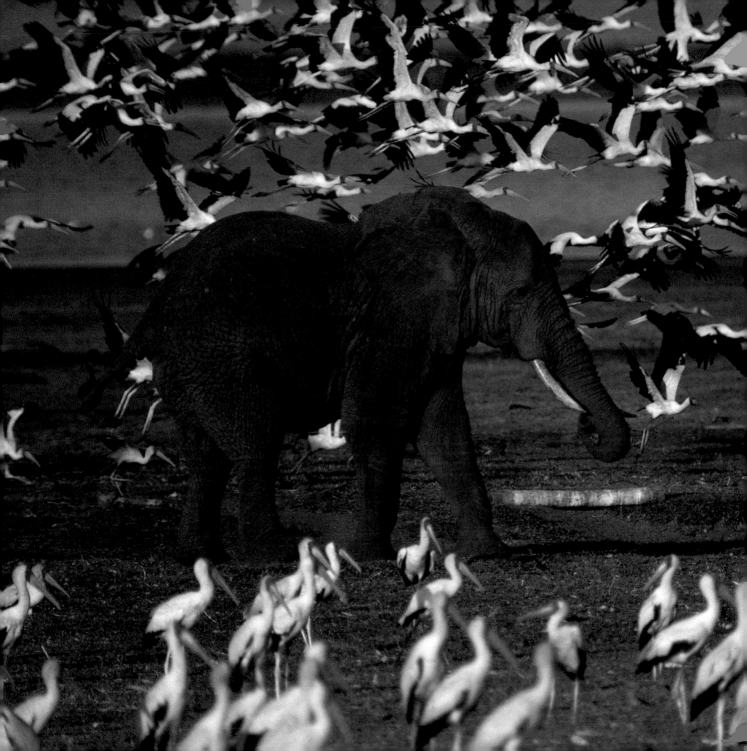

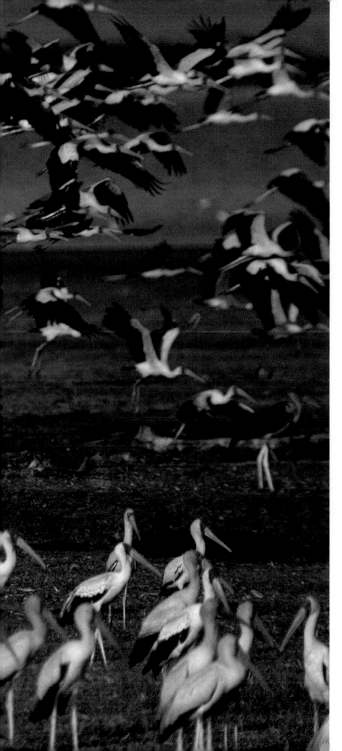

An old bull elephant strolls
among storks in Lake
Manyara National Park.
Strong flyers able to
migrate long distances
using thermals of air, storks
mainly feed on small
mammals and insects.

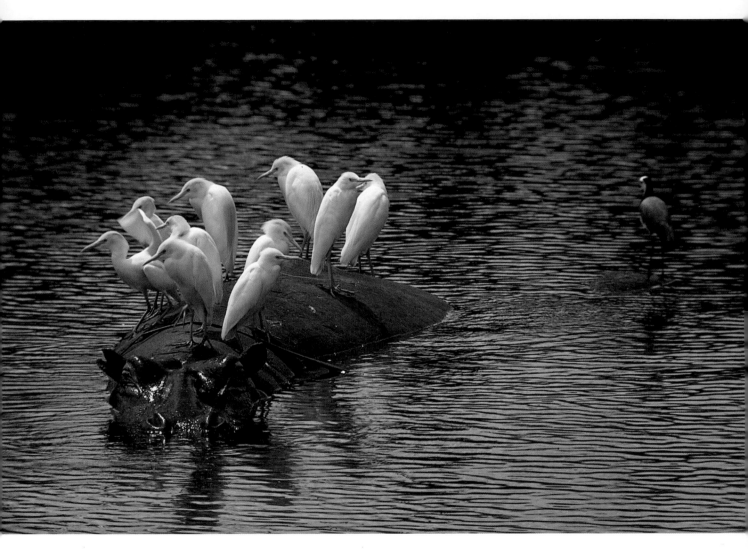

Cattle egrets stand on a cow hippopotamus and her calf.
When the cow submerged, her calf came up. When the
calf submerged, the cow came up. She was probably
nursing the calf, which can suckle underwater.

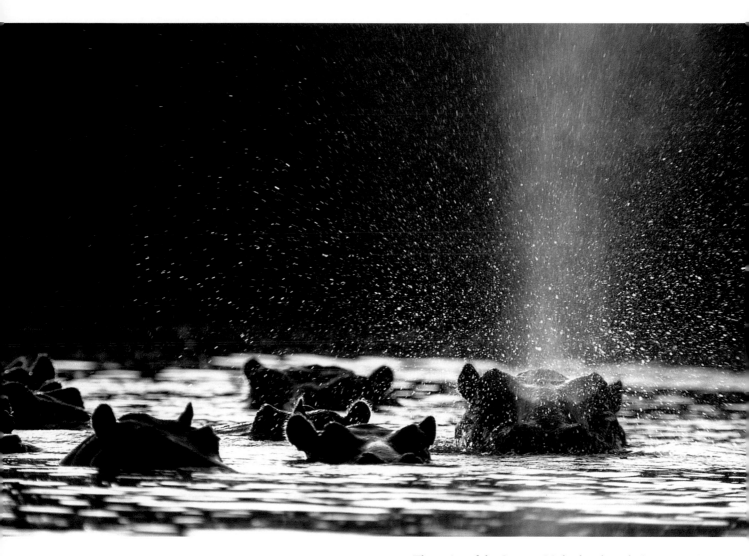

The quiet of the Serengeti is broken by echoing water
spouts sent skyward by hippopotamuses as they surface.

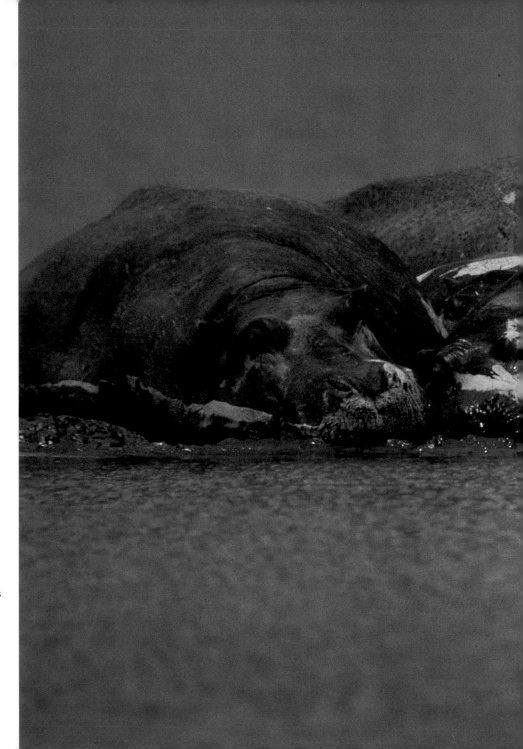

During the day, hippopotamuses spend most of their time in or near the water. Because they lose body water much more rapidly than other mammals, hippos dehydrate very quickly.

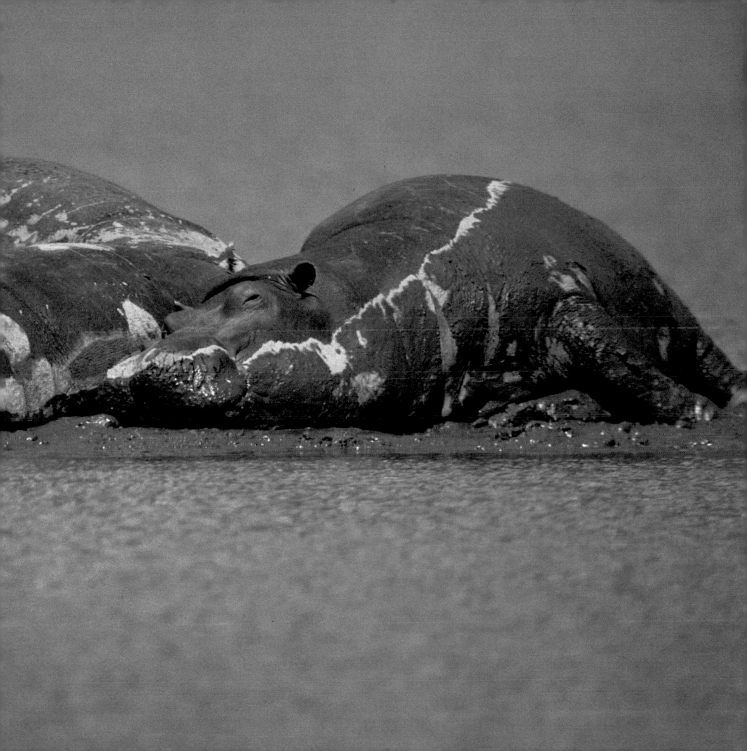

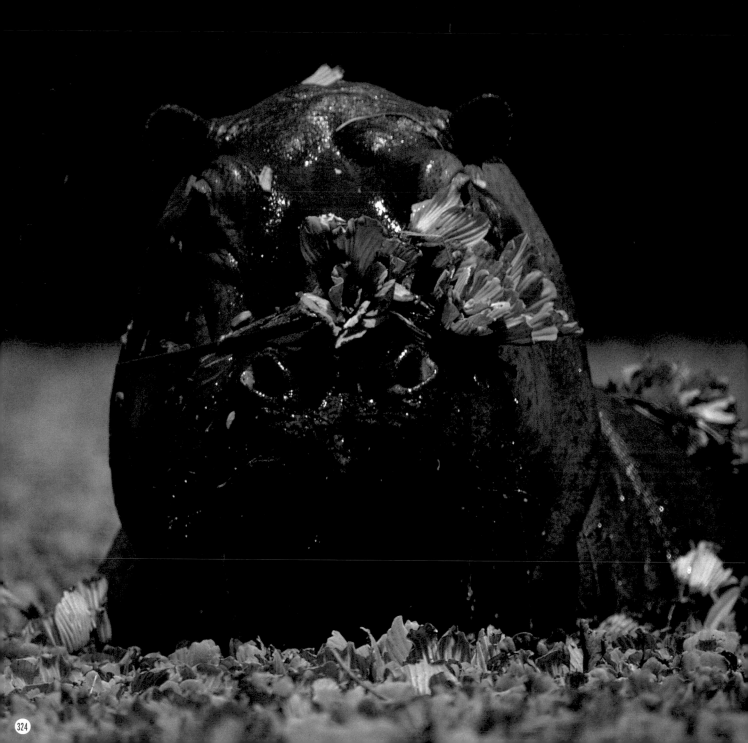

left: In West Kilawila, Serengeti, one of eight hippopotamuses lifts its head as it feeds on Nile cabbage.

Like many other species, the hippopotamus yawns as a threat, one of many highly ritualized activities of hippo life.

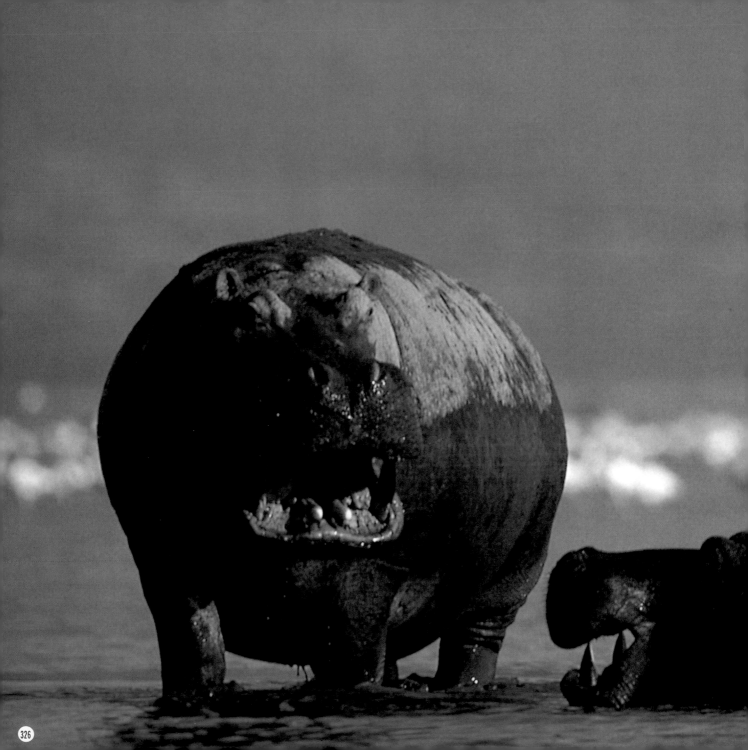

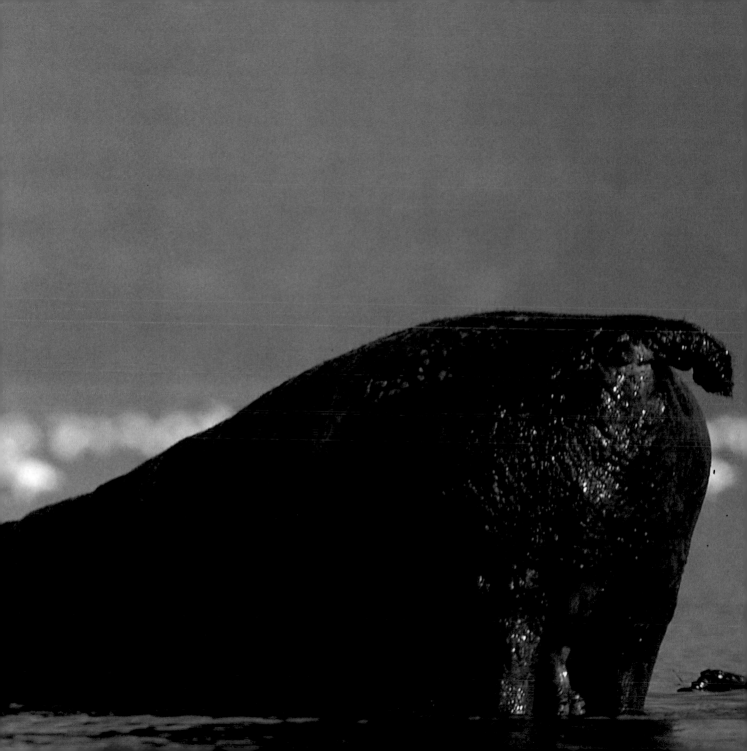

preceding pages: Fights between bull hippopotamuses can be ferocious. Generally, the wounds are not serious, but the tusks can be dangerous weapons.

Normally solitary, black rhinoceroses gather together when their breeding period begins. Here, they are inside the Ngorongoro Crater.

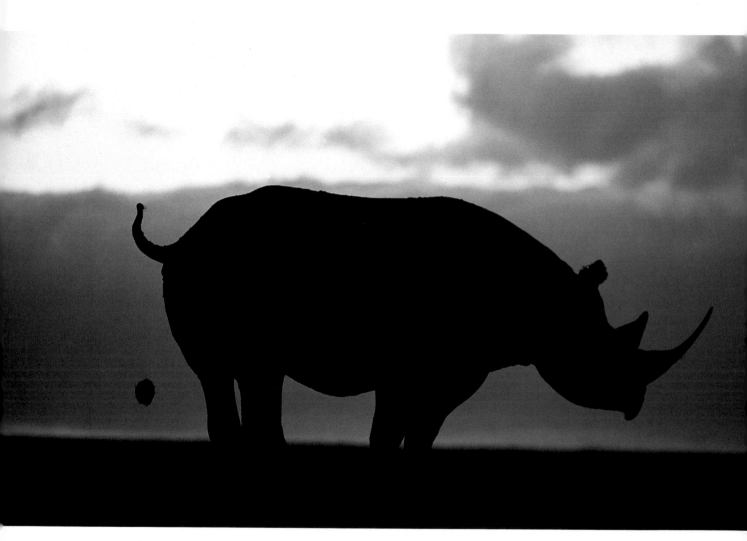

A black rhinoceros comes out of the forest into the
clearing to defecate. His dung piles leave a signal to
others of his passage and his territory.

Mother rhinoceroses and their calves stay together for two to three years.

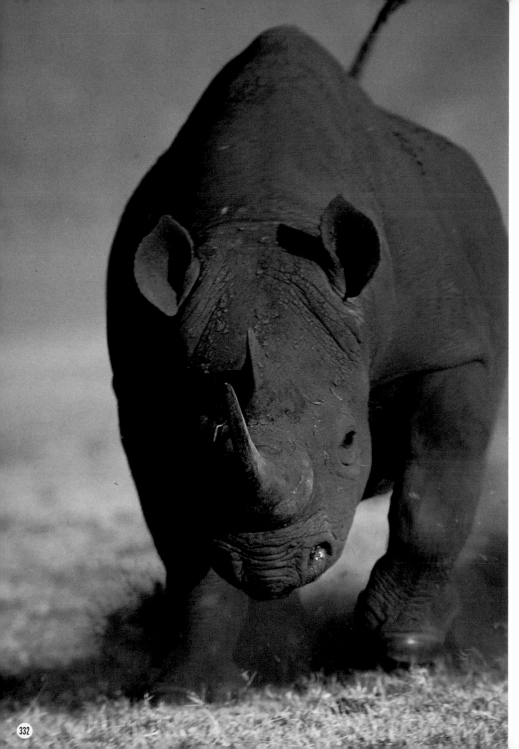

When the black rhinoceros gets angry, he charges. Because rhinoceros horns are highly valued as a sexual stimulant in Asia, many rhinoceroses are killed by poachers, and their population in Africa has declined alarmingly.

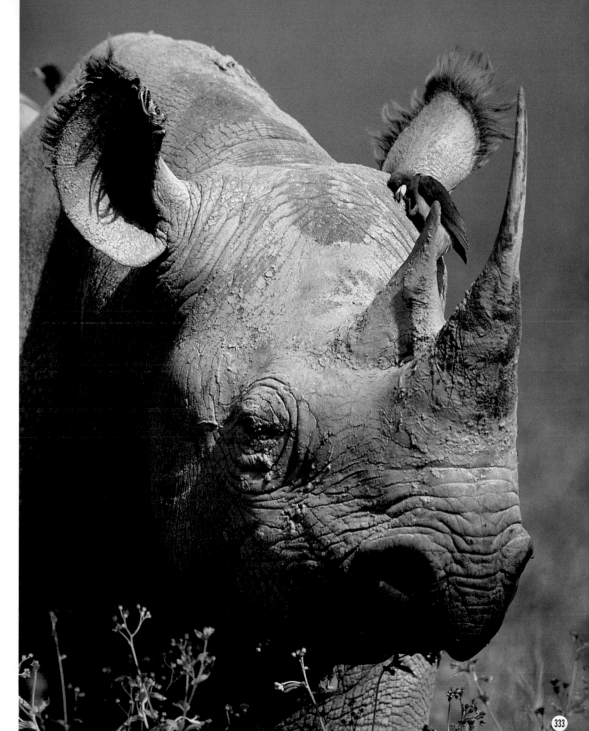

Yellow-billed oxpeckers
and large animals such as
the black rhinoceros have
developed a mutually
beneficial living arrange-
ment. The rhino tolerates
the bird because it
removes insects from the
rhino's skin.

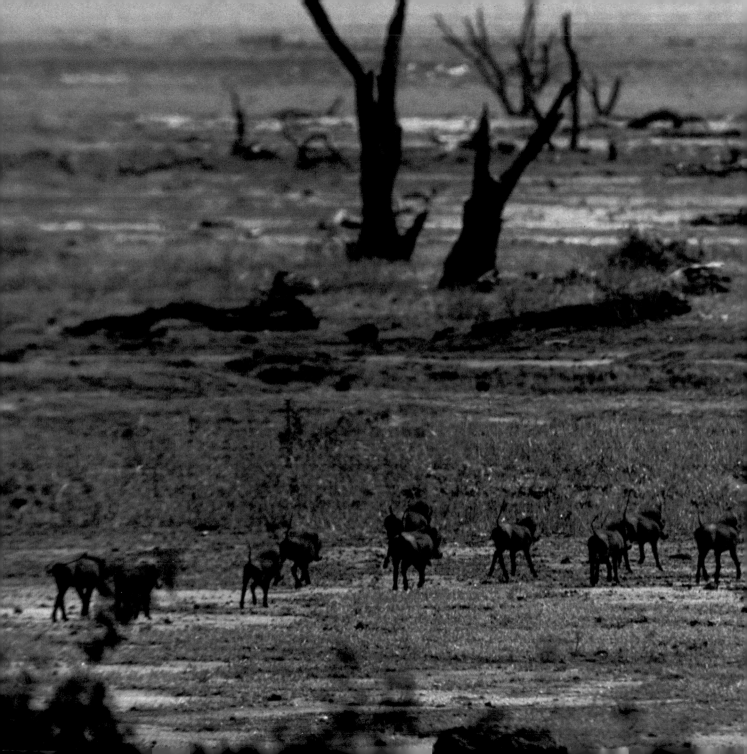

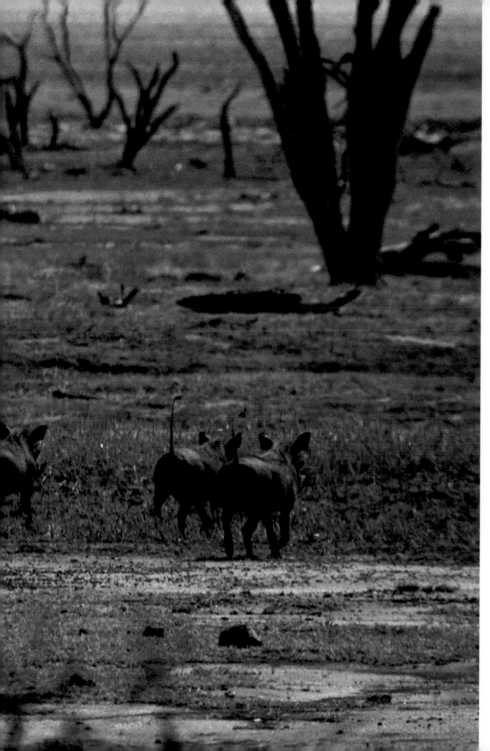

A herd of warthogs is on the run. Not sufficiently speedy to elude predators, the warthog heads for its burrow when threatened. Parents vigorously defend their home and young.

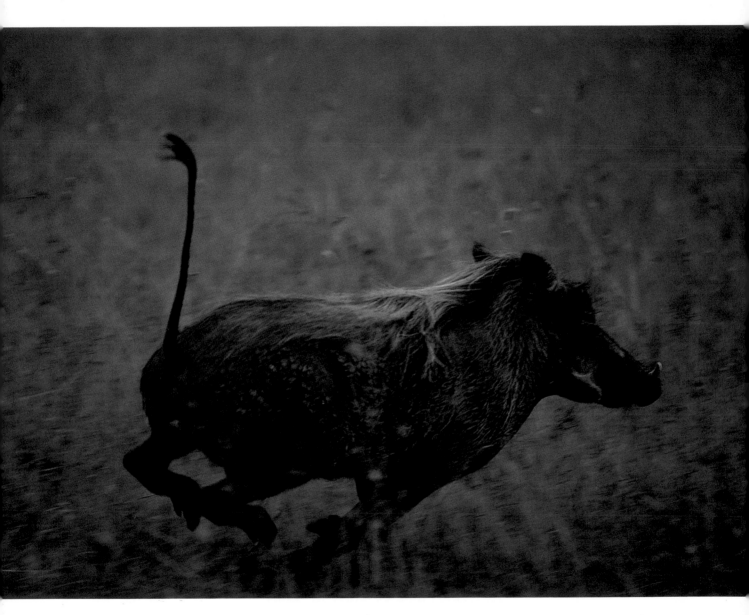

Because warthogs of the Serengeti are extremely
cautious, it is very hard to get close to them.

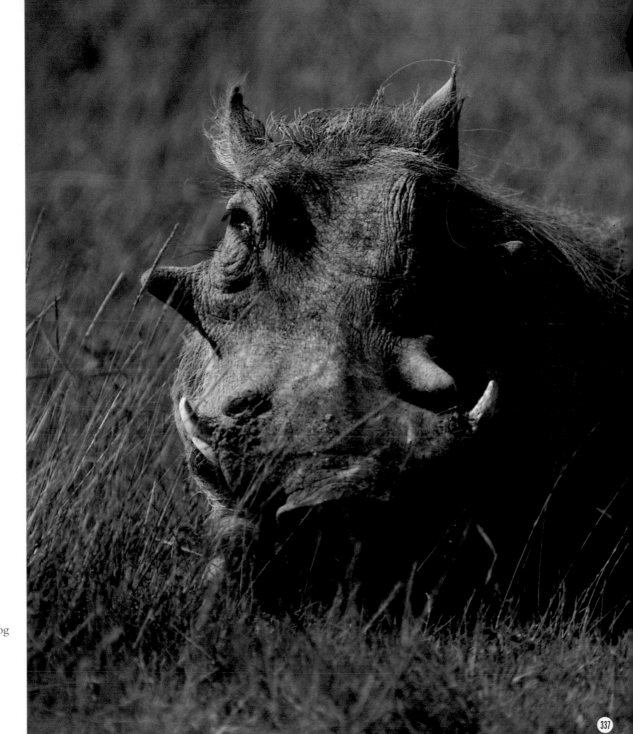

The "warts" made of skin and thickened gristle give the warthog its name. These warts grow bigger as time passes.

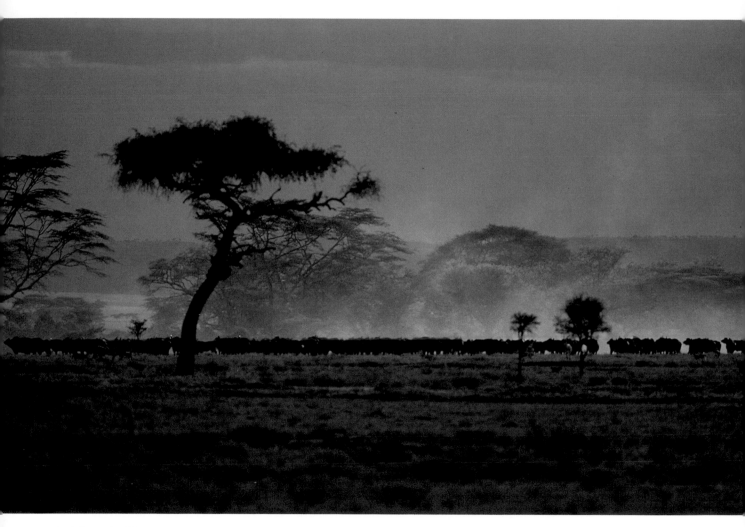

As African buffalo pass near Seronera in the center of
the Serengeti, the ground rumbles and a cloud of dust
rises from their hooves.

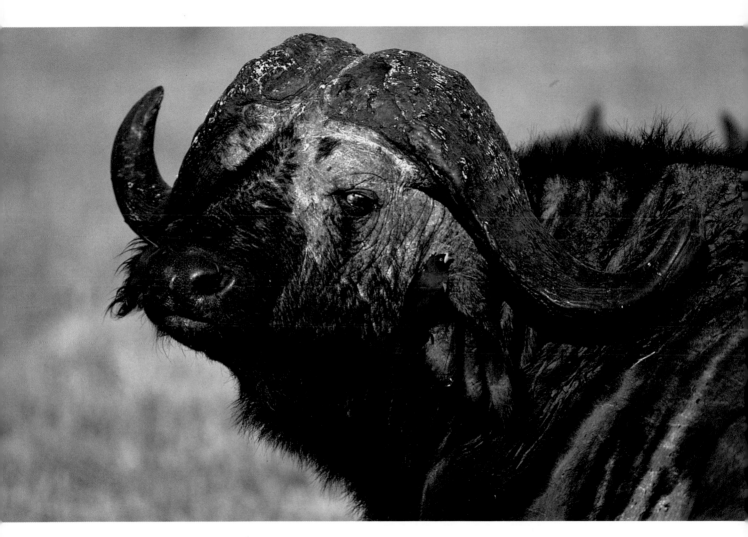

A yellow-billed oxpecker perches on an old buffalo's face.
The buffalo does not seem pleased with the bird's attentions.

following pages: During the rainy season, low clouds
often hang in the sky. Having visited a water hole,
this herd of giraffes returns to the woods.

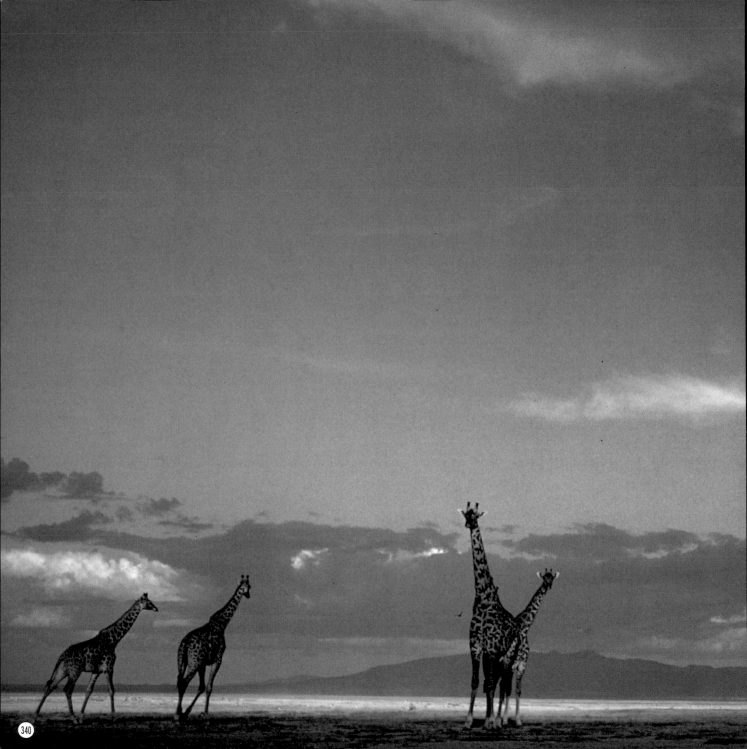

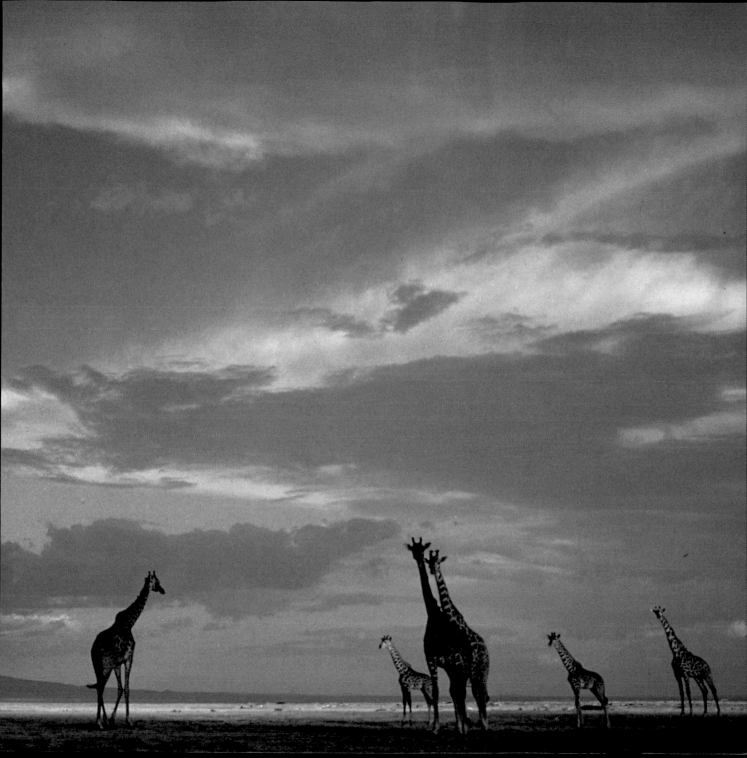

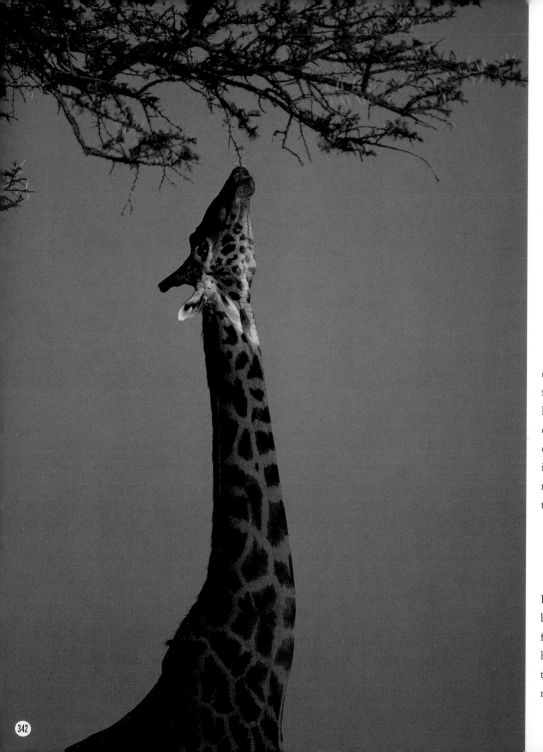

right: Although a giraffe's forelegs are longer than its hind legs, the animal moves easily because the legs on each side of the body work in unison. The long neck moves in synchrony, helping to maintain balance.

Its tongue and lips protected by tough knobs, a giraffe feeds on an acacia tree. The head tilts vertically through the action of a specialized neck joint.

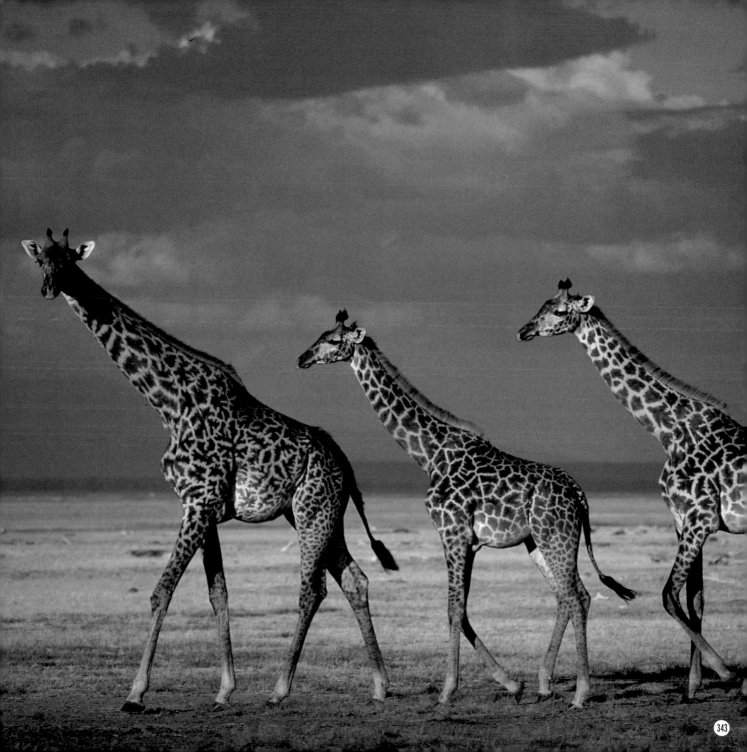

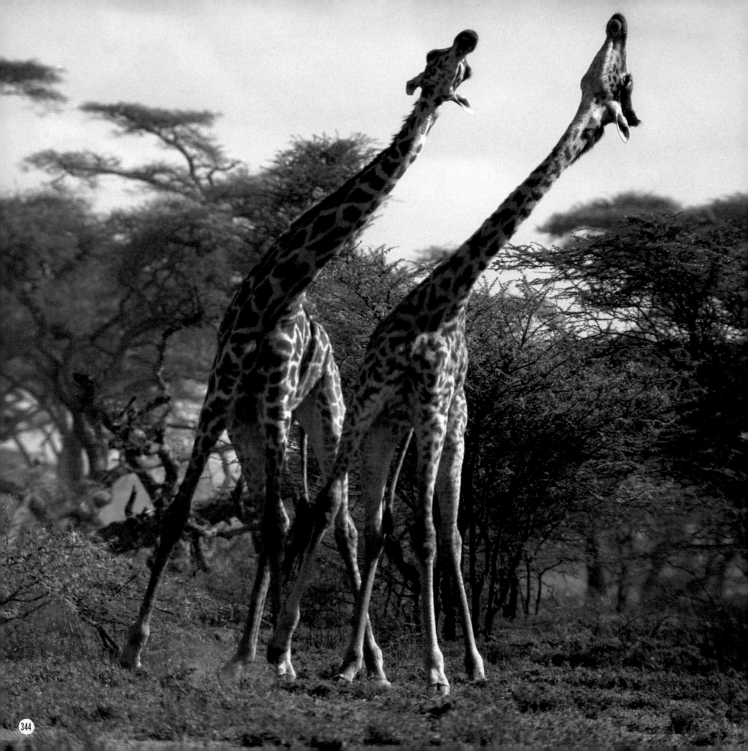

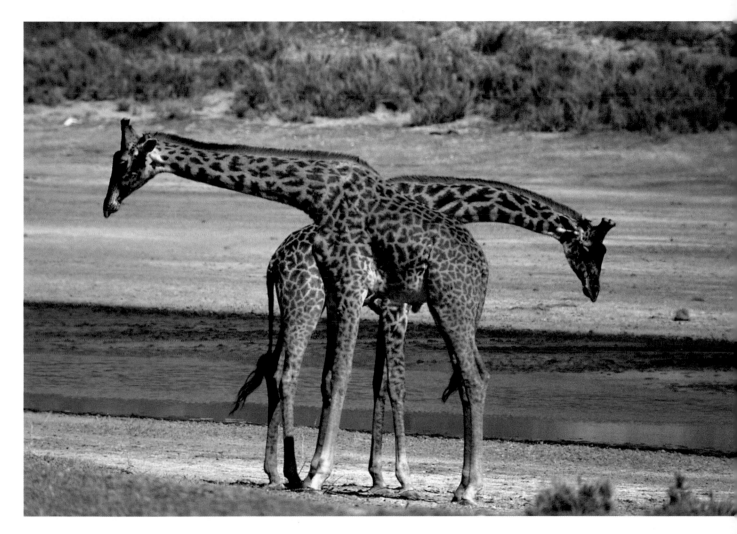

Each giraffe's dapple is unique.

left: Fights between bulls are somewhat stylized, side-by-side engagements. Nonetheless, a blow from a mature giraffe can be staggering.

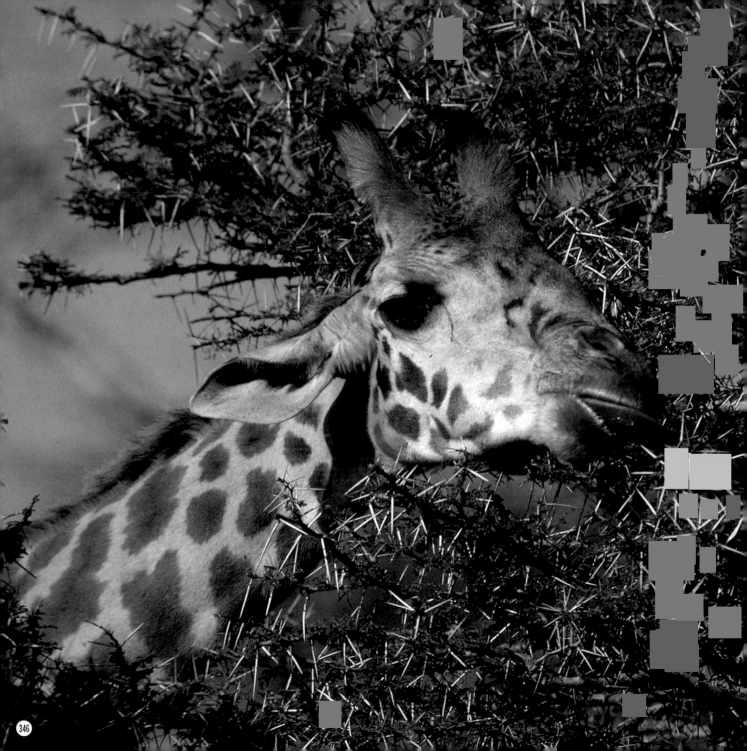

left: The bond between mothers and calves is strong. About two months after birth, a baby giraffe begins to eat leaves.

Despite its thorns, the acacia tree is a giraffe's favorite food. The giraffe's horns, particularly in a male giraffe, strengthen the head for fighting, which is generally a contest for sexual dominance and, hence, reproductive success.

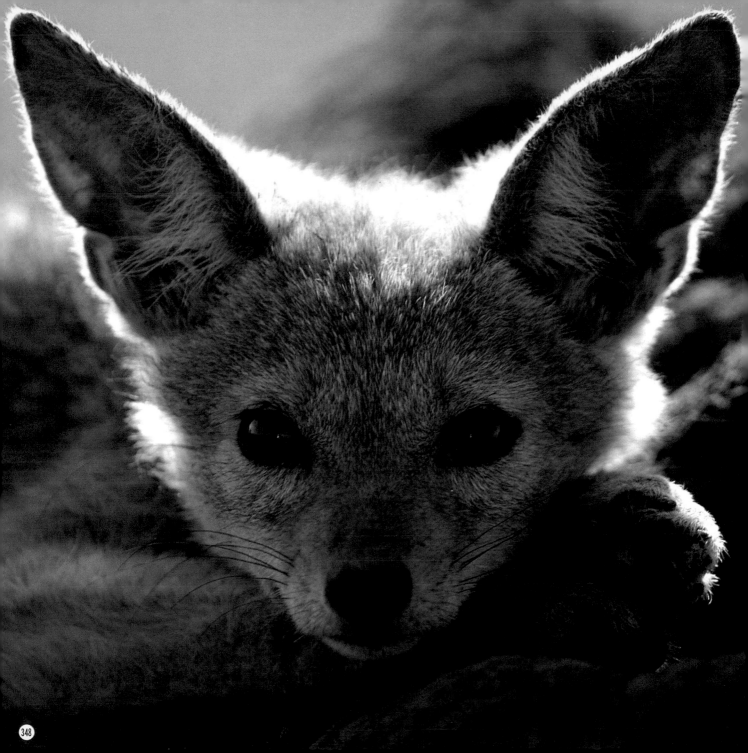

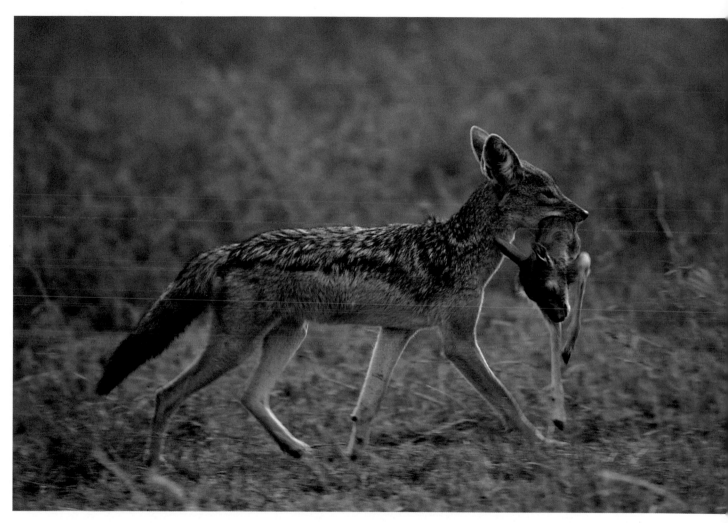

Silver-backed jackals prey regularly and successfully on Thomson's gazelles; however, the jackal will also consume insects, small rodents, and fruit.

left: About three weeks after birth, young silver-backed jackals emerge from the burrow and play together.

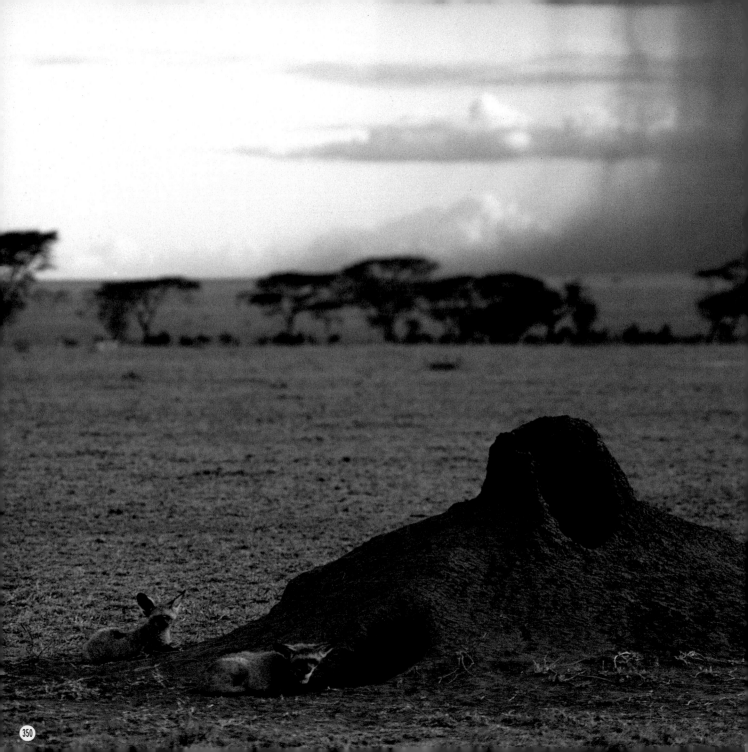

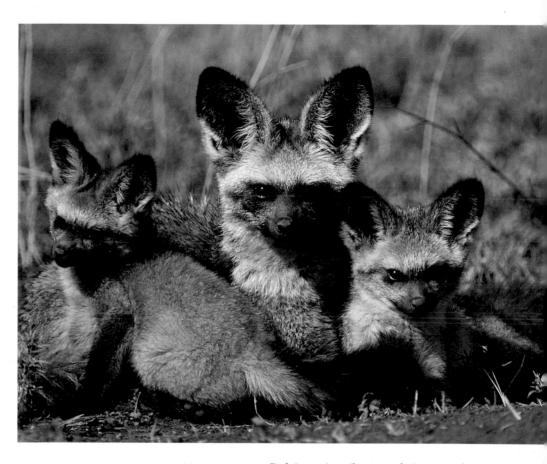

left: Preferring habitats with bare ground or short grasses, bat-eared foxes generally do not dig their own burrows but take over other animals' abandoned nests, such as this anthill.

Relying primarily upon their ears and nose—not their eyes—bat-eared foxes can locate insects even underground. When hunting, the fox moves its ears like two radars. When prey is located, it digs rapidly into the earth.

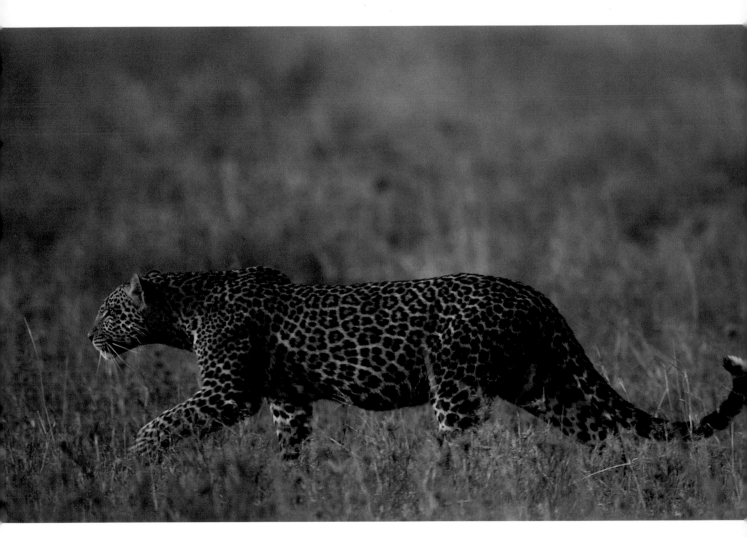

Barely two years old, this young leopard has failed to
capture a fleeing zebra. Leopards hunt most successfully
at night and from ambush; this youngster has not yet
learned either method.

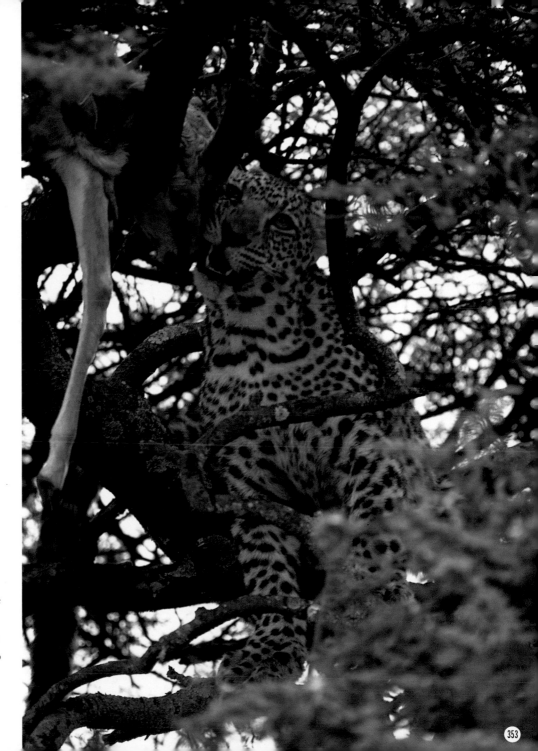

Strong, long-lasting bonds usually develop between mothers and cubs. This mother leopard pulled a Thomson's gazelle into a tree, then fetched her male and female cubs. First, the male cub went up the tree to eat, then the female cub ate. The mother left without eating.

following pages: Cape hunting dogs attack a blue wildebeest. A weakened or slow animal is spotted, and the dogs chase it until one of the pack can grab the victim's leg or tail. The rest of the pack soon swarms over the prey, attacking its back, not the front, and literally eating the animal to death.

Cape hunting dogs probably could not survive as single hunters. In a pack, however, they are highly efficient, exhibiting a great degree of canine cooperative behavior. Able to maintain a pace of thirty-five miles per hour for several miles, they usually run their quarry to exhaustion.

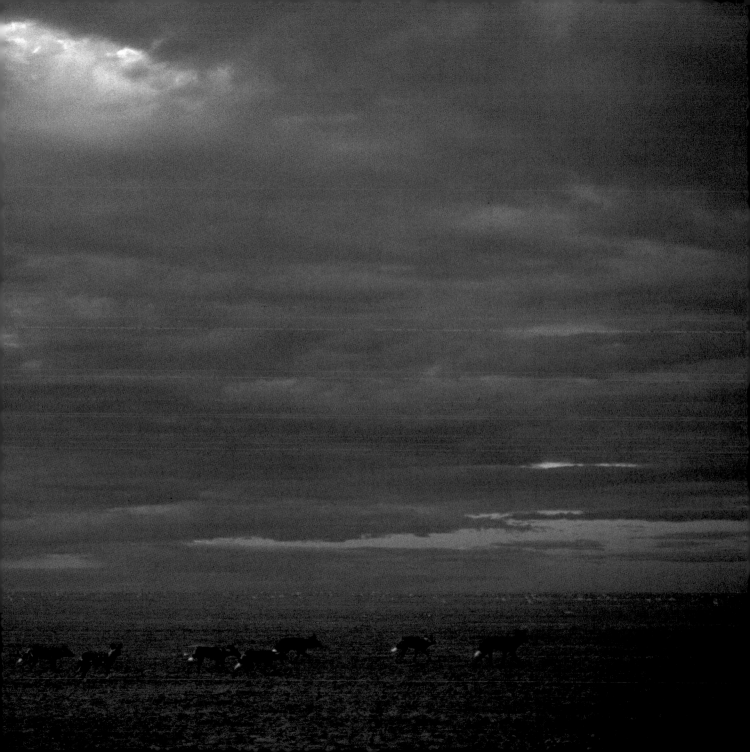

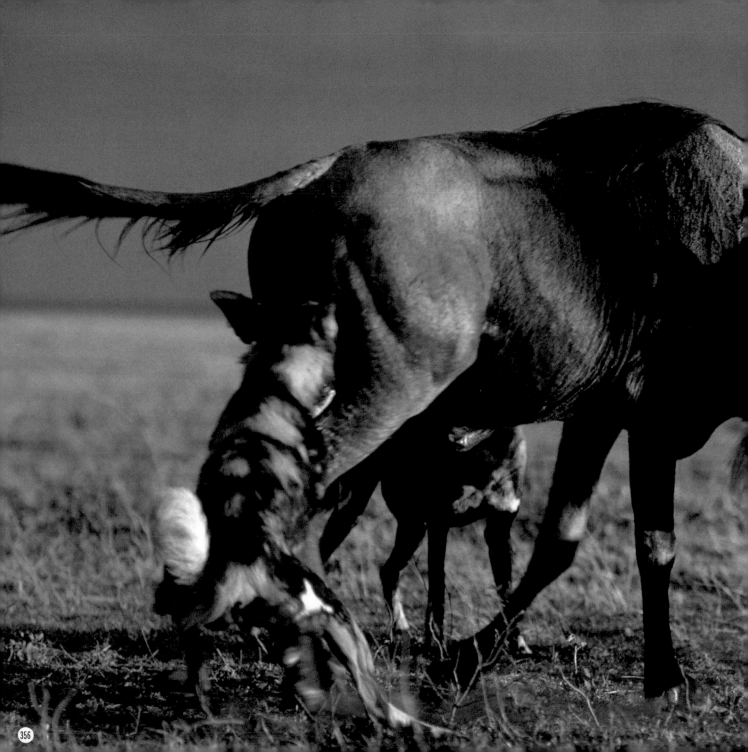

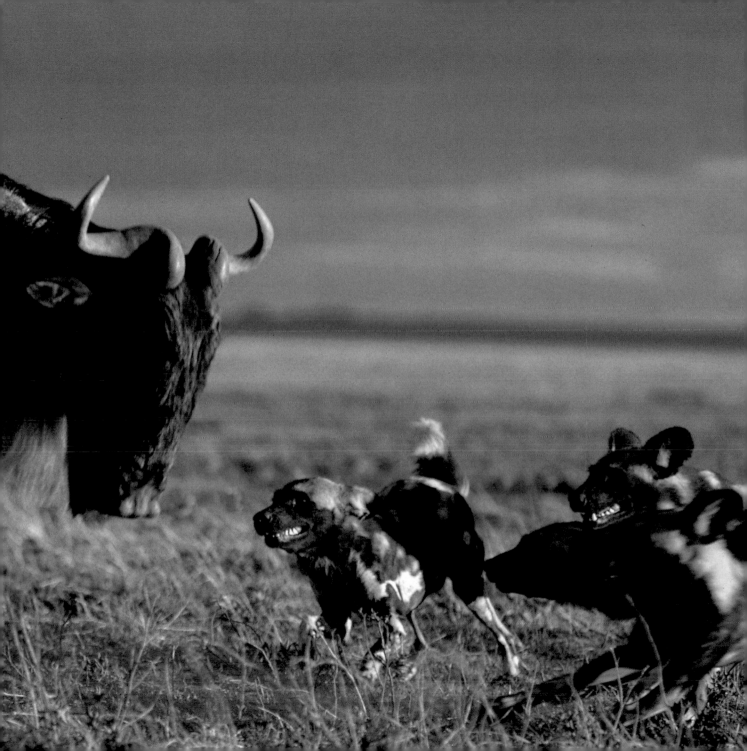

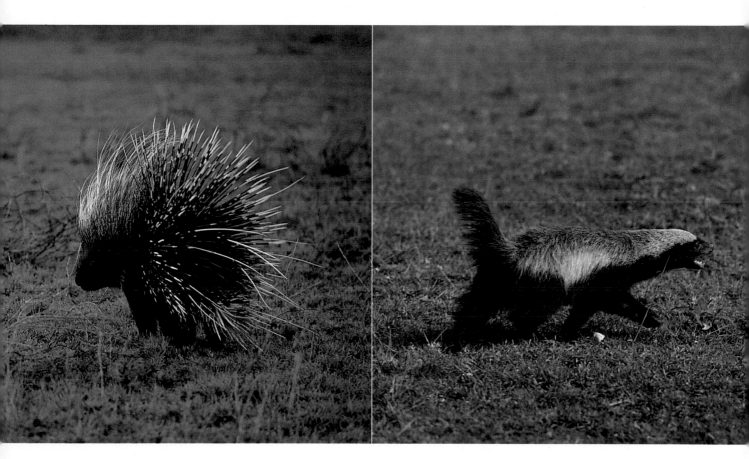

left: The tufted ears and strong hindquarters are characteristic of the caracal, which can jump so quickly and so high that it can take birds in flight.

The Cape porcupine may grow to be as large as a medium-sized dog. It shakes its sharp spines to threaten its enemies.

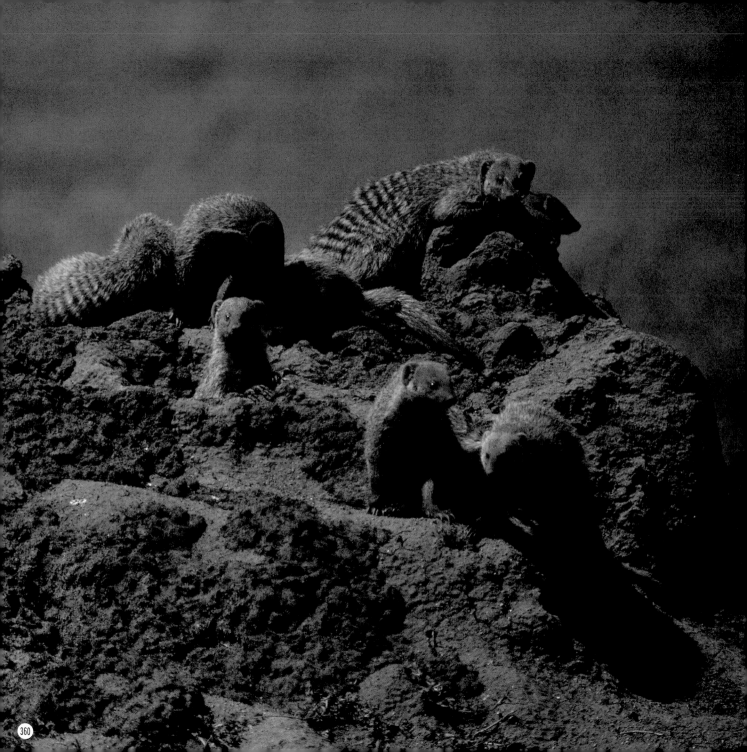

left: Gregarious and loyal to other pack members, banded mongooses have a well-developed social system with rank determined not so much by gender as by age and temperament.

When banded mongooses are on alert, they all stand up together. When they run, they all run together. Mob attacks against predators make the pack a fearsome adversary, even for animals such as jackals or eagles.

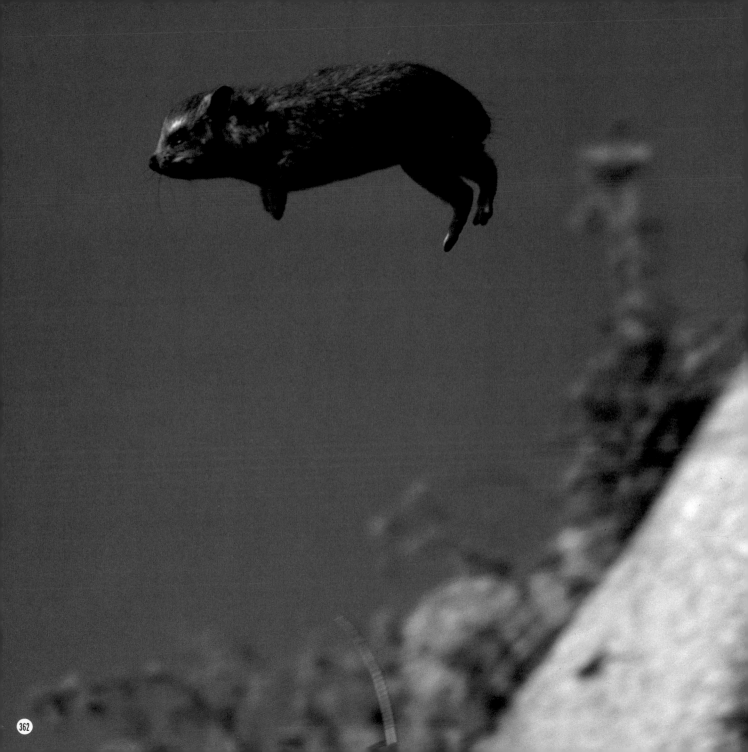

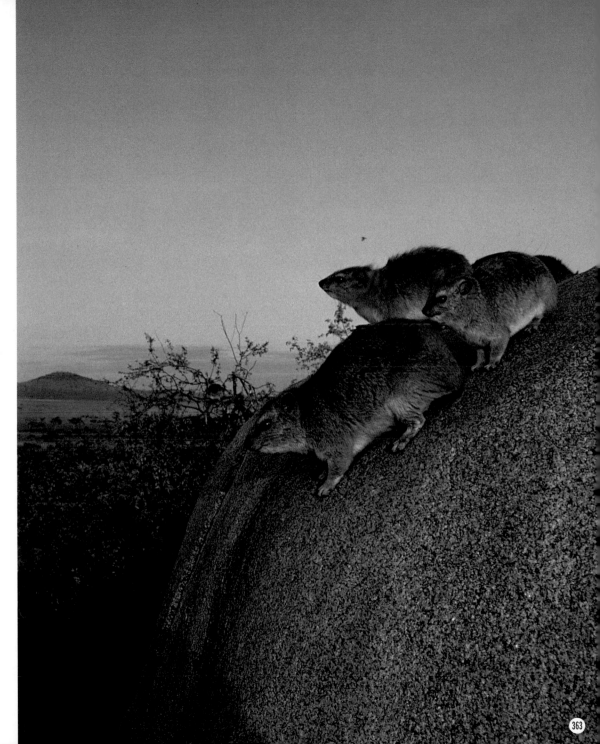

left: Approximately the size of a marmot, the Cape hyrax has very little control over its body temperature. On chilly mornings, they are often seen on rocks, basking in the sun. When warm enough, they can begin to forage.

Small and distant relatives of the elephant, hyraxes have evolved from terrestrial herbivores to a species at home on steep rocky terrain. Their rubbery-soled feet are particularly adapted for climbing.

In the evening sun, a
cheetah reaches speeds of
ninety miles per hour in
pursuit of prey. It must
capture its quarry in the
first thousand feet of a
chase, or the cheetah will
become too winded to
continue.

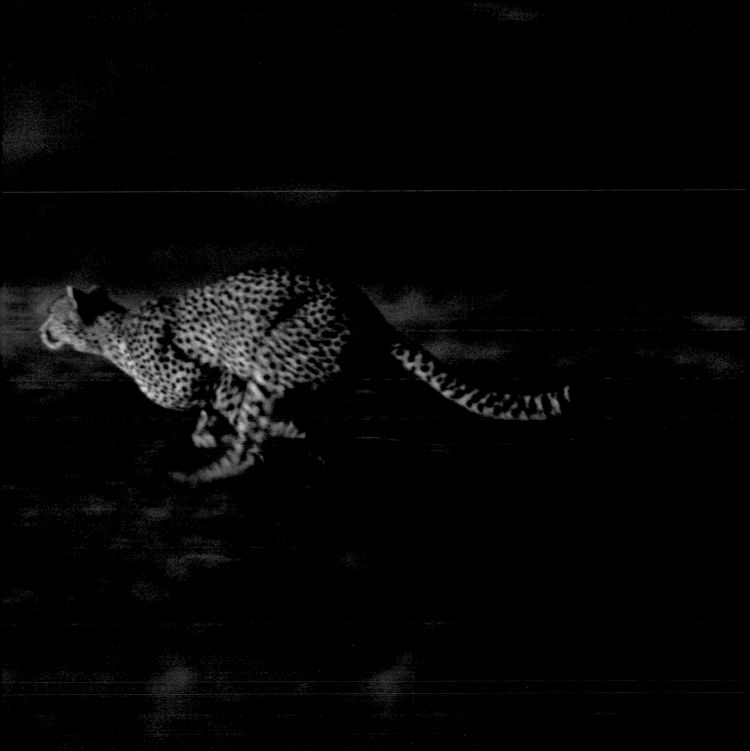

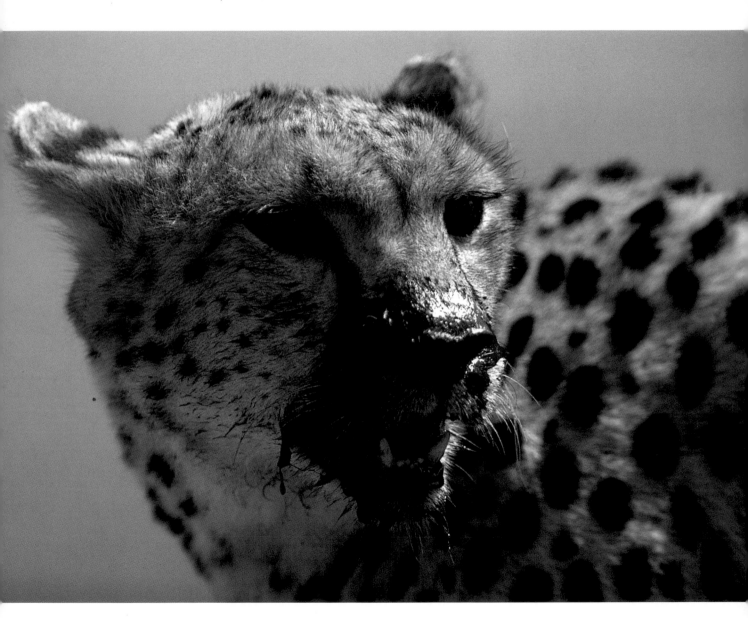

Once the prey is caught, it is eaten as soon as possible, because
other predators—such as hyenas, lions, and leopards—may try
to intimidate the cheetahs into giving up their quarry.

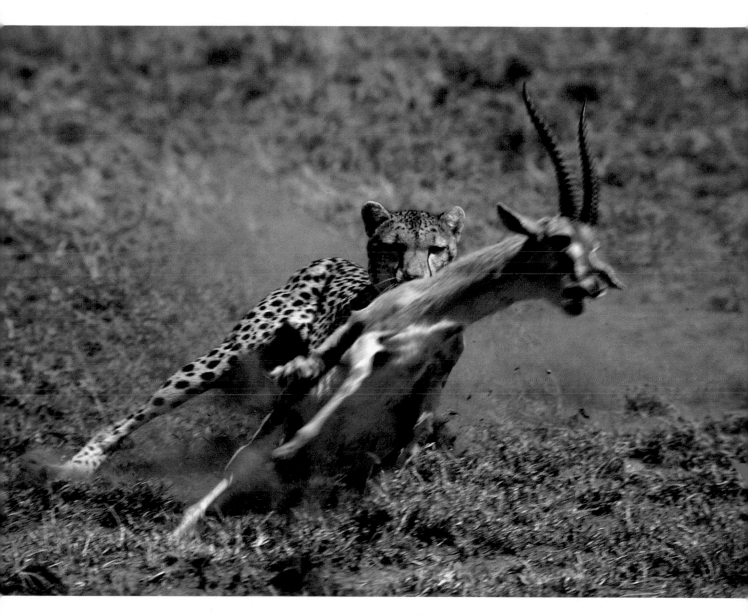

Cheetahs hunt in the daytime. Overtaking its quarry, the cheetah knocks it off balance with a strike to its haunches, then lunges for the throat to bite the windpipe and suffocate the struggling animal.

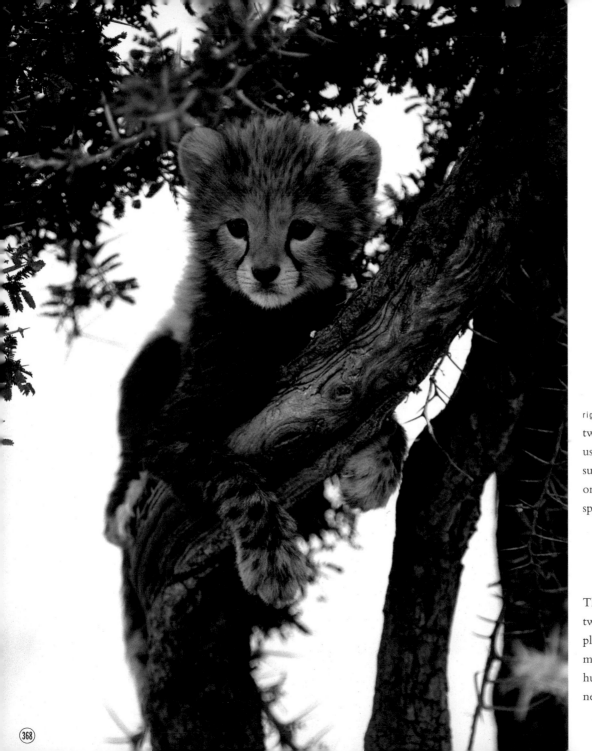

right: A mother and her two cubs. Cheetahs often use an anthill to view the surrounding area, relying on their keen eyesight to spot prey or threats.

This cub is about one to two months old. Through play and emulation of their mother, cubs learn the hunting skills they will need to survive.

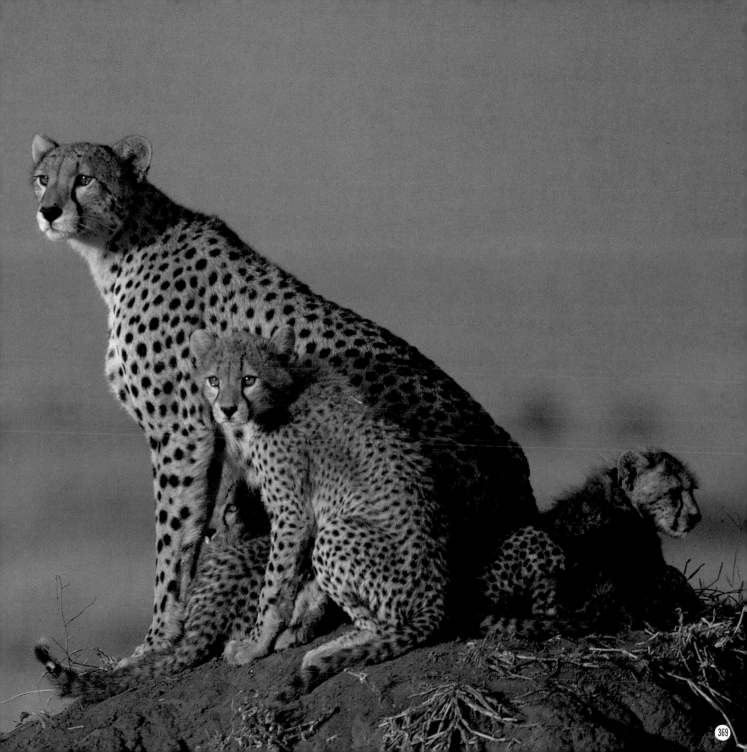

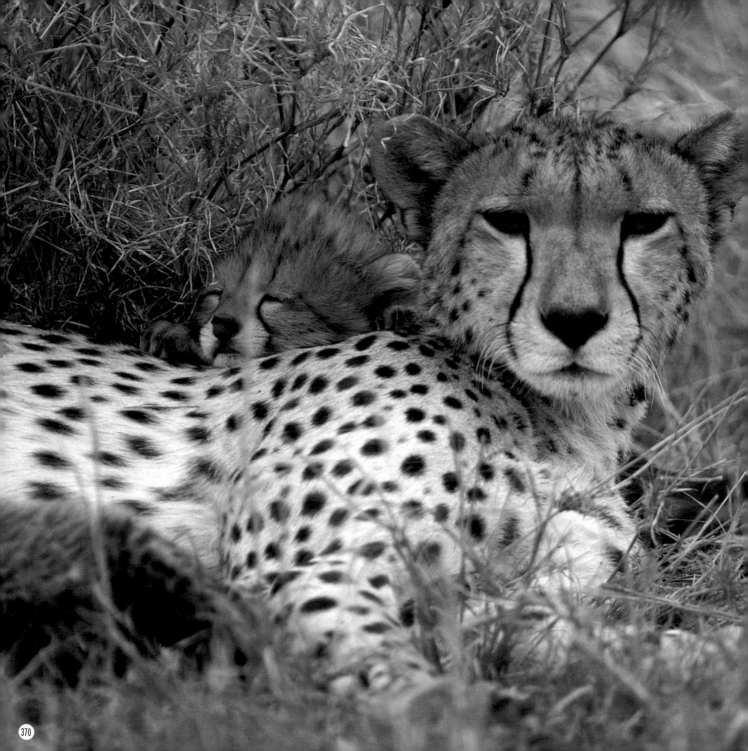

left: When cheetahs lie down, they are difficult to find. The cubs stay hidden until they hear their mother's call, which sounds like that of a bird.

A sudden downpour drenches this cheetah family.

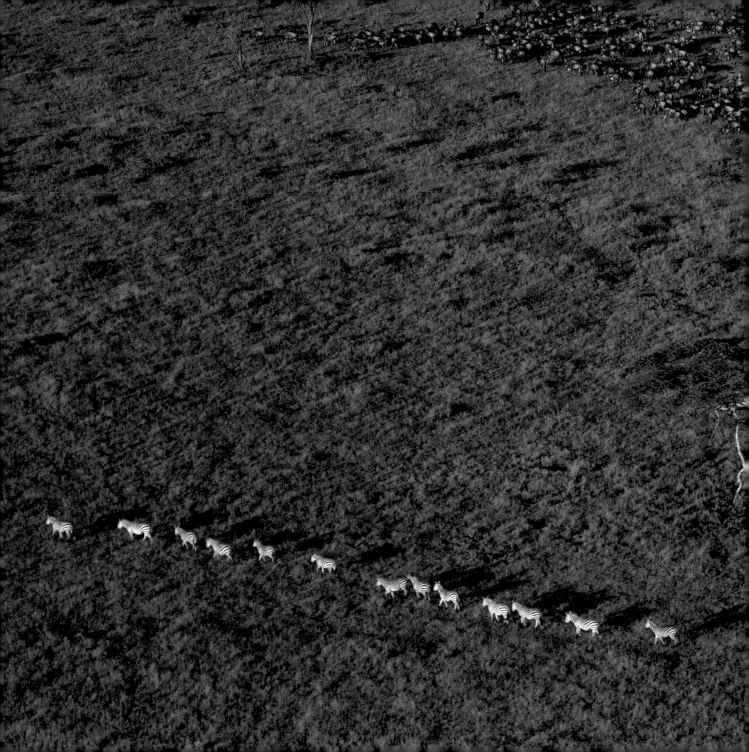

Burchell's zebras and
wildebeests walk to water.
In Seronera, a river is
formed during the rainy
season. In the mornings
and evenings, herds of ani-
mals flock there to drink.

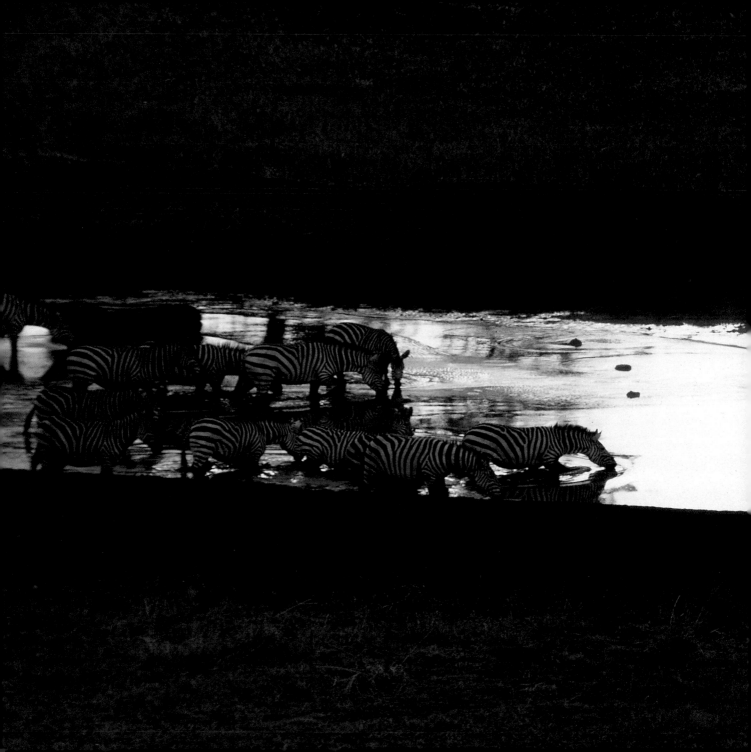

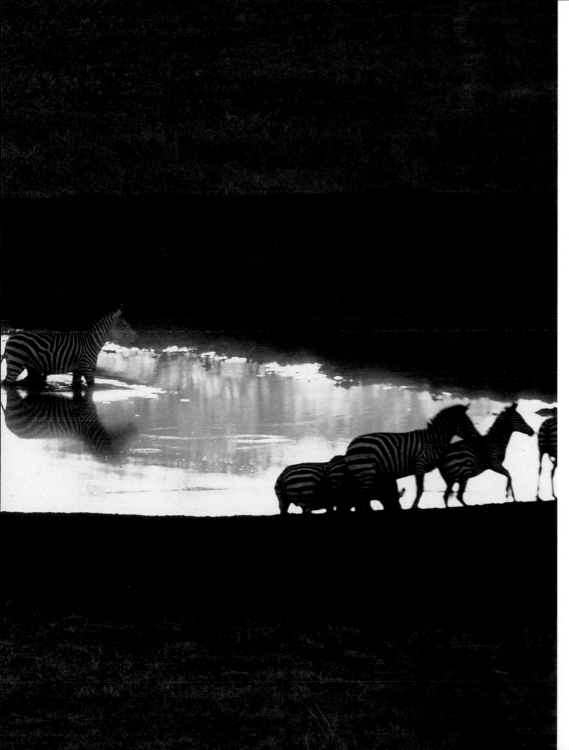

As Burchell's zebras approach the water, they become increasingly cautious. When one finally starts drinking, others will follow. Once they begin to drink, the zebras seem to become less alert, and stragglers are often attacked by lions.

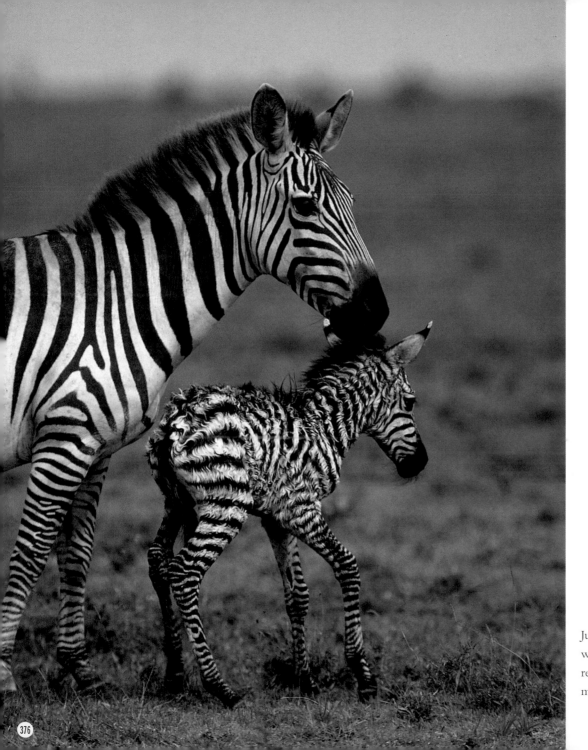

Just born, with its fur still wet, this young zebra is ready to follow behind its mother.

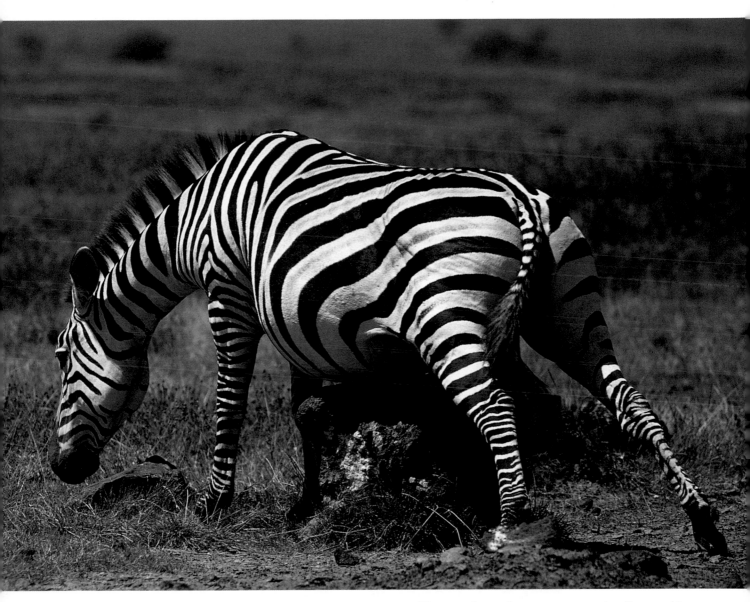

There are few rocks or trees appropriate for scratching in the Serengeti. When zebras find a good rock, several of them might stand in line for their turn.

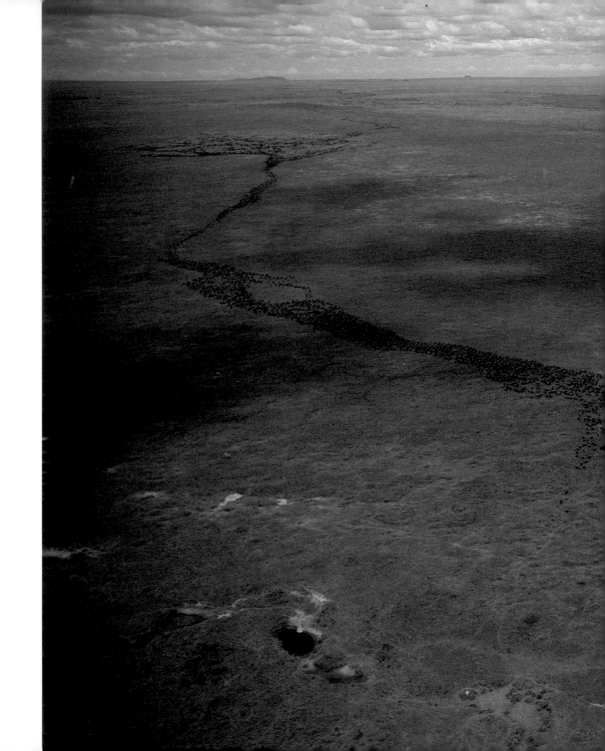

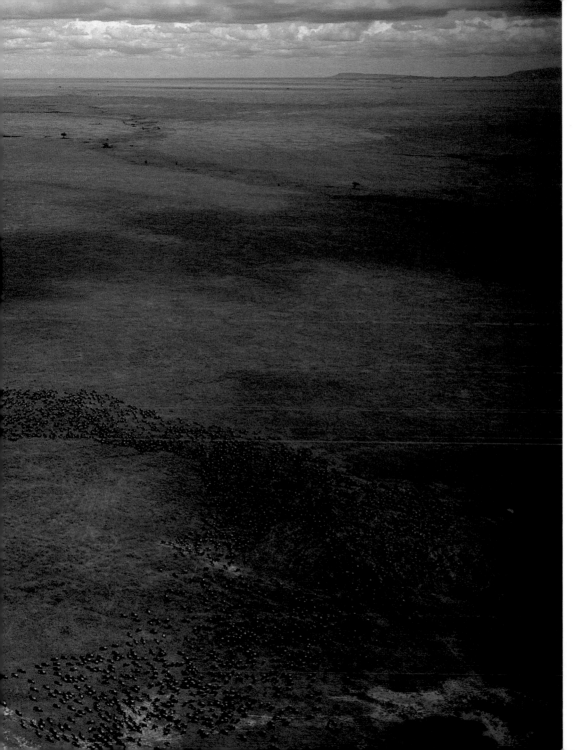

A huge herd of wildebeests moves across the plain. For a few days a year, several million wildebeests gather together to migrate.

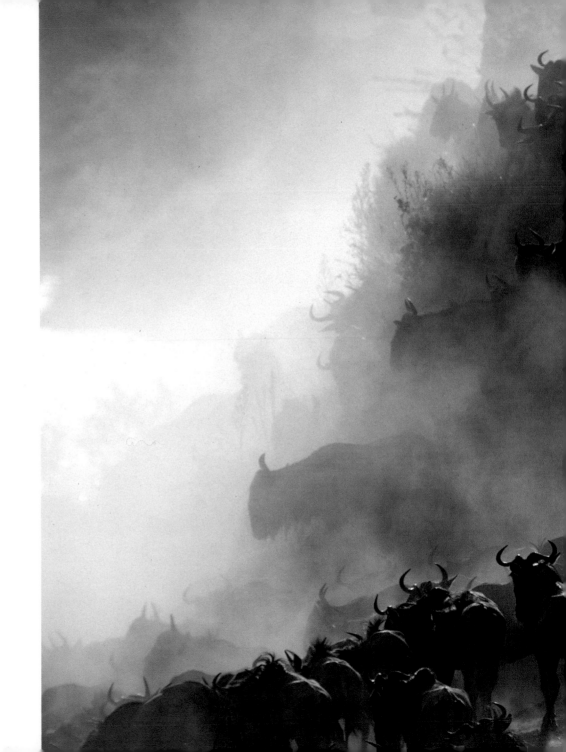

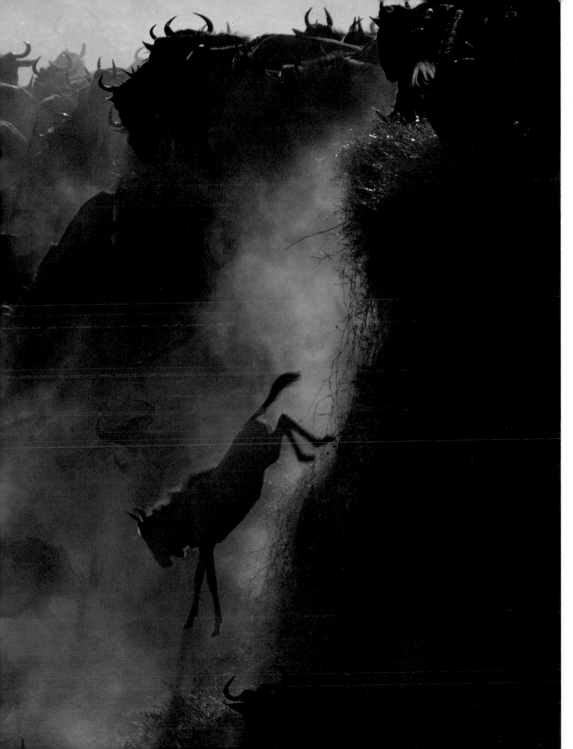

On the cliff above the river, the wildebeests pause briefly. One jumps off the cliff at last, and then millions follow, their fear overcome by the migrating instinct.

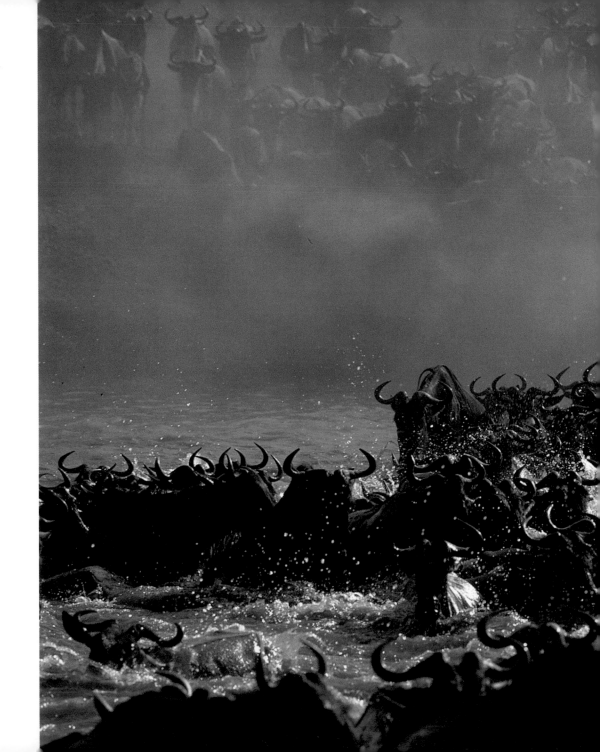

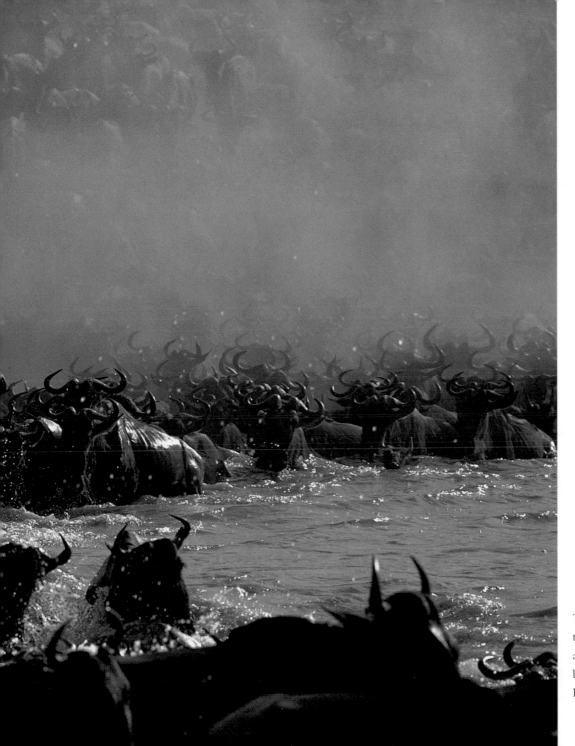

The wildebeests have
to push their way
across the Mara River
between Tanzania and
Kenya.

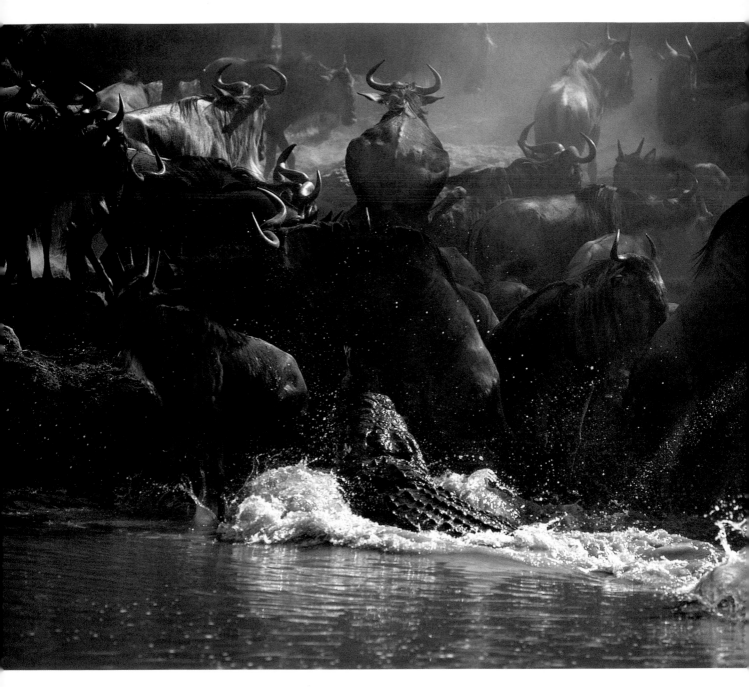

Nile crocodiles hide where wildebeests cross. One surprised wildebeest fell in the deep water, where the crocodile attacked him.

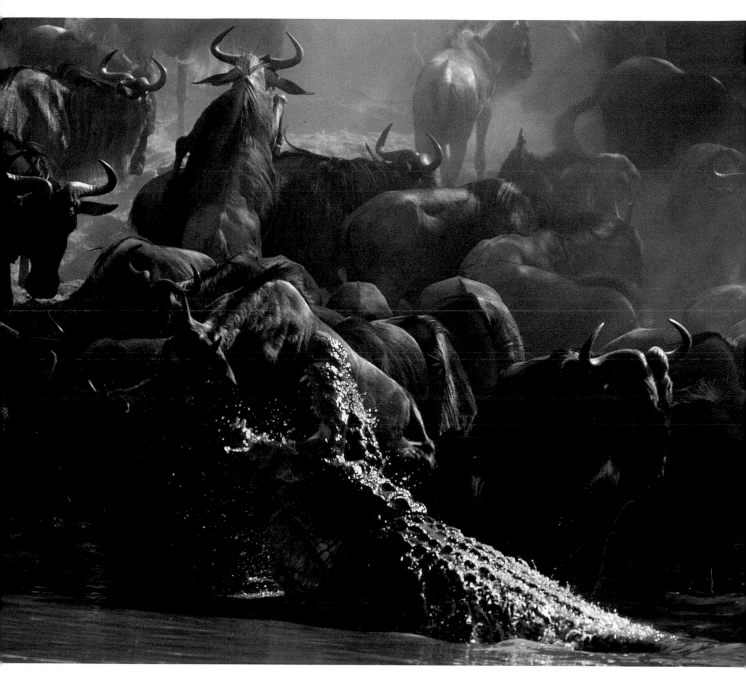

In the blink of an eye, the crocodile grabbed the wildebeest and pulled it into the water.

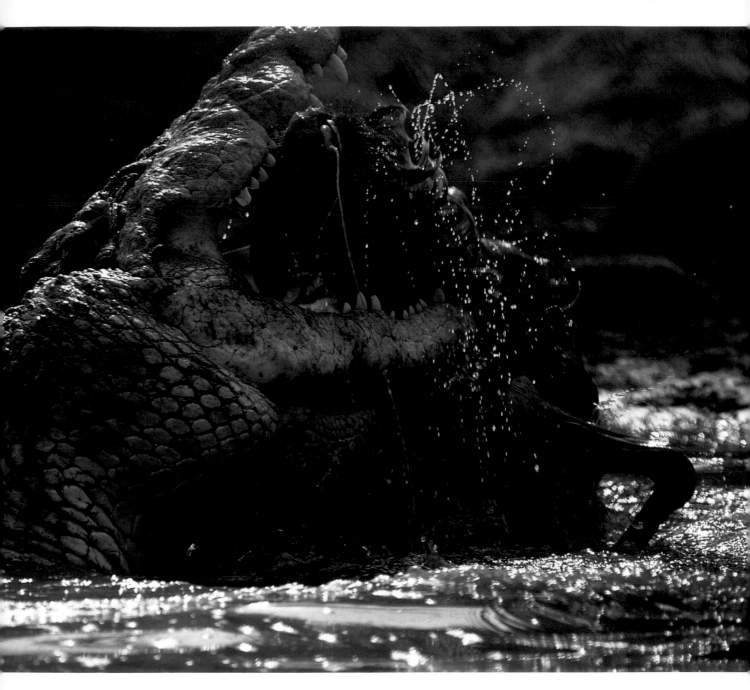

The crocodile drowns its victim on the river bottom and then brings it to the surface to eat.

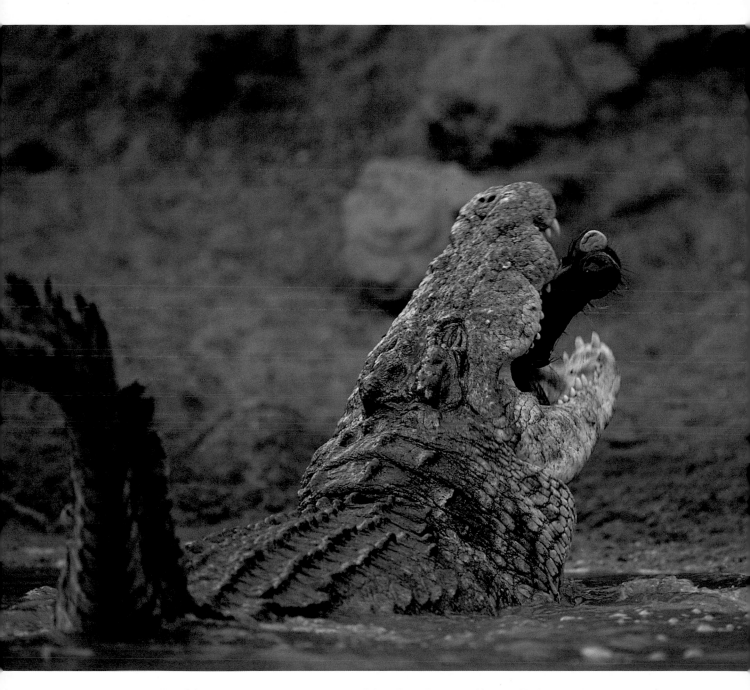

A crocodile of this size faces no competitors. Catfish and smaller crocodiles usually feed on the victim underwater.

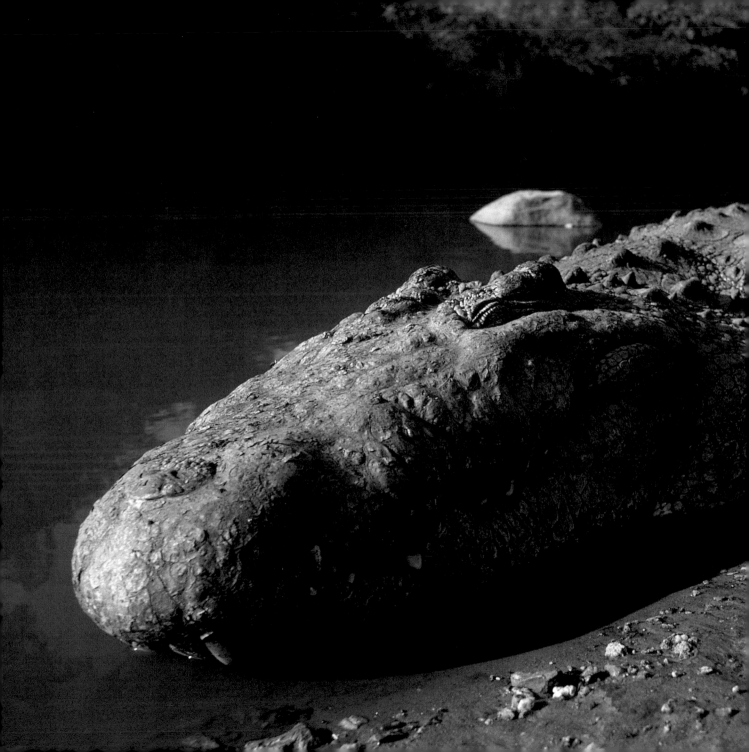

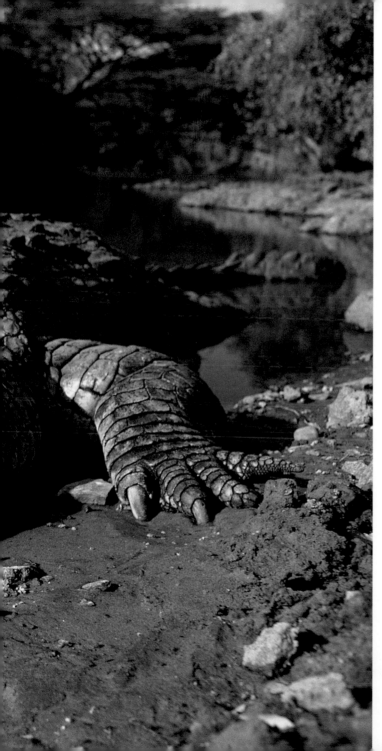

Only during the two
seasonal migrations can
crocodiles prey on big
animals such as wildebeests.
When the migration starts,
the crocodile stays in the
same spot, waiting for
a victim.

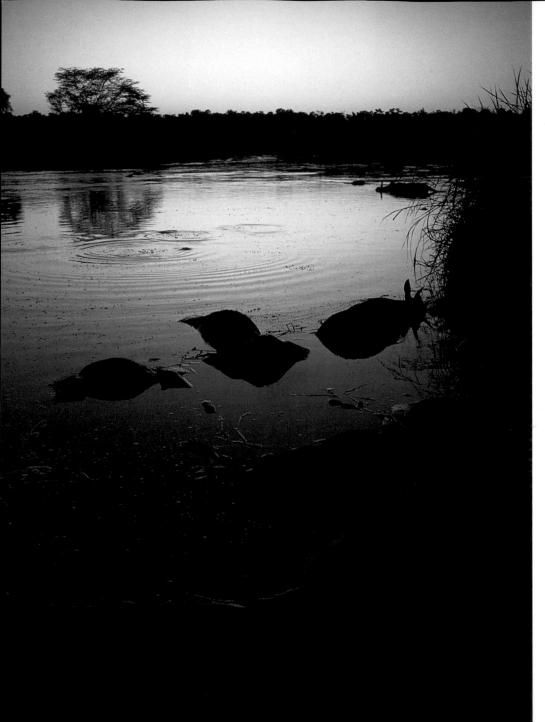

Unable to clear the cliff, the last difficult stretch in the migration, hundreds of blue wildebeests die every year. Bald eagles, crocodiles, and fish feed on them.

following pages: Wildebeests on the move. While they travel several hundred miles between the Serengeti Plain in Tanzania, and Masai-Mara National Park in Kenya, many thousand will die, but the herd will complete its migration.

Insect attacks are constant irritations. Bull wildebeests are also kept busy watching their cows and fending off other bulls.

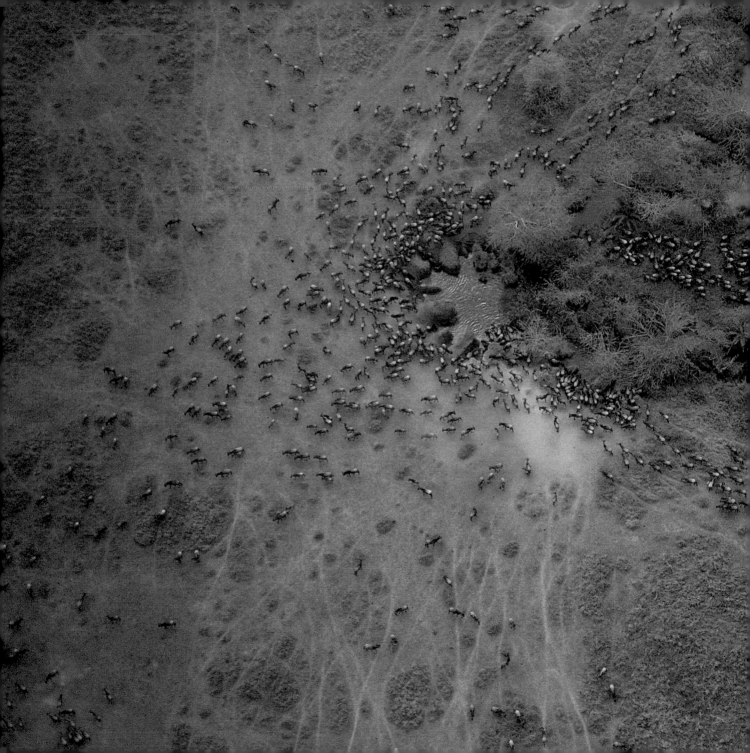

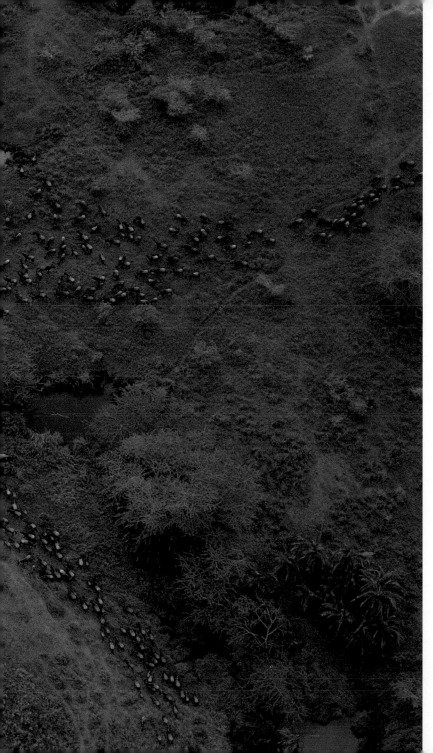

Wildebeests flock to the river for water. The light reflecting off the pool hides the crocodiles.

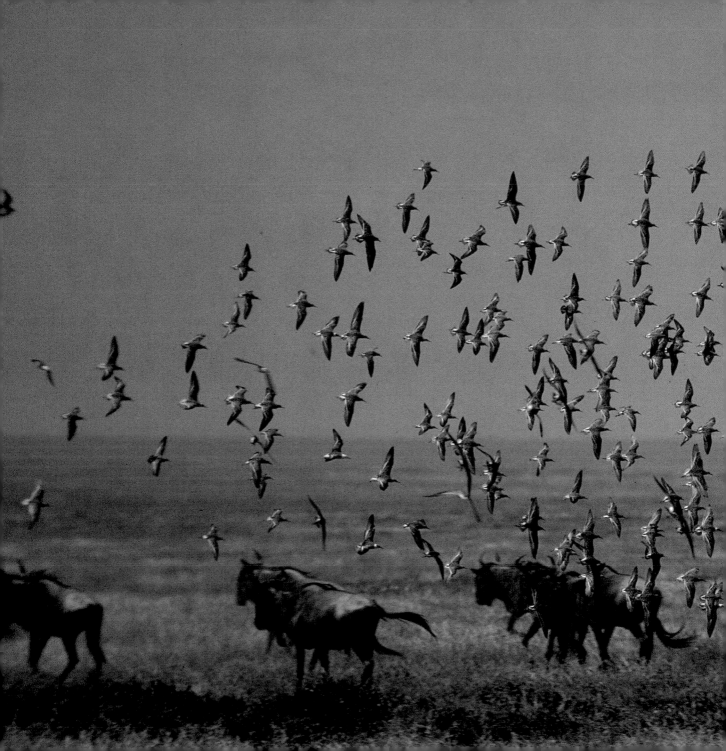

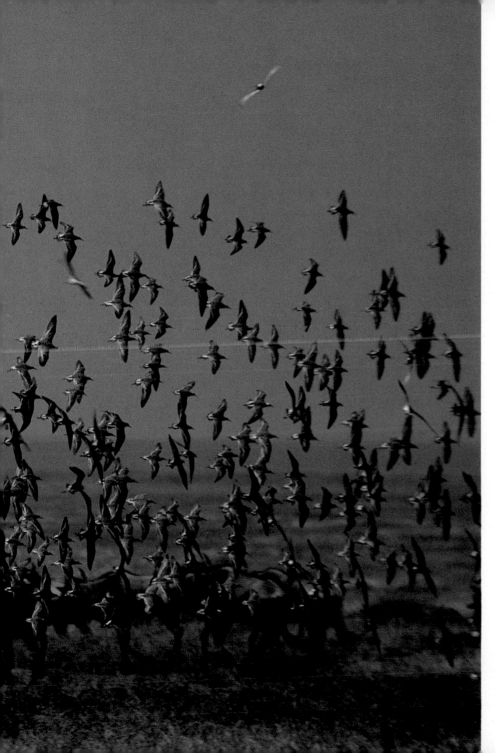

Red knots fly in formation above these blue wildebeests. By the time the wildebeests arrive on the plain, they are so thin that their ribs show. With the rain, grass begins to grow; in a month, the wildebeests' bodies and hides are healthy and lustrous.

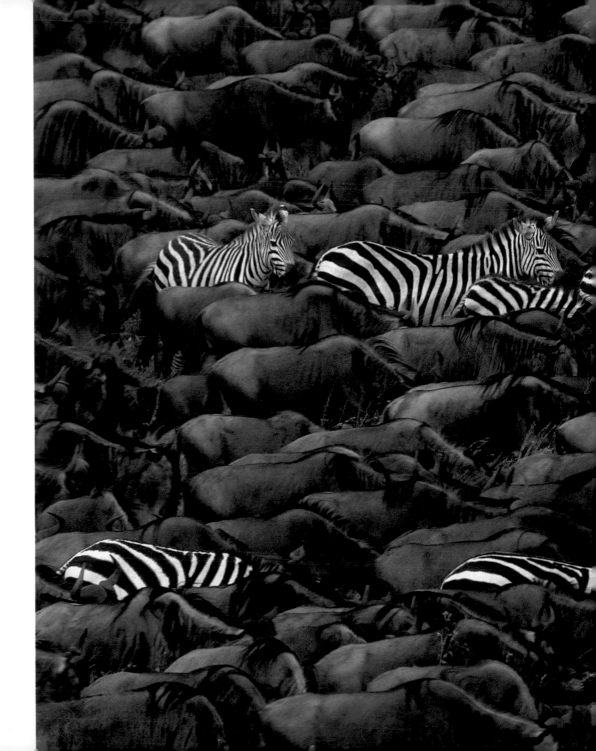

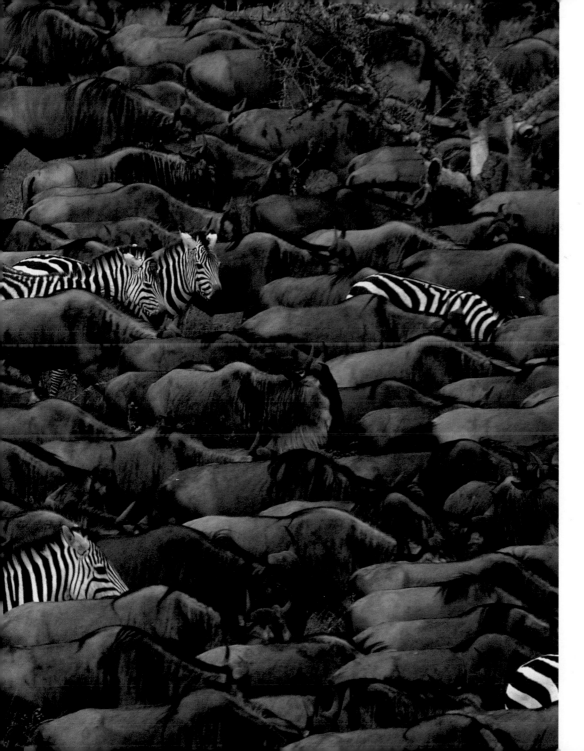

Sometimes zebras join blue wildebeests in migration. Blue wildebeests march in groups of bulls, cows, and calves. Zebras march in families.

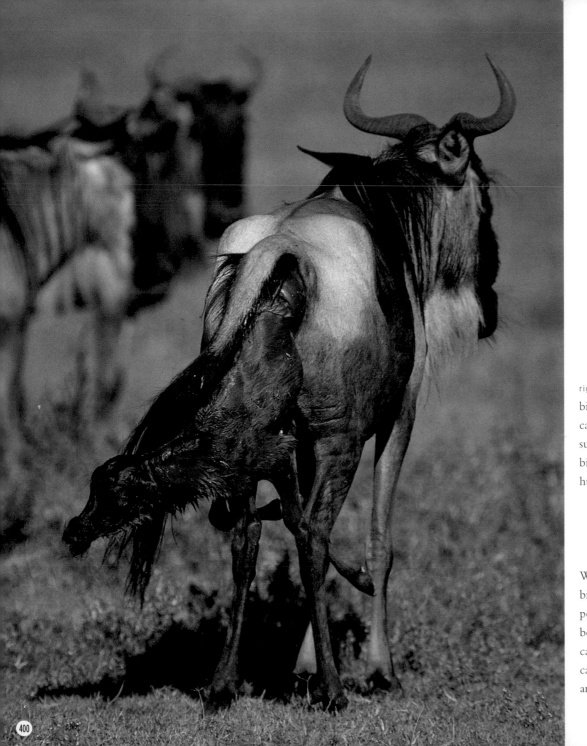

right: Within minutes of birth, a young wildebeest can run with its mother, a survival necessity since the birthing season attracts hundreds of predators.

Wildebeests generally give birth during a three-week period. Few youngsters are born early, and once one calf is born in a herd, other calves will be born one after another in a chain reaction.

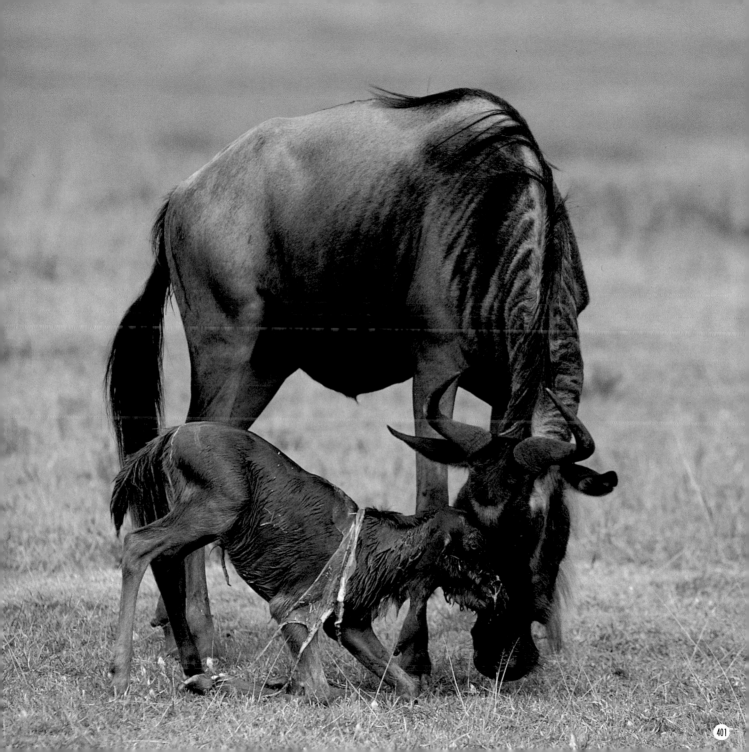

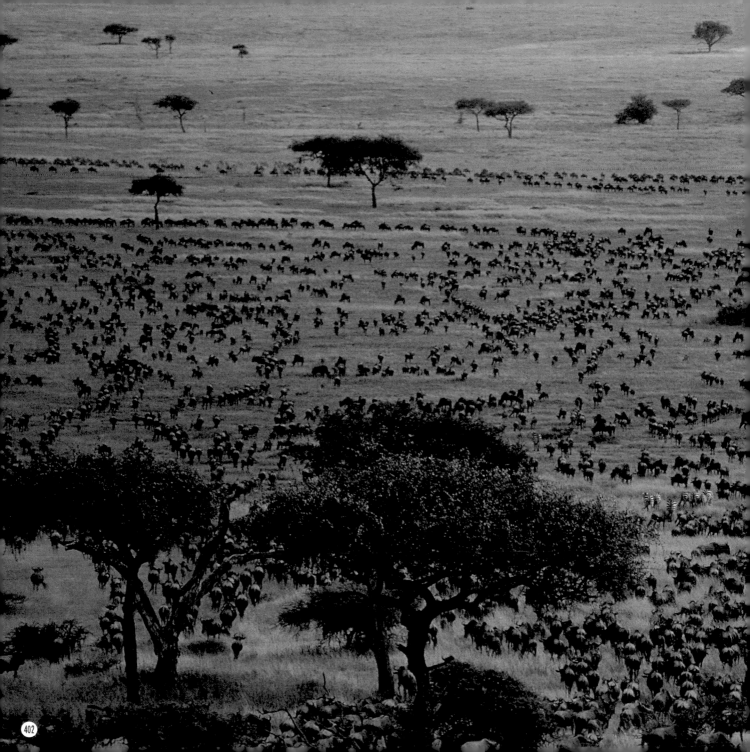

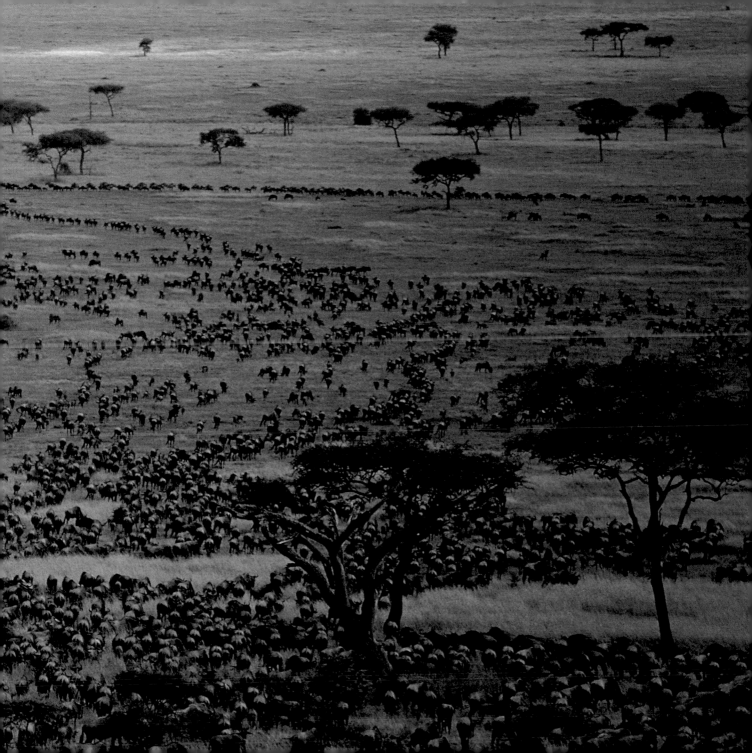

preceding pages: Coming from every corner of the plain, blue wildebeests gather for the migration.

Rain and fog bring the grass on which the wildebeests will feed.

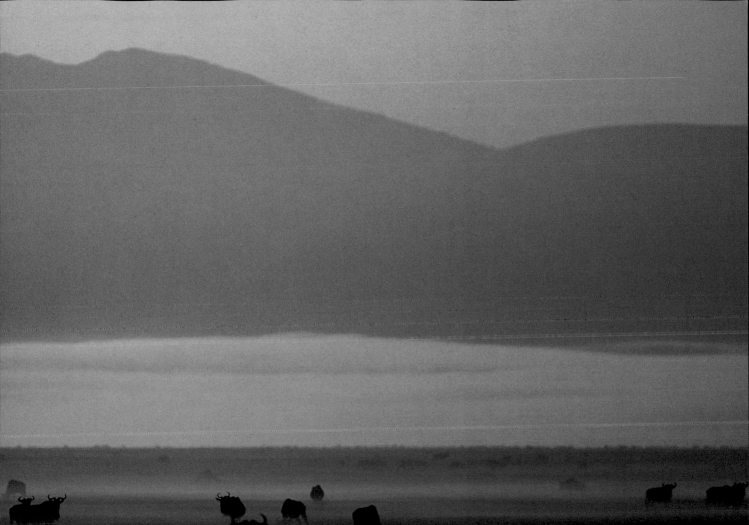

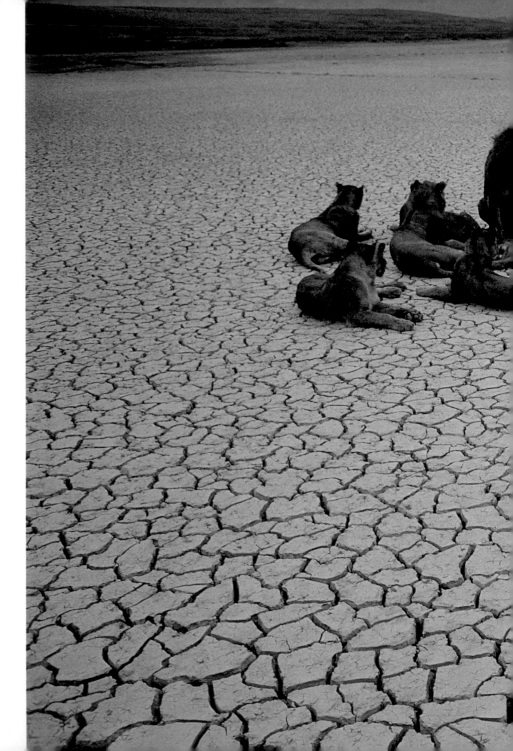

following pages: When
the blue wildebeests and
zebras have migrated
from the plain, the lions
go after big prey such as
the African buffalo. As
the buffalo bellows,
white breath comes out
of his mouth.

A desolate landscape
during the dry season
in Ngorongoro will
be a swamp when the
rains come.

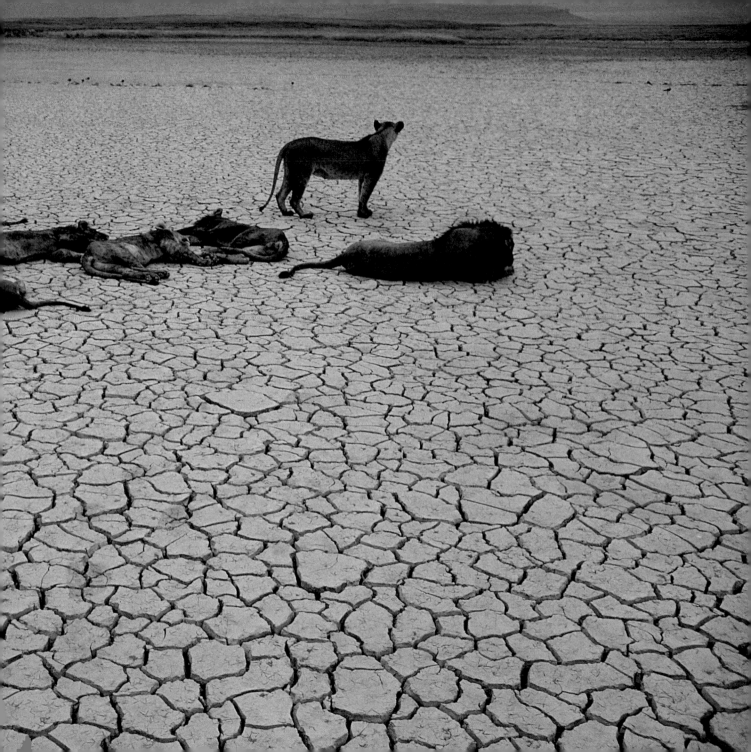

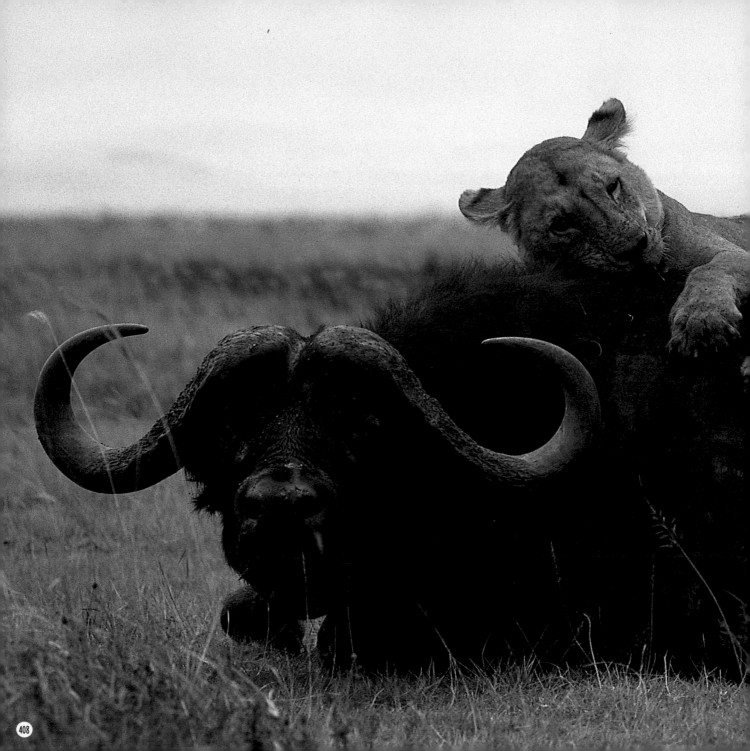

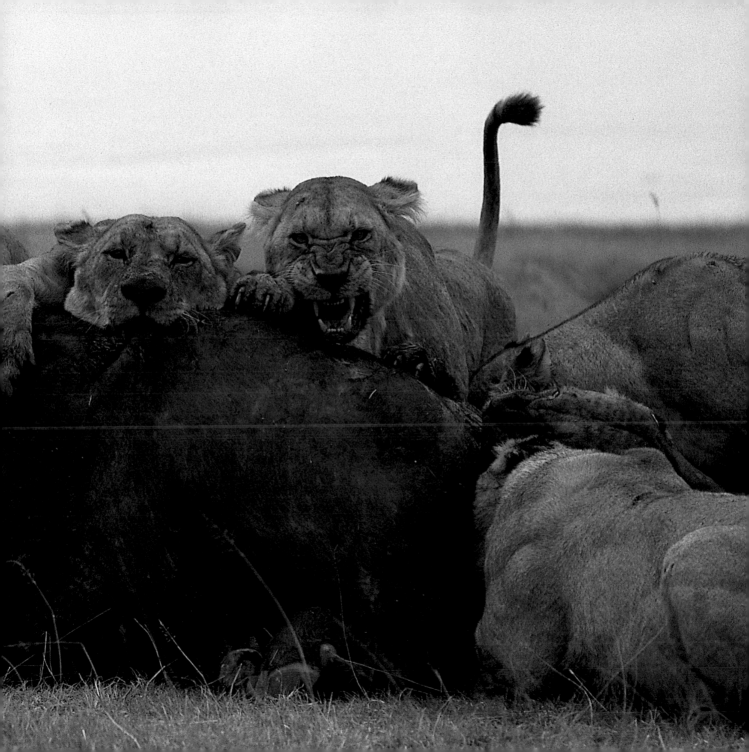

Urinating in fear, a lion is being chased because he went too close to this buffalo.

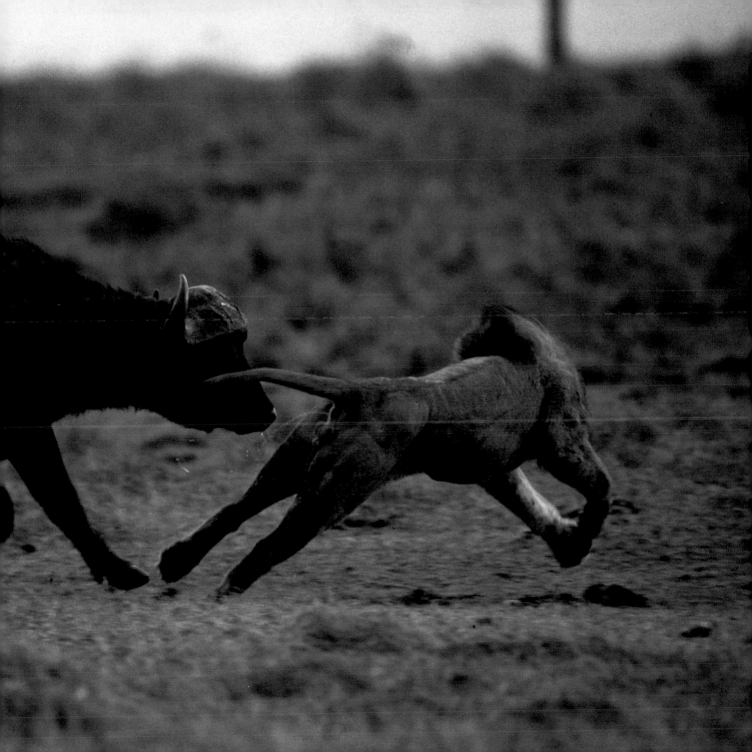

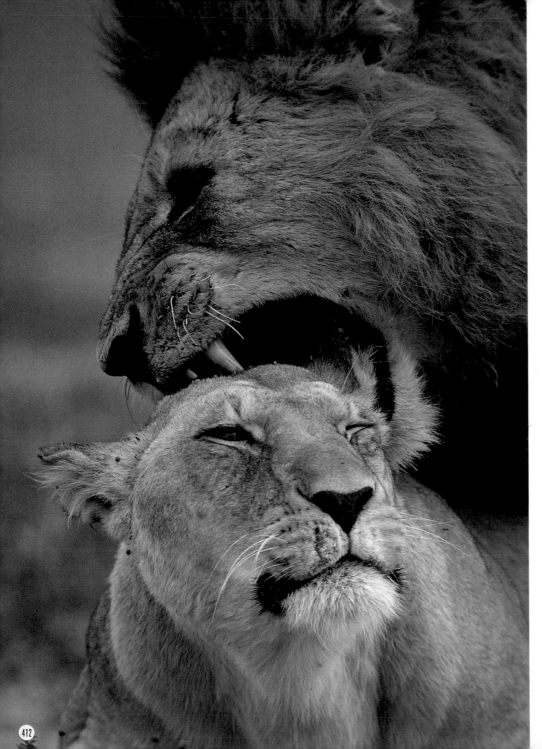

While mating, the lion nips at the neck of the lioness. After mating, he jumps clear, fearing she will attack him.

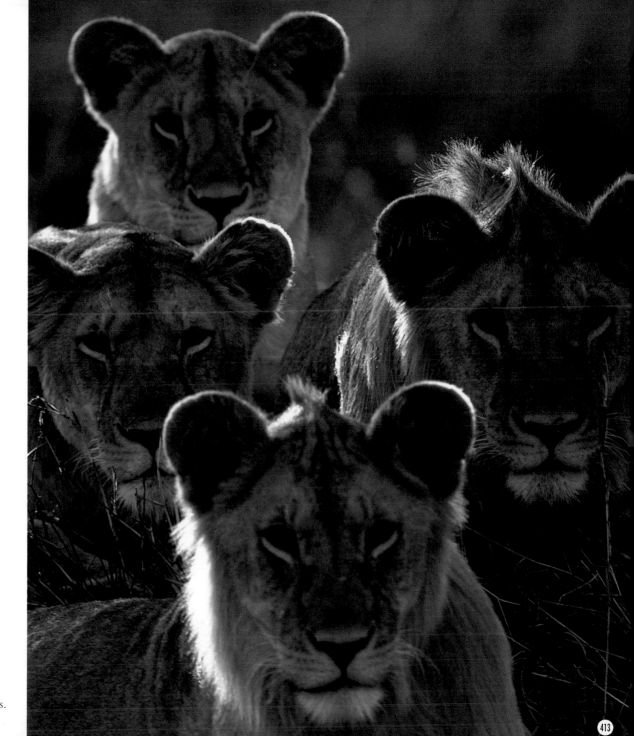

These fully grown lions and lionesses are two to three years old. A group, or pride, of lions is primarily composed of five to ten lionesses, their cubs, and a few adult males.

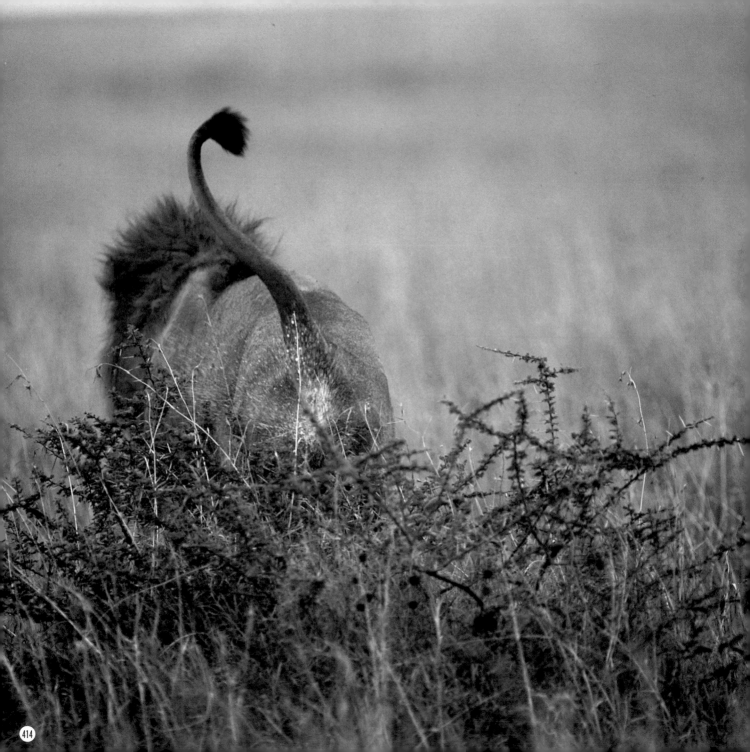

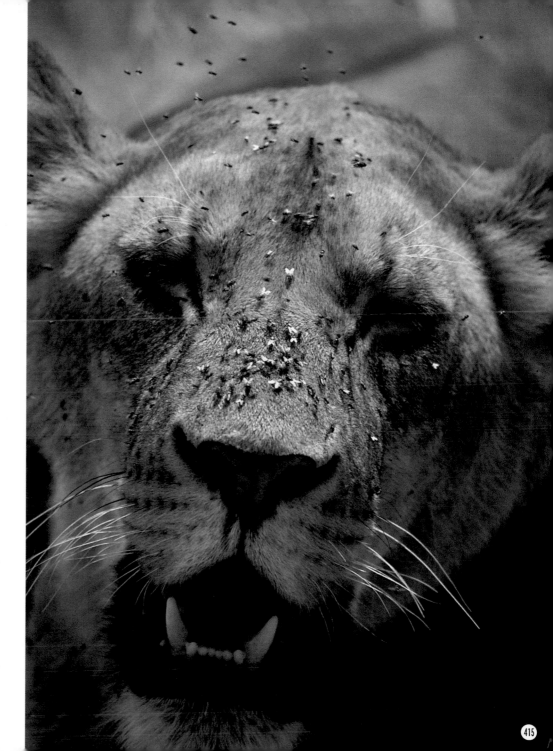

left: To mark his territory and a pride's location, this male lion urinates on certain strategic bushes.

Flies are a normal part of life in the African brush.

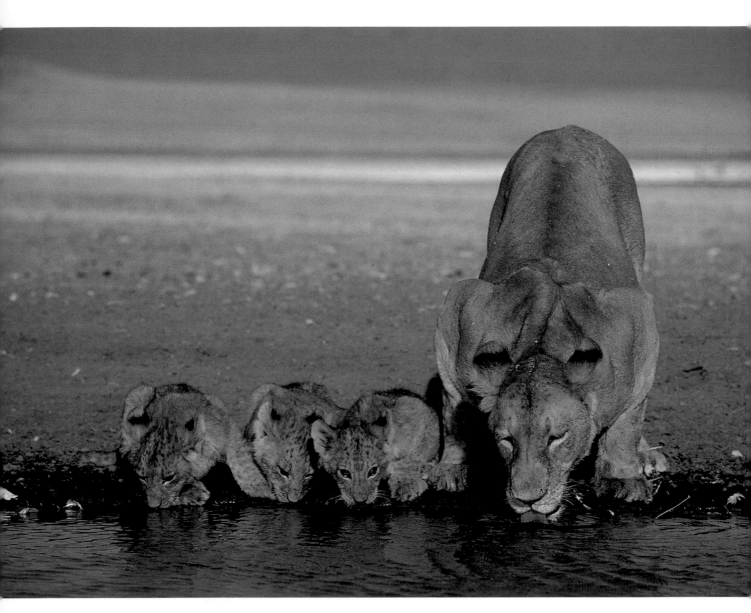

A lioness and her cubs of about three months drink in
the Ngorongoro Crater. Alert even while drinking water,
the mother turns her ears to listen behind her.

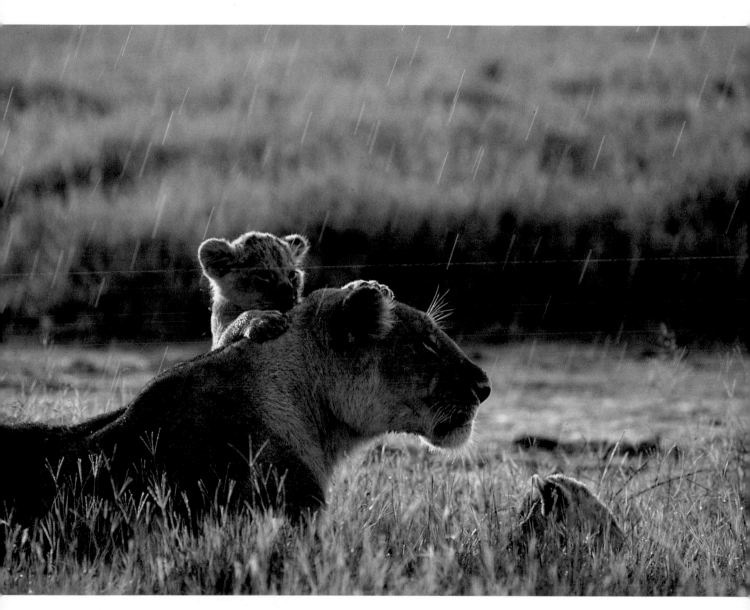

Their color blending well with the bush and tall grass, a mother and her cubs rest beside a stream.
Young cubs can be victims, at any time, of leopards, hyenas, eagles, and even male lions of another pride.

Battling over a female in
estrus, two lions—probably
of the same pride—attacked
and killed a challenger.

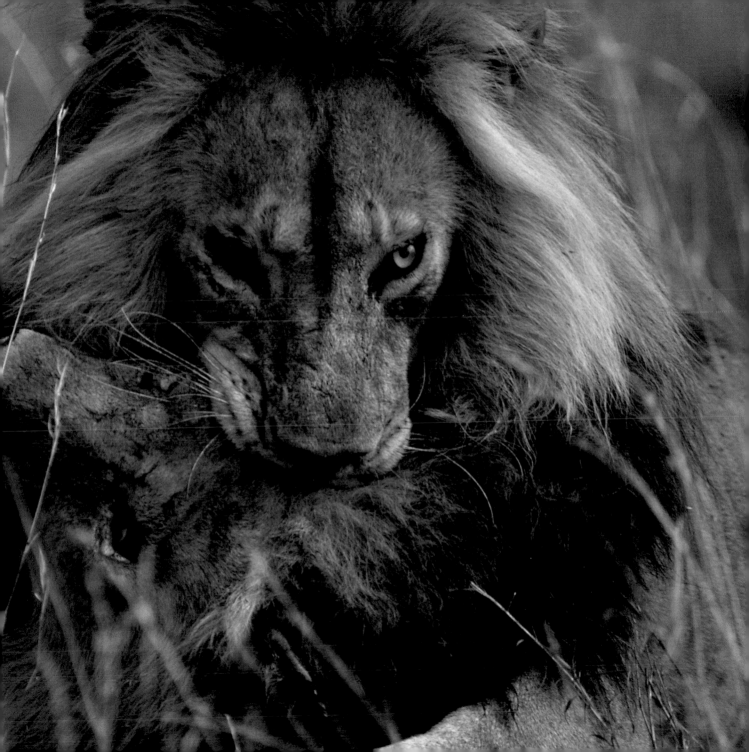

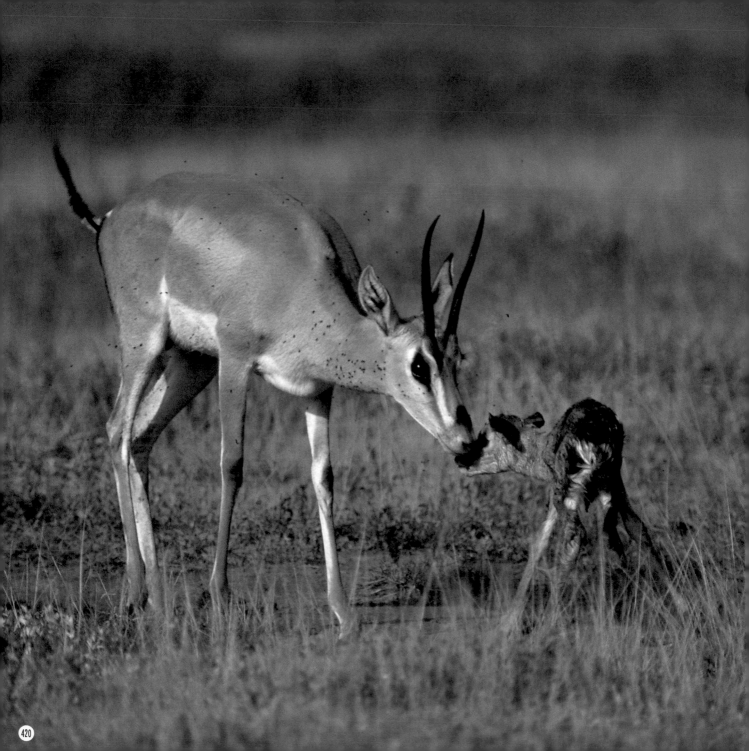

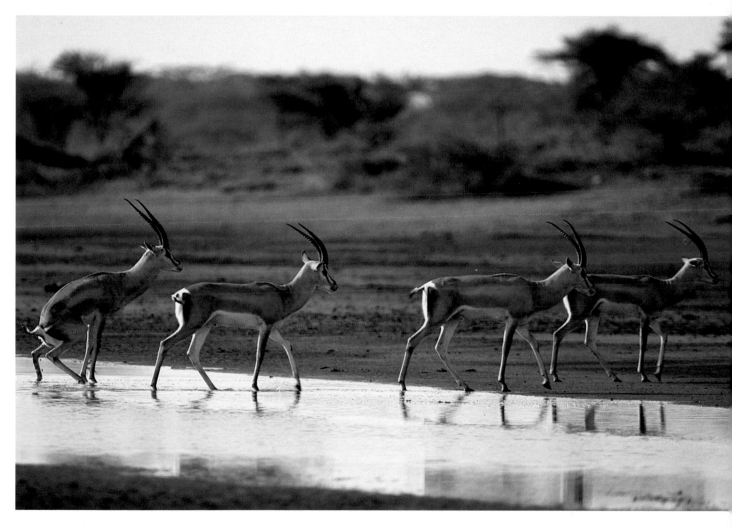

As a group of single bucks crosses the water, they crouch and urinate, one after another.

left: A newly born Grant's gazelle struggles to stand. The baby will feed on its mother's milk for about one month.

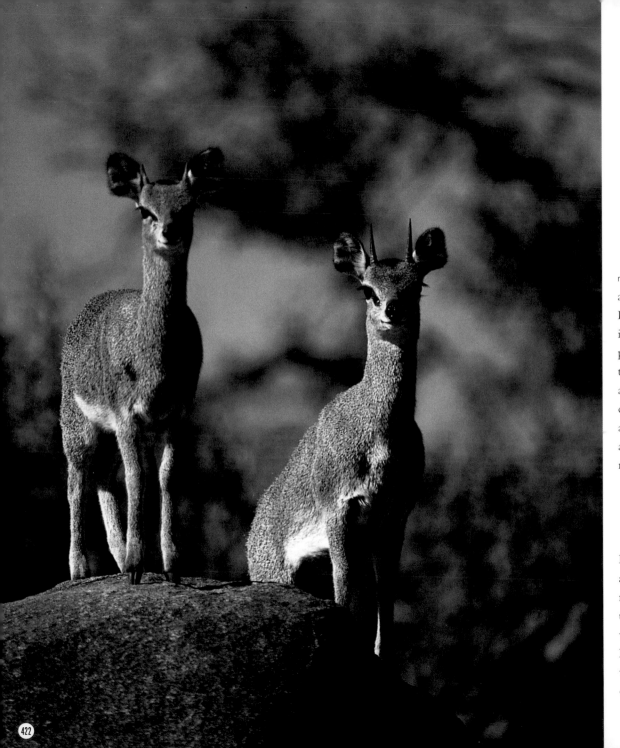

right: The smallest antelope in Africa, Kirk's dik-diks live in bushes, each pair protecting its own territory. This male and female stand in a dunghill to perform a "dunging ceremony," an important territory-marking ritual.

Klipspringers are small antelope that live in rocky places and mountains. Their hooves, which are grooved and look like hobnails, are well suited for moving on rocks.

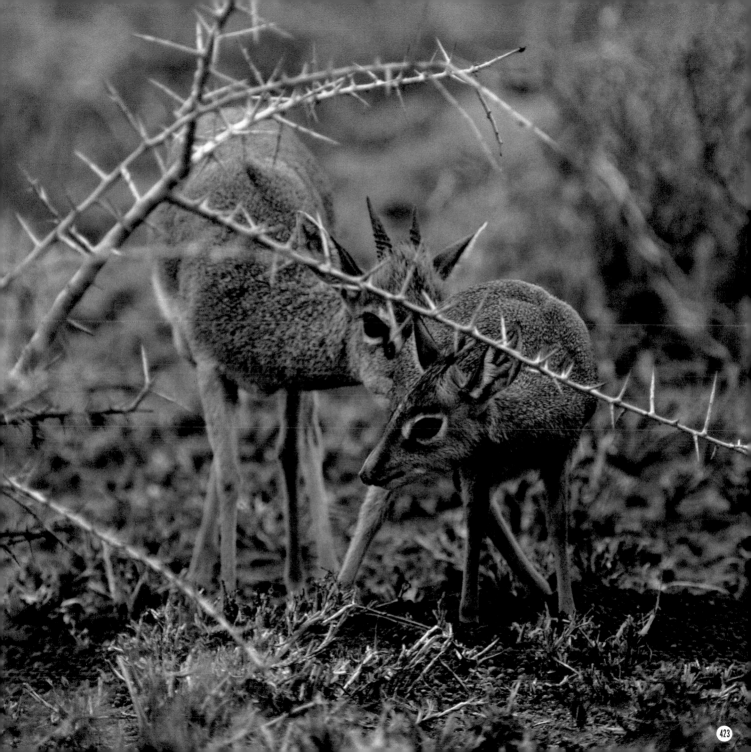

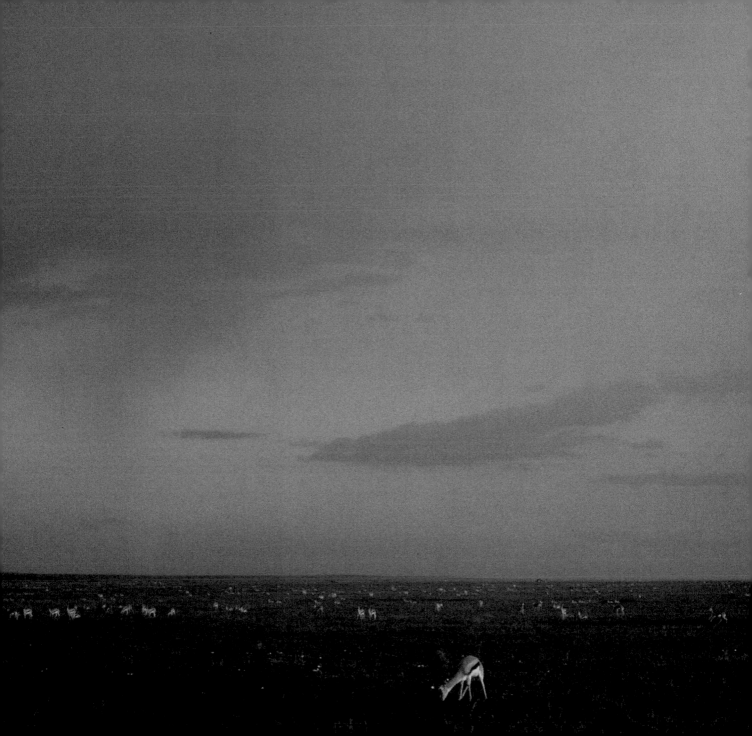

Foraging beneath a rainbow,
these Thomson's gazelles
have well-developed senses
of sight, smell, and hearing.

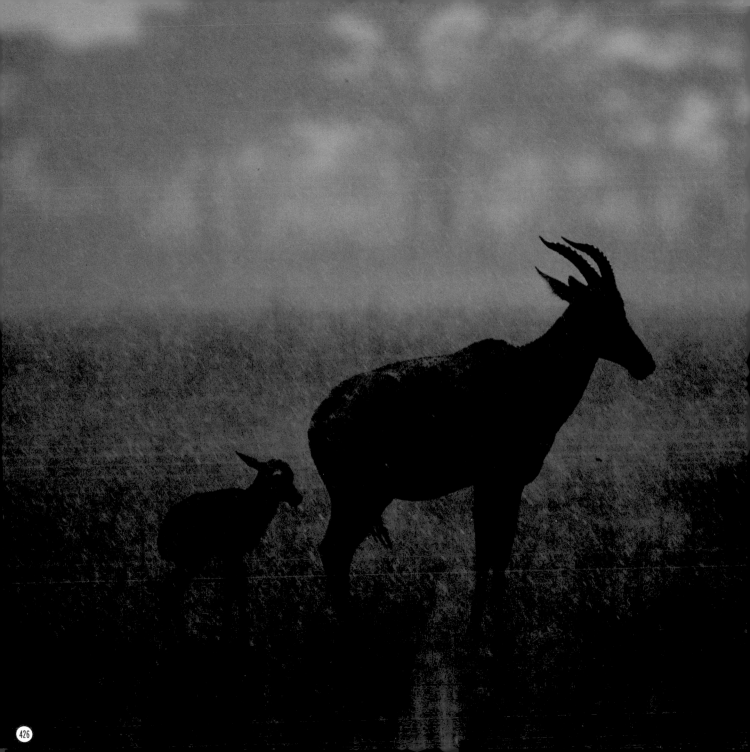

left: Under the onslaught of a sudden, violent storm, this freezing topi calf huddles near its mother.

The topi is an extremely cautious animal that does not appear to be a primary prey for any of Africa's predators.

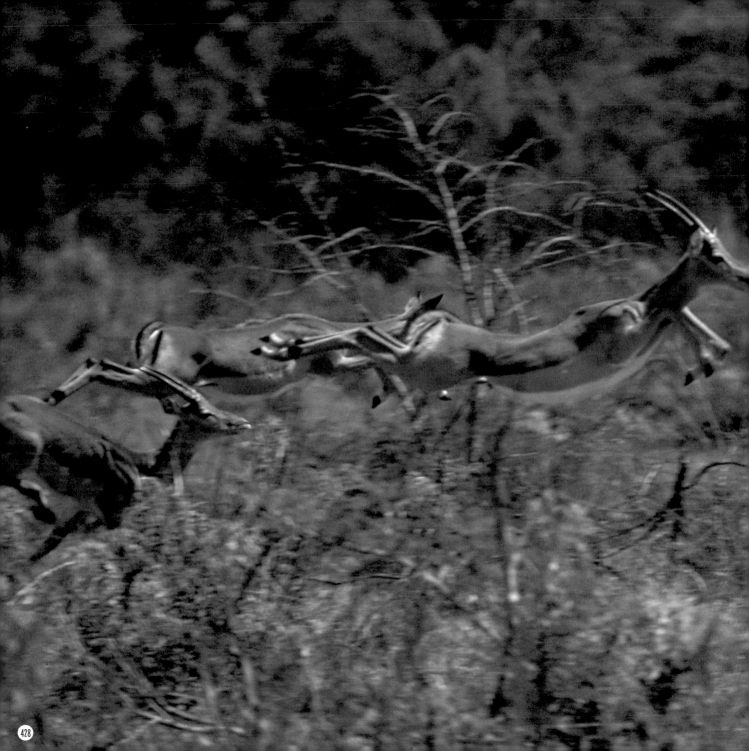

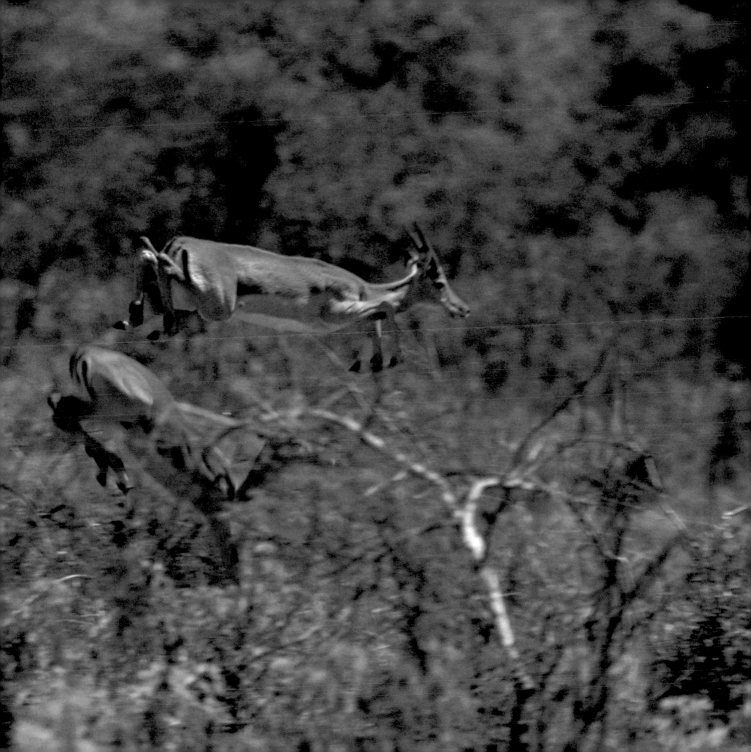

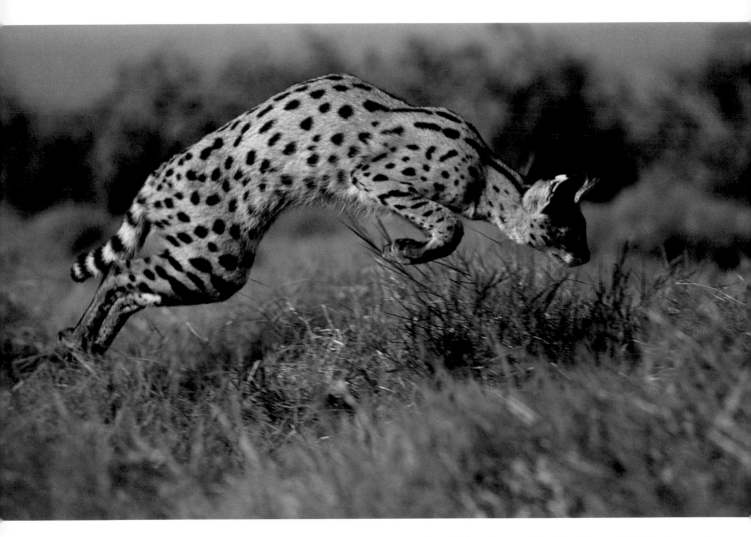

preceding pages: Impalas are known for their spectacular leaps, and normally live in a group of one buck and several does. Here, females flee one male to join another group.

An efficient hunter of small rodents and birds, the serval is an astonishing jumper and can catch birds in flight.

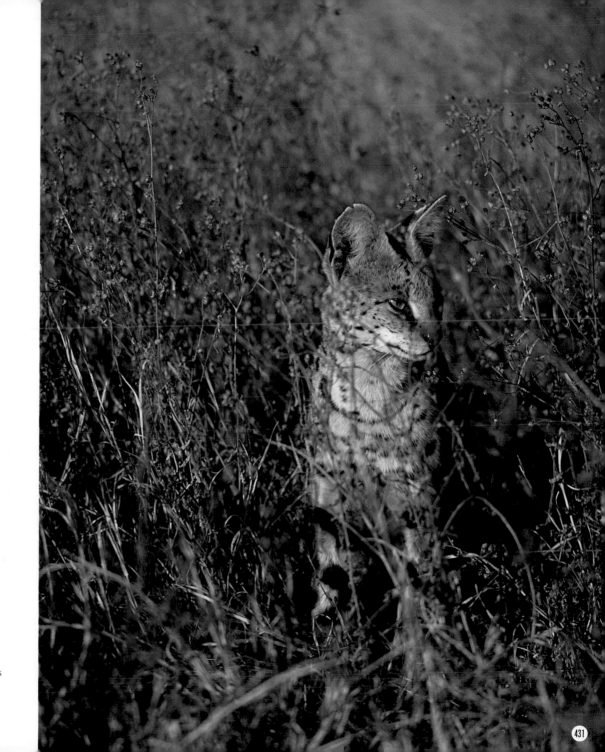

Servals have excellent
hearing, which helps
them locate prey that is
underground.

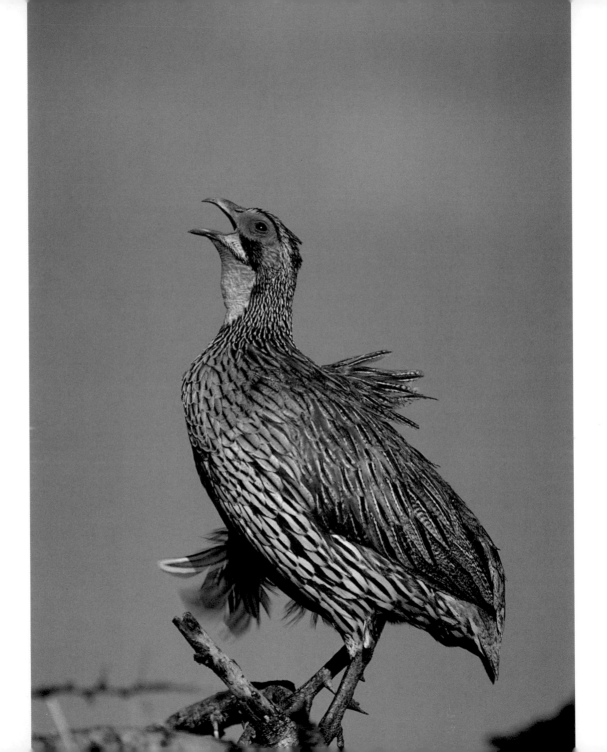

left: A relative of the pheasant and domestic chicken, the gray-breasted francolin greets the dawn. These birds are widely hunted in Africa for food.

Yellow-billed storks feed on fish and crabs. During the breeding season, the light pink blush of the shoulder feathers and wing coverts becomes a deeper pink.

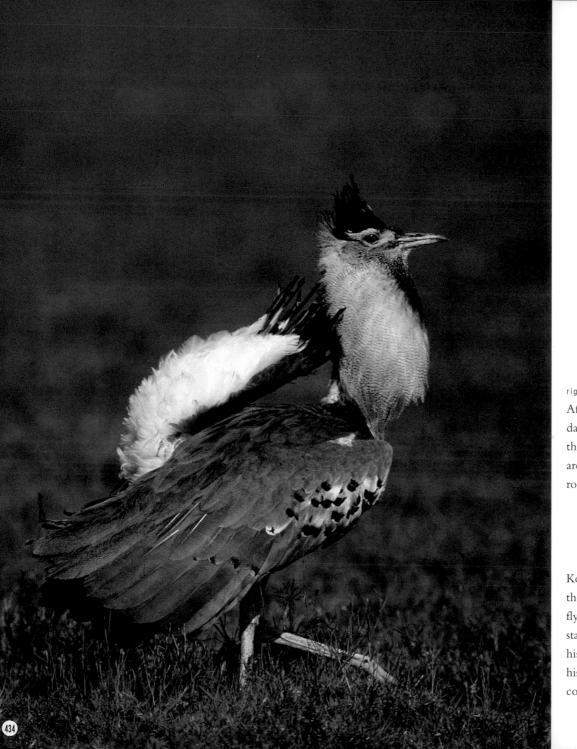

right: Both sexes of South African crowned cranes dance, most often prior to the breeding season. These are the only cranes that roost in trees.

Kori bustards are among the heaviest and the largest flying birds. This male is standing on a small mound, his tail feathers raised and his neck enlarged in courtship display.

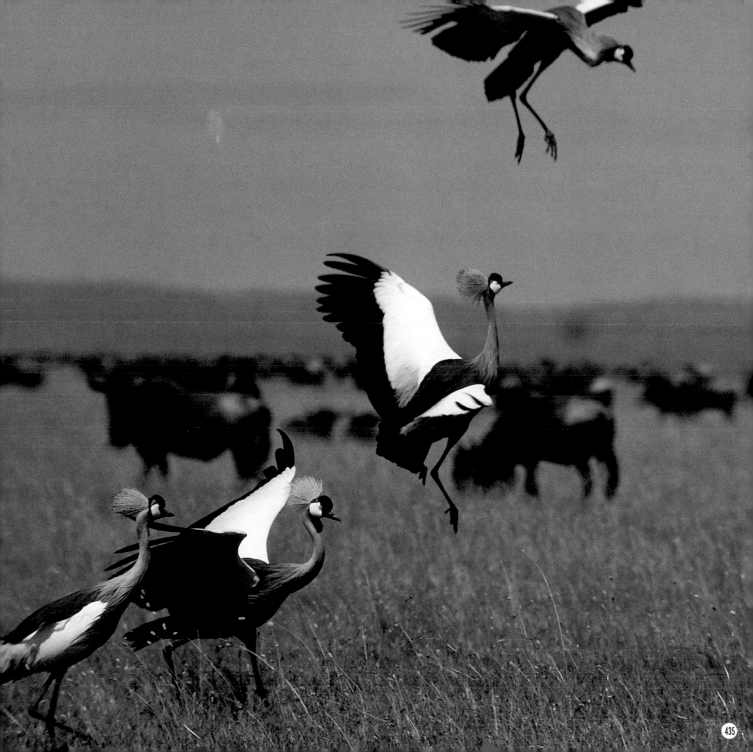

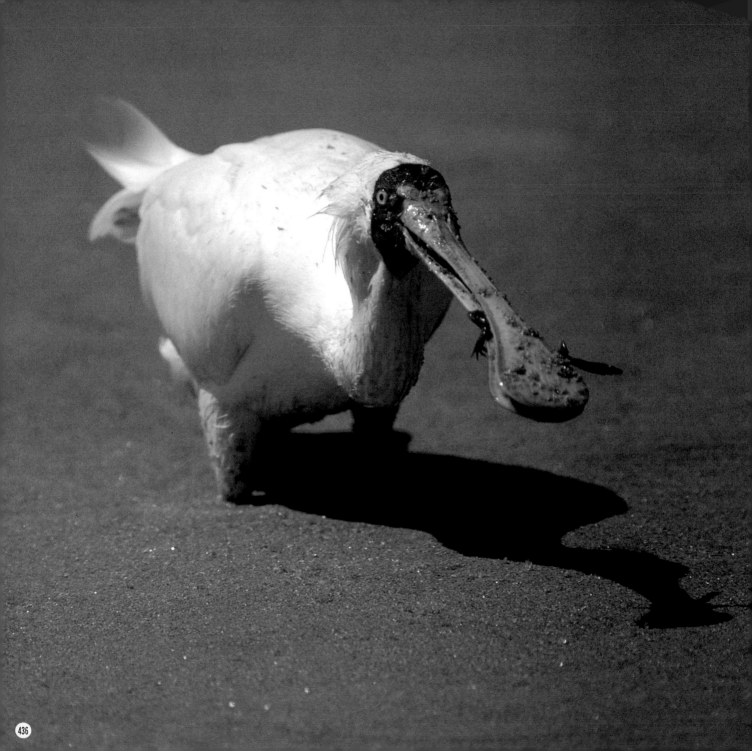

left: Wading in a soup of algae, this spoonbill proudly displays its catch, a hapless frog. While wading, spoonbills sweep their partly open bills from side to side to capture small fish and frogs.

The saddle-bill stork appears to be carrying a saddle on the base of its beak. Males and females have the same feather colors, but their eye colors are different. Males' eyes are brown, females' yellow.

The lilac-breasted roller is the
size of a pigeon and sings loudly.
The birds are named for their
habit of somersaulting or rolling
during display flight.

right: The helmeted guinea fowl is mainly terrestrial,
its strong legs and feet adapted to finding insects
and vegetation in its dry habitat. When feeding,
guinea fowls scratch at the ground like chickens.

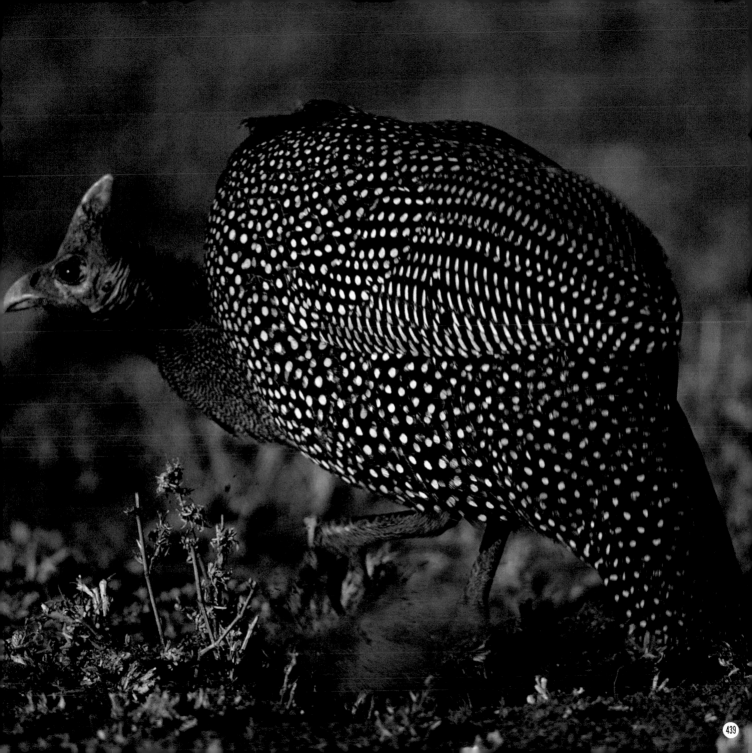

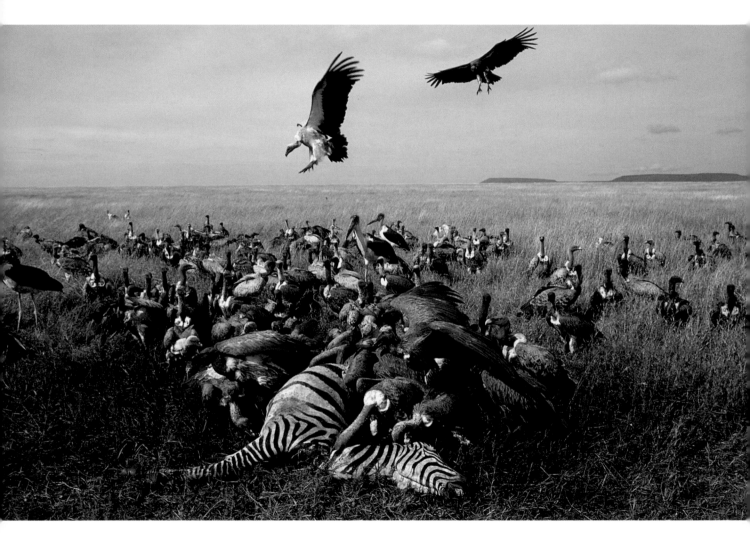

Having died a natural death, this zebra provides food for Ruppell's griffons, African white-backed vultures, and marabou storks. With so many birds around the carcass, no jackals and hyenas can approach.

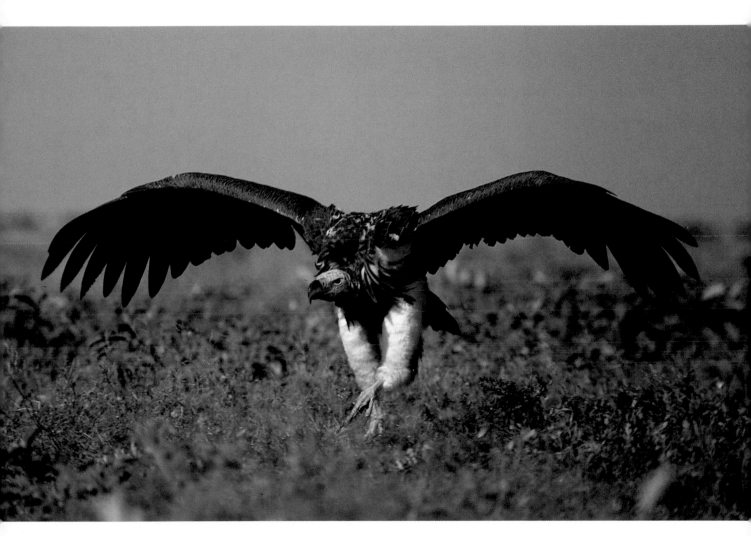

Taking advantage of its nine-foot wingspan, this lappet-faced vulture jumps into the midst of the other birds and robs them of their prey.

following pages: Greater flamingos nest in huge colonies. This flock on the salt lake in Ngorongoro had come from Lake Natron in Tanzania and Lake Elmenteita in Kenya.

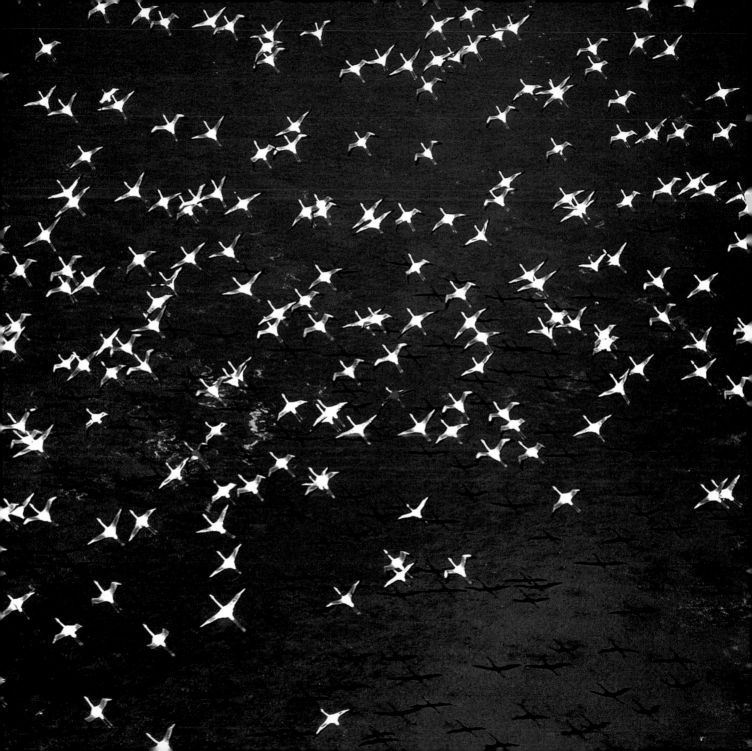

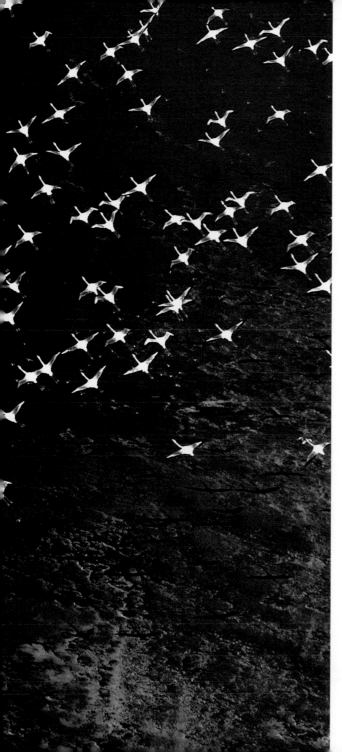

Flamingos nest in alkaline
and saline lakes or lagoons.
Their nests, circular for-
mations of mud and stones,
rise above the water's
surface like chimneys.

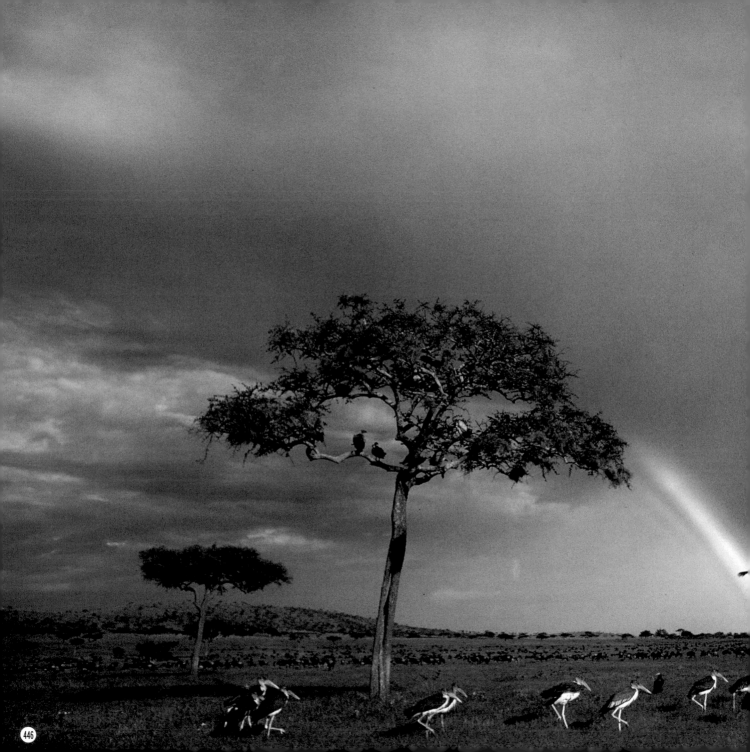

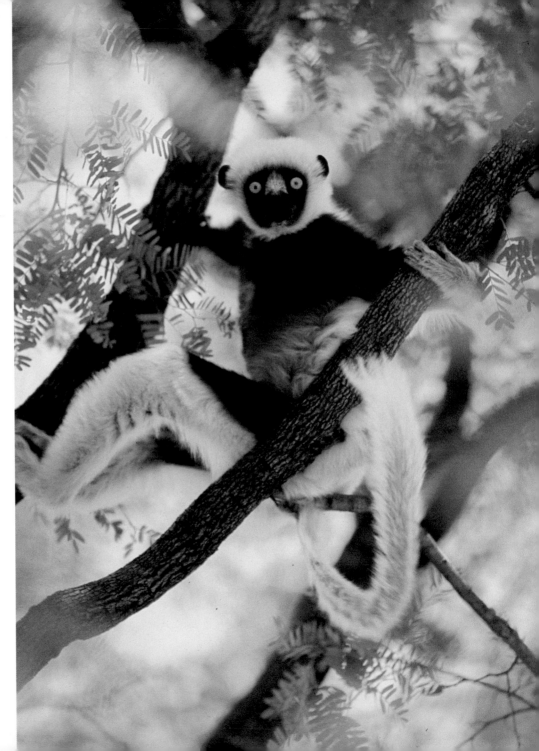

Madagascar is the fourth-largest
island in the world. It contains
an astonishing diversity of flora
and fauna, most of which are
found nowhere else. Widely
known for its lemur population
(90% of the world's lemurs can
be found only in Madagascar),
the island is also home to a wide
variety of chameleons. Sadly,
over 80% of Madagascar's habitat
has been cleared. With its dimin-
ishing habitat, Madagascar's
wildlife have become highly
endangered, and the island is
now considered one of the
world's most urgent conservation
priorities.

preceding pages: Marabou storks
shadow herds of gazelles and
blue wildebeests. The marabou's
primary food is carrion, usually
large animals. Their heads and
throats are bare of feathers, like
those of the vulture.

Verreaux's sifakas live primarily
in trees. When they have to
move on the ground, they
jump with their long hind
legs instead of walking.

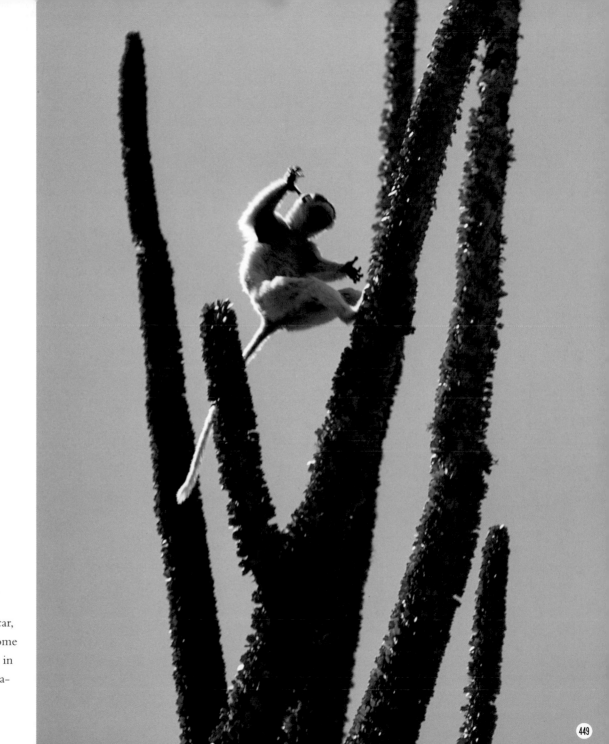

Indigenous to Madagascar, euphorbias provide a home for this Verreaux's sifaka in Berenty, a private reservation area.

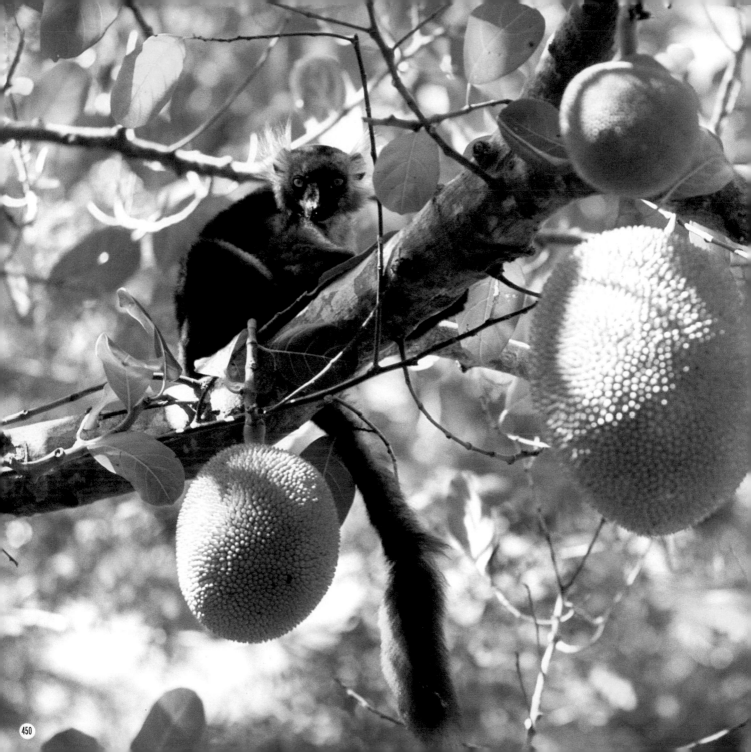

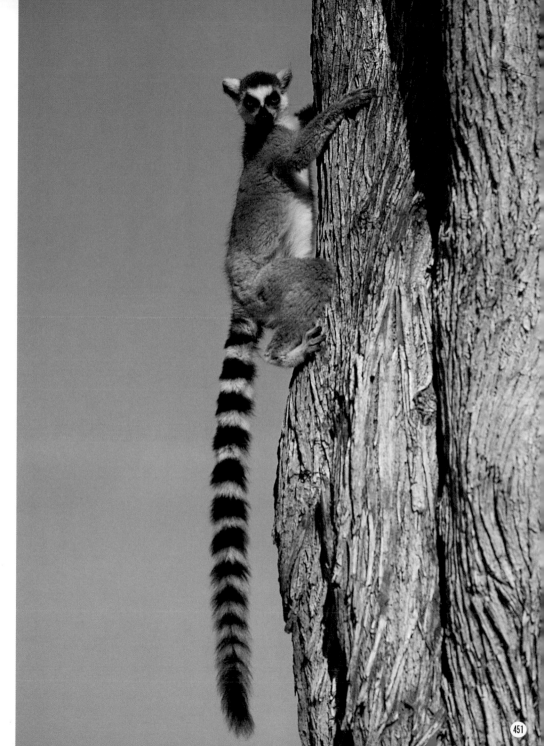

left: Male and female black lemurs were once thought to be two distinct species. This female black lemur, on a jackfruit tree in the tropical rain forest of Nossi-Bé, has reddish brown fur; the male has black fur as the name indicates.

An inhabitant of arid regions, the ring-tailed lemur lives in troops of fifteen to twenty animals. On the ground, the lemur keeps its balance by raising its long tail high.

451

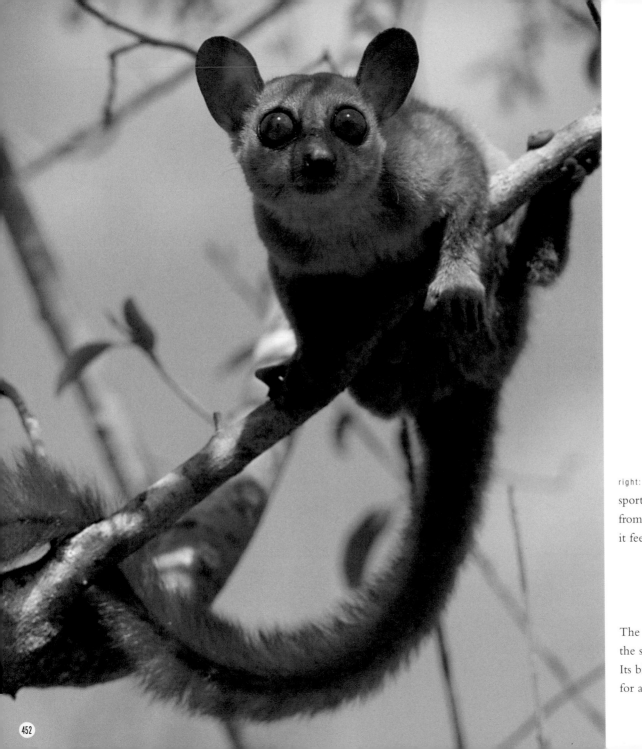

right: A white-footed sportive lemur peers from a tree hollow as it feeds on insects.

The mouse lemur is the size of a squirrel. Its big eyes are suited for a nocturnal animal.

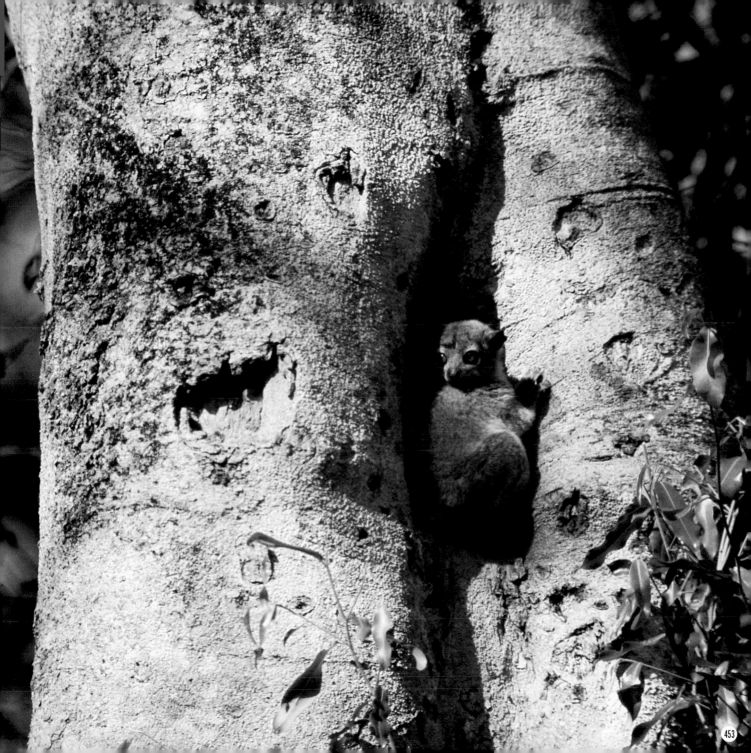

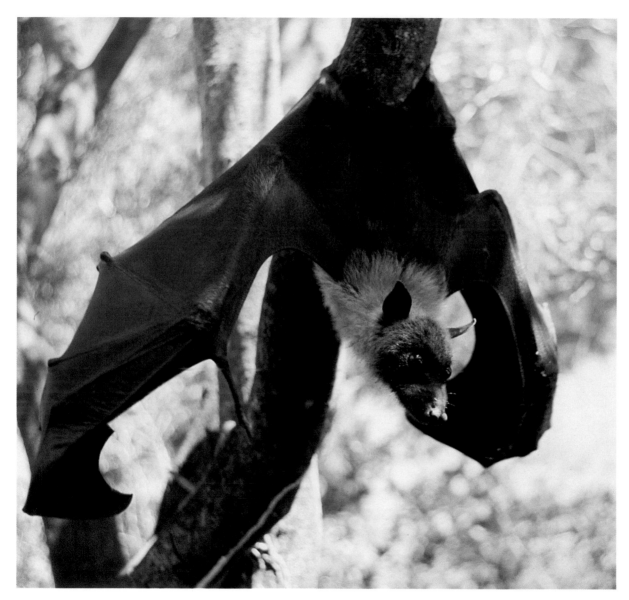

The Madagascar flying fox subsists
on fruit it finds in trees.

right: Almost bat-like, Madagascar flying foxes spend
the day hanging from branches high in trees. The for-
est rings with their chatter.

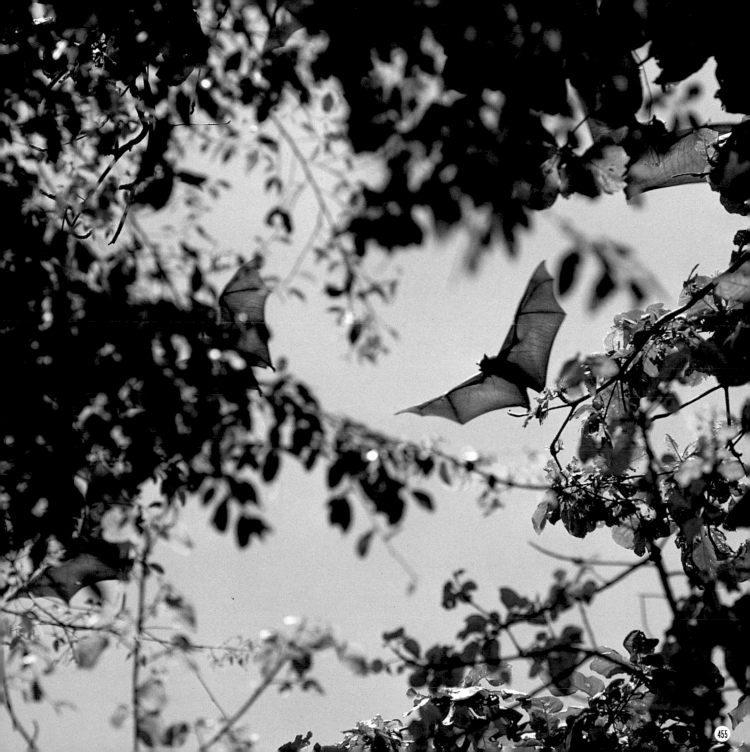

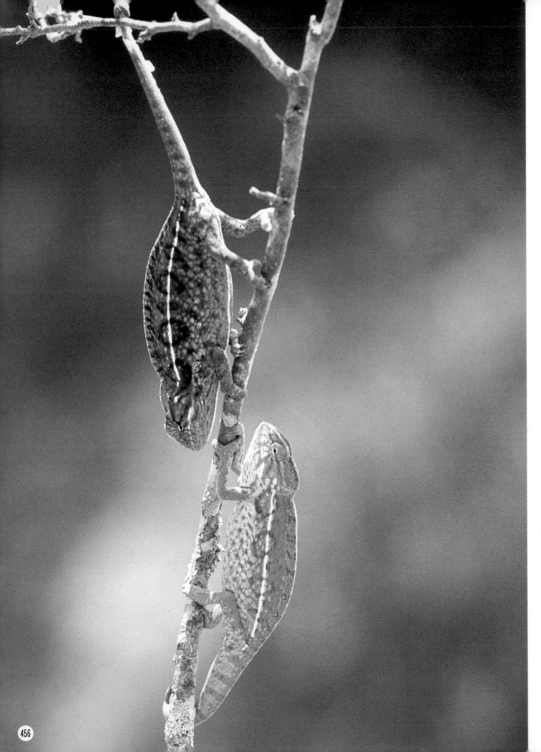

right: A radiated tortoise—
walking through a small
bush of euphorbias in the
woods of Berenty—has
strong colors that match
well with its surroundings.

Chameleons of all types
are common in
Madagascar. This is a
jewelled chameleon.

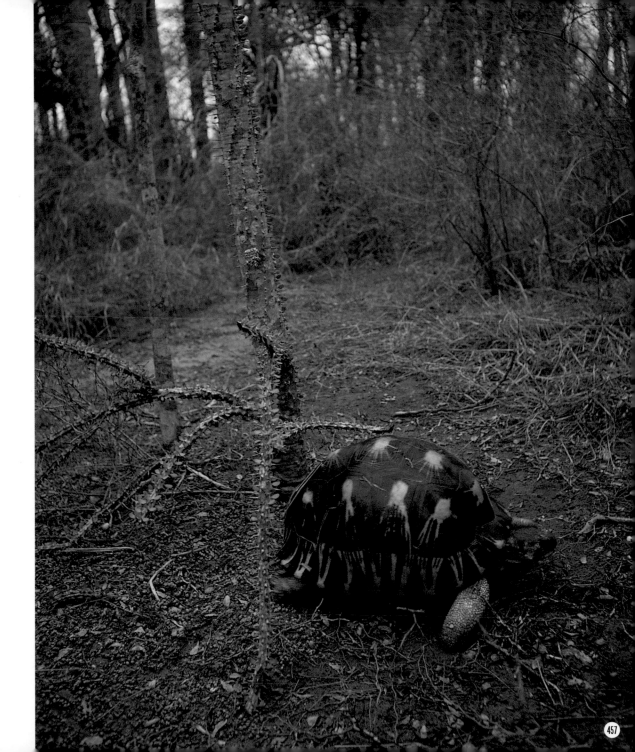

THE HIMALAYAS BROADLY DIVIDE
Asia into two parts. To the south
is the tropical zone between
India and Borneo; to the north
lies most of the continent and
Japan. South of the Himalayas, in
the tropical zone, a relatively rich
fauna still exists. There are
species similar to the animals in
Africa: Asiatic elephants, rhinoc-
eroses, and leopards; there are
even a few lions. Tigers, the
largest member of the cat family,
are indigenous to Asia. Their
range covers both sides of the
Himalayas. Unhappily, the habi-
tats of all these animals are being
reduced as humans encroach on
their territory.

preceding pages: Asian elephants
and villagers in Sri Lanka often
compete for food. The elephants'
habitat has been severely reduced
and many elephants have been
moved to sanctuaries.

Compared with African elephants,
Asian elephants tend to be smaller
and rounder.

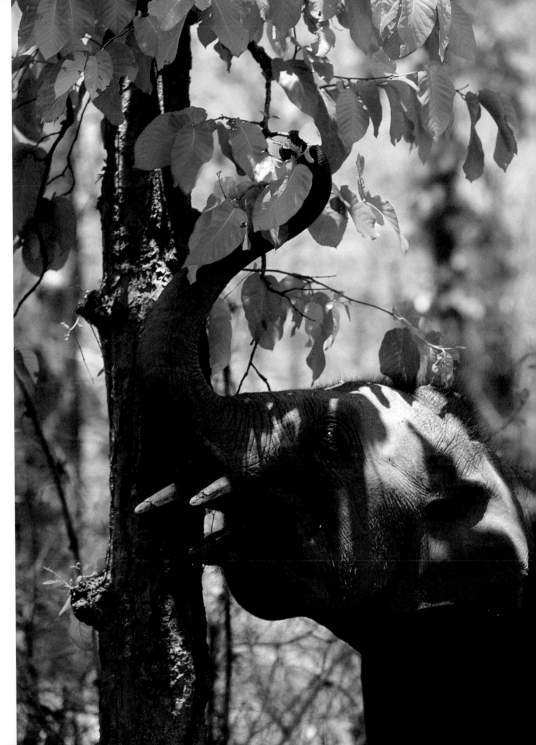

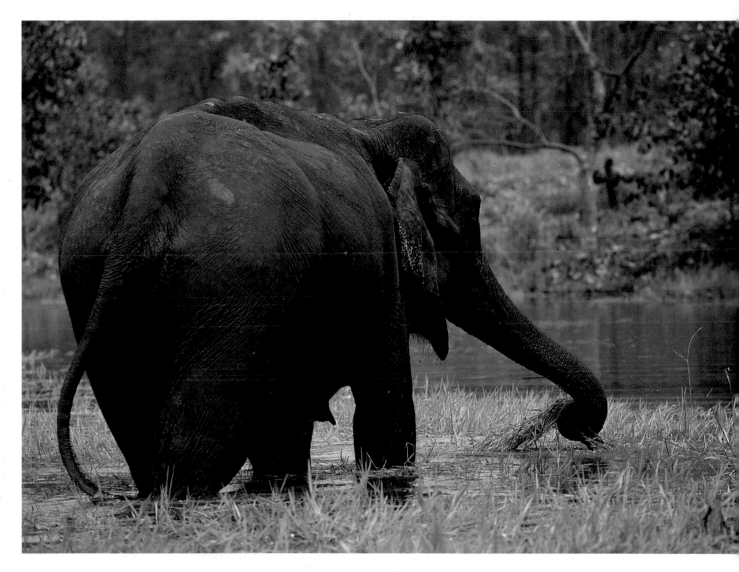

Asian elephants may look tame, but they can cause problems because their habitat is close to villages and farms. As a precaution, people plant trees in the center of their fields as a refuge from elephants.

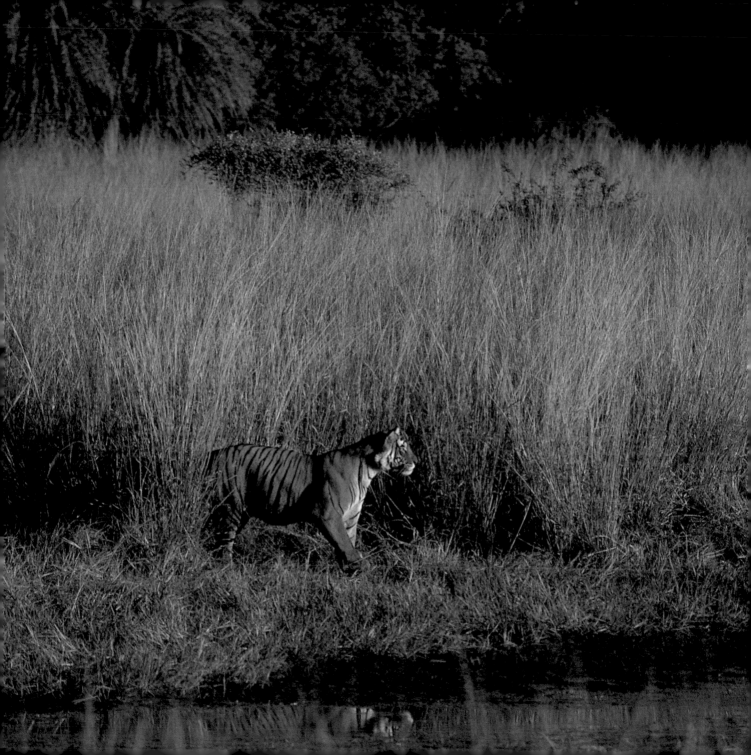

This tiger appeared suddenly
from behind the bush,
intent upon a sambar that
came to the swamp to eat
water plants in Ranthambore
National Park.

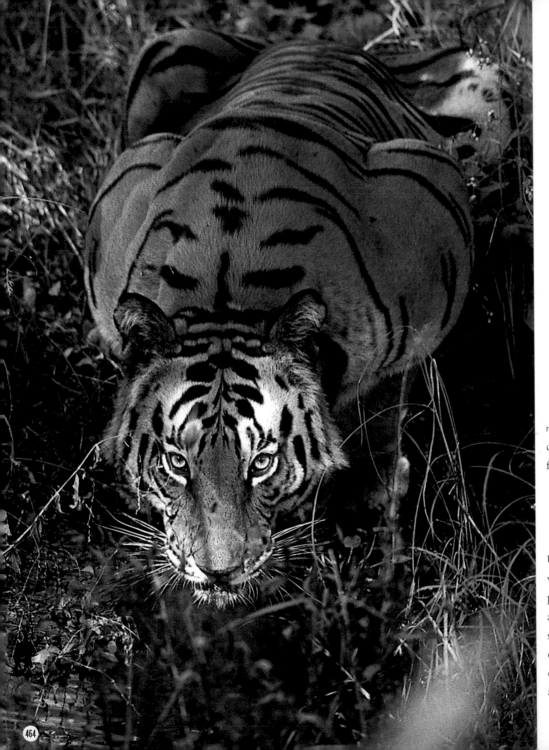

right: A tiger at rest in the dappled light of an Asian forest.

Unlike lions and cheetahs, which hunt on an open plain, tigers spring from ambush, using their great strength to bring down deer, wild boars, and calves of rhinoceroses and elephants.

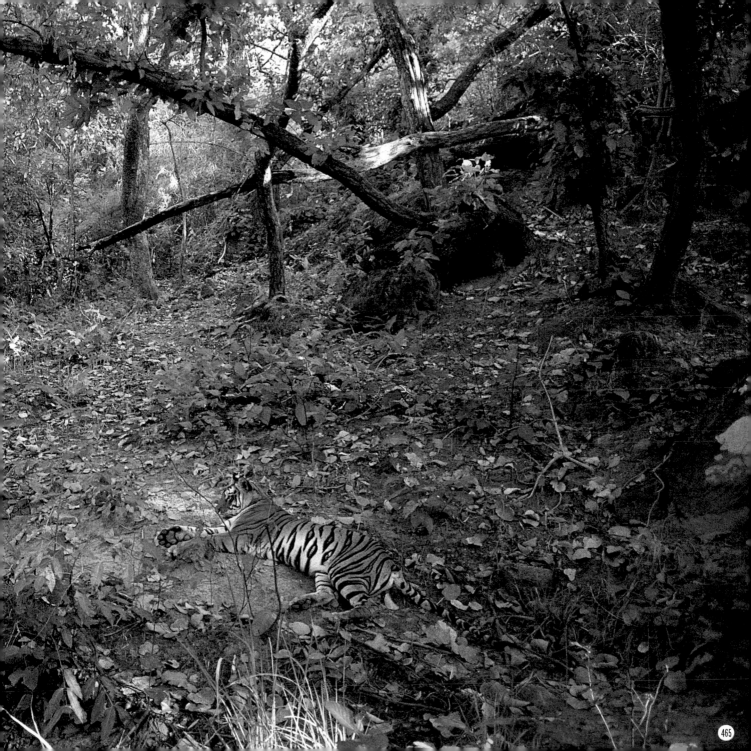

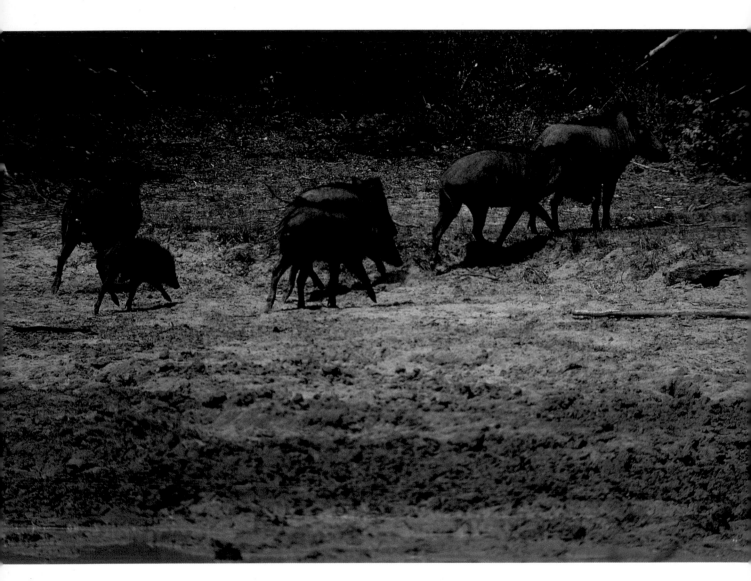

Indian wild pigs are disliked by farmers in Sri Lanka because they destroy crops. When chased, the pigs run with surprising speed.

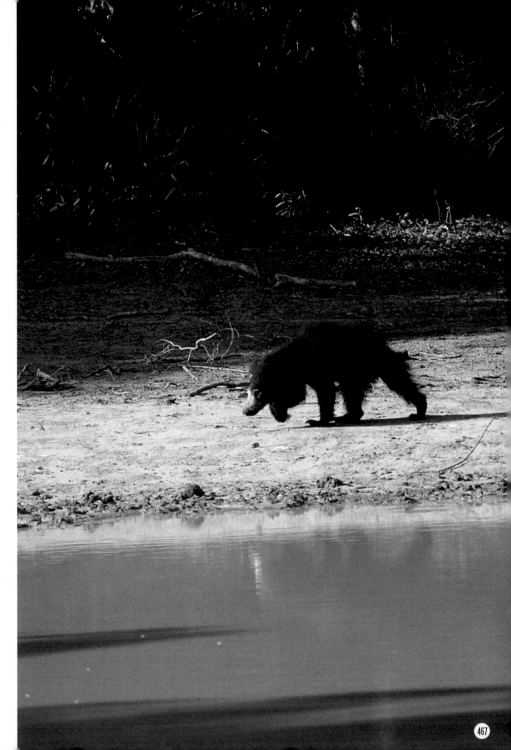

Nocturnal and very cautious, sloth bears hang from tree branches like sloths. Using their long snouts, the bears vacuum up termites after digging open the insects' mound.

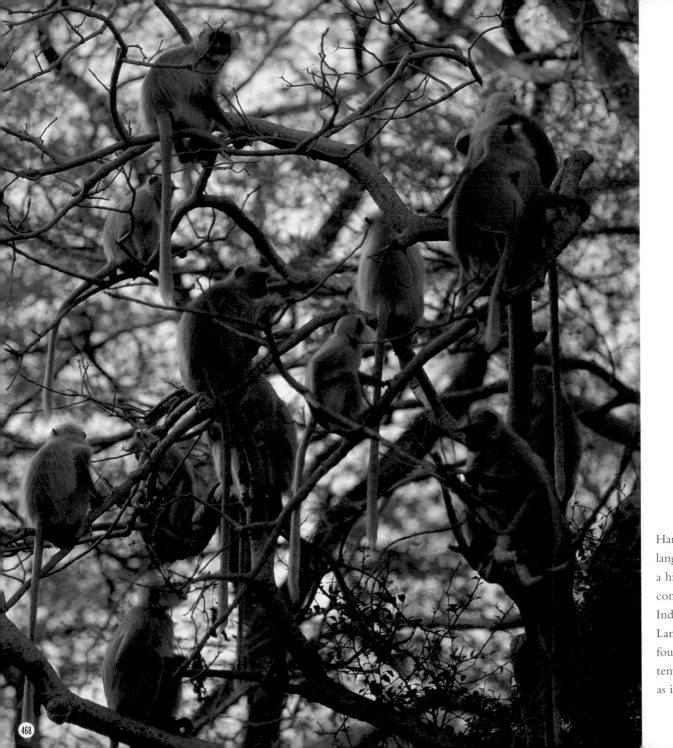

Hanuman langurs maintain a highly social community. In India and Sri Lanka, they are found around temples as well as in the forests.

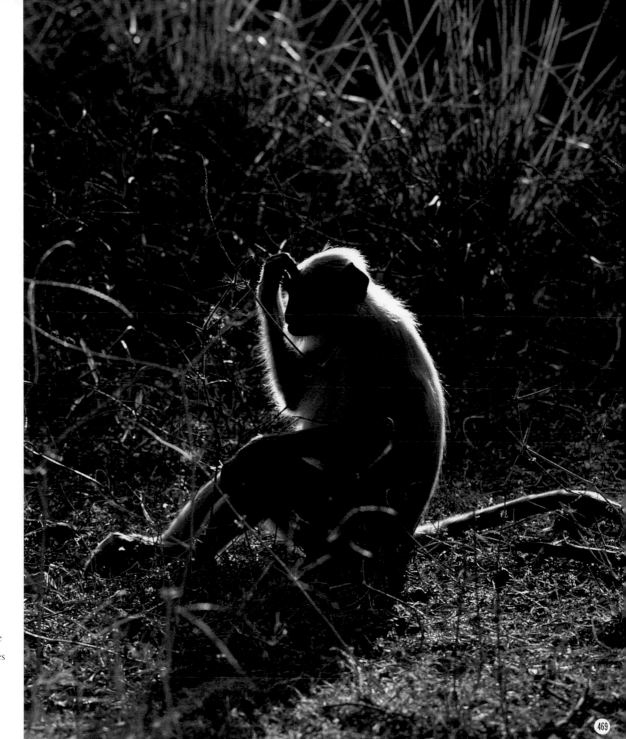

A Hanuman langur feeds on nuts that have fallen from nearby trees where monkeys were foraging.

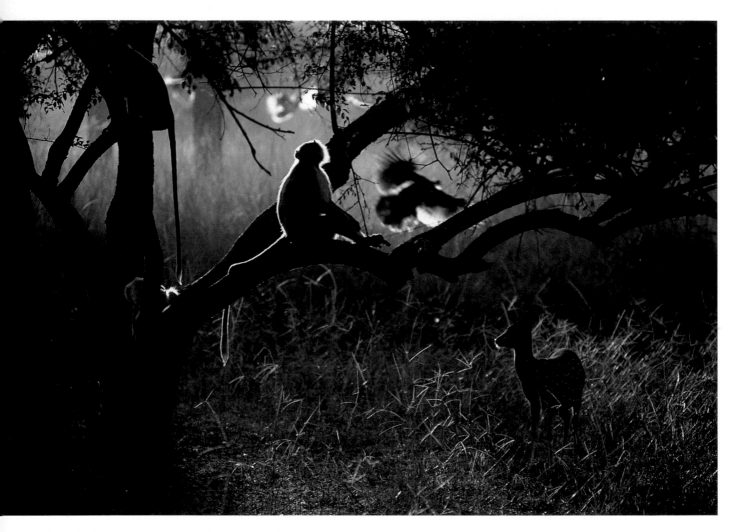

To avoid the intense sun of midday, Hanuman langurs
and axis deer search for food during the cooler
morning and evening hours.

right: A sambar, also called Aristotle's deer, snacks on
water plants.

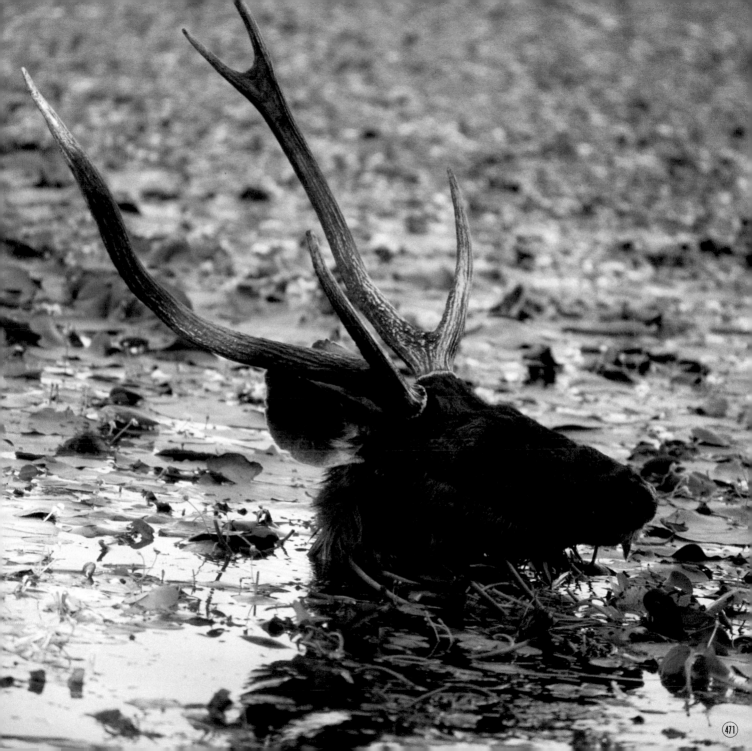

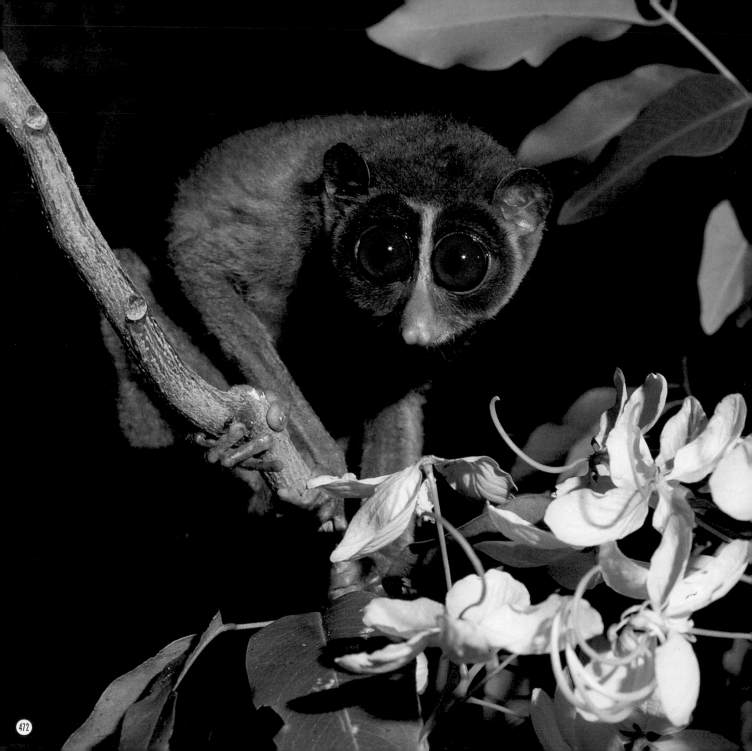

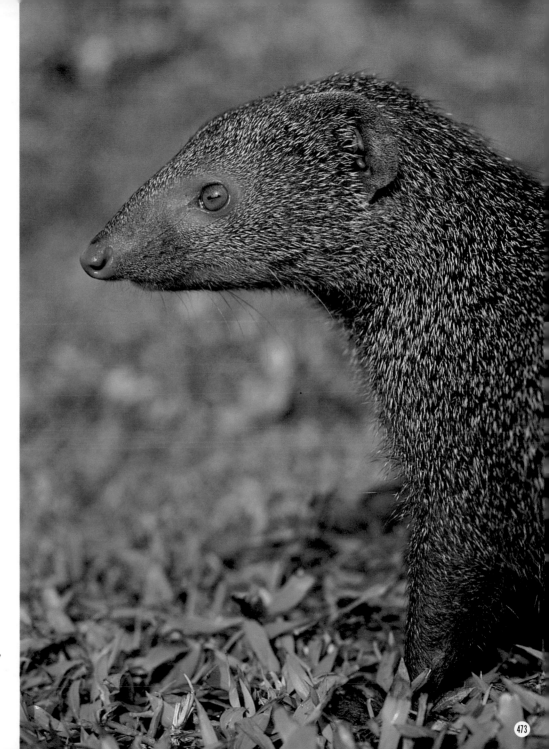

left: The slender loris,
a primitive monkey in
southern Asia, eats insects
that come to the flowers.

Ruddy mongooses, which
live in India and Sri Lanka,
are solitary hunters that
seldom join a colony.

A Japanese macaque samples
wild cherry blossoms. When
the flowers are no longer in
full bloom, few monkeys
will touch them.

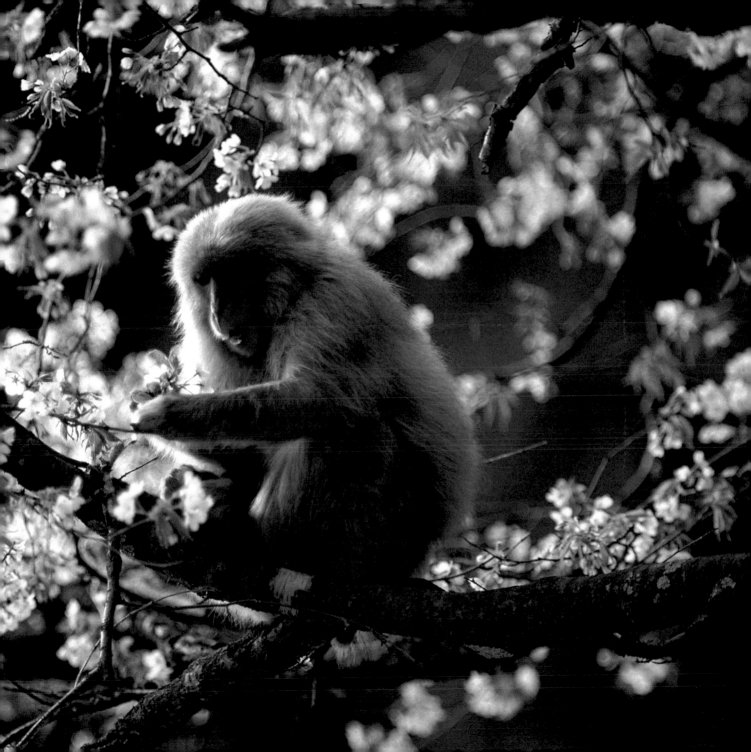

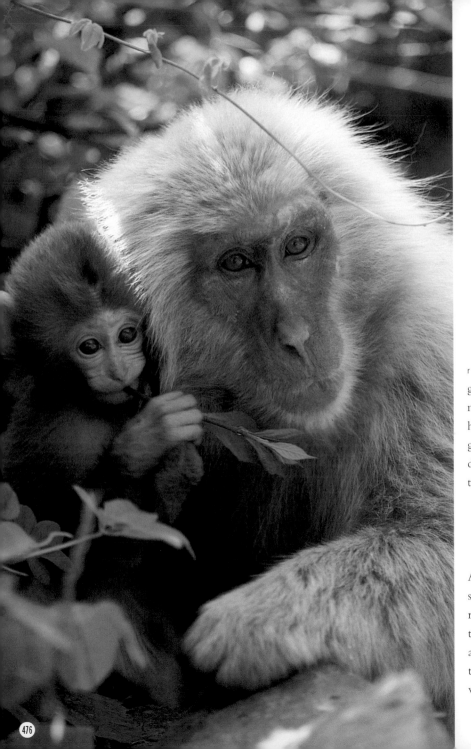

right: A young monkey grooms a mother monkey, which is holding her baby. The grooming method differs according to their blood relationship.

A mother monkey spends about two years raising her offspring. At the age of one month, a young monkey is able to cling to its mother without her help.

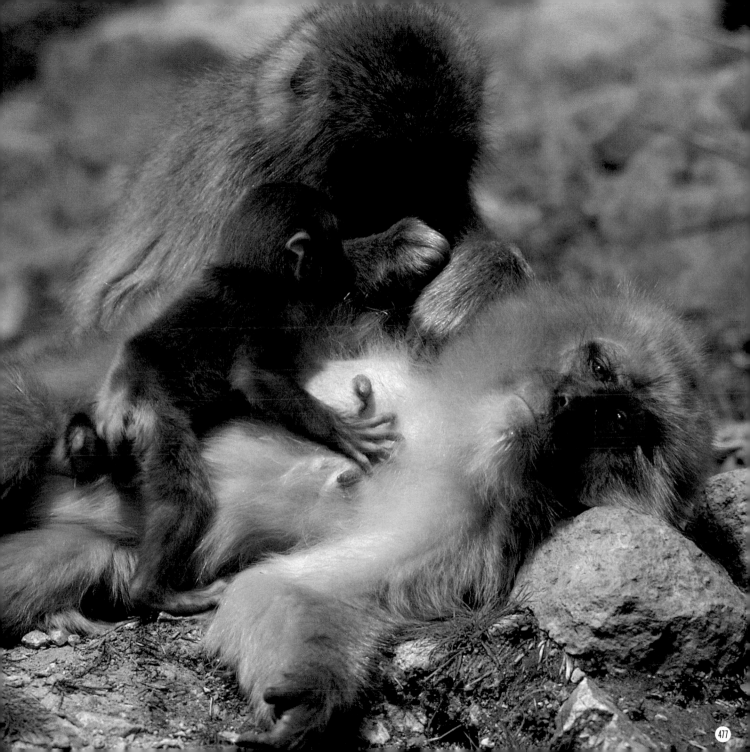

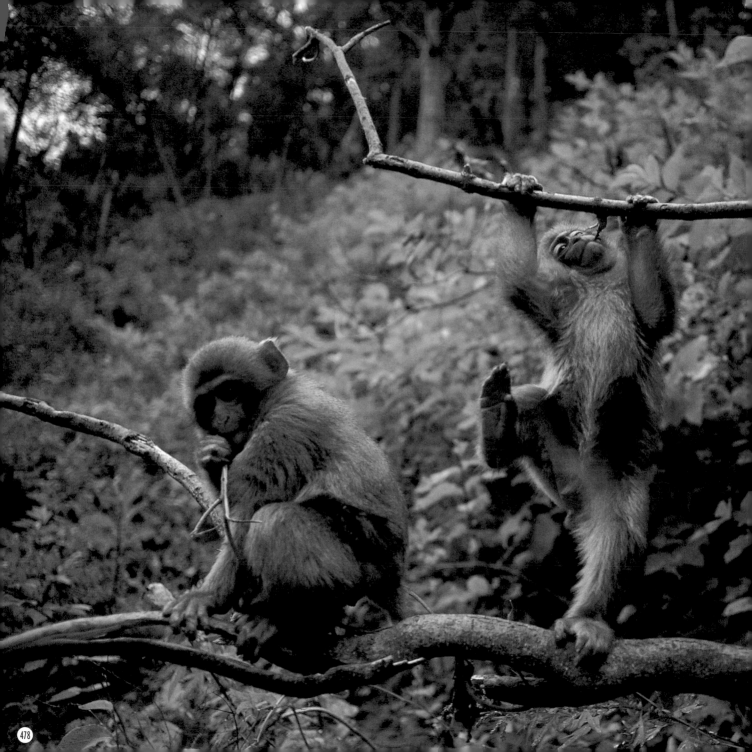

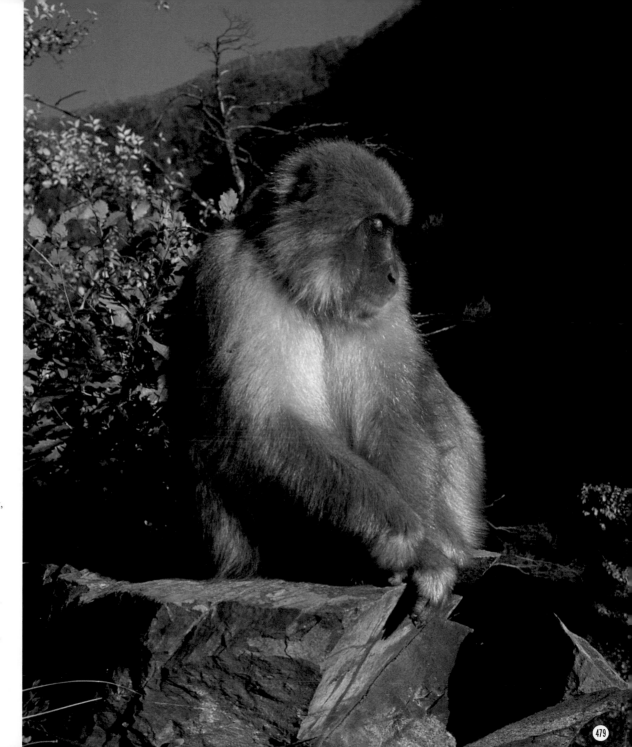

left: Monkeys seem never to tire of playing, and they know many games.

In the breeding season, the red color of their face and bottom becomes darker.

right: Monkeys of the area called Hell Valley are fond of hot springs. This old monkey stayed in the spring all day. He seldom moved, and the snow piled on his head.

No other monkeys live as far north as the Japanese macaques. Normally, they subsist on leaves and fruit, but in winter they must find tree buds and bark.

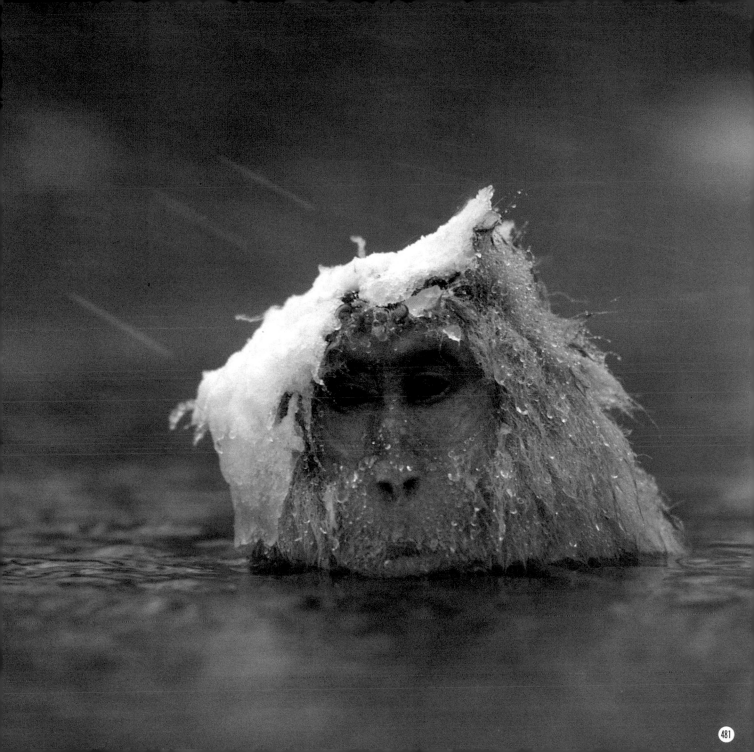

Flying squid soar elegantly
over the sea near Singapore.

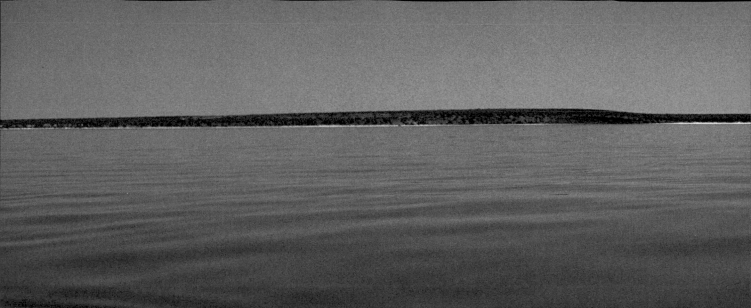

OCEANIA

THE CONTINENT OF AUSTRALIA is thought to have separated from the Antarctic continent about eighty million years ago, becoming an isolated island continent. Consequently, marsupials such as kangaroos and koalas experienced a special evolution in Australia and became diversified. The introduction of domestic animals and continued human development threaten many species in both Australia and New Zealand. Here, as in other regions of the world, animals will need to be protected from their human neighbors.

preceding pages: A bottle-nosed dolphin cruises Shark Bay on the Australian west coast.

Bottle-nosed dolphins are found in coastal areas from the North Sea to South Africa.

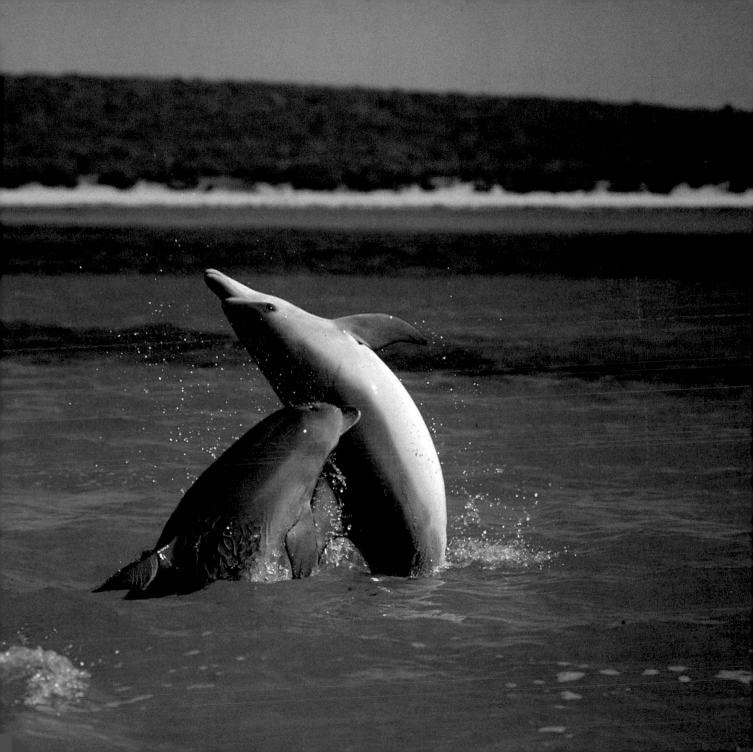

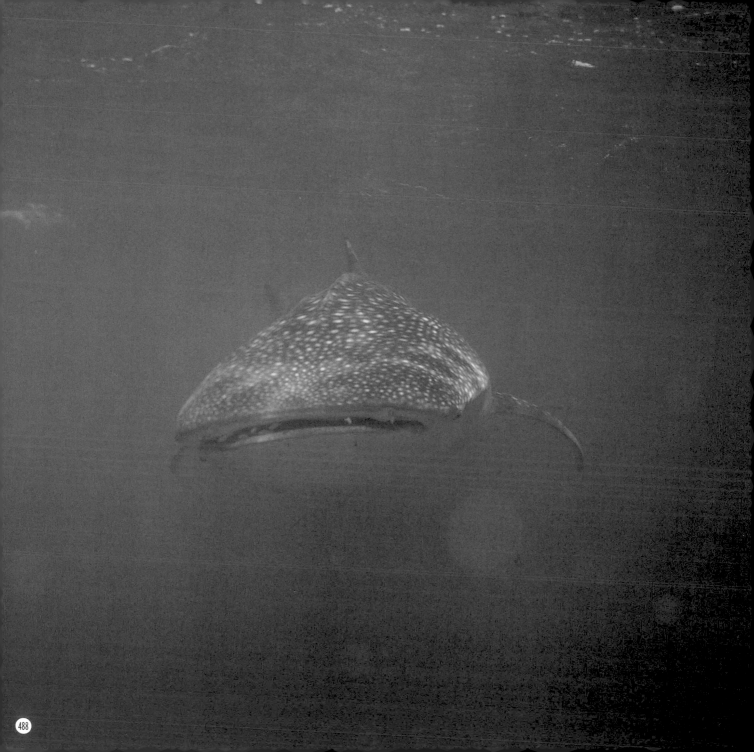

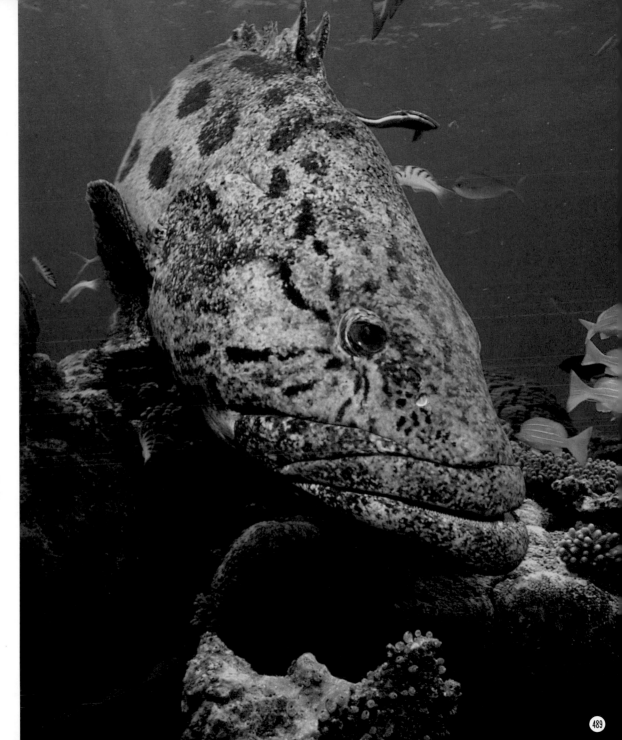

left: Largest of sharks and also very gentle, whale sharks feed on plankton. This one searches for coral eggs in the Ningaloo Reef of Exmouth.

In Cod Hall of the Great Barrier Reef, potato cods flourish, often growing to several feet in length.

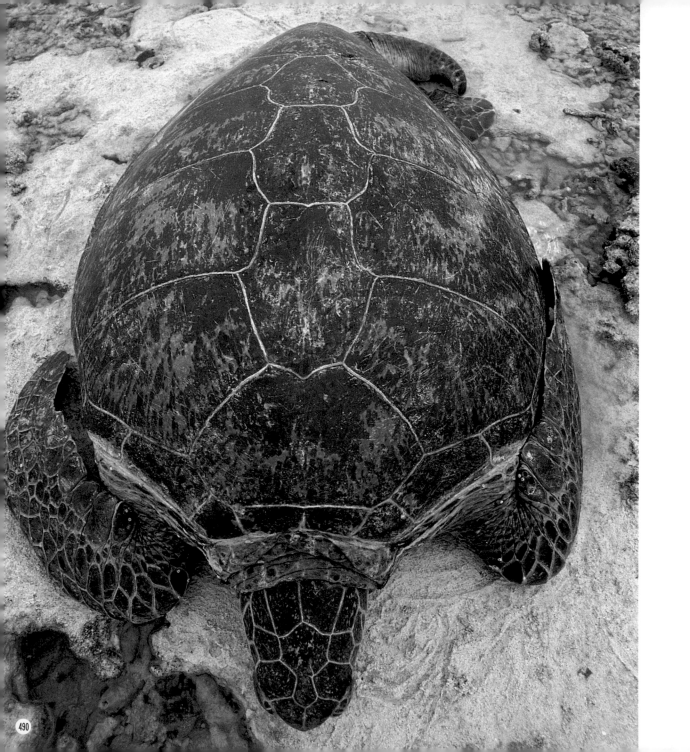

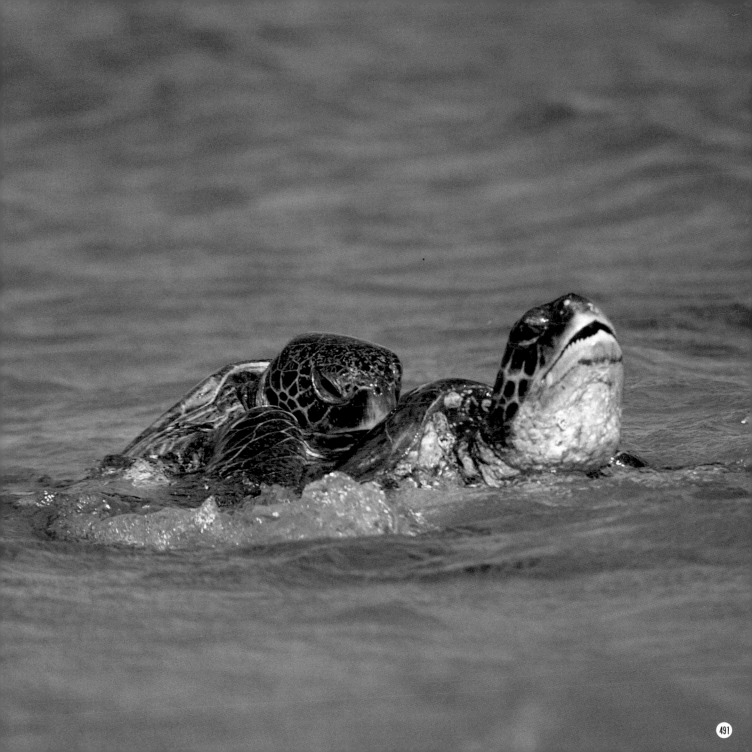

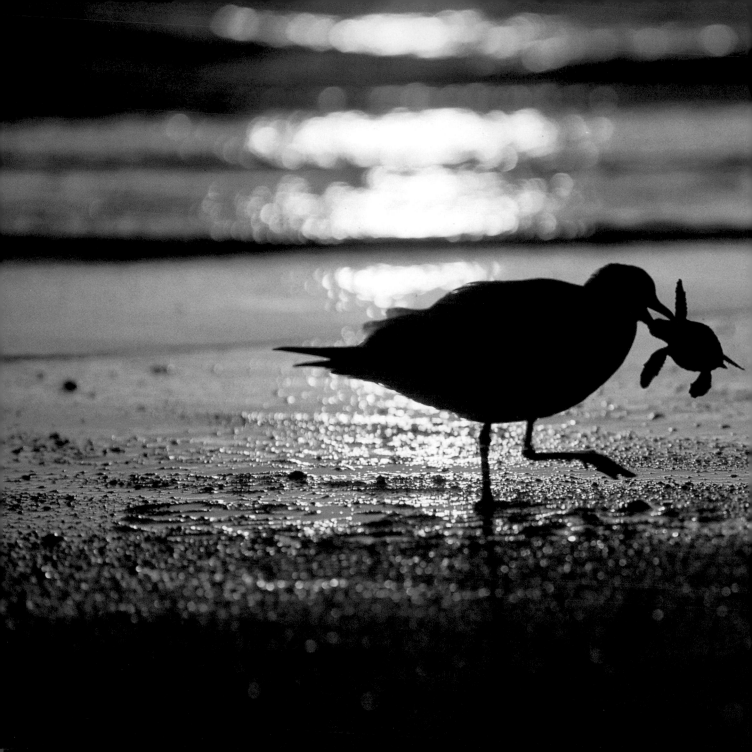

Green sea turtles lay eggs on islands around the Great Barrier Reef. Once, more than ten thousand turtles laid their eggs on Rain Island, the biggest of the islands, in a single night.

Turtles mate in the water.

Shark Bay has huge tide pools formed on the sandbar of the peninsula.

Although thousands of turtle eggs hatch, many young are eaten by gulls. Their shells are not yet hard enough to protect them.

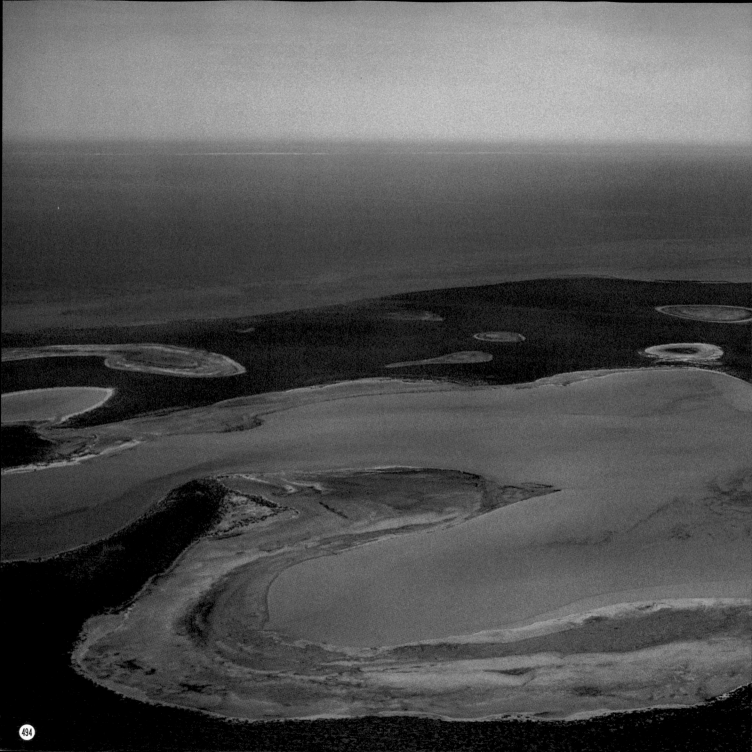

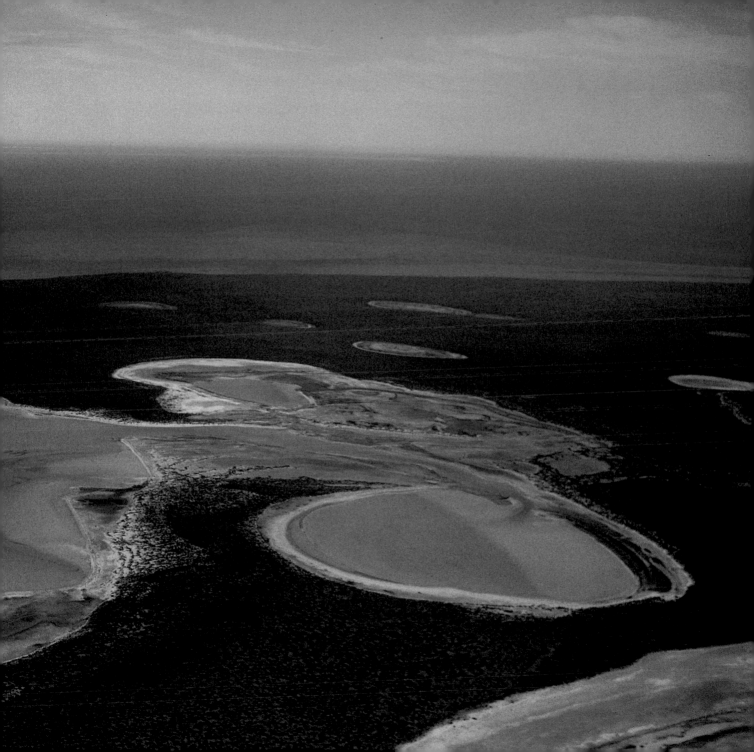

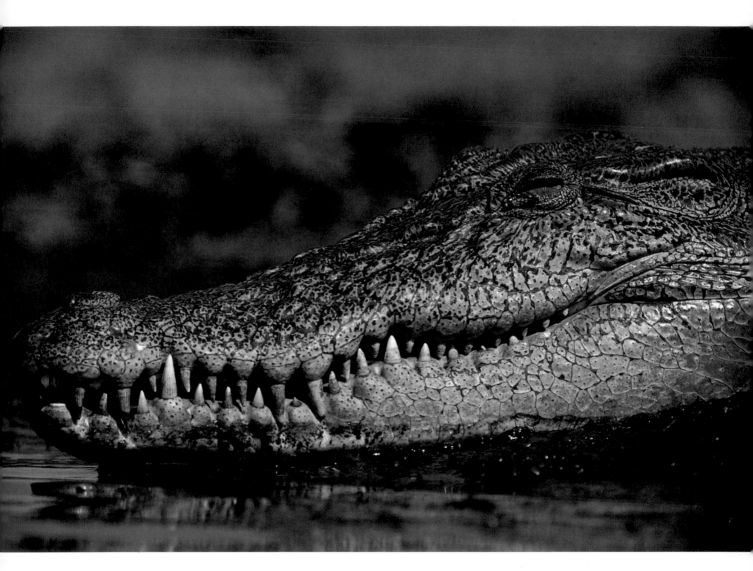

This twelve-foot-long saltwater crocodile is in the
river of Kakadu National Park in northern Australia.

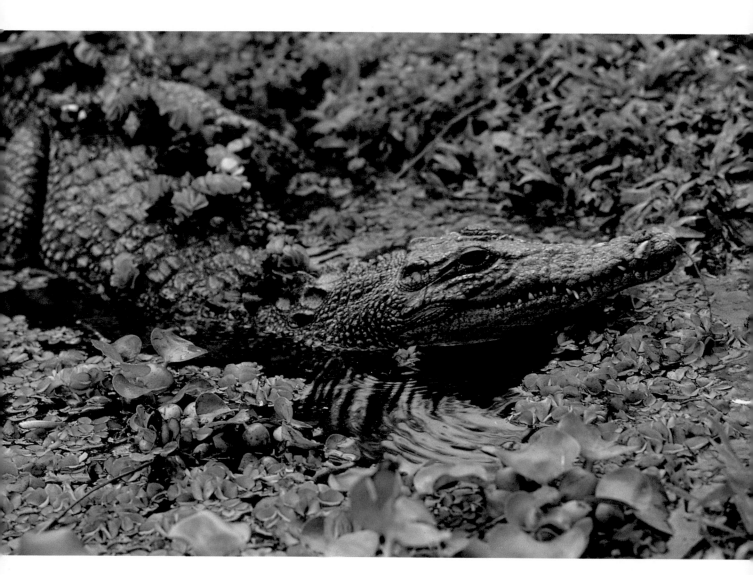

A relatively small, six-foot Johnston's crocodile
hunts in the freshwater of an inland valley.

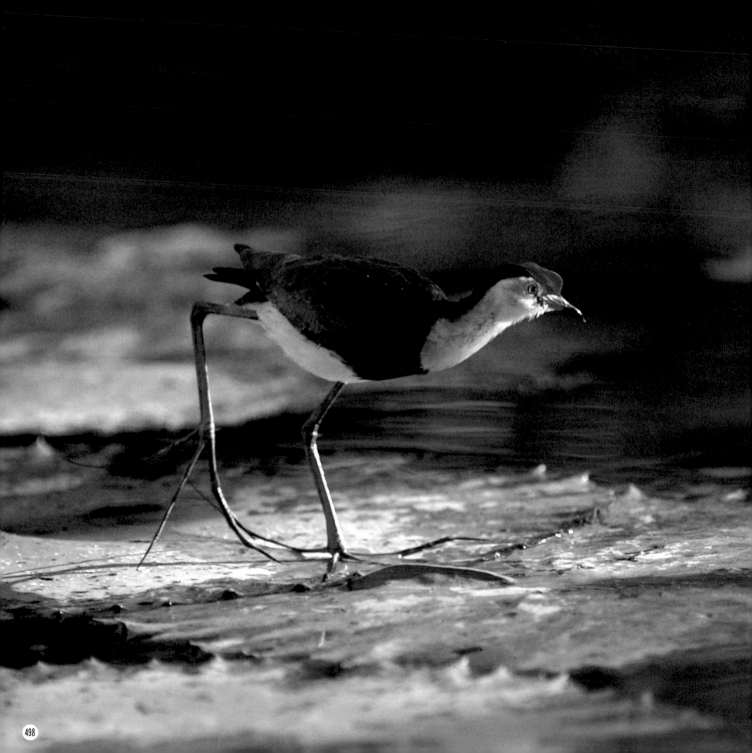

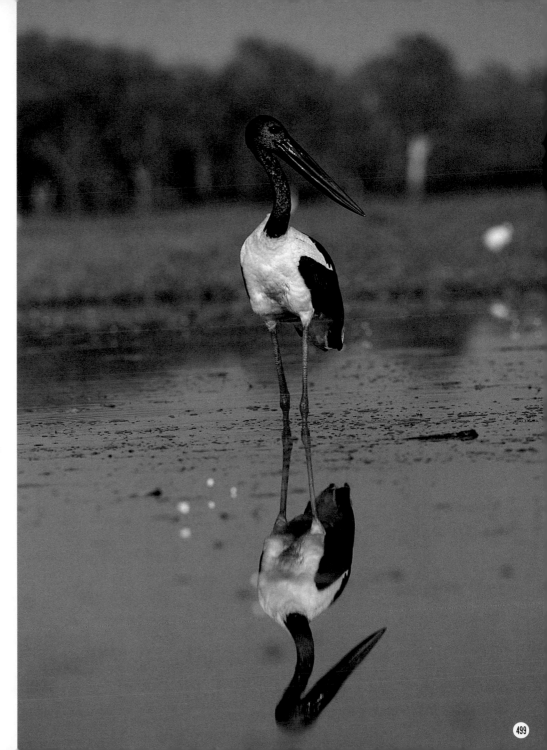

left: Although not webbed, the feet of comb-crested jacanas have very long toes that enable them to walk on floating water plants. Sometimes the adults carry their chicks under their wings, making them look almost like centipedes when the chick's legs poke out.

Many waterfowl come to Fog Dam, which became a nature conservation area after the dam was constructed. The black-necked stork is well known in Australia and is the symbol of Kakadu National Park.

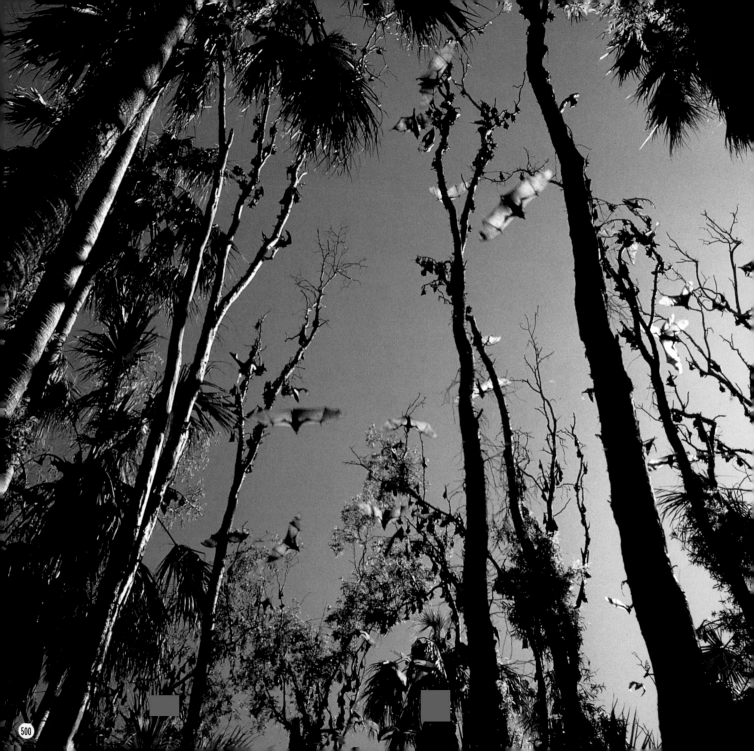

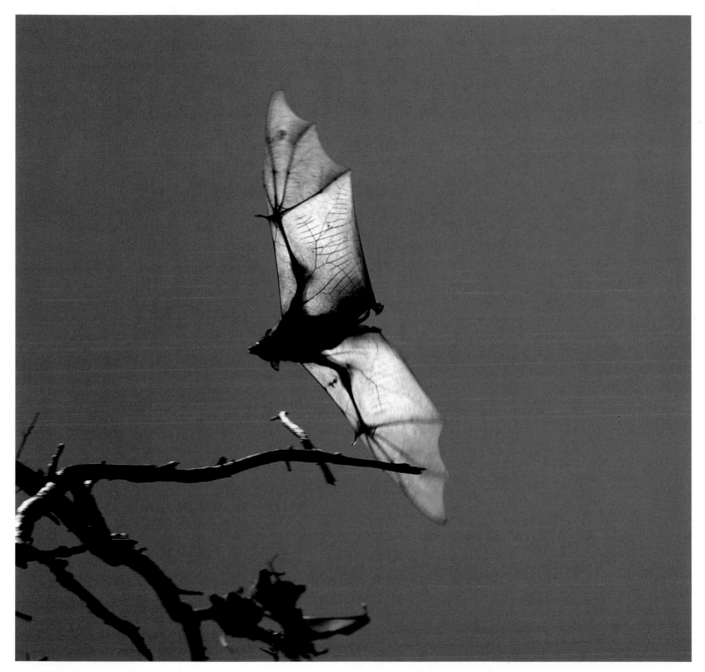

left: Although normally nocturnal, these black flying foxes glide through the woods by the springwater of Mataranka.

Like their Asian relatives, they feed mainly on fruit.

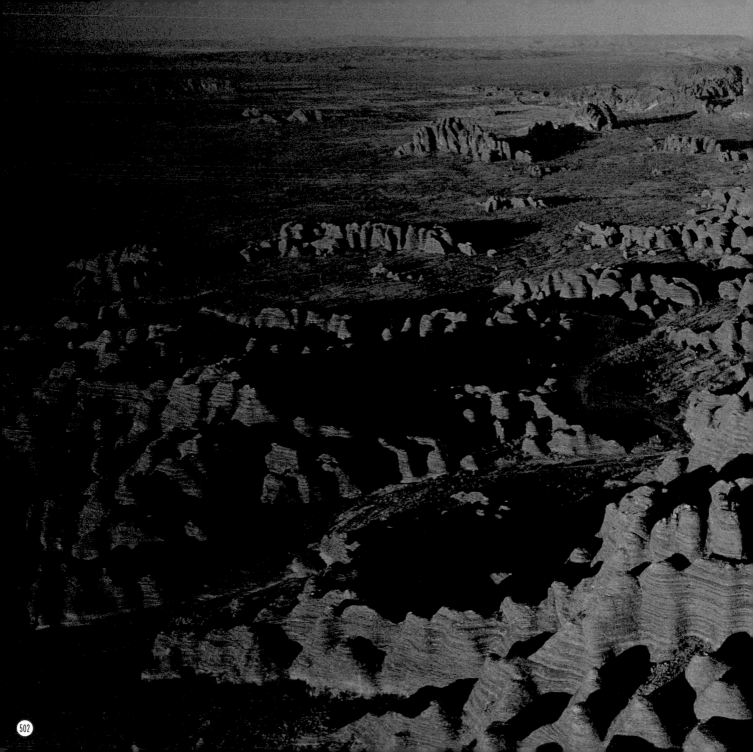

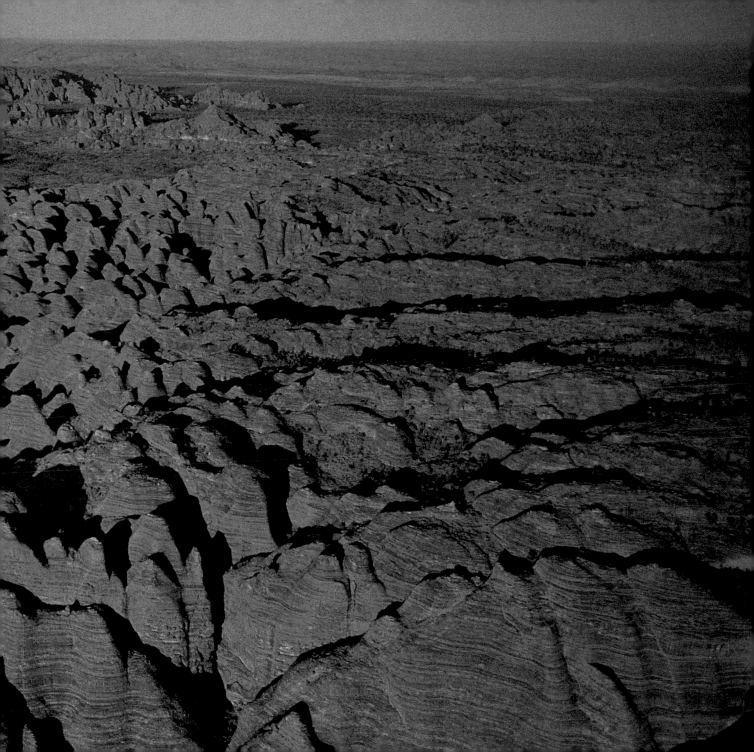

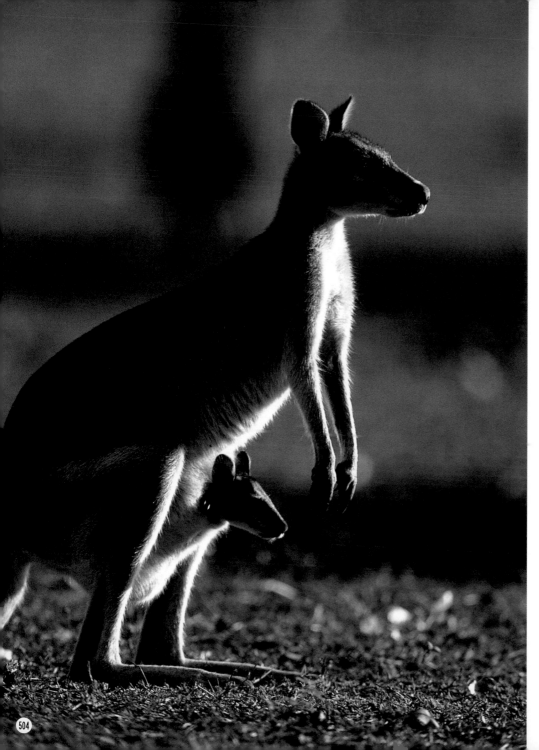

preceding pages: Recording
350 million years of geologic
history, the sandstone of
Bangle-bangle has been chiseled
by rain and wind.

A sandy wallaby alert to possible
danger.

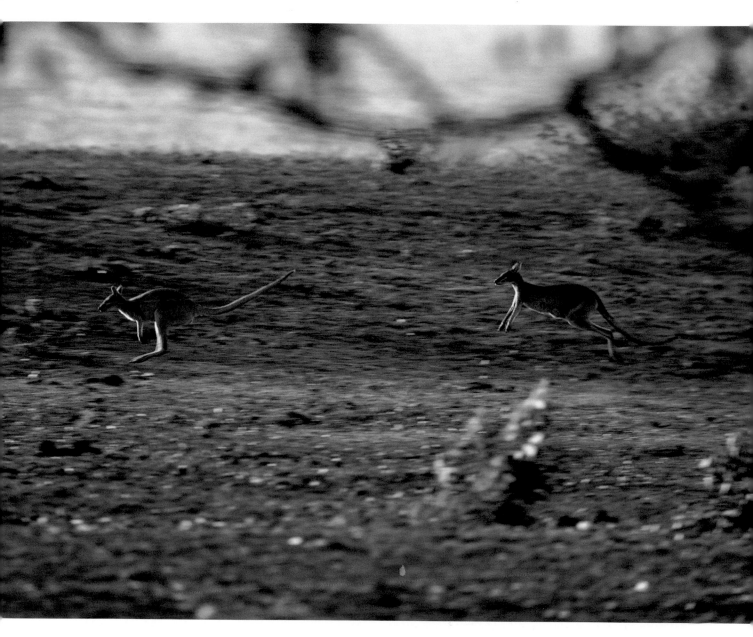

Wallabies hop in a manner similar to kangaroos. These wallabies live in a protected area.

A true kangaroo in all aspects but size, a rat kangaroo eats grass in the woods of Lamington National Park, Queensland.

right: Dingoes are found all over Australia. Ranchers consider them pests.

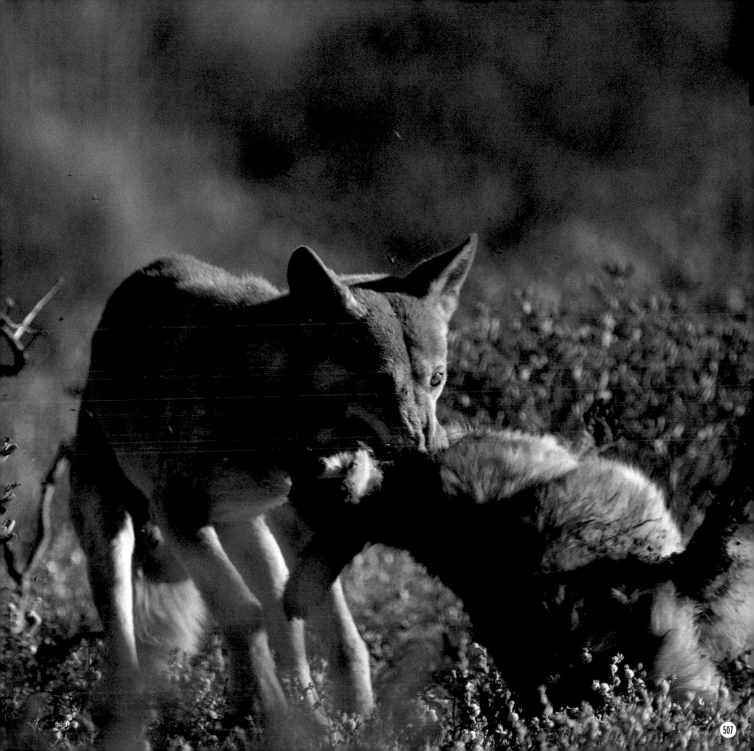

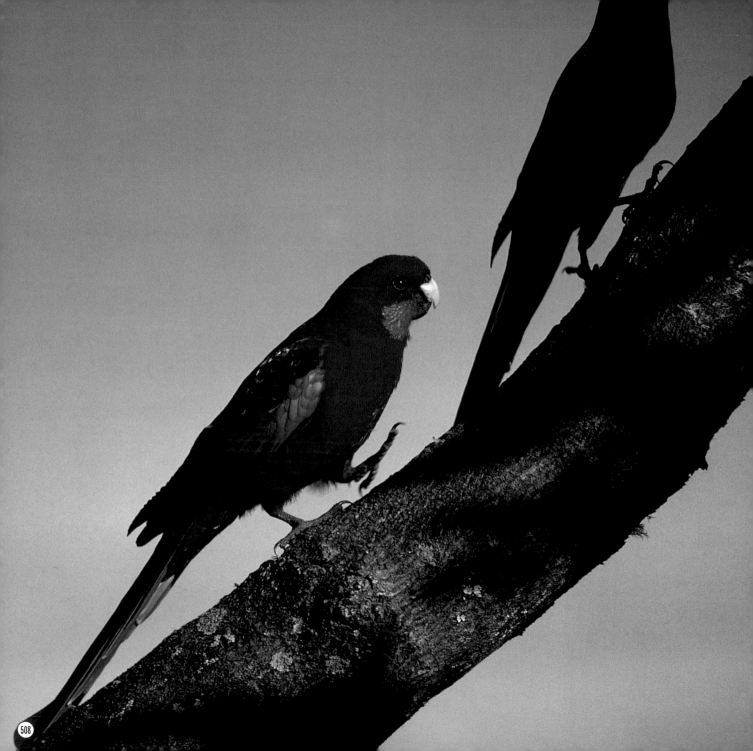

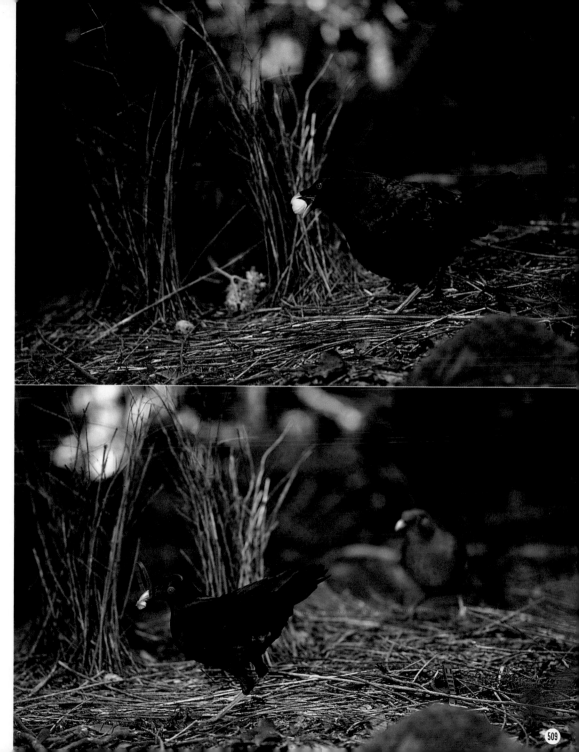

following page: Several thousand rainbow lorikeets fly in the park in Canungra, a town on Queensland's Gold Coast. They come here because they have learned that tourists will feed them.

left: A type of parrot, these crimson rosellas were flying among the trees of Lamington National Park, calling to each other.

Satin bowerbirds display in a very elaborate ritual. A male bird builds a bower with twigs, adorning it with blue flowers and berries, and invites a female over. When she arrives, he holds blue flowers, blue berries, and yellow berries in his beak and gives a display dance, singing and puffing up his body. If the female doesn't like the bower, she will break it.

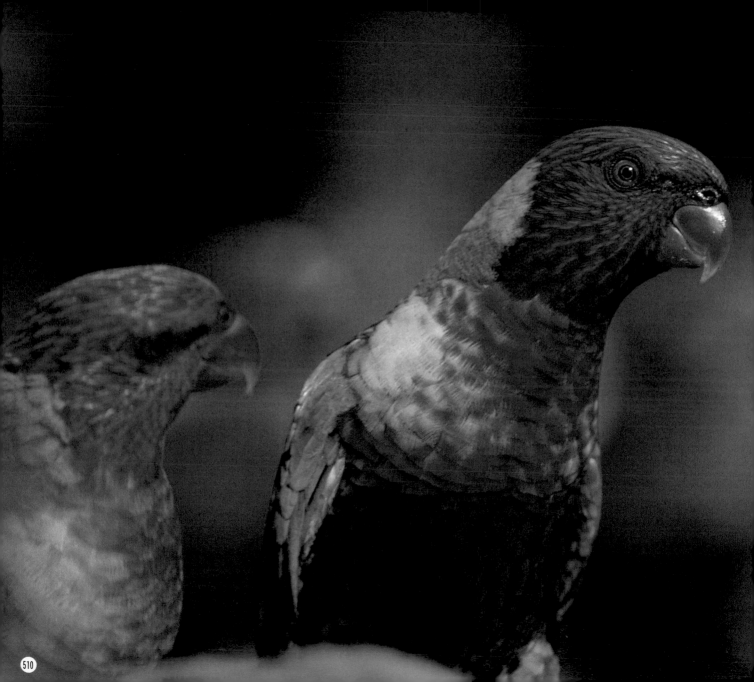

This scaly-breasted lorikeet is eating nectar from the flowers of garden trees in Kanangra. (511)

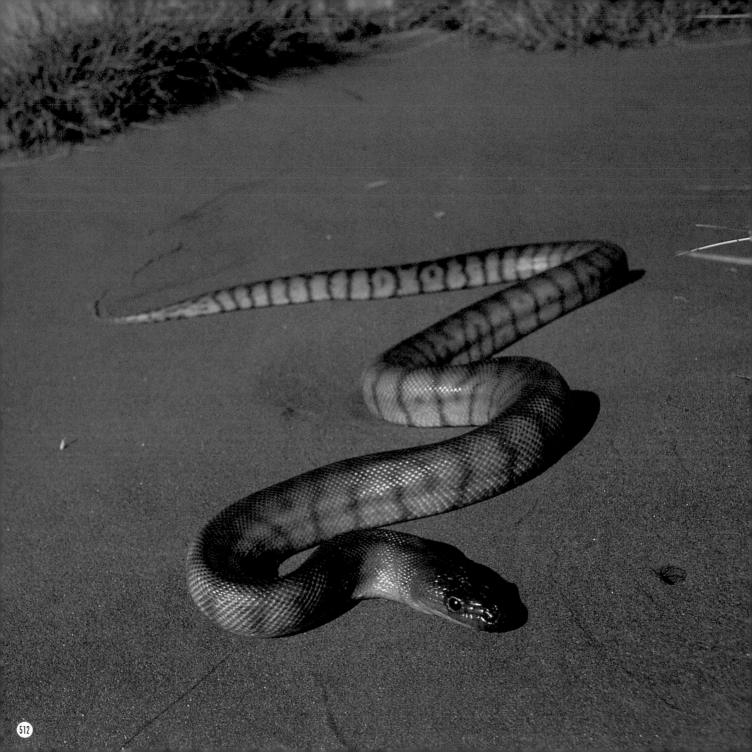

left: The Red Center, the woma's habitat, is in central Australia and is named for the region's extreme heat. Not a constrictor, this snake kills its prey with poison.

The blue-tongued skink also lives in the Red Center.

About the size of a hand,
the moloch is covered with
prickly spines.

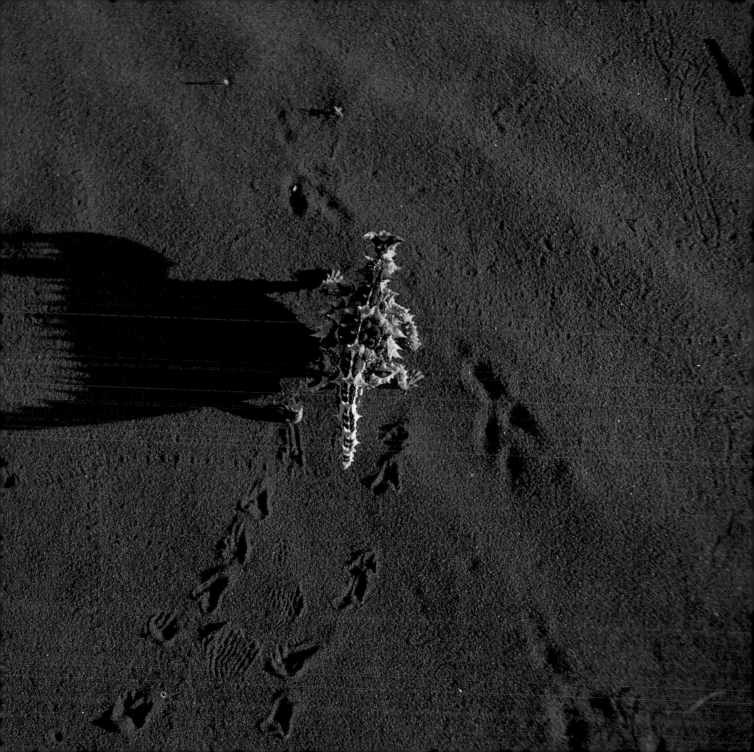

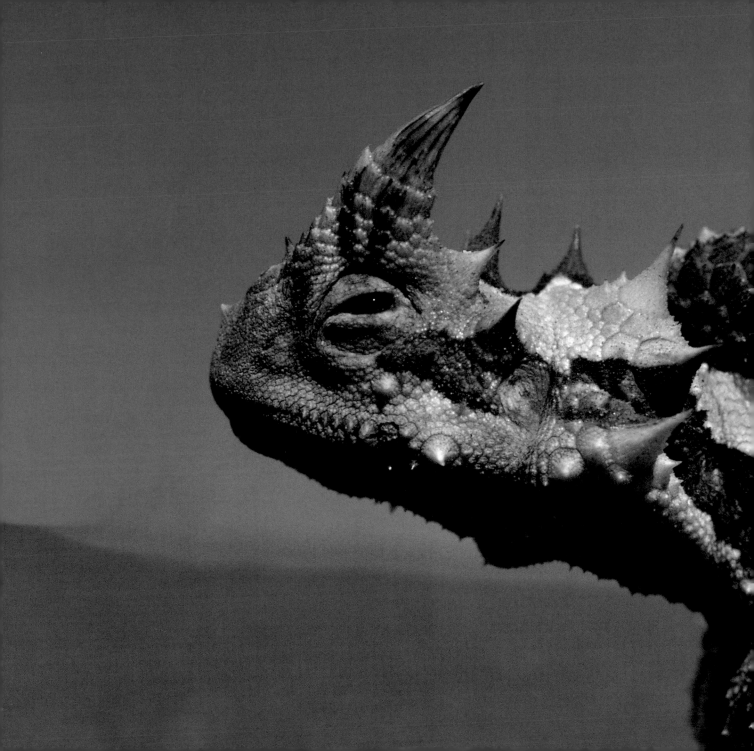

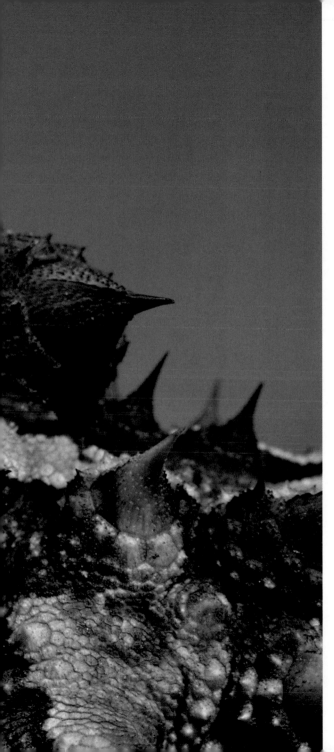

pages 518-519: Ayers Rock,
with a circumference of
several miles, rose from
the seabed hundreds of
millions of years ago.

pages 520-521: The emu, the
world's second-largest bird,
is a relative of the cas-
sowary. Male emus incubate
the eggs and take care of
the chicks for eighteen
months. Females do not
help raise the chicks.

Molochs like to eat black
ants. Standing in front of a
marching line of ants,
the lizards may lick up
and devour hundreds or
thousands of insects.

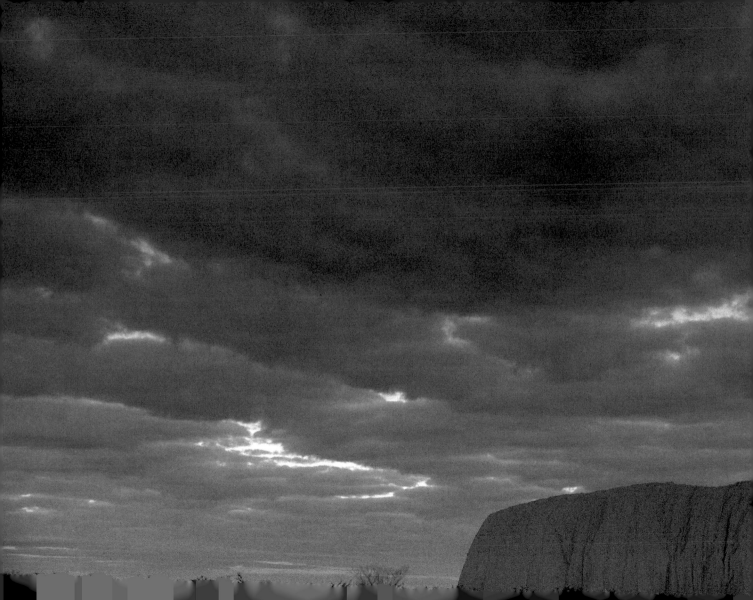

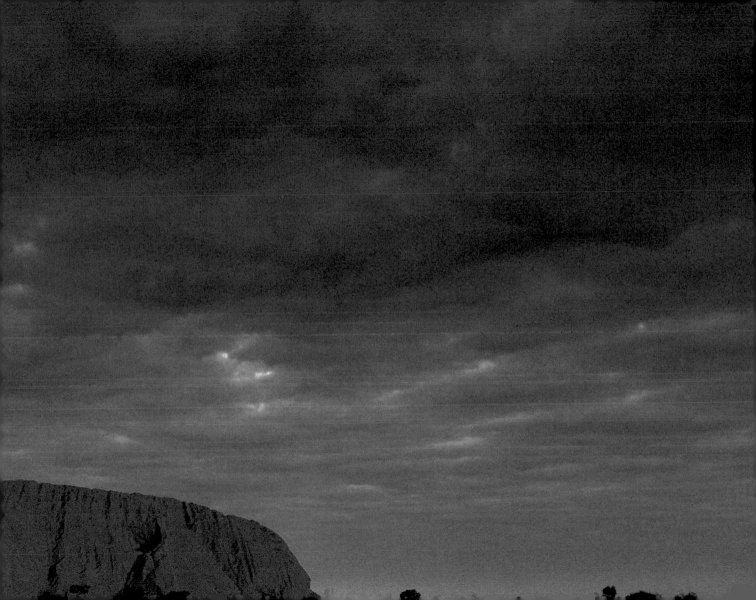

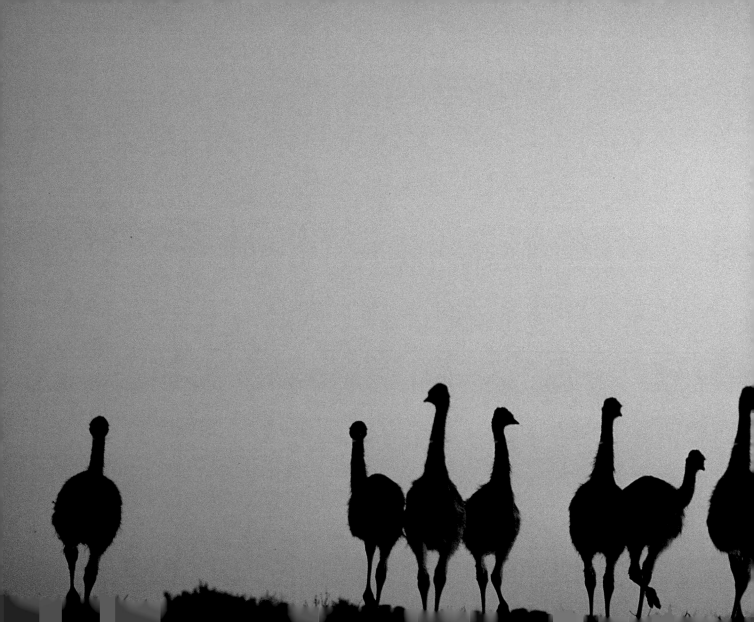

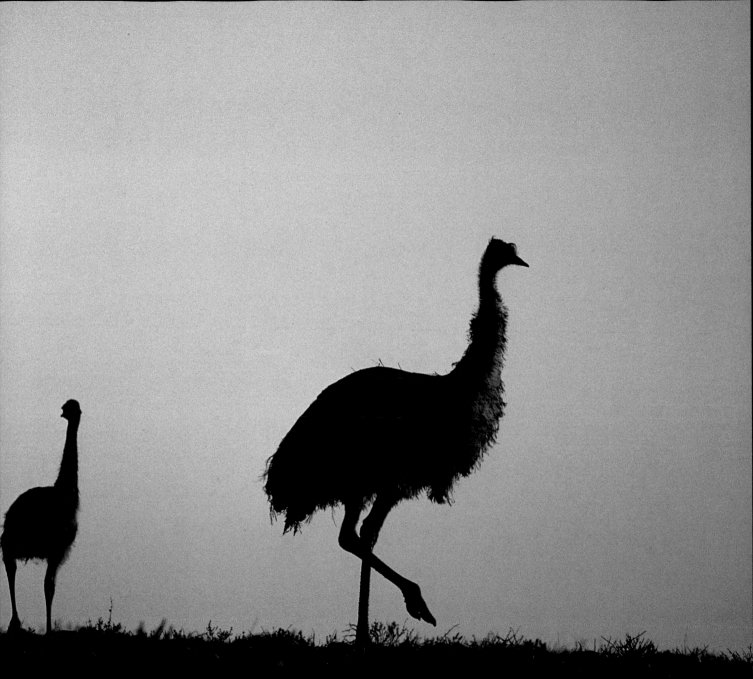

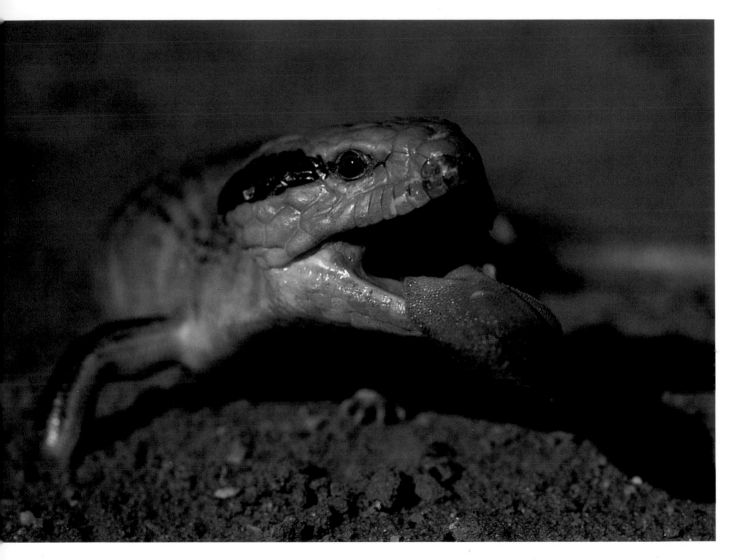

Centralian blue-tongued skinks show their blue
tongues to threaten their enemies.

right: This red kangaroo is caught in a violent
sandstorm and hops quickly to shelter.

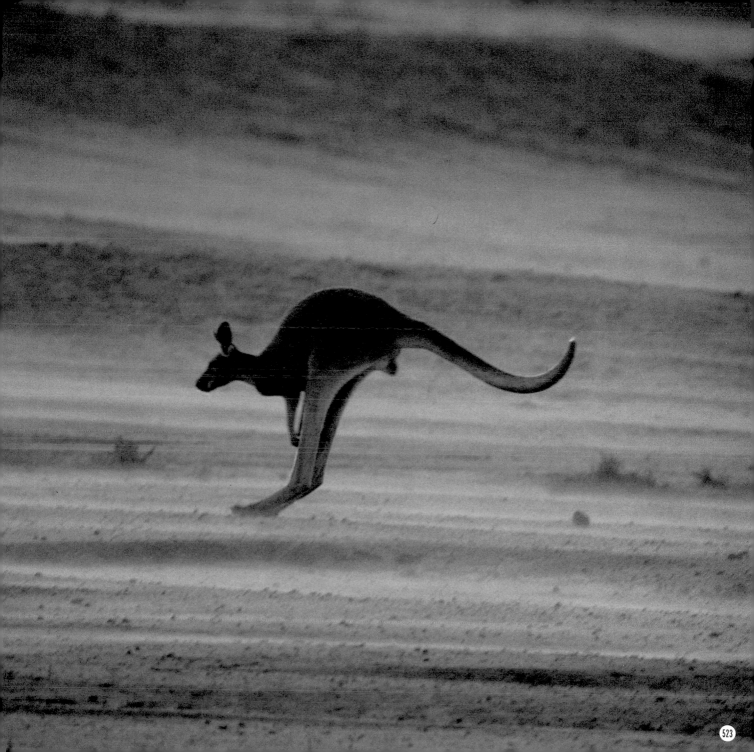

left: After finishing breakfast, this male kangaroo in Kinchega National Park needed to scratch an itch.

Cockatiels in Sturt National Park build their nests in the hollows of trees growing on the dried-up riverbed. In addition to cockatiels, galahs and budgerigars also build nests in the sparse trees.

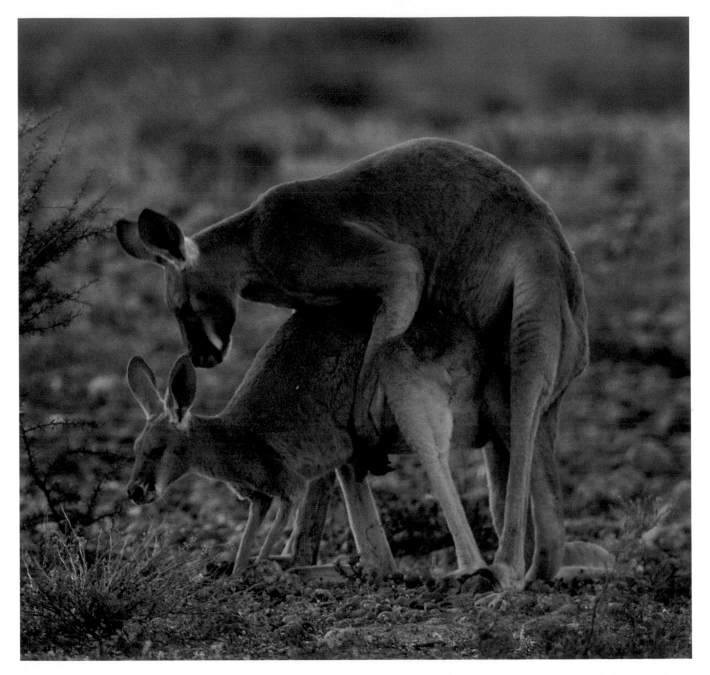

Red kangaroos mate just before the rain comes to the dry interior.

right: Summer in the interior is dry, and the heat is intense. An old male kangaroo licks his forelegs to lower his body temperature. The evaporating water cools his body.

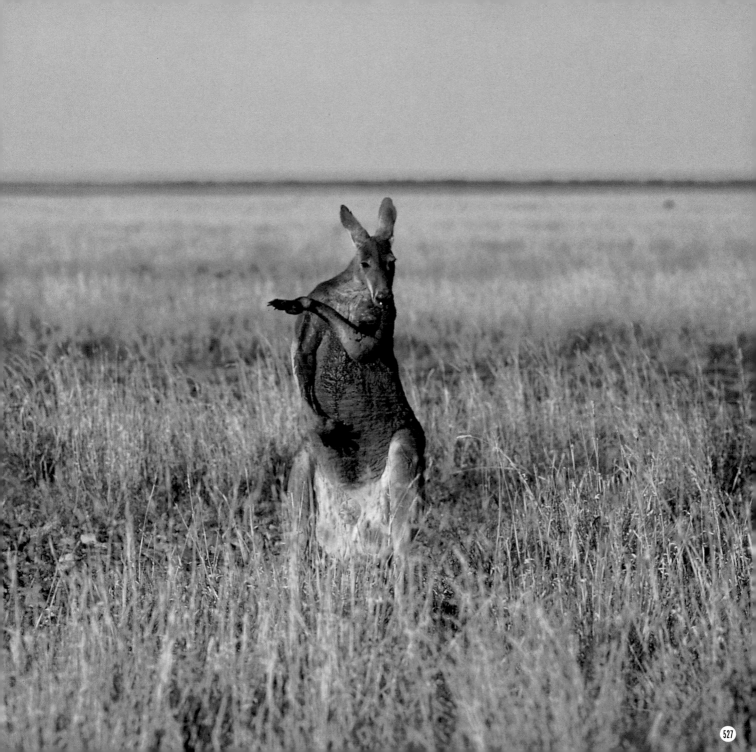

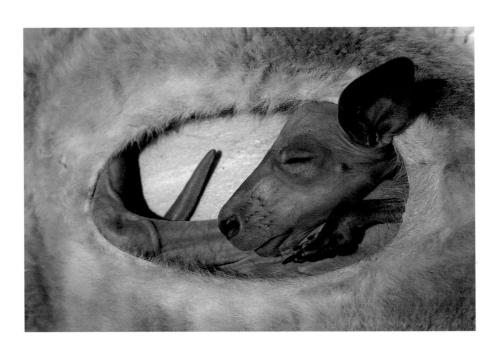

Inside a mother kangaroo's pouch. For the first six months, a baby kangaroo survives on its mother's milk. Here, the baby is now 130 days old and is beginning to look like a kangaroo.

right: Safe and sound, a baby kangaroo stays in its mother's pouch until it has grown fairly large.

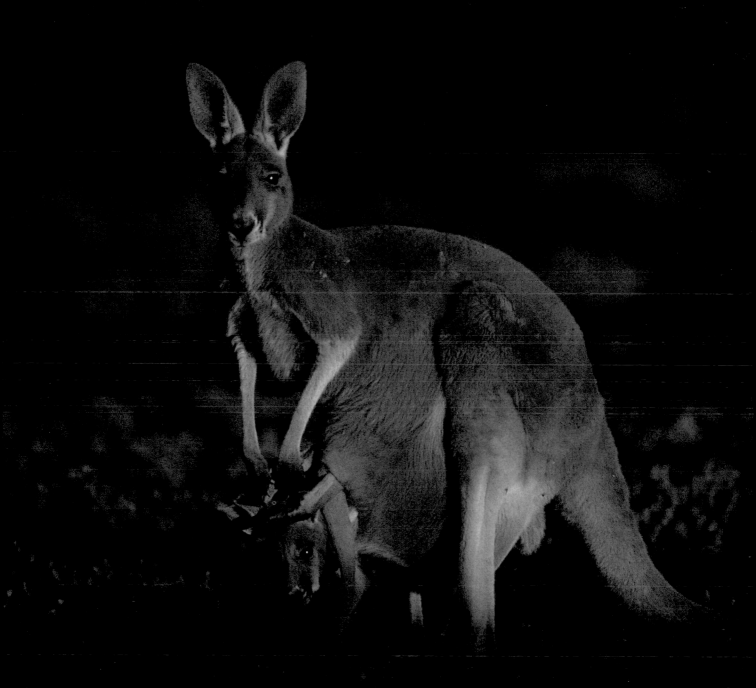

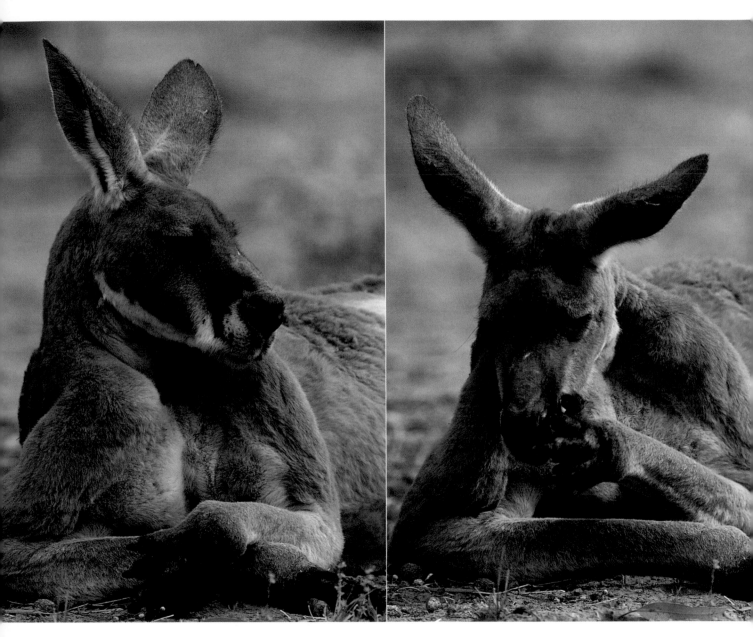

Showing signs of age, this old red kangaroo remained still even when approached.

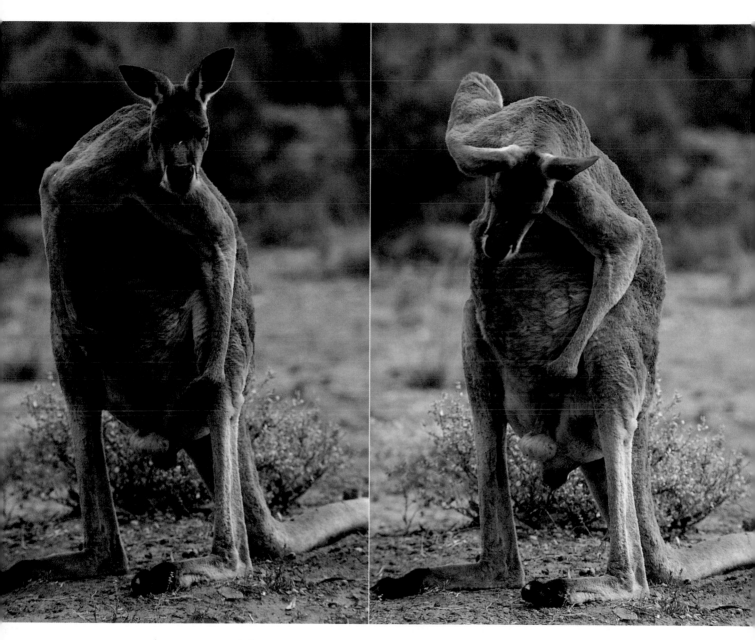

Like most creatures that live close to the earth, the kangaroo spends a long time scratching.

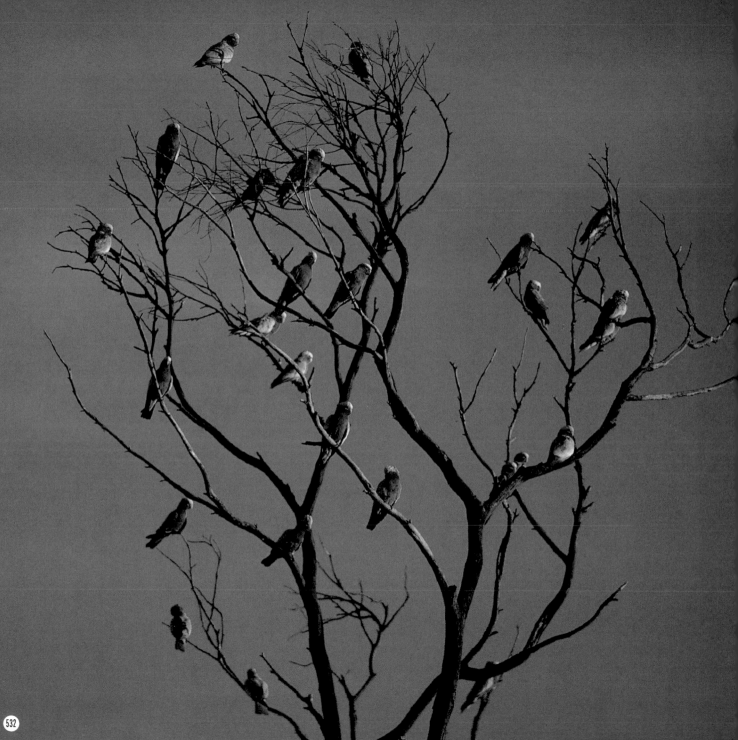

Galahs cuddle near their nest.

left: A flock of galahs roosts on a tree in Sturt National Park. The monotonous blue Australian sky becomes more vivid when thin clouds appear in the evening.

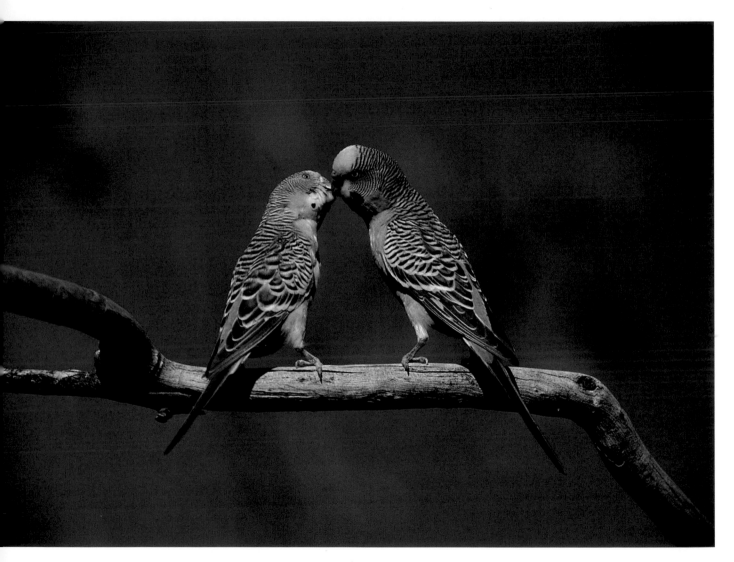

Budgerigars are one of the most widely known pet birds. In the breeding season, the base of the upper beak becomes dark blue.

right: A large flock of budgerigars descends on a water hole for a quick drink.

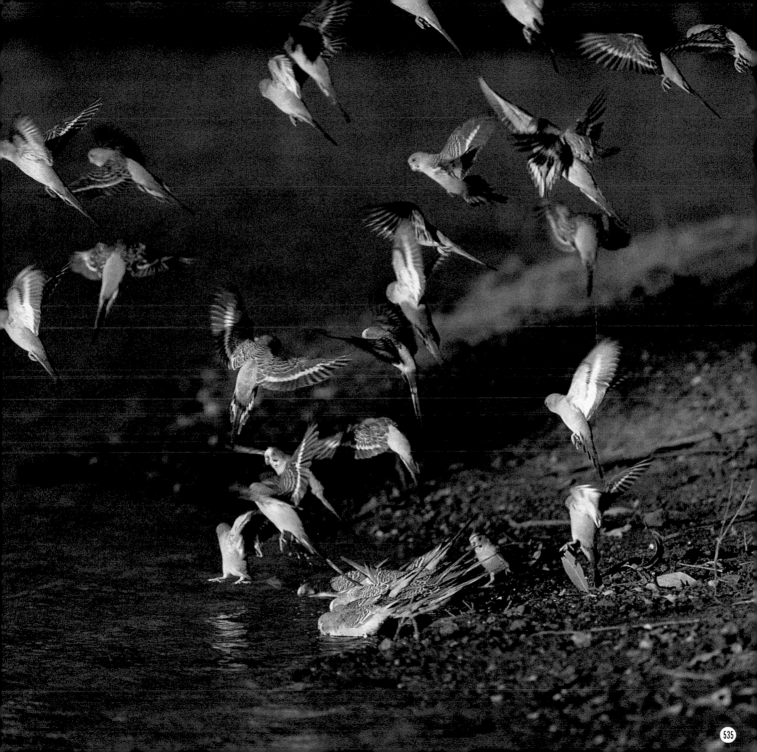

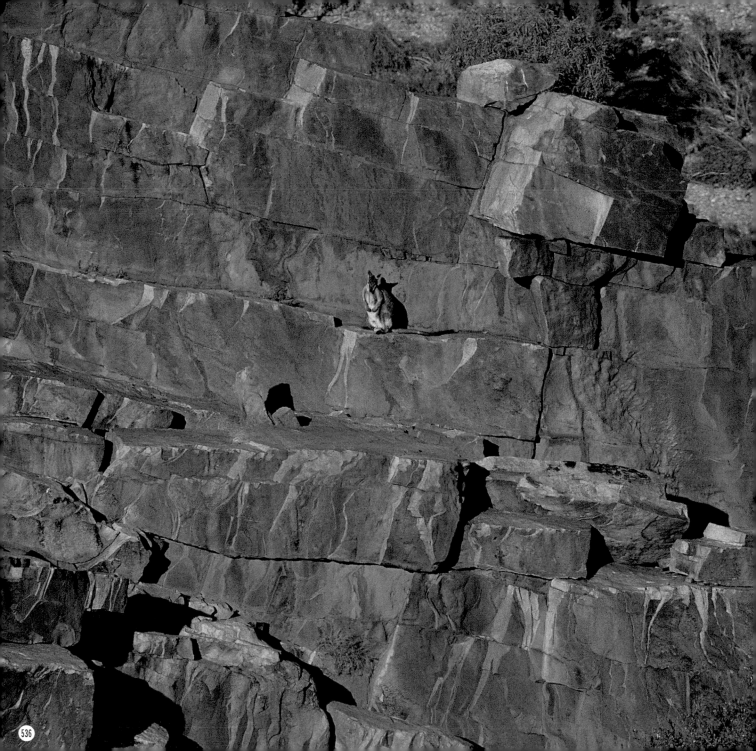

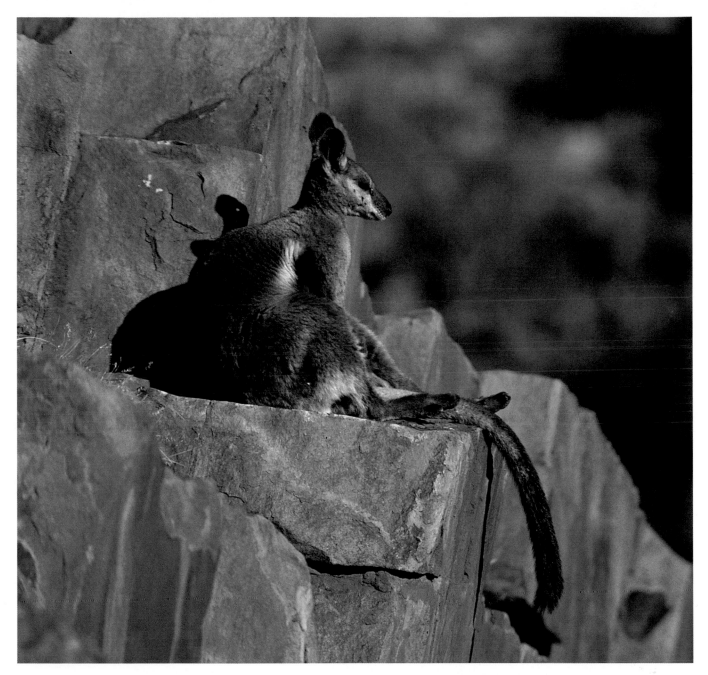

left: The size of a small dog, bush-tailed rock wallabies live on the rocks of the arid interior of Australia. They come out at night to eat sparse grass that grows in the water seeping between the rocks.

Rock wallabies are masters of their rocky heights. Their tails, covered with long fur, are valuable aids to moving on the steep cliffs.

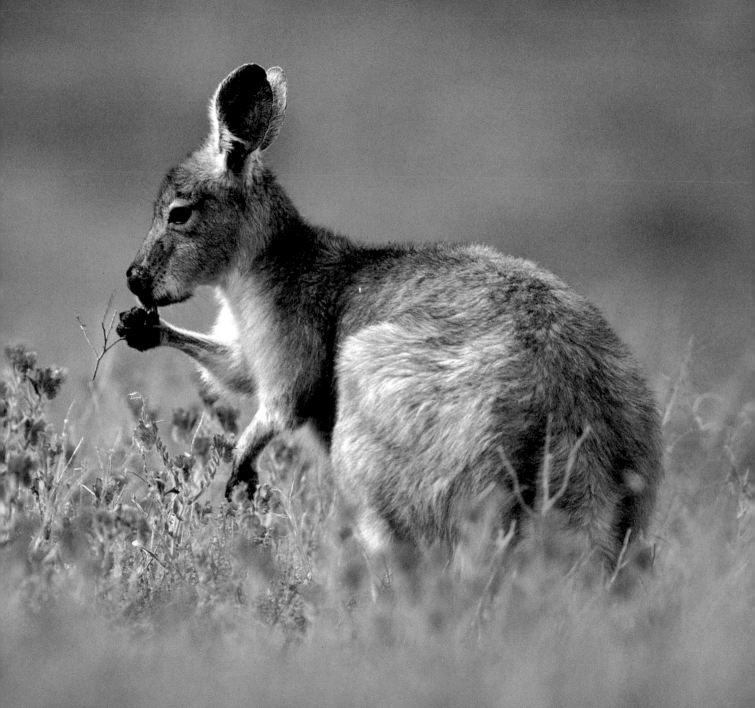

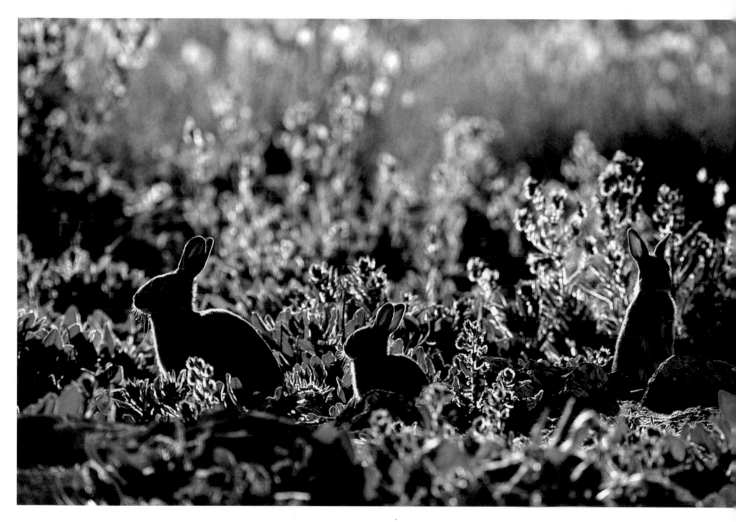

left: The flowering plant is Celebration Jane. Brought from Europe, it paints the mountains of Flinders Ranges National Park purple. Kangaroos shun the plant.

Since they were brought to Australia, European rabbits have multiplied extraordinarily. Efforts to contain them have failed.

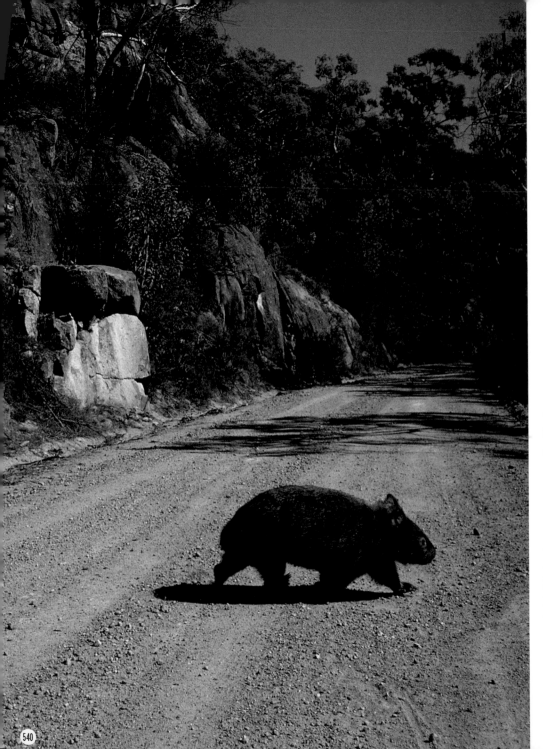

right: A wombat peers from its burrow, one of many dug into a mountain slope.

A common wombat crosses the road to Mount Kosciusko. A marsupial—like kangaroos and wallabies—wombats resemble koalas. While koalas live in tall trees, wombats live on the ground and feed on grass.

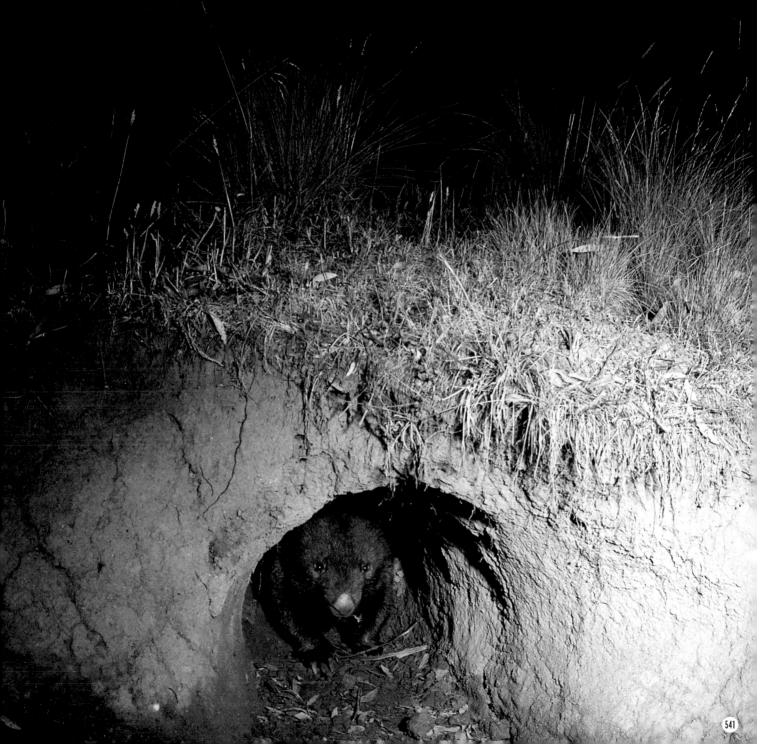

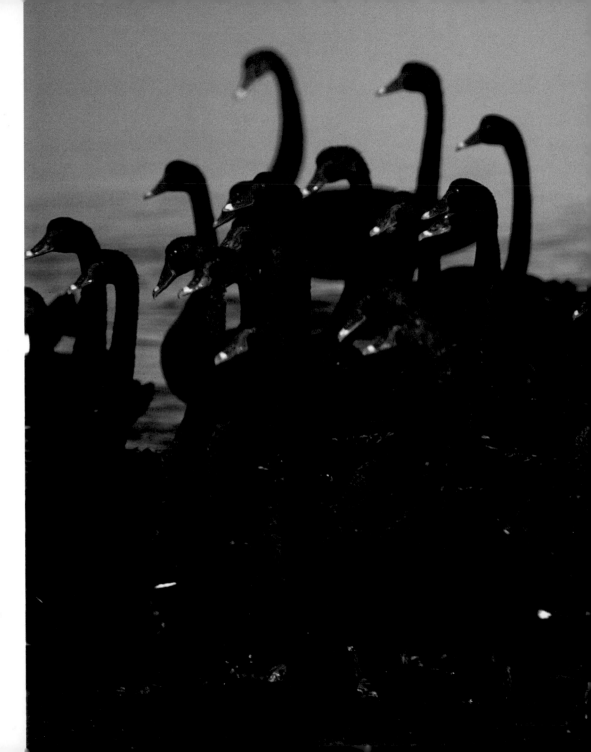

In the Younghusband Peninsula, black swans gather in the soak, a pool of water that has seeped from sand dunes.

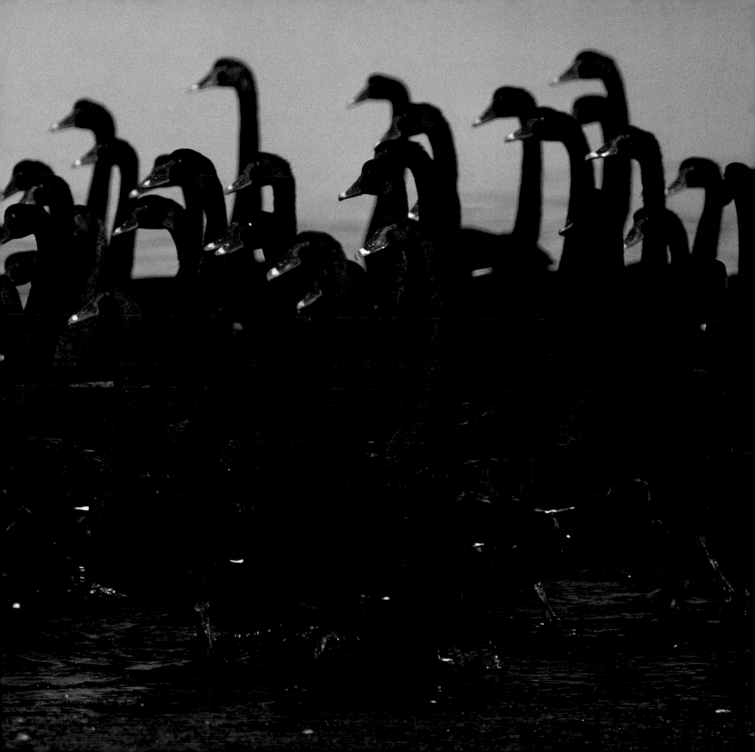

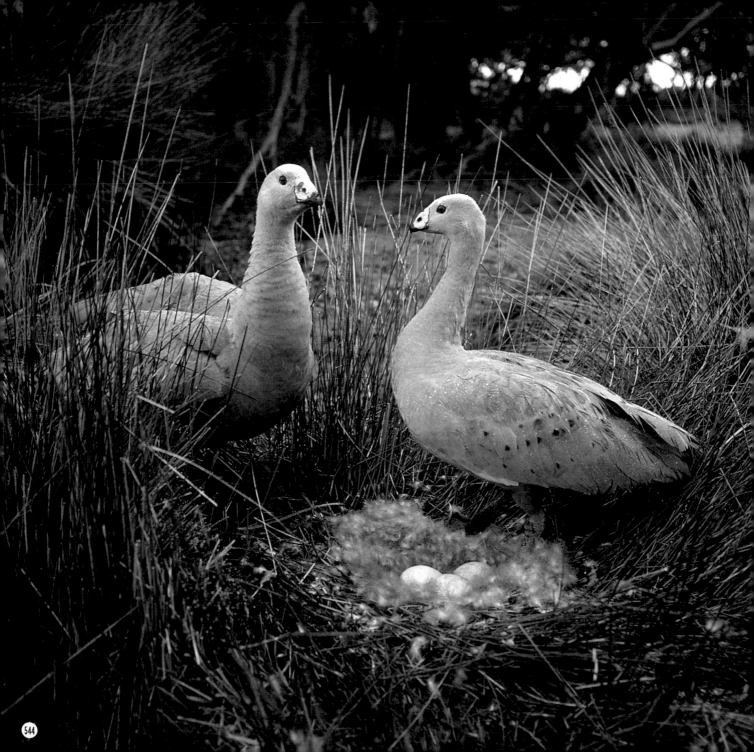

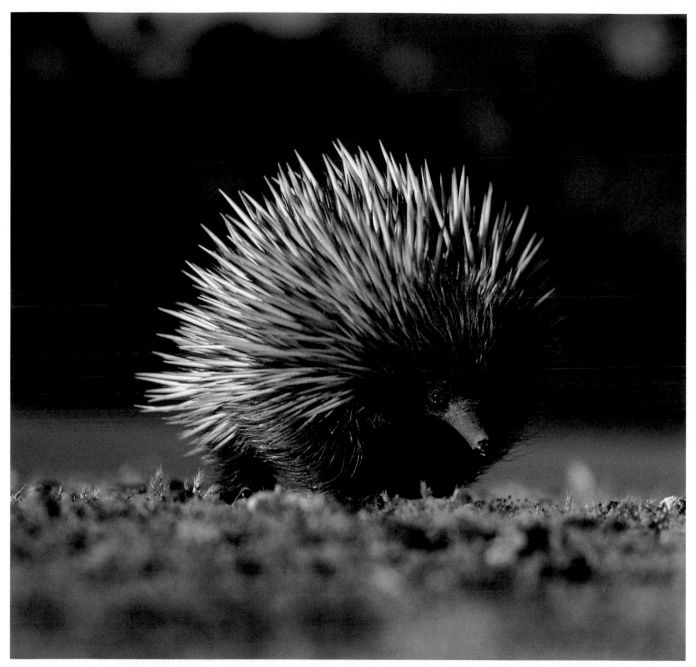

left: Using their own feathers, cape barren geese build
nests in the marshland of Kangaroo Island. Hunted
for their feathers, they once faced extinction.

Like the platypus, the spiny anteater is an egg-laying mammal.
This resident of Flinders Chase hurries through the open grassland.

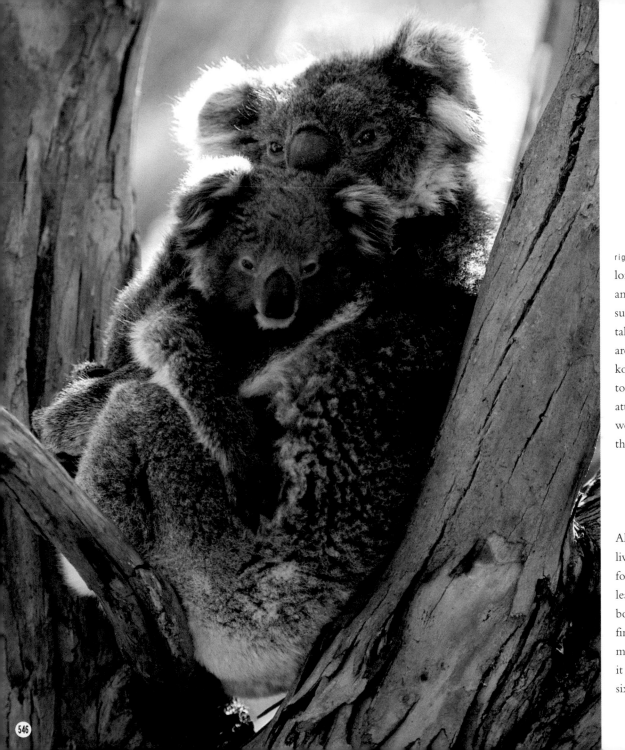

right: Koalas have long, sharp claws and a strong grip suited for living in tall trees. When they are physically weak, koalas come down to the ground, where attacks by ticks further weaken them until they die.

Also marsupials, koalas live in the eucalyptus forest and feed on leaves. After being born, a baby koala must find its own way to its mother's pouch, where it will live on milk for six months.

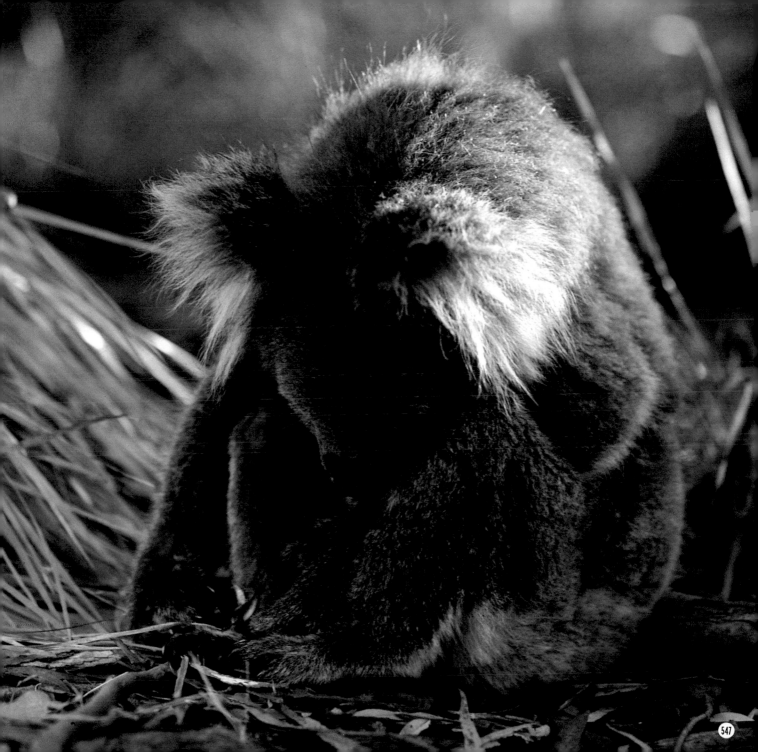

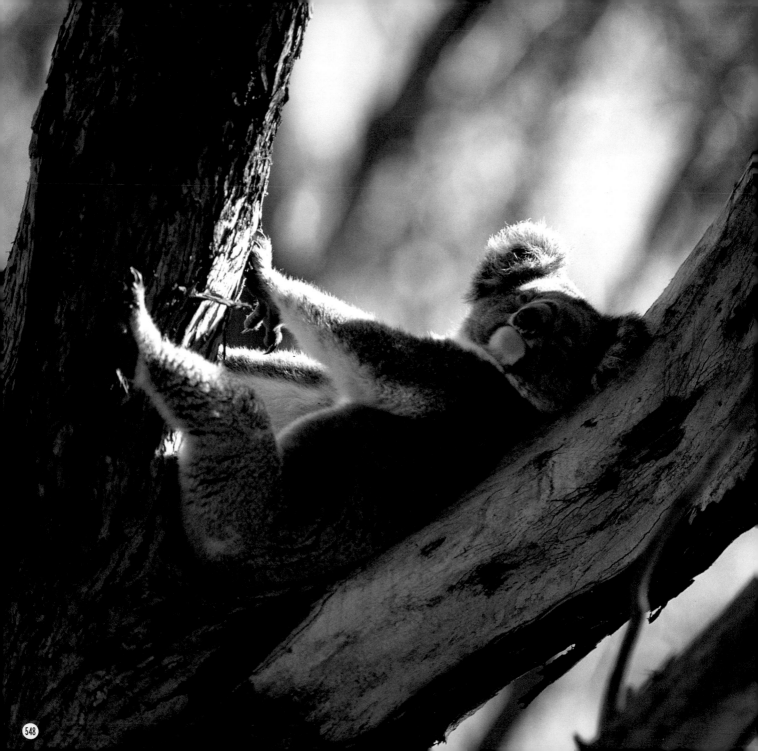

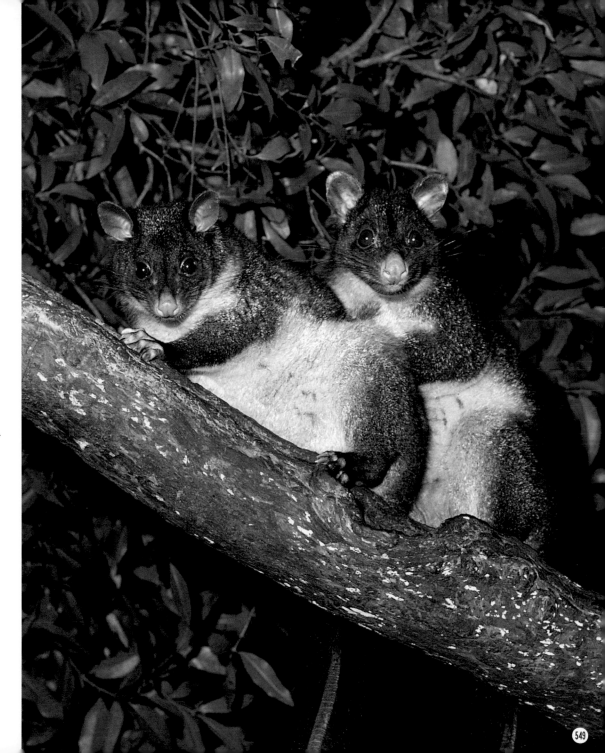

following page: The duck-billed platypus is closely related to reptiles, not mammals. Females lay eggs and nurse the new babies with their milk.

left: Normally quiet and content to sleep away the day, koalas are active when the breeding season comes. Males eagerly chase females and fights between males are common. The act of mating is over very quickly, signaled by the female's squeak of displeasure.

Mountain possums are nocturnal marsupials.

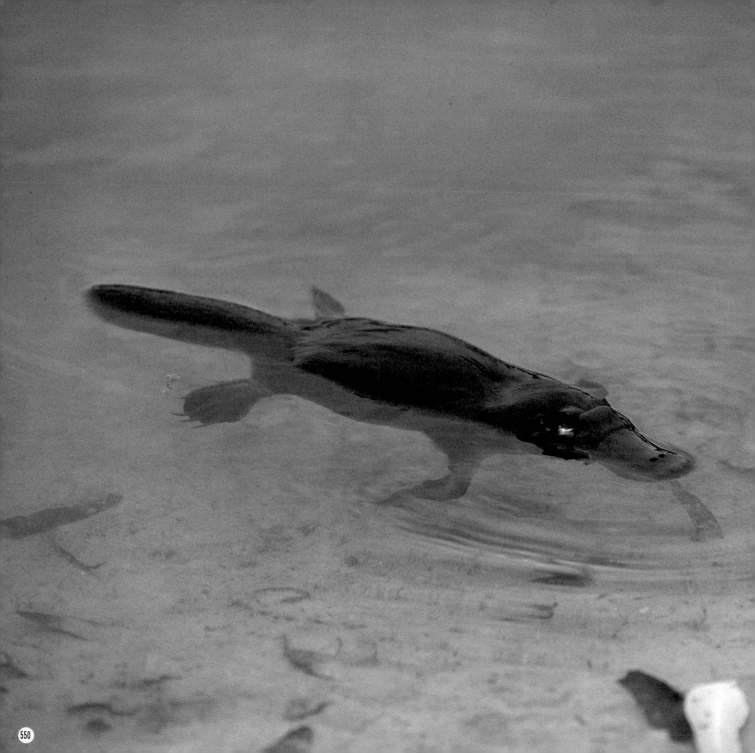

Well adapted to its aquatic habitat, the platypus hunts by touch for small animals underwater, its eyes and ears closed, its pliable, sensitive bill guiding the search.

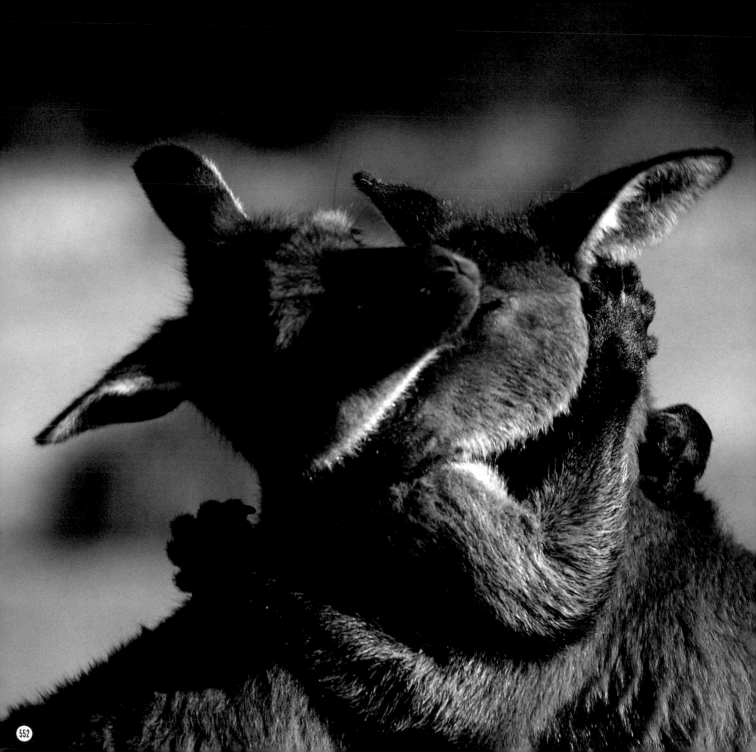

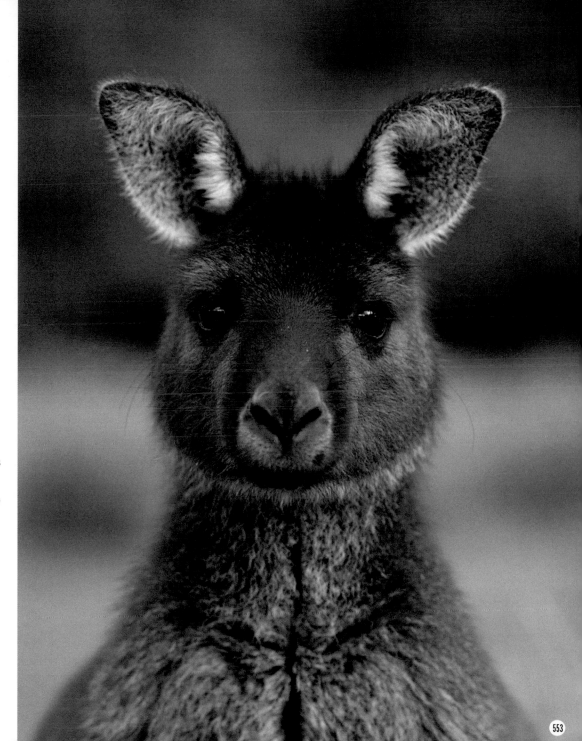

left: Western gray kangaroos are found only on Kangaroo Island. These two are not fighting seriously.

Similar in appearance to a wallaby, the western gray kangaroo is slightly larger, with a rounder face and eyes.

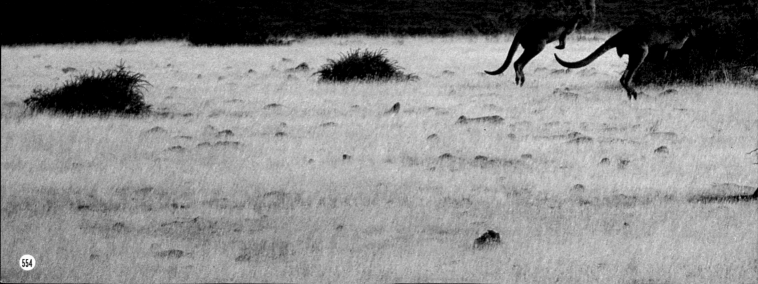

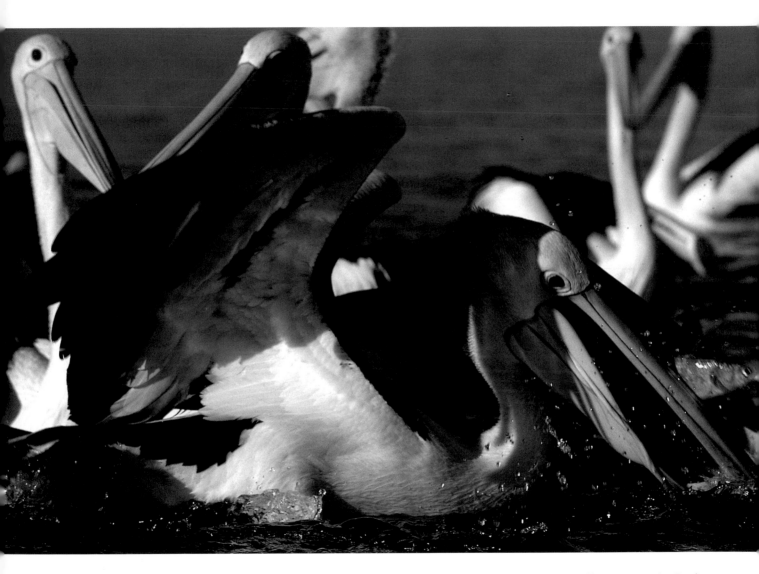

preceding pages: Kangaroo Island was settled about one hundred years later than the Australian mainland. The island is not as dry as Australia, and its geographic isolation has allowed its wildlife to thrive.

Australian pelicans breed annually in groups. At Coulon National Park, which is in the lagoon formed along Younghusband Peninsula, sand dunes block the cold water and winds from the Antarctic. Because of the favorable environment, many other kinds of waterfowl gather here, too.

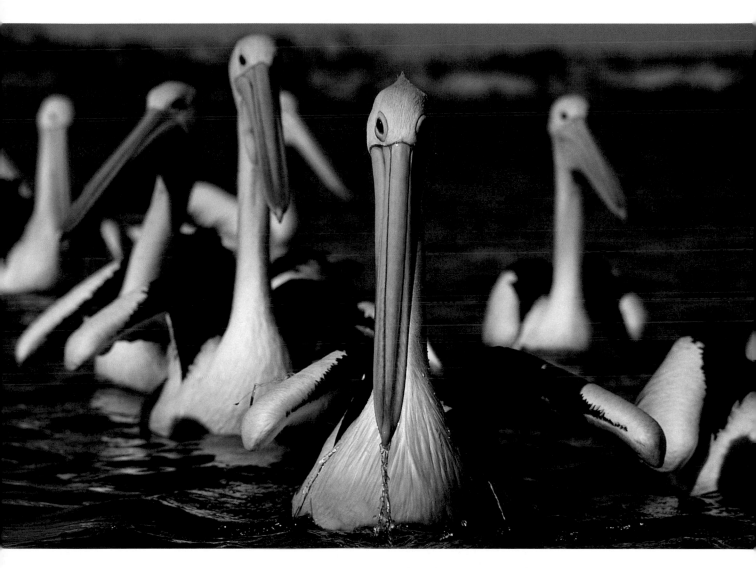

The pelicans come to Lake Menindee for fish. They line up side by side, then, as if by agreement, they all dive, catch fish, and lift their heads up together.

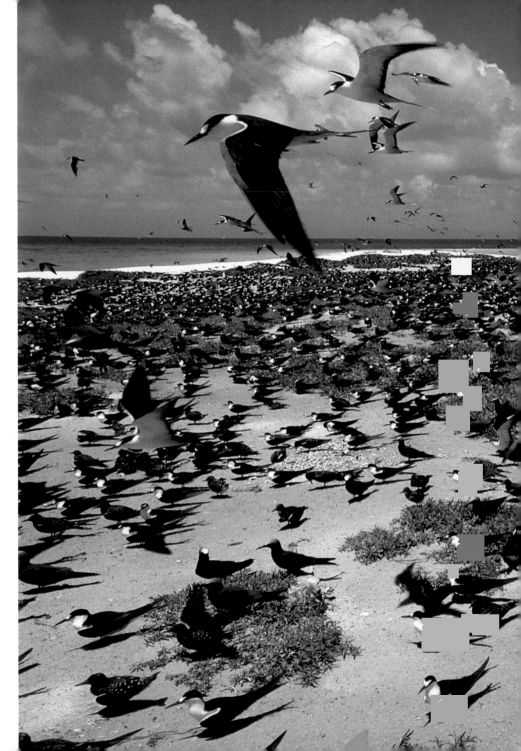

Sociable sooty terns gather in breeding colonies on Younghusband Peninsula. Terns seldom build nests, preferring to lay their eggs on shallow sand.

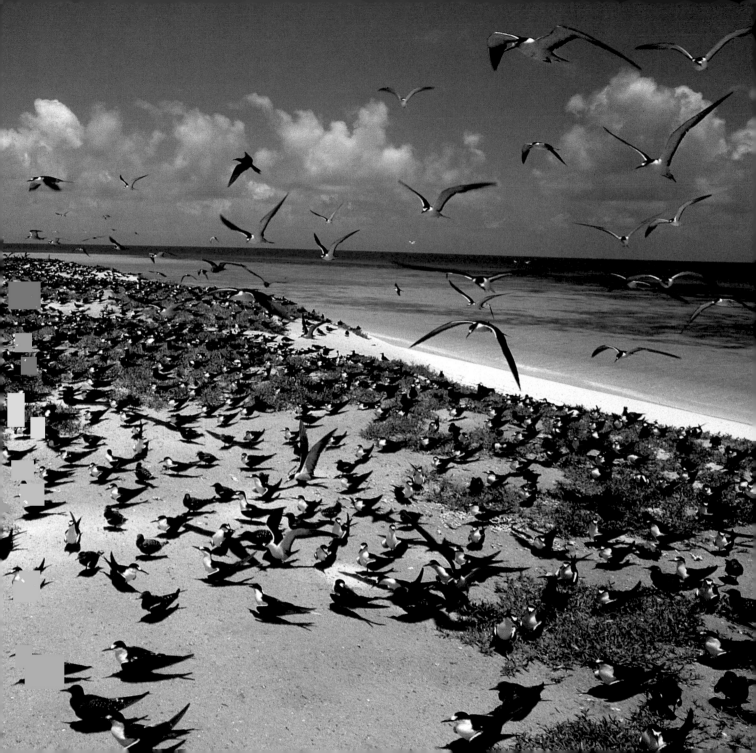

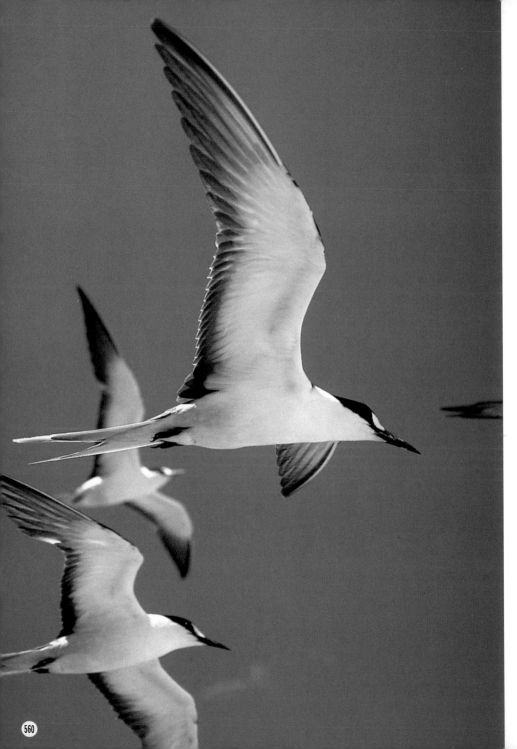

right: A tern flying over
the breeding site in Cairns
with a fish for her young.

Like most terns, these fairy
terns have short legs that
are ill-adapted for swim-
ming or walking. They are
powerful flyers, often
spending the greater part
of each day aloft.

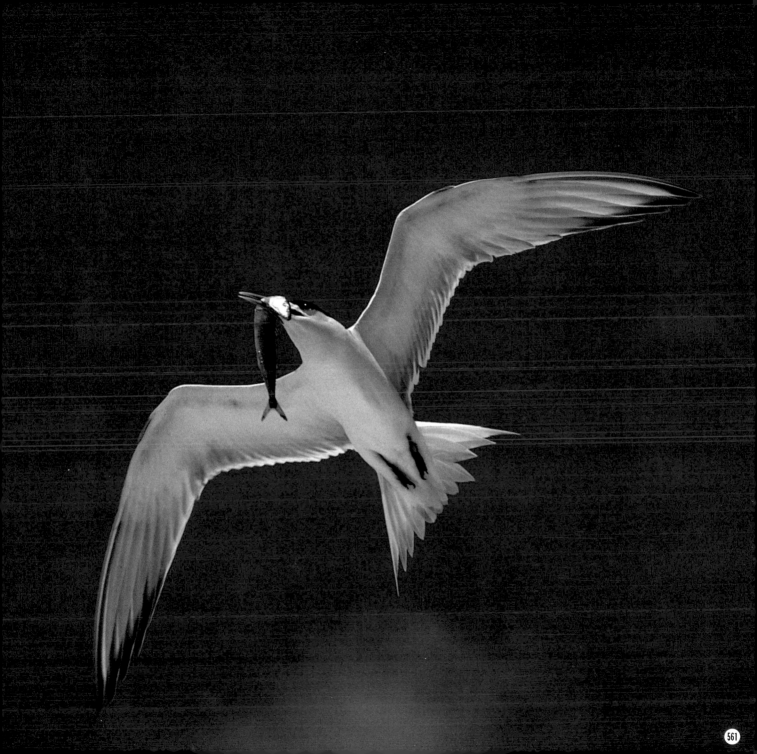

A male Australian sea lion approaches a female. The difference in size is obvious. Sea lions were not hunted for their fur, but for food and for a source of low grade oil. This pair lives on a sea lion preserve.

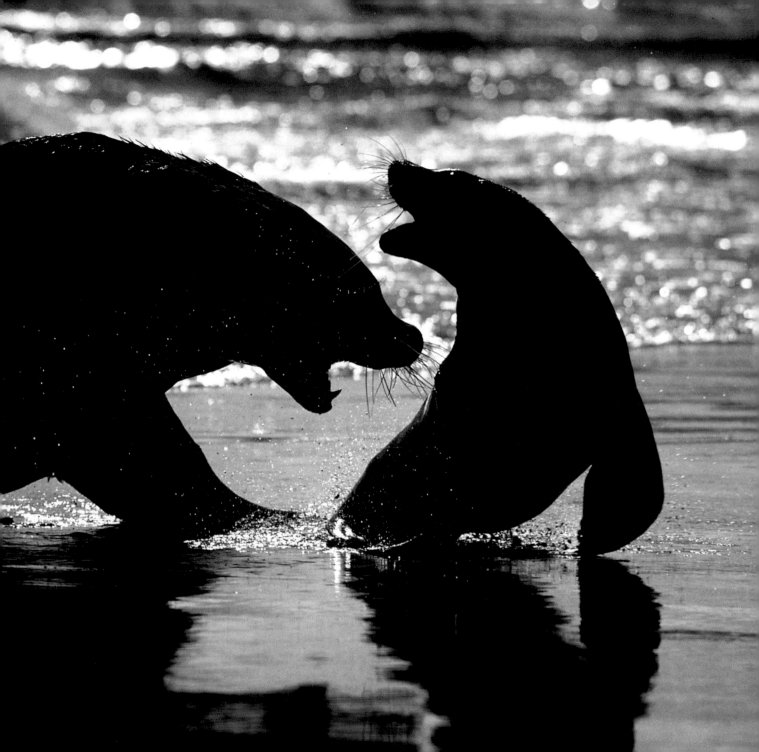

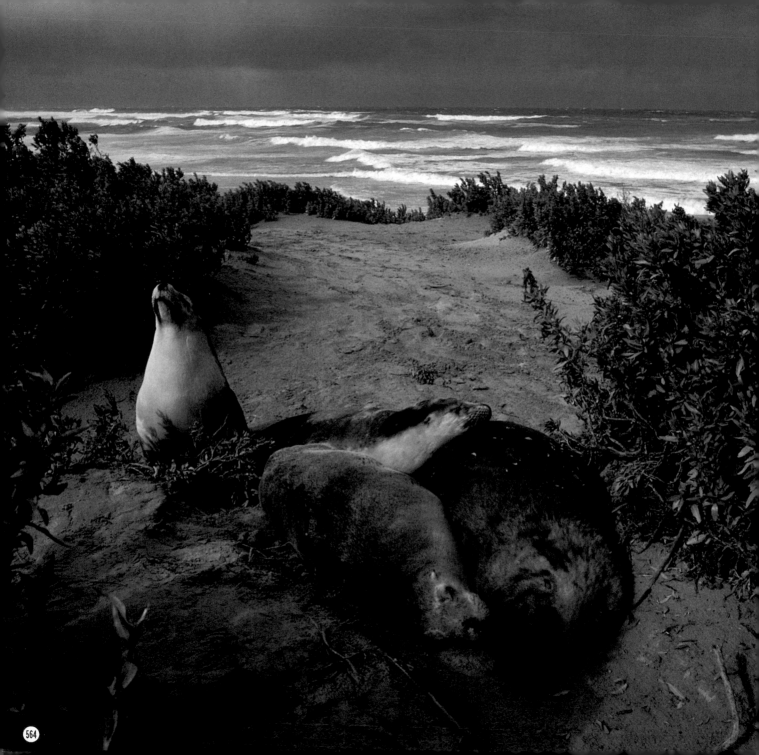

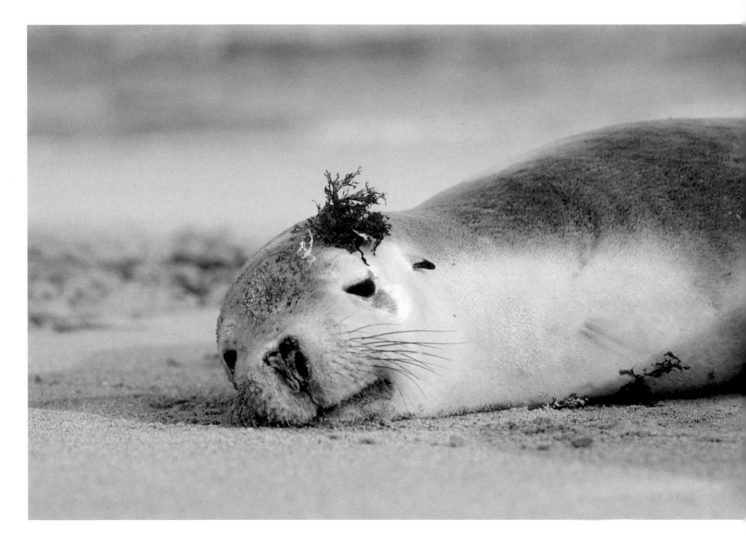

After a fierce storm, a young female
sea lion rests on the beach.

left: Ashore, sea lions use their flippers like legs and
can cover ground at a surprising speed.

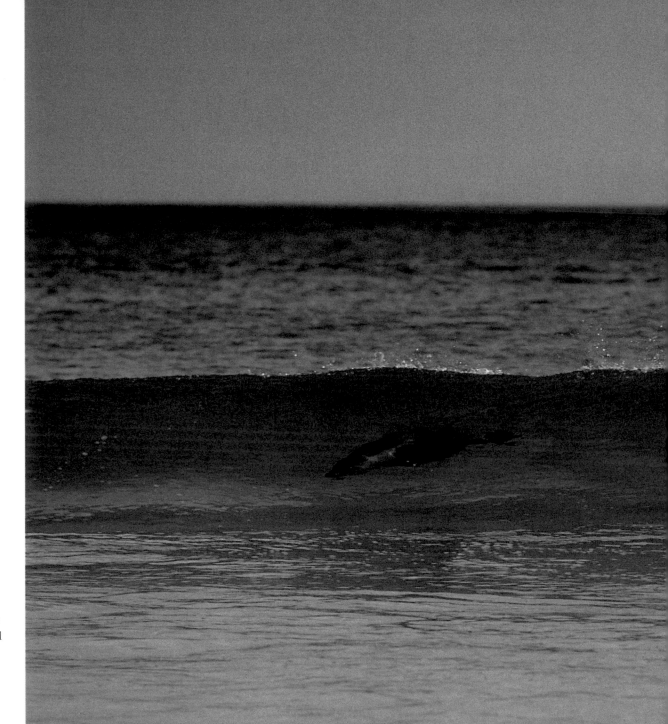

Australian sea lions cavort in the surf at Seal Bay, South Australia.

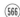

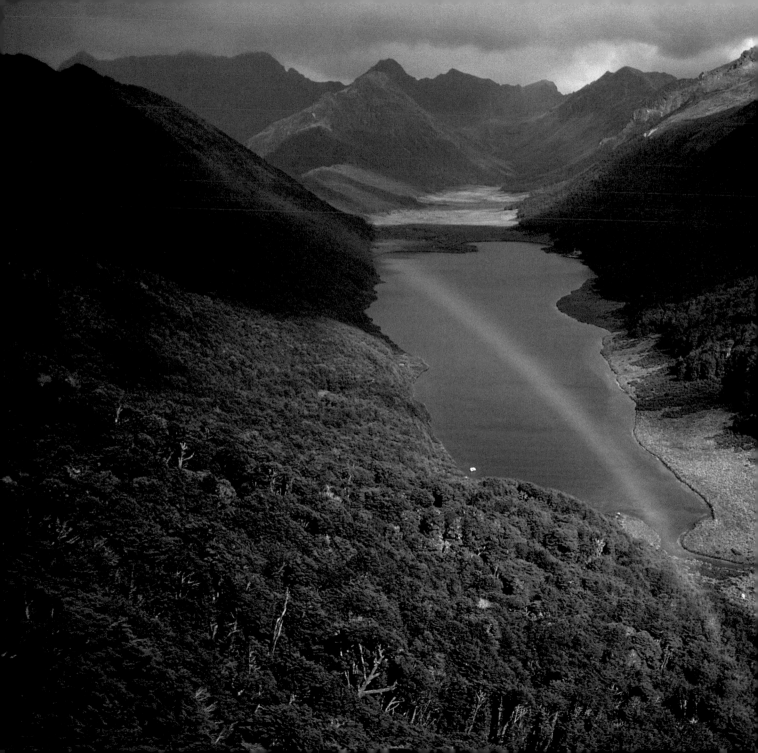

Takahes—members of the
railbird family—were once
thought to be extinct;
however, a small number
have been found in this
isolated valley in New
Zealand.

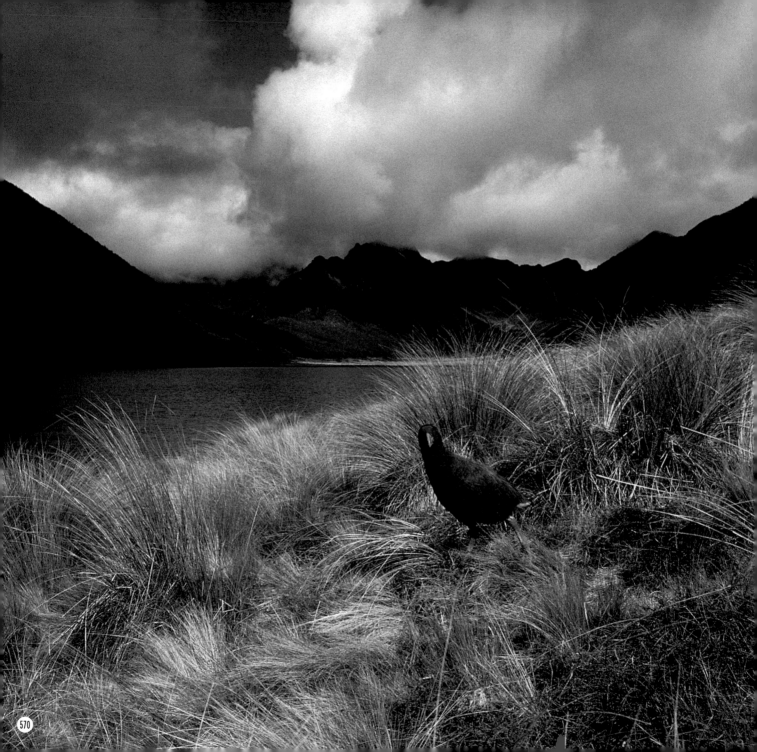

left: Takahes are as big as ducks and live on the ground. Efforts are underway to try to increase their numbers.

In New Zealand, there are several flightless birds. The takahes and others probably declined in number because of the introduction of animals such as cats, dogs, weasels, martens, and deer or because newly arrived species of birds carried diseases against which native birds had no resistance.

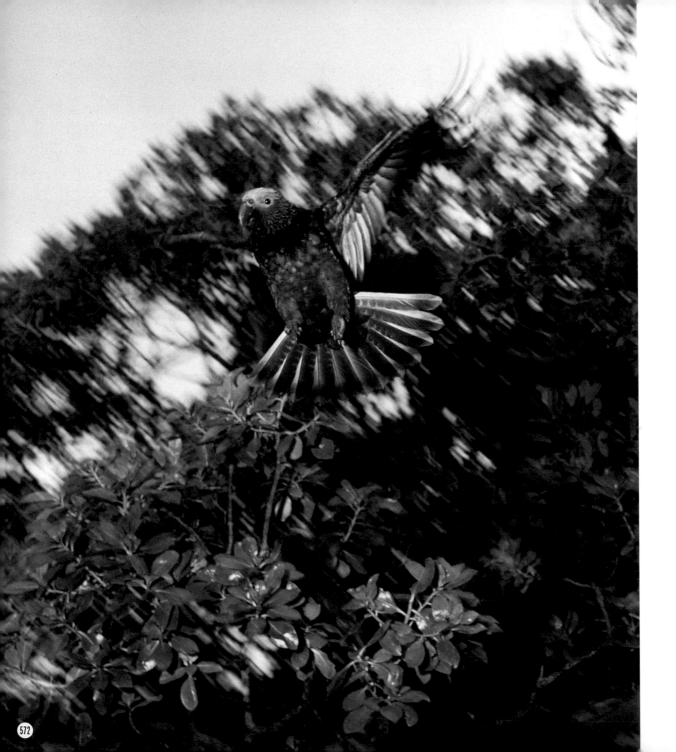

left: Another native of New Zealand, kakas can fly, but build their nests on the ground. With natural predation and destruction of habitats, the population of kakas is declining.

Kiwis, the national symbol of New Zealand, are flight-less, nocturnal birds. They build their nests in tree hollows, and they feed on insects, using their long beaks to probe the ground.

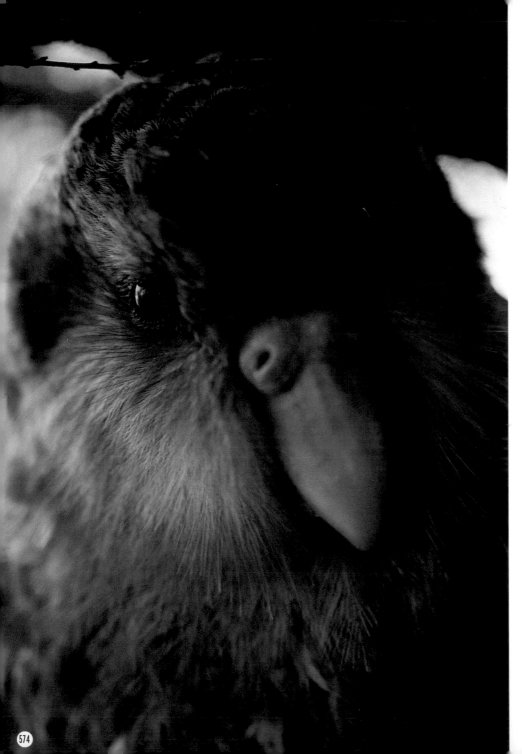

The kakapo, also called the owl parrot, is a poor flyer, so it lives primarily on the ground. These large birds are also in danger of extinction.

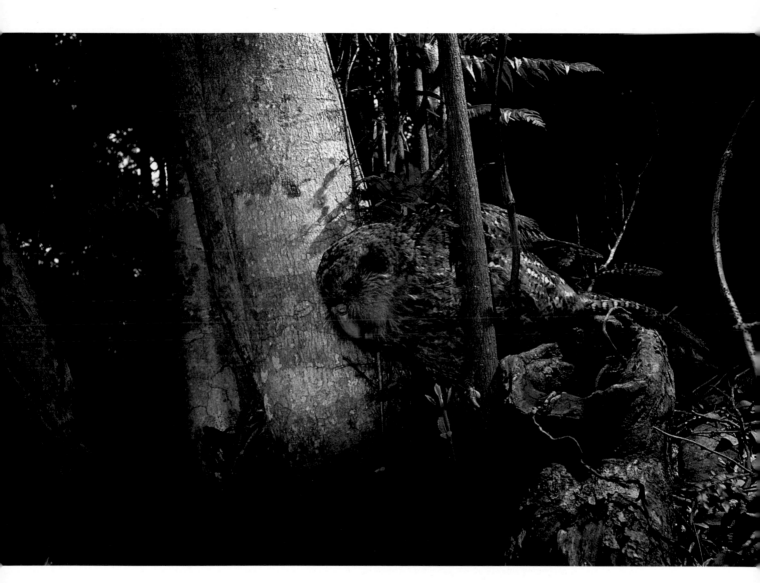

Species such as kakapos have uniquely evolved in an
isolated environment, and they are very vulnerable to
the rapid changes of the ecosystem.

A Note to the Reader

The notes for each species follow the order indicated below. In some cases, one or more pieces of information was not available.

1. Common name
2. Scientific Name
3. Order and Family
4. Distribution
5. Habitat
6. Size: Total Length = TL;
 Head–Body Length = HBL;
 Carapace Length = CL;
 Wingspan
7. Weight
8. Miscellaneous notes

mammals

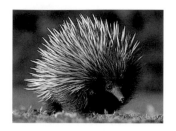

Spiny Anteater
Tachyglossus aculeatus
Monotremata Tachyglossdae
Australia and New Guinea
Semi-arid to alpine regions
12–18" (30–45 cm) (HBL)
4½–15½ lbs. (2–7 kg)
p. 545

Platypus
Ornithorhynchus anatinus
Monotremata Ornithorhynchidae
Australia
Rivers, lakes, and marshes
16–24" (40–60 cm) (HBL)
1½–4¾ lbs. (.68–2 kg)
pp. 550–551

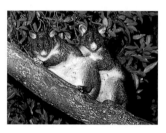

Mountain Brushtailed Possum
Trichosurus caninus
Marsupialia Phalangeridae
Australia and New Zealand
Forests
14–22" (35–55cm) (HBL)
Males, up to 10 lbs. (4.5 kg);
 Females, up to 8 lbs. (3.5 kg)
Those in New Zealand are an
 introduced species.
p. 549

Long-nosed Potoroo
Potorous tridactylus
Marsupialia Macropodiae
Australia
Forests
Approx. 16½" (41 cm) (HBL)
2–5 lbs. (1–2.2 kg)
p. 506

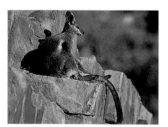

Brush-tailed Rock Wallaby
Petrogale penicillata
Marsupialia Macropodiae
Australia
Rocky terrains
18–23" (45–58 cm) (HBL)
105½ lbs. (48 kg)
pp. 536, 537

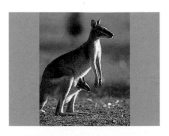

Sandy Wallaby
Macropus agilis
Marsupialia Macropodiae
Australia
Grasslands
Males 28–34" (70–85 cm);
 Females 23½–29" (59–72 cm) (HBL)
Males 35–39½ lbs. (16–27 kg);
 Females 20–33 lbs. (9–15 kg)
pp. 504, 505

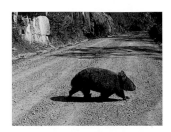

Common Wombat
Vombatus ursinus
Marsupialia Vombatidae
Australia
Grasslands and shrubberies
34–46" (85–115 cm) (HBL)
48½–86 lbs. (22–39 kg)
pp. 540, 541

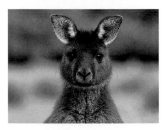

Western Gray Kangaroo
Macropus fuliginosus
Marsupialia Macropodiae
Australia
Grasslands
20–48" (0.5–1.2 cm) (HBL)
61½–119 lbs. (28–54 kg)
pp. 552–555

Giant Anteater
Myrmecophaga tridactyla
Edentata Myrmecophagidae
Central America to central South
 America
Grasslands and forests
Approx. 48" (122 cm) (HBL)
48½–86 lbs. (22–39 kg)
p. 166

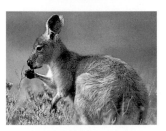

Euro
Macropus robustus
Marsupialia Macropodiae
Australia
Grasslands
23–43" (57–108 cm) (HBL)
55–104 lbs. (25–47 kg)
p. 538

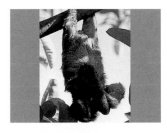

Brown-throated Three-toed Sloth
Bradypus variegatus
Edentata Bradypodidae
Central America to central South
 America
Forests
Approx. 24" (60 cm) (HBL)
5–12 lbs. (2.3–5.5 kg)
p. 164

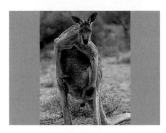

Red Kangaroo
Macropus rufus
Marsupialia Macropodiae
Australia
Grasslands and deserts
Approx. 28–56" (71–142 cm) (HBL)
49–187 lbs. (22–85 kg)
pp. 523, 524, 526–531

Common Long-nosed Armadillo
Dasypus novemcinctus
Edentata Dasypodidae
Southern part of North America to
 Central America and the central
 part of South America
Forests
Approx. 14–23" (35–57 cm) (HBL)
6–14 lbs. (2.7–6.3 kg)
p. 144

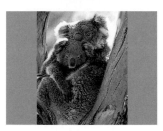

Koala
Phascolarctos cinereus
Marsupialia Phascolarctidae
Australia
Forests
27–33" (68–82 cm) (HBL)
11–27 lbs. (5–12 kg)
pp. 546–548

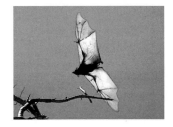

Black Flying Fox
Pteropus alecto
Chiroptera Pteropodidae
Northern Australia, New Guinea,
 and Sulawesi
Forests
Approx. 12" (30 cm) (HBL)
pp. 500, 501

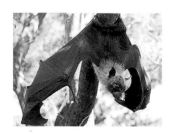

Madagascar Flying Fox
Pteropus rufus
Chiroptera Pteropodidae
Madagascar
Forests
Approx. 40" (1 m) (W)
pp. 454, 455

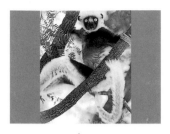

Verreaux's Sifaka
Propithecus verreauxi
Primates Indriidae
Madagascar
Forests
Approx. 16" (40 cm) (HBL)
12–13¼ lbs. (5.5–6 kg)
pp. 448, 449

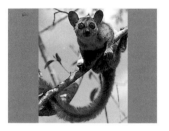

Gray Lesser Mouse Lemur
Microcebus murinus
Primates Cheirogaleidae
Madagascar
Forests
Approx. 5" (13 cm) (HBL)
Approx. 2.2 oz. (65 g)
p. 452

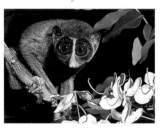

Slender Loris
Loris tardigradus
Primates Lorisidae
Southeast Asia
Forests
Approx. 12" (30 cm) (HBL)
Approx. 10½ oz. (300 g)
p. 472

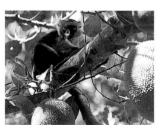

Ring-tailed Lemur
Lemur catta
Primates Lemuridae
Madagascar
Forests
Approx. 16" (40 cm) (HBL)
5½–8 lbs. (2.5–3.7 kg)
p. 451

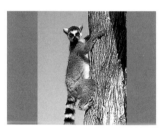

Japanese Macaque
Macaca fuscata
Primates Cercopithecidae
Japan
Forests
Approx. 20" (50 cm) (HBL)
17½–39½ lbs. (8–18 kg)
pp. 474–481

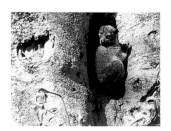

Black Lemur
Lemur macaco
Primates Lemuridae
Madagascar
Forests
Approx. 16" (40 cm) (HBL)
Approx. 4½ lbs. (2 kg)
p. 450

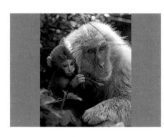

Anubis Baboon
Papio anubis
Primates Cercopithecidae
Central and eastern parts of Africa
Grasslands and forests
Approx. 28" (70 cm) (HBL)
22–55 lbs. (10–25 kg)
pp. 306, 307

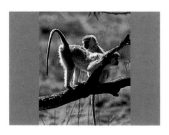

White-footed Sportive Lemur
Lepilemur mustelinus leucopus
Primates Lemuridae
Madagascar
Forests
Approx. 12" (30 cm) (HBL)
1–2¼ lbs. (0.5–1 kg)
Subspecies of sportive lemur.
p. 453

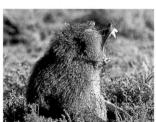

Vervet Monkey
Cercopithecus aethiops
Primates Cercopithecidae
South of the Sahara Desert, exclud-
ing the central part of Africa
Grasslands
Approx. 24" (60 cm) (HBL)
5½–17 lbs. (2.5–7.7 kg)
p. 308

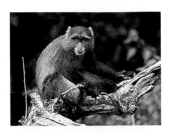

Blue Monkey
Cercopithecus mitis
Primates Cercopithecidae
Central and southern Africa
Forests
Approx. 24" (60 cm) (HBL)
8–15½ lbs. (3.5–7 kg)
p. 309

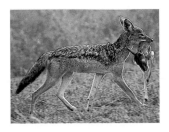

Silver-backed Jackal
Canis mesomelas
Carnivora Canidae
Eastern and southern Africa
Grasslands
Approx. 24–40" (60 cm–1 m) (HBL)
17½–33 lbs. (8–15 kg)
pp. 288, 348, 349

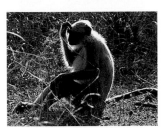

Hanuman Langur
Presbytis entellus
Primates Cercopithecidae
South Asia
Forests
Approx. 28" (70 cm) (HBL)
11–53 lbs. (5–24 kg)
pp. 468–470

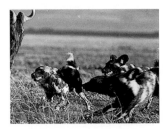

Cape Hunting Dog
Lycaon pictus
Carnivora Canidae
South of the Sahara Desert
Semideserts, grasslands, and forests
Approx. 32–40" (80 cm–1 m) (HBL)
37½–79 lbs. (17–36 kg)
pp. 294, 354–357

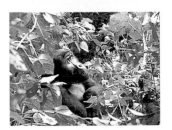

Eastern Lowland Gorilla
Gorilla gorilla graueri
Primates Pongidae
Eastern Zaire
Forests
Males 6' (1.8 m); Females up
 to 5' (1.5 m)
Males 308–440 lbs. (140–200 kg);
 Females 154–242 lbs. (70–110 kg)
pp. 310, 311

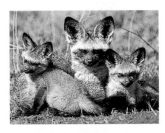

Bat-eared Fox
Otocyon megalotis
Carnivora Canidae
Eastern and southwest Africa
Grasslands
Approx. 20" (50 cm) (HBL)
6½–10 lbs. (3–4.5 kg)
pp. 350, 351

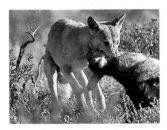

Dingo
Canis dingo
Carnivora Canidae
Australia and Southeast Asia
Arid regions and semi-arid
 grasslands
47–49½" (117–124 cm) (HBL)
22–44 lbs. (10–20 kg)
p. 507

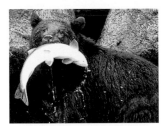

American Black Bear
Ursus americanus
Carnivora Ursidae
North America
Forests
Approx. 4½–6' (1.3–1.8 m) (HBL)
99–330 lbs. (45–150 kg)
pp. 116–117

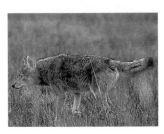

Coyote
Canis latrans
Carnivora Canidae
North America and Central America
Forests and grasslands
Approx. 28–39" (70–97 cm) (HBL)
22–39½ lbs. (10–18 kg)
p. 137

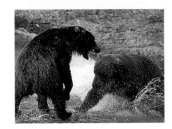

Brown Bear
Ursus arctos
Carnivora Ursidae
Northwestern part of North America,
 Hokkaido (Japan), Russia, the
 Scandinavian Peninsula, the Alps,
 and the Himalayas
Mainly forests
Approx. 5' 8"–6' (1.7–2.8 m) (HBL)
154–1,716 lbs. (70–780 kg)
pp. 96–101

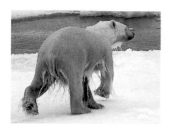

Polar Bear
Thalarctos maritimus
Carnivora Ursidae
Arctic Circle
Ice and coastal waters
Males 8–10' (2.5–3 m);
 Females 6½–8' (2–2.5 m) (HBL)
Males 770–1,430 lbs. (350–650 kg);
 Females 385–660 lbs. (175–300 kg)
pp. 112, 113

Ruddy Mongoose
Herpestes smithi
Carnivora Herpestidae
India and Sri Lanka
Forests and rocky terrains
15–19" (38–47 cm) (HBL)
2–6 lbs. (1–2.7 kg)
p. 473

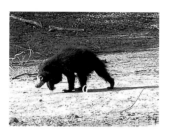

Sloth Bear
Melursus ursinus
Carnivora Ursidae
Eastern India and Sri Lanka
Forests
Approx. 5–6' (1.5–1.9 m) (HBL)
198–253 lbs. (90–115 kg)
p. 467

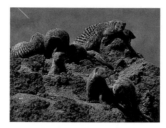

Banded Mongoose
Mungos mungo
Carnivora Herpestidae
South of the Sahara Desert,
 excluding the tropical rain forests
Grasslands and shrubberies
Approx. 16" (40 cm) (HBL)
2–3 lbs. (1–1.4kg)
pp. 360, 361

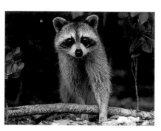

Common Raccoon
Procyon lotor
Carnivora Procyonidae
North America and Central
 America
Forests and other diversified
 environments
16–24" (40–60 cm) (HBL)
4–48½ lbs. (1.8–22 kg)
p. 145

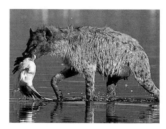

Spotted Hyena
Crocuta crocuta
Carnivora Hyaenidae
South of the Sahara Desert,
 excluding the tropical rain forests
Grasslands
Approx. 48–56" (1.2–1.4 m) (HBL)
Males 88–121 lbs. (40–55 kg);
 Females 99–143 lbs. (45–65 kg)
pp. 290–301

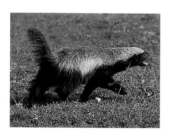

Ratel
Mellivora capensis
Carnivora Mustelidae
Africa, the Near and Middle East,
 and India
Grasslands and forests
24–31" (60–77 cm) (HBL)
15½–28½ lbs. (7–13 kg)
p. 359

Caracal
Felis caracal
Carnivora Felidae
Africa, Saudi Arabia, and Turkey
Grasslands
25–33" (62–82 cm) (HBL)
17½–31 lbs. (8–14 kg)
p. 358

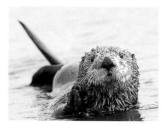

Sea Otter
Enhydra lutris
Carnivora Mustelidae
Northern Pacific Ocean
Coastal regions
Approx. 48–60" (1.2–1.5 m) (HBL)
Males 59½–83½ lbs. (27–38 kg);
 Females 35–59½ lbs. (16–27 kg)
pp. 90–95

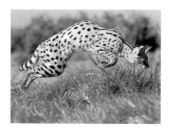

Serval
Felis serval
Carnivora Felidae
Africa
Grasslands
Approx. 28–40" (70 cm–1 m) (HBL)
15½–39½ lbs. (7–18 kg)
pp. 430, 431

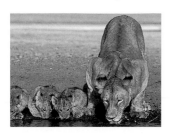

Lion
Panthera leo
Carnivora Felidae
South of the Sahara Desert,
 excluding tropical rain forests,
 and northwestern part of India
Grasslands and deserts
Males approx. 6½' (2 m);
 Females approx. 6' (1.8 m) (HBL)
Males 110–550 lbs. (50–250 kg);
 Females 264-396 lbs. (120–180 kg)
pp. 260–267, 298, 299, 406–419

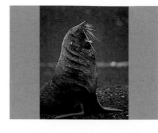

Antarctic Fur Seal
Arctocephalus gazella
Carnivora Otariidae
Islands around the Antarctic
Coastal terrains
Males approx. 6' (1.8 m);
 Females approx. 4' (1.3 m) (HBL)
Males approx. 440 lbs. (200 kg);
 Females approx. 110 lbs. (50 kg)
p. 210

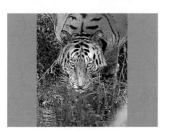

Leopard
Panthera pardus
Carnivora Felidae
South of the Sahara Desert,
 south Asia, Saudi Arabia, and
 the far eastern part of Eurasia
Forests and grasslands
Approx. 40–60" (1–1.5 m) (HBL)
66–176 lbs. (30–80 kg)
pp. 352, 353

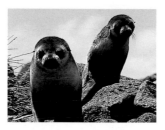

Cape Fur Seal
Arctocephalus pusillus pusillus
Carnivora Otariidae
Southwestern part of Africa
Coastal terrains
Males approx. 7½' (2.3 m);
 Females approx. 6' (1.8 m) (HBL)
Males approx. 660 lbs. (300 kg);
 Females approx. 220 lbs. (100 kg)
pp. 236, 241

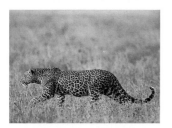

Tiger
Panthera tigris tigris
Carnivora Felidae
India
Forests
4½–8' (1.4–2.5 m) (HBL)
Males 396–616 lbs. (180–280 kg);
 Females 253–407 lbs. (115–185 kg)
pp. 462–465

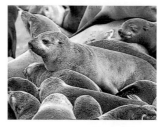

Subantarctic Fur Seal
Arctocephalus tropicalis
Carnivora Otariidae
Islands in the south Atlantic and the
 south Indian Oceans
Coastal terrain
Males approx. 6' (1.8 m);
 Females approx. 5' (1.5 m) (HBL)
Males approx. 363 lbs. (165 kg);
 Females approx. 121 lbs. (55 kg)
pp. 182, 183

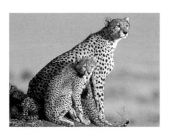

Cheetah
Acinonyx jubatus
Carnivora Felidae
Africa, south Asia, and the Near
 and Middle East
Grasslands and semideserts
48–60" (1.2–1.5 m) (HBL)
61½–143 lbs. (28–65 kg)
pp. 364–371

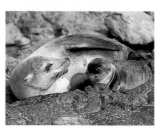

California Sea Lion
Zalophus californianus californianus
Carnivora Otariidae
Southwestern part of North America
Coastal terrains
Males approx. 8' (2.4 m);
 Females approx. 6' (1.8 m) (HBL)
Males 616 lbs. (280 kg);
 Females up to 198 lbs. (90 kg)
pp. 154, 155

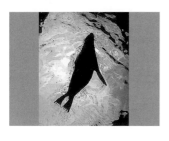

Galápagos Fur Seal
Arctocephalus galapagoensis
Carnivora Otariidae
Galápagos Islands
Coastal terrains
Males approx. 60" (1.5 m);
 Females approx. 48" (1.2 m) (HBL)
Males approx. 141 lbs. (64 kg);
 Females approx. 59½ lbs. (27 kg)
p. 36

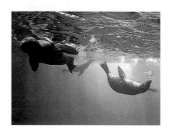

Galápagos Sea Lion
Zalophus californianus wollebaeki
Carnivora Otariidae
Galápagos Islands
Coastal terrains
Males approx. 60" (2 m);
 Females approx. 72" (1.5 m) (HBL)
Males 616 lbs. (280 kg);
 Females up to 198 lbs. (90 kg)
p. 34

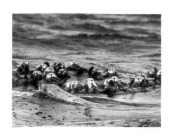

Northern Sea Lion
Eumetopias jubatus
Carnivora Otariidae
North Pacific Ocean
Coastal terrains
Males approx. 9½' (2.9 m);
 Females approx. 8' (2.4 m) (HBL)
Males approx. 2,200 lbs. (1,000 kg);
 Females up to approx. 660 lbs. (300 kg)
p. 90

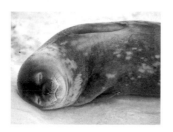

Weddell Seal
Leptonychotes weddelli
Carnivora Phocidae
Islands around the Antarctic
Coastal terrains
Approx. 8' (2.5 m) (HBL)
Approx. 1,100 lbs. (500 kg)
pp. 230, 231

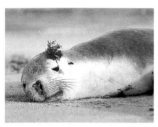

Australian Sea Lion
Neophoca cinerea
Carnivora Otariidae
Australia
Coastal terrains
Males approx. 6½' (2 m);
 Females approx. 5' (1.5 m) (HBL)
Males approx. 660 lbs. (300 kg);
Females approx. 220 lbs. (100 kg)
pp. 562–567

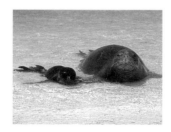

Hawaiian Monk Seal
Monachus schauinslandi
Carnivora Phocidae
Northwestern Hawaiian Islands
Coastal terrains
Males approx. 7' (2.1 m);
 Females approx. 7½' (2.3 m) (HBL)
Males approx. 374 lbs. (170 kg);
 Females approx. 594 lbs. (270 kg)
pp. 44–49

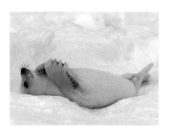

Harp Seal
Phoca groenlandica
Carnivora Phocidae
Northeastern part of North
 America, Greenland, and
 northern Siberia
Oceans
Approx. 5½' (1.7 m) (HBL)
Up to approximately 330 lbs. (150 kg)
pp. 102–107

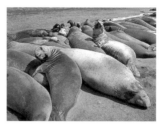

Northern Elephant Seal
Mirounga angustirostris
Carnivora Phocidae
Southwestern part of North America
Coastal terrains
Males approx. 14' (4.2 m);
 Females approx. 10' (3.1 m) (HBL)
Males 6,600 lbs. (3,000 kg);
 Females up to 1,980 lbs. (900 kg)
p. 157

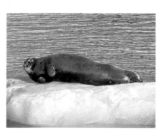

Bearded Seal
Erignathus barbatus
Carnivora Phocidae
Mainly the Arctic Circle, with
 Hokkaido (Japan) as the
 southern limit
Oceans
Approx. 7' (2.2 m) (HBL)
Approx. 660 lbs. (300 kg)
p. 114

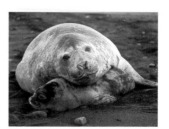

Southern Elephant Seal
Mirounga leonina
Carnivora Phocidae
Islands around the Antarctic
Coastal terrain
Males approx. 15' (4.5 m);
 Females approx. 9' (2.8 m) (HBL)
Males approx. 8,800 lbs. (4,000 kg);
 Females up to approx. 1,980 lbs.
 (900 kg)
pp. 188, 189, 194

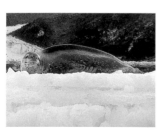

Leopard Seal
Hydrurga leptonyx
Carnivora Phocidae
Islands around the Antarctic
Coastal terrains
Approx. 120" (3 m) (HBL)
Males 715 lbs. (325 kg);
 Females up to 792 lbs. (360 kg)
pp. 211, 228

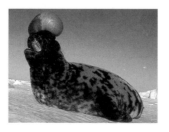

Hooded Seal
Crystophora cristata
Carnivora Phocidae
Northern Pacific Ocean to the
 North Sea
Oceans
Males approx. 8' (2.5 m);
 Females approx. 7' (2.2 m) (HBL)
Males approx. 880 lbs. (400 kg);
 Females approx. 770 lbs. (350 kg)
pp. 108, 109

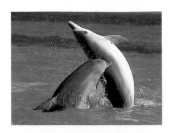

Bottle-nosed Dolphin
Tursiops truncatus
Cetacea Delphinidae
Tropical, semitropical, and
 temperate waters
Coastal waters
Approx. 11–13' (3.4–3.9 m) (HBL)
330–770 lbs. (150–350 kg)
pp. 484–487

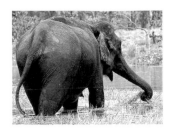

Asian Elephant
Elephas maximus
Proboscidea Elephantidae
South and southeastern Asia
Forests
Approx. 20' (6 m) (HBL)
Up to 5.2 tons (up to 4.7 metric tons)
There are four subspecies, including
 Indian elephants.
pp. 458–461

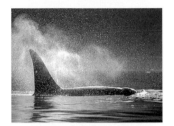

Orca
Orcinus orca
Cetacea Delphinidae
Oceans of the world
Males 21½–26½' (6.5–8 m);
 Females 16½–21½' (5–6.5 kg) (HBL)
2.8 tons (2.57 metric tons)
pp. 86–89

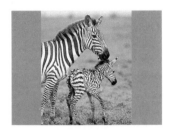

Burchell's Zebra
Equus burchelli
Perissodactyla Equidae
Eastern Africa
Grasslands
7½' (2.3 m) (HBL)
385–781 lbs. (175–355 kg)
pp. 372–377, 398

Minke Whale
Balaenoptera acutorostrata
Cetacea Balaenopteridae
Oceans of the world
Oceans
26½–33' (8–10 m) (HBL)
76 tons (69 metric tons)
p. 235

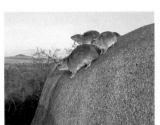

Black Rhinoceros
Diceros bicornis
Perissodactyla Rhinocerotidae
Eastern and southern Africa
Grasslands and forests
10–12' (3–3.6 m) (HBL)
1,540–3,520 lbs. (700–1,600 kg)
pp. 328–333

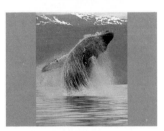

Humpback Whale
Megaptera novaeangliae
Cetacea Balaenopteridae
Oceans of the world
Oceans
Males 46½–56½' (14–17 m);
 Females 50–63' (15–19 m) (HBL)
33–49.5 tons (30–45 metric tons)
pp. 64–85

Cape Hyrax
Procavia capensis
Hyracoidea Procaviidae
Eastern and southern Africa
Rocky terrains in grasslands
Approx. 20" (50 cm) (HBL)
5½–11 lbs. (2.5–5 kg)
pp. 362, 363

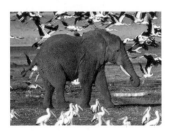

African Elephant
Loxodonta africana
Proboscidea Elephantidae
South of the Sahara Desert
Grasslands and forests
20–25' (6–7.5 m) (HBL)
Up to 6.6 tons (up to 7.5 metric
 tons)
pp. 248–263, 268, 312–319

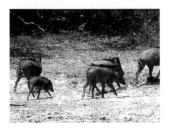

Indian Wild Pig
Sus cristatus
Artiodactyla Suidae
India, Sri Lanka, and Burma
Forests
Approx. 60" (1.5 m) (HBL)
198–297 lbs. (90–135 kg)
p. 466

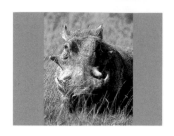

Warthog
Phacochoerus aethiopicus
Artiodactyla Suidae
South of the Sahara Desert
Sparsely grown wood in savannas
 and grasslands
Approx. 40–60" (1–1.5 m) (HBL)
105½–314½ lbs. (48–143 kg)
pp. 281, 334–337

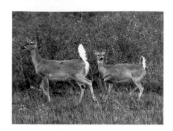

White-tailed Deer
Odocoileus virginianus virginianus
Artiodactyla Cervidae
North America, Central America,
 and the northern part of South
 America
Forests and swamps
Males approx. 6½' (2 m);
 Females approx. 5½' (1.7 m) (HBL)
Approx. 143–299 lbs. (65–136 kg)
p. 136

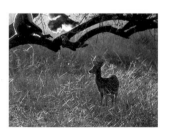

Hippopotamus
Hippopotamus amphibius
Artiodactyla Hippopotamidae
South of the Sahara Desert,
 excluding tropical rain forests
Lakes, marshes, and rivers
Approx. 11–18' (3.4–5.4 m) (HBL)
Approx. 3.5 tons (3,200 kg)
pp. 283, 320–327

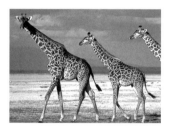

Key Deer
Odocoileus virginianus clavium
Artiodactyla Cervidae
Florida Keys and the southern part
 of Arizona
Forests and grasslands
Approx. 34" (85 cm) (HBL)
39½–48½ lbs. (18–22 kg)
pp. 146, 147

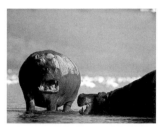

Axis Deer
Cervus axis
Artiodactyla Cervidae
India and Sri Lanka
Forests and grasslands
3½–9' (1.1–2.7 m) (HBL)
Approx. 198 lbs. (90 kg)
p. 470

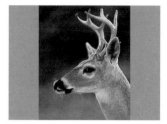

Giraffe
Giraffa camelopardalis
Artiodactyla Giraffidae
South of the Sahara Desert
Grasslands
12½–15½' (3.8–4.7 m) (HBL)
Males 1,760–4,180 lbs. (800–1,900 kg);
 Females 1,210–2,596 lbs.
 (550–1,180 kg)
pp. 272, 273, 340–347

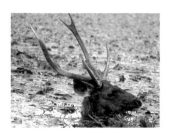

Sambar
Cervus unicolor
Artiodactyla Cervidae
Southeastern and south Asia
Forests
5½–9' (1.7–2.7 m) (HBL)
Approx. 550 lbs. (250 kg)
p. 471

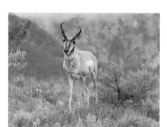

Pronghorn
Antilocapra americana
Artiodactyla Antilocapridae
North America
Grasslands and shrubberies
Approx. 56" (1.4 m) (HBL)
103½–154 lbs. (47–70 kg)
p. 121

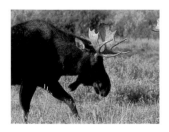

Moose
Alces alces
Artiodactyla Cervidae
North America and the northern
 part of Eurasia
Forests
8–10' (2.4–3.1 m) (HBL)
880–1,760 lbs. (400–800 kg)
p. 120

Sitatunga
Tragelaphus spekei
Artiodactyla Bovidae
Central Africa
Marshes and swamps
Approx. 44–68" (1.1–1.7 m) (HBL)
88–264 lbs. (40–120 m)
p. 276

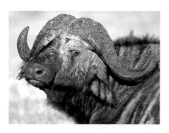

African Buffalo
Syncerus caffer
Artiodactyla Bovidae
South of the Sahara Desert
Grasslands and forests
Approx. 7–11' (2.2–3.4 m) (HBL)
583–1,496 lbs. (265–680 kg)
pp. 271, 274, 338, 339, 408–411

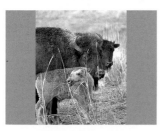

American Bison
Bison bison
Artiodactyla Bovidae
North America
Grasslands
Approx. 12½' (3.8 m) (HBL)
Males up to 1,799 lbs. (818 kg);
 Females up to 1,199 lbs. (545 kg)
pp. 118–119

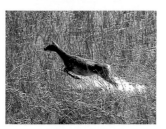

Lechwe
Kobus leche
Artiodactyla Bovidae
Central Africa
Marshes
52–72" (1.3–1.8 m) (HBL)
132–286 lbs. (60–130 kg)
p. 277

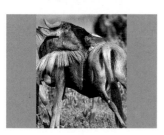

Blue Wildebeest
Connochaetes taurinus
Artiodactyla Bovidae
Eastern Africa to the northern part
 of South Africa
Grasslands
Approx. 6½' (2 m) (HBL)
308–638 lbs. (140–290 kg)
pp. 295, 356, 373, 378–386,
 390–405

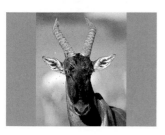

Topi
Damaliscus lunatus
Artiodactyla Bovidae
South of the Sahara Desert, exclud-
 ing tropical rain forests
Grasslands
Approx. 6½' (2 m) (HBL)
165–352 lbs. (75–160 kg)
There are nine subspecies.
pp. 426–427

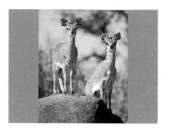

Klipspringer
Oreotragus oreotragus
Artiodactyla Bovidae
Eastern and central parts of Africa
Alpine and rocky terrains
Approx. 32" (80 cm) (HBL)
22–39½ lbs. (10–18 kg)
p. 422

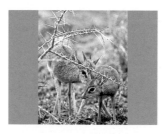

Kirk's Dik-dik
Madoqua kirkii
Artiodactyla Bovidae
Eastern and southwestern Africa
Scrub in grasslands
Approx. 24" (60 cm) (HBL)
6–14 lbs. (2.7–6.5 kg)
p. 423

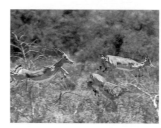

Impala
Aepyceros melampus
Artiodactyla Bovidae
Eastern and southern Africa
Grasslands and open woods
Approx. 52" (1.3 m) (HBL)
88–176 lbs. (40–80 kg)
pp. 258, 428

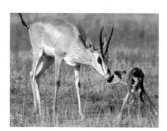

Grant's Gazelle
Gazella granti
Artiodactyla Bovidae
Eastern Africa
Grasslands and semideserts
Approx. 60" (1.5 m) (HBL)
77–176 lbs. (35–80 kg)
pp. 420, 421

Thomson's Gazelle
Gazella thomsoni
Artiodactyla Bovidae
Eastern Africa
Grasslands
32–44" (80–110 cm) (HBL)
33–66 lbs. (15–30 kg)
pp. 367, 425

Mountain Goat
Oreamnos americanus
Artiodactyla Bovidae
North America
Alpine terrains
Approx. 56–68" (1.4–1.7 m) (HBL)
Males up to 308 lbs. (140 kg);
 Females up to 125½ lbs. (57 kg)
p. 125

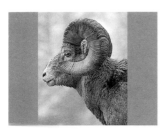

Muskox
Ovibos moschatus
Artiodactyla Bovidae
Alaska and Greenland
Tundras
Approx. 6–8' (1.8–2.5 m) (HBL)
Males 770 lbs. (350 kg); Females
 370–670 lbs. (168–304 kg)
p. 110

American Bighorn Sheep
Ovis canadensis
Artiodactyla Bovidae
North America
Alpine terrains and deserts
Males approx. 6' (1.8 m);
Females approx. 3½' (1 m) (HBL)
Males 125½–308 lbs. (57–140 kg);
 Females 123–176 lbs. (56–80 kg)
pp. 122–124

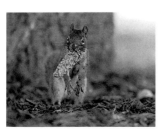

American Red Squirrel
Tamiasciurus hudsonicus
Rodentia Sciuridae
North America
Forests
Approx. 12" (30 cm) (HBL)
5–11 oz. (140–310 g)
p. 127

Smith's Bush Squirrel
Paraxerus cepapi
Rodentia Sciuridae
Western part of Tanzania, Zambia,
 Angola, and Botswana
Forests and shrubberies
5–8" (13–20 cm) (HBL)
Approx. 4–5 oz. (120–150 g)
p. 289

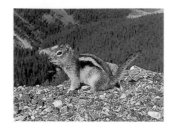

Golden-mantled Ground Squirrel
Spermophilus lateralis
Rodentia Sciuridae
North America
Forests and shrubberies
Approx. 7" (18 cm) (HBL)
6–10 oz. (170–284 g)
p. 126

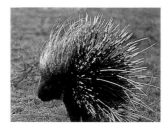

Cape Porcupine
Hystrix africaeaustralis
Rodentia Hystricidae
Southern, central, and eastern parts
 of Africa
Grasslands and deserts
26–34" (65–85 cm) (HBL)
33–59½ lbs. (15–27 kg)
p. 359

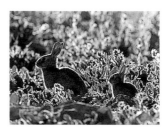

European Rabbit
Oryctolagus cuniculus
Lagomorpha Leporidae
North and South America, Europe,
 Africa, and Australia
Grasslands
Approx. 20" (50 cm) (HBL)
3–6½ lbs. (1.3–3 kg)
Native to the Iberian Peninsula and
 the northwestern part of Africa.
p. 539

birds

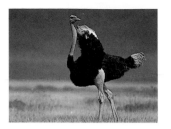

Ostrich
Struthio camelus
Struthioniformes Struthionidae
Africa
Savannas and grasslands
Height approx. 7½' (2.3 m)
pp. 302–305

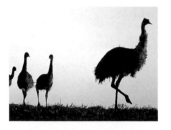

Emu
Dromaius novaehollandiae
Struthioniformes Dromaiidae
Australia
Grasslands, shrubberies, and arid
 regions
Approx. 6' (1.8 m) (TL)
p. 520

Great Spotted Kiwi
Apteryx haastii
Struthioniformes Apterygidae
South Island of New Zealand
Forests on alpine terrains
Approx. 20" (50 cm) (TL)
p. 573

Wandering Albatross
Diomedea exulans
Procellariiformes Diomedeidae
Southern Hemisphere
Oceans
48" (1.2 m) (TL);
 Wingspan approx. 10½' (3.2 m)
pp. 172, 234

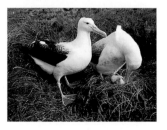

Royal Albatross
Diomedea epomophora
Procellariiformes Diomedeidae
Coastal waters of New Zealand and
 the southern part of South
 America
Coastal terrains
Approx. 48" (1.2 m) (TL);
 Wingspan approx. 10–11½'
 (3–3.5 m)
p. 173

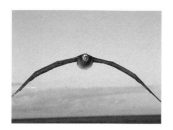

Black-footed Albatross
Diomedea nigripes
Procellariiformes Diomedeidae
North Pacific Ocean
Oceans
Approx. 28" (70 cm) (TL);
 Wingspan approx. 80" (2 m)
pp. 51, 62

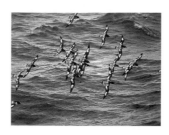

Pintado Petrel
Daption capense
Procellariiformes Procellariidae
Southern Hemisphere
Oceans
Approx. 14½" (36 cm) (TL);
 Wingspan approx. 35½" (89 cm)
p. 170

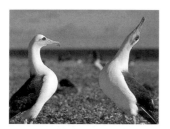

Laysan Albatross
Diomedea immutabilis
Procellariiformes Diomedeidae
Pacific Ocean
Oceans
Approx. 32" (80 cm) (TL);
 Wingspan approx. 80" (2 m)
pp. 54, 55

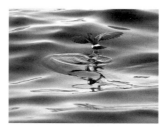

Elliot's Storm-Petrel
Oceanites gracilis
Procellariiformes Hydrobatidae
Waters in the west of South
 America and the Galápagos Islands
Oceans
6" (15 cm) (TL)
p. 37

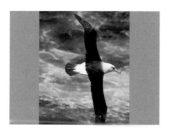

Black-browed Albatross
Diomedea melanophrys
Procellariiformes Diomedeidae
Subantarctic
Oceans
Approx. 34½" (86 cm) (TL);
 Wingspan 88" (2.2 m)
pp. 174, 175

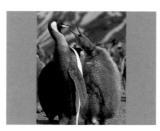

King Penguin
Aptenodytes patagonicus
Sphenisciformes Spheniscdae
Islands in the subantarctic
Coastal terrains
Up to 36" (90 cm) (TL)
pp. 192–201

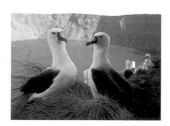

Yellow-nosed Albatross
Diomedea chlororhynchos
Procellariiformes Diomedeidae
South Atlantic Ocean and the
 Indian Ocean
Ocean
Approx. 34½" (86 cm) (TL);
 Wingspan approx. 80" (2 m)
p. 176

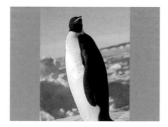

Emperor Penguin
Aptenodytes forsteri
Sphenisciformes Spheniscdae
Antarctic
Coastal terrains
48" (1.2 m) (TL)
pp. 224, 225

Southern Giant Petrel
Macronectes giganteus
Procellariiformes Procellariidae
Antarctic and subantarctic to the
 tropical regions of the Southern
 Hemisphere
Ocean
Approx. 36" (90 cm) (TL);
 Wingspan approx. 84" (2.1 m)
p. 177

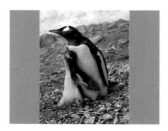

Gentoo Penguin
Pygoscelis papua
Sphenisciformes Spheniscdae
Antarctic and the subantarctic
Coastal terrains
Approx. 30½" (76 cm) (TL)
pp. 178, 180, 181, 226

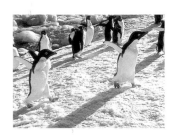

Adélie Penguin
Pygoscelis adeliae
Sphenisciformes Spheniscdae
Islands in the Antarctic and in its
 vicinity
Coastal terrains
Approx. 30½" (76 cm) (TL)
pp. 168, 197, 202, 208, 209,
 216–223, 227

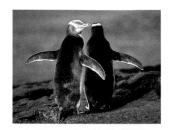

Yellow-eyed Penguin
Megadyptes antipodes
Sphenisciformes Spheniscdae
South Island of New Zealand and
 the Auckland Islands
Coastal terrains
Approx. 30½" (76 cm) (TL)
pp. 186, 187

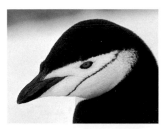

Chinstrap Penguin
Pygoscelis antarctica
Sphenisciformes Spheniscdae
Islands in the Antarctic and the
 subantarctic
Coastal terrains
30½" (76 cm) (TL)
pp. 202, 212–215

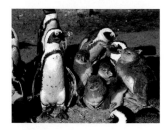

Jackass Penguin
Spheniscus demersus
Sphenisciformes Spheniscdae
South Africa
Coastal terrains
Approx. 26" (65 cm) (TL)
pp. 238–240

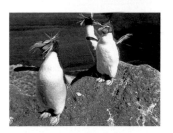

Rock-hopper Penguin
Eudyptes chrysocome
Sphenisciformes Spheniscdae
Southern part of South America,
 the south Atlantic Ocean, and the
 subantarctic
Coastal terrains
Approx. 25" (63 cm) (TL)
pp. 232, 233

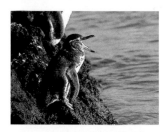

Galápagos Penguin
Spheniscus mendiculus
Sphenisciformes Spheniscdae
Galápagos Islands
Coastal terrains
20" (50 cm) (TL)
pp. 32, 33

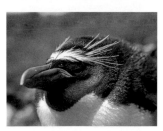

Macaroni Penguin
Eudyptes chrysolophus
Sphenisciformes Spheniscdae
Islands in the Antarctic and the
 subantarctic
Coastal terrains
Approx. 28" (70 cm) (TL)
pp. 190, 191

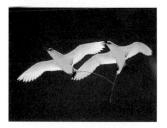

Red-tailed Tropicbird
Phaethon rubricauda
Pelecaniformes Phaethontidae
Tropical and semitropical regions
 in the Pacific Ocean and the
 Indian Ocean
Oceans
Approx. 18½" (46 cm) (36½" or
 91 cm to the tip of the tail) (TL);
 Wingspan approx. 40" (1 m)
pp. 56, 57

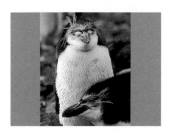

Royal Penguin
Eudyptes (chrysolophus) schlegeli
Sphenisciformes Spheniscdae
Macauley Island in the southwest of
 New Zealand
Coastal terrains
Approx. 28" (70 cm) (TL)
Sometimes classified as a subspecies
 of the macaroni penguin.
pp. 184, 185

Great Frigatebird
Fregata minor
Pelecaniformes Fregatidae
Tropical and semitropical regions of
 the world
Oceans
37" (93 cm) (TL)
 Wingspan approx. 7' (2.2 m)
pp. 26, 52, 53

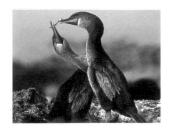

Flightless Cormorant
Phalacrocorax harrisi
Pelecaniformes Phalacrocoracidae
Galápagos Islands
Coastal terrains
Approx. 32" (80 cm) (TL)
p. 27

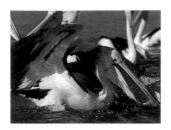

Australian Pelican
Pelecanus conspicillatus
Pelecaniformes Pelecanidae
Australia
Shallow inland and ocean waters
Approx. 6' (1.8 m) (TL); Wingspan
 approx. 8' (2.5 m)
pp. 556, 557

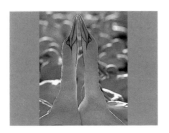

Cape Gannet
Sula capensis
Pelecaniformes Sulidae
South Africa
Coastal terrains
Approx. 35½" (89 cm) (TL);
 Wingspan 64" (1.6 m)
pp. 242, 243

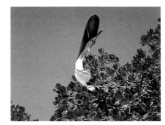

Brown Pelican
Pelecanus occidentalis
Pelecaniformes Pelecanidae
North, Central, and South America
Coastal waters
44" (1.1 m) (TL); Wingspan
 approx. 7½' (2.3 m)
p. 141

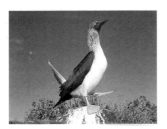

Blue-footed Booby
Sula nebouxii
Pelecaniformes Sulidae
Pacific coasts of Central and South
 America
Oceans
Approx. 36" (90 cm) (TL);
 Wingspan approx. 60" (1.5 m)
pp. 42–43, 150

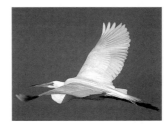

Great Egret
Ardea alba
Ciconiiformes Ardeidae
Tropical to temperate regions of
 the world
Lakes, marshes, rivers, and tidelands
Approx. 35½" (89 cm) (TL);
 Wingspan 52" (1.3 m)
p. 134

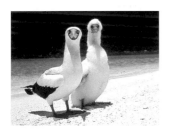

Masked Booby
Sula dactylatra
Pelecaniformes Sulidae
Tropical and semitropical regions
of the Atlantic, the Pacific, and
 the Indian Oceans
Oceans
36" (90 cm) (TL); Wingspan
 approx. 60" (1.5 m)
p. 59

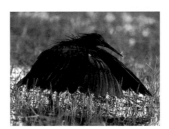

Black Heron
Egretta ardesiaca
Ciconiiformes Ardeidae
South of the Sahara Desert
Lakes, marshes, and seacoasts
Approx. 26½" (66 cm) (TL)
p. 278

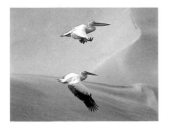

White Pelican
Pelecanus onocrotalus
Pelecaniformes Pelecanidae
Europe to the Indochina Peninsula
 and Africa
Estuarine waters and lowland lakes
 and swamps
Approx. 5½' (1.7 m) (TL);
 Wingspan approx. 10' (3 m)
pp. 244, 287

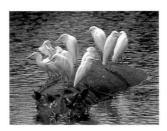

Cattle Egret
Egretta ibis
Ciconiiformes Ardeidae
All over the world, except Australia
 and its vicinity
Approx. 20" (50 cm) (TL)
p. 320

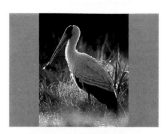

Yellow-billed Stork
Mycteria ibis
Ciconiiformes Ciconiidae
South of the Sahara Desert
Rivers, ponds, and estuarine swamps
Approx. 39" (97 cm) (TL)
pp. 318, 433

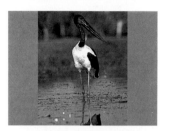

Black-necked Stork
Ephippiorhynchus asiaticus
Ciconiiformes Ciconiidae
South Asia, New Guinea, and
 Australia
Marshes and arid flatlands
52" (1.3 m) (TL)
p. 499

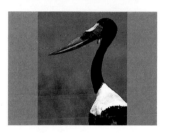

Saddle-bill Stork
Ephippiorhynchus senegalensis
Ciconiiformes Ciconiidae
Africa
Swamps and rivers
Approx. 60" (1.5 m) (TL)
p. 437

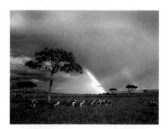

Marabou Stork
Leptoptilos crumeniferus
Ciconiiformes Ciconiidae
Africa
Open plains by the waters
Approx. 60" (1.5 m) (TL)
pp. 440, 446

Scarlet Ibis
Eudocimus ruber
Ciconiiformes Threskiornithidae
Northern part of South America
Seacoasts
Approx. 24" (60 cm) (TL)
p. 160

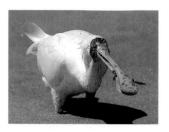

African Spoonbill
Platalea alba
Ciconiiformes Threskiornithidae
Africa
Marshes and ponds
Approx. 36" (90 cm) (TL)
p. 436

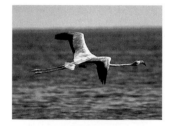

Greater Flamingo
Phoenicopterus ruber ruber
Phoenicopteriformes
 Phoenicopteridae
Africa and the southern part of
 Europe to India, the Caribbean
 Sea, and the Galápagos Islands
Estuaries
Approx. 49" (1.2 m) (TL);
 Wingspan 60" (1.5 m)
pp. 140, 442–445

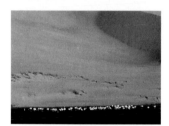

Lesser Flamingo
Phoeniconaias minor
Phoenicopteriformes
 Phoenicopteridae
Africa and India
Freshwater and saltwater lakes
Approx. 36" (90 cm) (TL);
 Wingspan approx. 40" (1 m)
p. 245

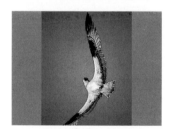

Osprey
Pandion haliaetus
Falconiformes Accipitridae
All over the world except the
 southern part of South America
 and the polar regions
Lakes, marshes, and seacoasts
Approx. 23" (58 cm) (TL);
 Wingspan approx. 64" (1.6 m)
pp. 138, 139

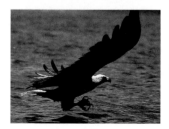

African Fish Eagle
Haliaeetus vocifer
Falconiformes Accipitridae
South of the Sahara Desert
Lakes, marshes, and seacoasts
28" (70 cm) (TL)
p. 279

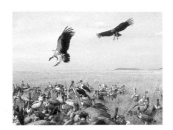

African White-backed Vulture
Gyps africanus
Falconiformes Accipitridae
South of the Sahara Desert
Savannas
Approx. 38" (95 cm) (TL)
p. 440

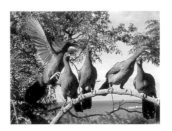

Rufous-vented Chachalaca
Ortalis ruficauda
Galliformes Cracidae
Northern part of Colombia and
 Venezuela, and Tobago
Shrubberies and farmlands
Approx. 24" (60 cm) (TL)
p. 161

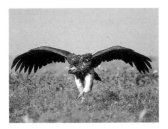

Lappet-faced Vulture
Aegypius tracheliotus
Falconiformes Accipitridae
South of the Sahara Desert
Semi-arid regions and deserts
Approx. 34½" (86 cm) (TL)
Wingspan 9'4" (2.8 m)
p. 441

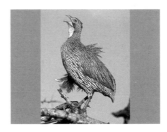

Gray-breasted Francolin
Francolinus rufopictus
Galliformes Phasianidae
Regions around Lake Victoria in
 Africa
Flatlands, farmlands, and shrubberies
Approx. 14" (35 cm) (TL)
p. 432

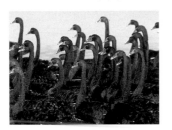

Black Swan
Cygnus atratus
Anseriformes Anatidae
Australia
Open waters
Approx. 52" (1.3 m) (TL);
 Wingspan approx. 76" (1.9 m)
Introduced to many countries
 including New Zealand
p. 542

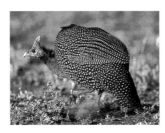

Helmeted Guinea Fowl
Numida meleagris
Galliformes Phasianidae
South of the Sahara Desert
Savannas and shrubberies
Approx. 22" (55 cm) (TL)
This is the original species of
 guinea fowl.
p. 439

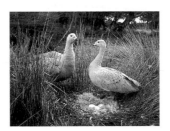

Cape Barren Goose
Cereopsis novaehollandiae
Anseriformes Anatidae
Islands off the southern coast of
 Australia
Grasslands near seacoasts
Approx. 34" (85 cm) (TL)
p. 544

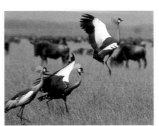

South African Crowned Crane
Balearica regulorum
Gruiformes Gruidae
South Africa
Grasslands and farmlands
Approx. 48" (1.2 m) (TL)
p. 435

Laysan Duck
Anas platyrhynchos laysanensis
Anseriformes Anatidae
Laysan Island of the northwestern
 Hawaiian Islands
Freshwater ponds
Approx. 16" (40 cm) (TL)
Subspecies of mallards.
p. 60

Takahe
Porphyrio mantelli
Gruiformes Rallidae
South Island of New Zealand
Grasslands in the valleys of moun-
 tainous regions
Approx. 25" (63 cm) (TL)
pp. 570, 571

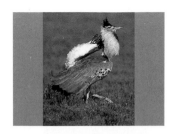

Kori Bustard
Ardeotis kori
Gruiformes Otidae
Eastern and southern Africa
Grasslands
Approx. 52" (1.3 m) (TL)
p. 434

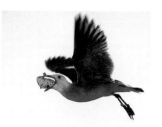

Heermann's Gull
Larus heermanni
Charadriiformes Laridae
Western part of North America
 and Mexico
Seacoasts
Approx. 17" (43 cm) (TL)
p. 151

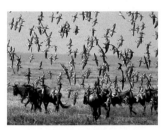

Comb-crested Jacana
Irediparra gallinacea
Charadriiformes Jacanidae
Philippines and Borneo to Australia
Marshes
Approx. 8" (20 cm) (TL)
p. 498

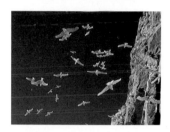

Silver Gull
Larus novaehollandiae
Charadriiformes Laridae
Australia, New Zealand, and
 New Caledonia
Seacoasts
Approx. 16½" (41 cm) (TL)
p. 493

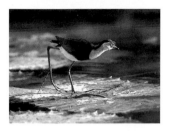

Red Knot
Calidris canutus
Charadriiformes Scolopacidae
All over the world
Swamps, seacoasts, and grasslands
Approx. 10" (25 cm) (TL)
p. 397

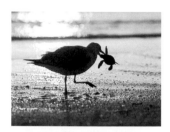

Black-legged Kittiwake
Rissa tridactyla
Charadriiformes Laridae
Northern Hemisphere
Oceans, lakes, and marshes
Approx. 16" (40 cm) (TL);
 Wingspan approx. 40" (1 m)
p. 115

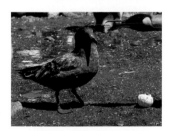

Great Skua
Catharacta skua
Charadriiformes Stercorariidae
Southern Hemisphere
Coastal terrains
Approx. 23" (57 cm) (TL);
 Wingspan 59" (150 cm)
p. 197

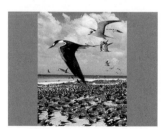

Sooty Tern
Sterna fuscata
Charadriiformes Laridae
Tropical and semitropical regions
Oceans and coastal terrains
Approx. 17½" (44 cm) (TL);
 Wingspan 35" (90 cm)
pp. 558–560

Pomarine Skua
Stercorarius pomarinus
Charadriiformes Stercorariidae
All over the world
Oceans and coastal terrains
Approx. 22" (55 cm) (TL);
 Wingspan 52" (130 cm)
p. 197

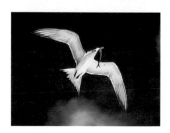

Fairy Tern
Sterna nereis
Charadriiformes Laridae
Australia, New Zealand, and
 New Caledonia
Seacoasts and inland waters
Approx. 10" (25 cm) (TL);
 Wingspan 20" (50 cm)
p. 561

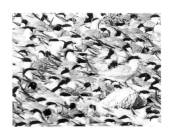

Elegant Tern
Thalasseus elegans
Charadriiformes Laridae
Western parts of North, Central,
 and South America
Seacoasts
Approx. 17" (42 cm) (TL)
p. 148

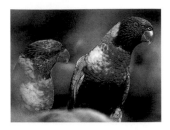

Rainbow Lory
Trichoglossus haematodus
Psittaciformes Loriidae
Bali to New Guinea, New
 Caledonia, and Australia
Tropical rain forests and eucalyptus
 forests
Approx. 12" (30 cm) (TL)
p. 510

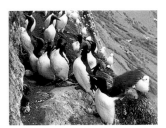

Brunnich's Guillemot
Uria lomvia
Charadriiformes Alcidae
Northern parts of the Pacific and
 Atlantic Oceans
Seacoasts
Approx. 17" (42 cm) (TL);
 Wingspan 30" (76 cm)
p. 133

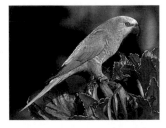

Scaly-breasted Lorikeet
Trichoglossus chlorolepidotus
Psittaciformes Loriidae
Australia
Eucalyptus forests near seacoasts
Approx. 9$\frac{1}{2}$" (24 cm) (TL)
p. 511

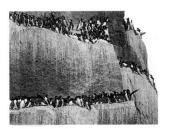

Common Guillemot
Uria aalge
Charadriiformes Alcidae
Northern parts of the Pacific and
 Atlantic Oceans
Seacoasts
Approx. 17" (42 cm) (TL)
 Wingspan 28" (71 cm)
p. 132

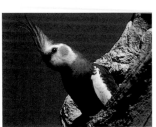

Galah
Eolophus roseicapillus
Psittaciformes Cacatuidae
Australia
Sparsely grown forests
Approx. 14$\frac{1}{2}$" (37 cm) (TL)
pp. 532, 533

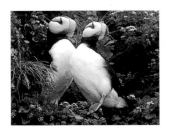

Horned Puffin
Fratercula corniculata
Charadriiformes Alcidae
Northern part of the Pacific Ocean
Seacoasts
Approx. 22$\frac{1}{2}$" (56 cm) (TL);
 Wingspan 22" (57 cm)
p. 129

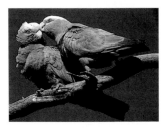

Cockatiel
Nymphicus hollandicus
Psittaciformes Cacatuidae
Australia
Sparsely grown forests and
 shrubberies
Approx. 12$\frac{1}{2}$" (32 cm) (TL)
Popular as pets worldwide.
p. 525

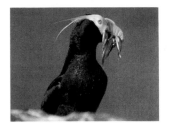

Tufted Puffin
Lunda cirrhata
Charadriiformes Alcidae
Northern part of the Pacific Ocean
Seacoasts
Approx. 15$\frac{1}{2}$" (39 cm) (TL)
pp. 128, 131

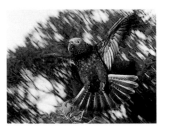

Kaka
Nestor meridionalis
Psittaciformes Psittacidae
New Zealand
Forests
Approx. 18" (45 cm) (TL)
p. 572

Crimson Rosella
Platycercus elegans
Psittaciformes Psittacidae
Australia
Tropical rain forests
Approx. 14" (35 cm) (TL)
p. 508

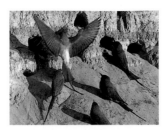

Carmine Bee-eater
Merops nubicus
Coraciiformes Meropidae
South of the Sahara Desert
Savannas and shrubberies
Approx. 15" (38 cm) (TL)
p. 284

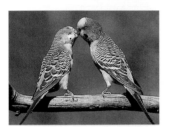

Budgerigar
Melopsittacus undulatus
Psittaciformes Psittacidae
Australia
Grasslands
Approx. 7½" (19 cm) (TL)
Many varieties were developed for
 use as pets.
pp. 534, 535

Lilac-breasted Roller
Coracias caudatus
Coraciiformes Coraciidae
Eastern and southern Africa
Savannas
Approx. 14½" (36 cm) (TL)
p. 438

Kakapo
Strigops habroptilus
Psittaciformes Psittacidae
New Zealand
Lowland forests to alpine forests
Approx. 25" (62 cm) (TL)
pp. 574, 575

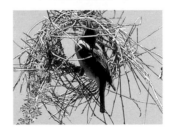

Grosbeak Weaver
Amblyospiza albifrons
Passeriformes Ploceidae
Africa
Marshes and woods
Approx. 7½" (19 cm) (TL)
p. 246

Oilbird
Steatornis caripensis
Caprimulgiformes Steatornithidae
Central America to the northern
 part of South America
Caves
Approx. 19" (48 cm) (TL);
 Wingspan approx. 40" (1 m)
p. 159

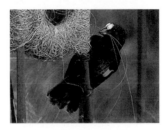

Red-headed Weaver
Anaplectes melanotis
Passeriformes Ploceidae
Africa, south of the Sahara Desert
Woods and shrubberies
Approx. 6" (15 cm) (TL)
p. 247

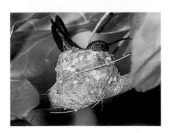

Hummingbird
Trochilidae sp.
Apodiformes Trochilidae
North America to South America
Various enviroments, from lowland
 to alpine terrains
Approx. 2½–8" (6–20 cm) (HBL)
There are 320 species.
p. 165

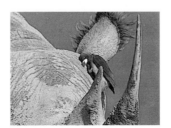

Yellow-billed Oxpecker
Buphagus africanus
Passeriformes sturnidae
South of the Sahara Desert
Around large mammals in
 swamps, grasslands, and woods
Approx. 9" (22 cm) (TL)
pp. 333, 339

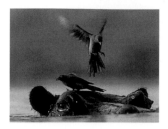

Red-billed Oxpecker
Buphagus erythrorhynchus
Passeriformes Sturnidae
South of the Sahara Desert
Around large mammals in
 swamps, grasslands, and woods
Approx. 9" (22 cm) (TL)
pp. 273, 283

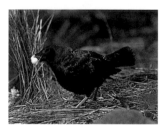

Satin Bowerbird
Ptilonorhynchus violaceus
Passeriformes Ptilonorhynchidae
Australia
Tropical rain forests and eucalyptus
 forests
Approx. 12" (30 cm) (TL)
p. 509

reptiles

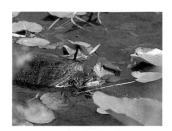

Florida Softshell
Apalone ferox
Testudinata Trionychidae
Florida peninsula
Rivers, lakes, and marshes
Males approx. 12" (30 cm);
 Females approx. 20" (50 cm) (CL)
p. 143

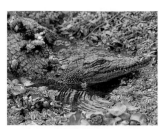

Freshwater Crocodile
Crocodylus johnstoni
Crocodylia Crocodylidae
Northern part of Australia
Rivers, lakes, and marshes
Approx. 10' (3 m) (TL)
p. 497

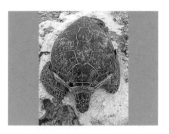

Green Turtle
Chelonia mydas
Testudinata Cheloniidae
All over the world; mainly ocean
 areas in low latitudes
Oceans
Approx. 44" (1.1 m) (CL)
pp. 62, 490–493

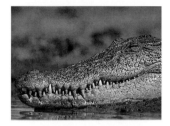

Saltwater Crocodile
Crocodylus porosus
Crocodylia Crocodylidae
Southern part of India to the
 northern part of Australia
Coastal terrains and brackish waters
Approx. 23' (7 m) (TL)
p. 496

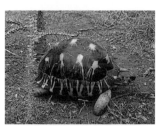

Radiated Tortoise
Geochelone radiata
Testudinata Testudinidae
Madagascar
Arid forests
Approx. 16" (40 cm) (CL)
p. 457

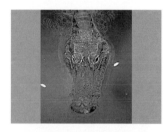

American Alligator
Alligator mississippiensis
Crocodylia Alligatoridae
Southern part of the United States.
Lakes, marshes, and swamps
Males approx. 13' (4 m);
 Females approx. 10' (3 m) (TL)
p. 142

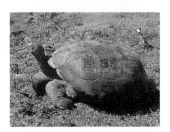

Galápagos Giant Tortoise
Geochelone nigra
Testudinata Testudinidae
Galápagos Islands
Inlands
Approx. 52" (1.3 m) (CL)
pp. 38–41

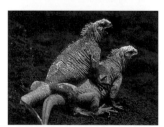

Marine Iguana
Amblyrhynchus cristatus
Squamata Iguanidae
Galápagos Islands
Seacoasts
Approx. 60" (1.5 m) (TL)
There are two to eight subspecies.
pp. 20–25

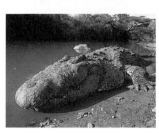

Nile Crocodile
Crocodylus niloticus
Crocodylia Crocodylidae
All over Africa, except desert regions
Rivers, lakes, and marshes
18' (5.5 m) (TL)
pp. 282, 384–389

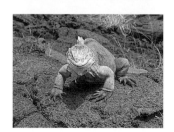

Galápagos Land Iguana
Conolophus subcristatus
Squamata Iguanidae
Galápagos Islands
Inlands
Approx. 48" (1.2 m) (TL)
pp. 28–29

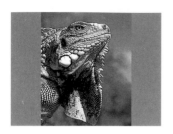

Green Iguana
Iguana iguana
Squamata Iguanidae
Central and South America
Forests
Approx. 6' (1.8 m) (TL)
p. 162

Centralian Blue-tongued Skink
Tiliqua multifasciata
Squamata Scincidae
Western part of Australia
Arid regions
16–20" (40–50 cm) (TL)
pp. 513, 522

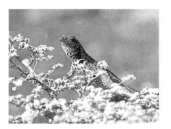

Lava Lizard
Tropidurus spp.
Squamata Iguanidae
Galápagos Islands
Sandy terrains and lava fields
Males 8–12" (20–30 cm) (TL);
 Females, less than half of the male
 size (TL)
There are seven species.
pp. 30, 31

Woma
Aspidites ramsayi
Squamata Boidae
Inlands of Australia
Deserts
Approx. 7½' (2.3 m) (TL)
p. 512

Moloch
Moloch horridus
Squamata Agamidae
Western part of Australia
Deserts
Approx. 6" (15 cm) (TL)
pp. 514–517

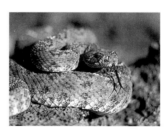

Tortuga Island Rattlesnake
Crotalus tortugensis
Squamata Viperidae
Tortuga Islands and Mexico
Rocky terrains
Approx. 40" (1 m) (TL)
p. 152

Jewelled Chameleon
Furcifer lateralis
Squamata Chamaeleonidae
Madagascar
Forests to inhabited areas
8–10" (20–25 cm) (TL)
p. 456

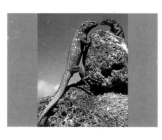

Jungle Runner
Ameiva sp.
Squamata Teiidae
Central and South America and the
 West Indies
Forests to seacoasts
16–24" (40–60 cm) (TL)
Naturalized into many regions.
p. 163

fishes

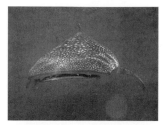

Whale Shark
Rhincodon typus
Chondrichthyes Orectolobiformes
 Rhincodontidae
Temperate and tropical oceans
Oceans
Approx. 33' (10 m) (TL)
p. 488

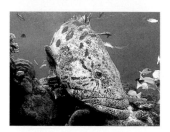

Potato Cod
Epinephelus tukula
Osteichthyes Perciformes
 Serranidae
Indian Ocean and the
 west Pacific Ocean
Oceans
Approx. 60" (1.5 m) (TL)
p. 489

cephalopods

Purpleback Flying Squid
Sthenoteuthis oualaniensis
Cephalopod Teuthida
 Ommastrephidae
Temperate and tropical regions of
 the Indian Ocean through the
 Pacific Ocean
Oceans
Mantle length up to 16" (40 cm)
p. 482

index | scientific names

index | common names